D0874569

Aesthetics, Empathy
and Education

This book is part of the Peter Lang Education list.
Every volume is peer reviewed and meets
the highest quality standards for content and production.

PETER LANG
New York • Washington, D.C./Baltimore • Bern
Frankfurt • Berlin • Brussels • Vienna • Oxford

Aesthetics, Empathy
and Education

Edited by BOYD WHITE & TRACIE COSTANTINO

PETER LANG
New York • Washington, D.C./Baltimore • Bern
Frankfurt • Berlin • Brussels • Vienna • Oxford

KH

Library of Congress Cataloging-in-Publication Data
Aesthetics, empathy and education / edited by Boyd White, Tracie Costantino.
pages cm
Includes bibliographical references.
1. Affective education. 2. Arts in education. I. White, Boyd.
LB1072.A39 370.15'34—dc23 2012046916
ISBN 978-1-4331-2011-4 (hardcover)
ISBN 978-1-4331-2010-7 (paperback)
ISBN 978-1-4539-1041-2 (e-book)

Bibliographic information published by **Die Deutsche Nationalbibliothek**.
Die Deutsche Nationalbibliothek lists this publication in the "Deutsche
Nationalbibliografie"; detailed bibliographic data is available
on the Internet at http://dnb.d-nb.de/.

Cover photo by Anniina Suominen Guyas

The paper in this book meets the guidelines for permanence and durability
of the Committee on Production Guidelines for Book Longevity
of the Council of Library Resources.

© 2013 Peter Lang Publishing, Inc., New York
29 Broadway, 18th floor, New York, NY 10006
www.peterlang.com

Printed in the United States of America

10/6/14

Contents

Introduction

BOYD WHITE

Introduction

In the early 1990s I happened upon David Swanger's (1990) text, *Essays in Aesthetic Education*. I found the text to be a helpful overview of the topic, especially on the parallels between Read, Dewey, and Plato, and the limitations of their respective views. However, the idea that had the most significant impact on me was David's notion: "The epistemology of art is empathy. And empathy must be part of education because knowledge without it is incomplete" (p.76). The idea struck me as so obvious that I wondered why it hadn't occurred to me before, and why I hadn't come across other educators saying more or less the same thing. Today, some of us are. As the ensuing chapters will show, the issue of empathy in the classroom is addressed in myriad ways and in increasing numbers in education literature today. We intend this text as a contribution to that growing body of literature.

When we sent out our call for papers, Tracie and I hoped that we would receive proposals that represented perspectives from across the curriculum. But perhaps it is in the arts that the connection is so readily made. Thus it is that all but one of the authors in this volume is affiliated with some facet of arts education. Perhaps, then, it is not surprising that the authors in this text share a

related interest—potential connections between empathy and aesthetic experi-
ence. Our voices are in differing keys. We each have our own particular emphases,
enthusiasms, and reservations. We are not looking for unanimity, except in our
pursuit of education that aims toward increased clarity in terms of our respective
practices. That is, the ideas articulated in this volume are intended to nudge, dis-
turb, or reinforce, and ultimately clarify our philosophical positions and educa-
tional practices regarding attention to aesthetics and empathy. We hope the
differing perspectives provide food for thought, not only for those involved in arts
education but also for those involved in the rest of the curriculum.

We could have included many more authors, but volume constraints forced
us to make difficult choices. Ultimately, we aimed to provide as wide a cross sec-
tion of teaching backgrounds and pedagogical perspectives as possible while
keeping within the limits set by our publisher.

To that end, we have divided the text into four sections. The reader should
consider the sections not so much as divisions but rather as links to the oth-
ers. Indeed, all the authors in each section address components in the other sec-
tions. So we intend the sections to be understood as emphases rather than
boundaries.

Thus, in Section I, the first three chapters address research methodology
from three quite differing perspectives. The second section consists of four chap-
ters. Here, the reader will find research addressed again but from a more sin-
gular focus: The self as research subject. The third section stakes out a more
philosophic stance in two chapters. And the fourth, in five chapters, looks at
a variety of approaches to classroom practice.

More specifically, in Chapter 1, Liora Bresler describes a strategy she uses
in a research methodology course. The strategy involves prolonged observation,
contextualization, and inquiry into two artworks that the author chose in
order to invoke quite opposite responses. In the one case, the students tended
to have positive responses. In the other case, responses were negative. Bresler's
goal was to expand individuals' perspectives, to disrupt their usual sense of self
while engaging with others' points of view. Such acts of engagement, Bresler
argues, are fundamentally empathic in nature, and crucial to the development
of a researcher's and teacher's personas.

In Chapter 2, Terry Barrett describes the premises underlying an undergrad-
uate art-writing course for preservice teachers and provides compelling examples
from several of his students. The course is modeled on the principles of arts-based
research, the conducting of research through artistic lenses. The particular lens
in use here is narrative. Underlying the student-produced research is a quest for

an understanding and cultivation of empathy—for self, others, and features in our world—through a careful study of particular artworks.

Laura Evans also makes extensive use of narrative in her research. In Chapter 3 she describes her use of narrative inquiry and auto-ethnography in a project that came to fruition within a museum education context. To initiate her research, Evans used a photographic exhibition entitled THIN, featuring girl culture. Evans examines the responses of 10 women to one image to see how educators might enhance compassion and a sense of community through interactions with socially sensitive imagery.

Section II begins with Chapter 4. Here, Sherry Mayo discusses her use of haven balls as avenues to reflections on and of herself. The term haven ball derives from works such as Vermeer's depiction of a globe in his *The Allegory of Faith* (1670).Such depictions are said to be spiritual symbols that unlock peace, beauty, and consciousness. Through her use of drawings in the framework of haven balls and what she refers to as a semiotic grid, Mayo explores the relationship between consciousness, empathy, and education.

In Chapter 5, Indrani Margolin discusses her quest for empathy within adolescent females through the use of dance, an embodied curriculum. Margolin describes her own evolution of self-awareness through dance and, similarly, the capacity for dance, especially when performed as a collaborative endeavor, to be empowering for the young women in her study. Evidence of compassion for self and others emerges in Margolin's chapter.

In Chapter 6, I (Boyd White) examine relations between empathy and aesthetics through the lens of evocative art criticism. The form of criticism I employ is ekphrasis, a poetic interpretation of, in this case, a painting. The point of the exercise is, in the first place, to exercise my own empathic powers to engage with an artwork; then, to invite others to share in the exchange. That is, ekphrasis has the capacity to move between the first- and third-person perspectives. The research is based on phenomenological epistemology and borrows from what Lawrence-Lightfoot and Davis referred to as Portraiture, for investigation of the self. It also provides an evocative teaching strategy.

Chapter 7, by David Swanger, is similarly poetry-focused. He begins the chapter with a brief dissertation on poetic theory, while at the same time acknowledging his homage to Coleridge and Wordsworth. Swanger then addresses the role of empathy in poetry, a component that, he argues, his two models do not address. Examples from Swanger's own poetry exemplify the need for empathic engagement, not just for the sake of the exercise but also in order to encourage living more fully.

Section III begins with Sean Wiebe's Chapter 8. Like the authors in the two preceding chapters, Wiebe's focus is specifically on poetry. We have placed Wiebe in this section because his chapter is more explicitly philosophically based, in this case, on the work of Jacques Lacan (and others with a similar bent). Wiebe's intent is to demonstrate connections between empathy, knowing, and being within an educational context.

In Chapter 9, Donald Blumenfeld-Jones examines, through the lens of French philosopher Emmanuel Levinas, relations between aesthetics and ethics, and the problematic nature of empathy in that relationship. The author then proceeds to argue that Levinas failed to grasp the potential of aesthetic experience to foster an ethical consciousness. In the final section of his chapter Blumenfeld-Jones links imagination and the Levinasian position to posit an education for ethical life through art experience.

Section IV, devoted more specifically to classroom practice, is divided into two sub-sections. The first of these addresses environmental education. The second is more diverse in focus.

In Chapter 10, Juli Kramer provides an extended overview of recent studies on multisensory experience, neurological processes, and how an understanding of such processes provides an enlarged view of both empathy and aesthetic experience. Kramer then suggests some possible applications of empathic and aesthetic experiences across the school curriculum. Kramer concludes her chapter by showing how theory fits practice as she describes a field trip taken by a small group of high school students to a wolf sanctuary.

Tom Anderson and Anniina Suominen Guyas continue the environmental theme, in Chapter 11, with their discussion of an Earth Education paradigm for art education. By this they mean an art education program that fosters an empathic stance toward, and a way of reconnecting with, the natural world. The authors conclude by presenting nine principles for Earth Education.

In a move away from the natural environment to the social environment in Chapter 12, Tracie Costantino explores the role aesthetic reflection might play in cultivating empathy in preservice teachers through practicum experiences with diverse populations. Costantino takes as her starting point Maxine Greene's notion of the imagination and its essential role in the exercise of empathy. She then provides examples gleaned, over two semesters, from her preservice teachers' experiences in aesthetic reflection as they assisted and taught in local schools. Costantino has her students make extensive use of visual journals to record their reflections, and these, in turn, provide her with data for her own reflections on teacher education.

Lauren Phillips and Richard Siegesmund continue the focus on the social environment in Chapter 13. More specifically, the authors address the place of caring as an aesthetic objective within a visual art curriculum. Care is their core content and chief educational objective pursued through the medium of art education and triggered by acts of empathy. The authors discuss the new (2009) Georgia State Visual Arts Performance Standards (GVAPS), which define aesthetics as, "a philosophy of what we care for and what we take care of. It is a philosophy of responsibility." Thus, learning to care is expressly stated as an educational outcome through the study of a core subject area. The chapter concludes with Phillips' description of a series of art classes that epitomize her elementary-level students' understanding of the meaning of care and empathy.

Our concluding chapter, Chapter 14, is written by Richard Hickman. The author begins his chapter with some surprising, to me at any rate, notes on the etymology and current variable uses of the word "empathy." Hickman then gives the reader a brief overview of current neuroscientific and evolutionary psychology investigations into empathy. On the basis of these studies Hickman concludes that humans are biologically pre-disposed to create aesthetic significance. On the basis of that conclusion he then posits four interrelated aspects of visual art education that can be associated with the promotion and development of empathy. Briefly, these draw attention to studio work coupled with a focus on imagination. Hickman's chapter is ultimately an advocacy paper. It seems a fitting note on which to conclude our text.

·SECTION I·

RESEARCH
METHODOLOGY

· 1 ·

The Spectrum of Distance

Empathic Understanding *and the* Pedagogical Power *of the* Arts

LIORA BRESLER

The goal of empathic understanding is often referred to as the raison d'être of qualitative research, from Wilhelm Dilthey to Robert Stake. While some aspects of research lend themselves well to learning through theories and skills, achieving empathic understanding is not limited to cognitive teaching, reading a relevant theory, or following a textbook prescription. Rather, it is a type of engagement. The evaluation of whether empathy has been achieved, too, is complicated: Though its presence is recognized for the reader, empathy cannot be measured.[1] I suggest that if the "far enemy"[2] of empathy in qualitative research is aloof, abstract cognition, the "near enemy" is surface encounter manifested in a reporting/summarizing style (and often in jargon-decorated judgments). While reporting and summarizing data have an important role in scholarly work, they are means to interpretation and understanding rather than ends. In this chapter I discuss the pedagogical power of the arts in cultivating empathic understanding through a dynamic exploration of distances.

When I first embarked on qualitative research, I turned to the arts to provide structure and lenses for perception and meaning making (Bresler, 2003). Later, becoming increasingly curious about further lessons from the arts, I discovered deeper teaching: The arts taught me a certain kind of "tuning"—engagement in inquiry that felt connected yet not-attached. In this chapter, I claim that the field of research methodology can greatly benefit from moving beyond the

dichotomy of detachment versus connectedness through the concept of non-attachment. A space of heightened observation can, with guidance, allow us to see ourselves and our engagement with more clarity, leading to openness to perceive beyond ourselves. This is where empathic understanding starts.

Engagement with an artwork provides experience of heightened observation that is analogous to the qualitative research experience. Appreciation and understanding of the arts require aesthetic distance, suspension of immediate emotional response towards further exploration. Engagement with an artwork, analysis of what is there, and recognition of one's own responses at various levels, are pedagogically easier to handle, as the "data" are bounded and much smaller in scope.

In striving towards the precariously balanced mindset of non-attached connectedness, I find it useful to distinguish between the concept of connectedness, crucial to all research, and its "near enemy," attachment. Connectedness involves intellectual (and invariably emotional) investment in the process of inquiry (Bresler, 2006), with equanimity about the outcome, whereas attachment involves investment in a specific outcome. The distinction between non-attachment and detachment is as important. While detachment carries intellectual and emotional baggage and is associated with cold-heartedness and indifference, the concept of non-attachment can incorporate connectedness but is equanimous. Research is distinguished from advocacy (or fraud) by its commitment to non-attachment. The challenge of qualitative research is maintaining an interest, a connectedness to what we study, and at the same time non-attachment to specific outcomes.

The mindset of connectedness and non-attachment involves finding the right balance of distances—moving dynamically and fluidly in a zone that incorporates different distances. This dynamic movement and navigation of distance, as I discuss below, is distinct from the fixed distance involved in positivist research (too far), as well as from the distance of everyday life (too close). Thus, qualitative research requires extrication from our habitual forms of seeing and judging, attachment and aversion, upholding the necessary distance involved in disciplined scholarship. The arts, I propose, can be great pedagogues in cultivating this dynamic space for the right set of distances towards empathic understanding.

The notion of empathy originated within the context of aesthetic theories in the 18th and 19th centuries. More recently Maxine Greene (2001) referred to empathy as "the capacity to see through another's eyes, to grasp the world as it looks and sounds and feels from the vantage point of another"[3] (p. 102). The arts, Greene argued, make possible the creation of "as-if" perspectives,

through the exercise of empathy. Candace Stout (1999) characterized empathy as "a disposition for sympathetic awareness" (p. 33). Inherent in each painting, poem, and piano sonata, Stout wrote, there is what Rader called a "living presence that calls to the beholder: Welcome to my world. When we attend to this artwork, we reach out to this living presence, and they to us, and we enter a dialogue about life" (Rader, 1973, in Stout, 1999, p. 33). This chapter focuses on establishing the right distance to create dialogues with artworks with an immediate transfer to qualitative inquiry.

In exploring how to cultivate this mindset in my research education courses, I design experiential assignments aimed to support students in finding the right distance to cultivate engagement and wonder for the development of empathic understanding. In the first assignment in the course, described here, the artworks function as cases, "bounded systems" (Stake, 2010) that provide rich encounters for interpretation, evoking personal (positive and negative) resonance. The setting of museums as places of contemplation supports the cultivation of a spectrum of distances.[4]

The first section addresses the right distance in relation to artwork and qualitative research. Next, I present the concept of non-attached connection as facilitating this distance and the arousal of empathic understanding. Addressing the attributes of empathy, and what makes it useful for expanding perceptions and perspectives, I refer to some of the contexts and uses of empathy, briefly mapping the conceptual journey of this term across disciplines, from philosophy and aesthetics to psychology and anthropology, and its recent entrance to various disciplines, including nursing, industrial design, and education. I conclude by portraying the museum activity as part of a qualitative research course, presenting a sample of students' papers, and reflecting on the ways in which the activity supports the cultivation of empathy. [5]

Artwork and the Cultivation of Wonder: Establishing the Right Distance

Why artwork? Fundamental to the power of the arts is their ability to engage us. The arts, as psychiatrist Daniel Stern (2010) has argued, manifest vitality in a relatively purified form; pure in the sense that the dynamic features of an art performance have usually been amplified, refined, and rehearsed repeatedly (p. 75). It is because of the vitality of the arts and the amplification of their dynamic features that the arts help us pay attention.

The uniqueness of artworks heightens our attention to the singular as a source of knowledge and understanding beyond the specific. This is parallel to the interest of qualitative research to the individual, contextual, case informing our understanding of larger themes and issues (e.g., Stake, 2010; van Manen, 1990).

A third aspect that characterizes engagement with the arts has to do with the right distance. Just as the fish is the last to notice the water, we, too, often fail to notice the familiar. Philosopher Peter de Bolla (2001) contended that the ordinary is too close for attention. The ordinary, de Bolla observed, is extraordinary in its ability to go unremarked. The everyday often has a strange power, what he called the "uncanniness of their proximity," to slip *behind* attention, almost as if it constitutes the screen upon which attention shines its light, thereby making the screen itself both unavoidably visible and, at the same time, invisible—the surface past which we must look in order to see what is projected on it (p. 64). It is, wrote de Bolla, as if in order to survive we need to construct a mode of inattention, creating a domain too close for the reach of attention. In order to see, we need to take the right distance.

De Bolla (2001) termed the intense encounters with individual artworks the "practice of wonder" (p.130). Wonder creates a distance by taking things out of their "for granted" position. Wonder, as Terry Barrett (2003) observed, is closely tied with interpretation:

> Interpretation is articulated response based on wonder and reflection. Works of art are mere things until we begin to carefully perceive and interpret them—then they become alive and enliven us as we reflect on, wonder about, and respond to them. (p. xv)[6]

Wonder and interpretation are also at the heart of qualitative research. In my experience as a researcher, it is in the stage of wonder that the study moves beyond concepts and procedures, becoming "alive," energized, and energizing. Contrary to what textbooks imply, wonder can happen weeks after I have produced a proposal with an appropriate and genuine query. For me, it is often activated in fieldwork, in the encounter with people and real-life situations. Because wonder and interpretation are experiential, they cannot be summoned on demand and are elusive. They don't lend themselves to prescriptions and textbook knowledge. I experience wonder as gentle but with an energy that is distinctly present. It is that potent presence that enables the letting go of my habitual ways of seeing and responding, allowing an opening for a fresh encounter, and the possibility of empathic understanding.

Non-Attached Connection in the Arts and in Qualitative Research

The specific distance embodied in non-attached connection is well established in the field of aesthetic education.[7] Our response to food presented in the still life of Caravaggio and Cézanne is different from our responses to TV advertisements. However, within the context of research methodology the issue of the right distance between the researcher and the researched is contentious. Distance is often marked as the distinguishing line between the worldviews of positivist "hard" sciences on the one hand, versus post-positivist "soft" sciences on the other. The former requires objectivity and distance. The latter claims subjectivity and connection. Both communities regard distanced connection as an oxymoron. I suggest that both non-attachment and connection are most generative of empathic understanding when regarded as complementary.

Philosophies of science and research methodology trace the importance of detachment and objectivity to the Enlightenment's quest to reduce religious dogma in intellectual arenas (e.g., Lincoln & Guba, 1985). Descartes imported the Galilean concept of detachment from physics into the discipline of philosophy, later to be adopted as a fundamental axiom in the social sciences (Spinosa, Flores, & Dreyfus, 1997). Within a Cartesian research culture that has highlighted objectivity and distance, empathic connection—putting oneself in another's place—is a violation. Indeed, positivist social science tabooed connection to research participants, called "subjects," for fear of emotional entanglement.

Avoiding connection was relatively easy to follow in the field of laboratory psychology given its setting, structures, and key participants—mostly mice and rats. It was harder to maintain in disciplines that required prolonged engagement in social settings and extensive interaction with human participants. The discipline of anthropology was a pioneer in tackling the issue of distance in research (difficult to maintain through prolonged engagement in a remote setting when researchers were dependent on their participants, as Malinowski experienced nearly a century ago).[8] Empathic understanding came to distinguish the aims and processes of the human sciences (including educational research) from other forms of research (cf. van Manen, 1990; Stake, 2010).

In most social sciences (to various degrees and at a somewhat different pace), the pendulum swung in the last 40 years from the demand for objectivity to the acknowledgment of situated subjectivity. The rejection of the notion of objectivity (e.g., Lincoln & Guba, 1985; Peshkin, 1988) meant for many the rejection of detachment, a concept that has come under fierce attack by post-

modernist views. I claim that it is precisely the juxtaposition of connection within distance that is most generative for qualitative research, allowing expansion of perspectives and empathy. In this process, detachment has a useful role.

Detachment, Spinosa et al.(1997) contended, enables us to obtain a wider view by extracting ourselves from the immediate pressures of the moment, and to see what is before us in terms of its relationship to other matters.

> To understand what is happening, say, in a bustling port or on a battlefield, a port supervisor or a general who seeks detachment would find high ground from which to view operations below in their interrelations as a whole. Detachment enables us to extract ourselves from the passions of the moment so that we can be objective, that is, think and speak out of the composed mood that characterizes both our normal life and those moments when we feel ourselves to be thinking most clearly. (pp. 6–7)

These observations point to the two-sidedness of detachment, detachment *from* passion and detachment *in order to see* all the relevant interconnections. The former facilitates the latter. These two types, Spinosa et al. maintained, support a third type that is related to distance in both the arts and qualitative research methodology—detachment from habitual and practical forms of seeing. I propose that detachment from habitual seeing is characteristic of the practice of both artists and qualitative researchers, enabling one to go beyond recognition of the familiar, towards heightened perception,[9] to "make the familiar strange."

Empathy: The Journey of a Concept

Connectedness and non-attachment are central to empathy. Like the concept of aesthetics, empathy's linguistic roots are in ancient Greek, while its intellectual heritage dates from 18th- and 19th-century German philosophy. The concept of *Einfühlung*, "feeling-into," defining the ability to feel into nature through a process of poetic identification, was used by 18th-century philosophers and literary figures Herder and Novalis as a vital corrective against the modern scientific attitude of dissecting nature (Stueber, 2008).

By the end of the 19th century, "Einfühlung" was understood in German philosophical circles as an important category in philosophical aesthetics conveying our ability to "feel into" works of art and into nature (Stueber, 2008). German philosopher and aesthetician Theodor Lipps (1851–1914) developed the concept of *Einfühlung,* broadening it from philosophical aesthetics into a central category of the philosophy of social and human sciences. Lipps's notion of *Einfühlung* goes beyond aesthetic appreciation of objects to recognize other

people as minded creatures (Stueber, 2008). Lipps conceived of empathy as a psychological resonance phenomenon that is triggered in our perceptual encounter with external objects, thus linking aesthetic perception to perception of other people. The nature of aesthetic empathy, Lipps argued, is always the "experience of another human" (Lipps, 1905, p. 49, in Stueber, 2008, n.p.). Following on from these ideas, British psychologist Edward Titchener (1867–1927), a student of the German philosopher and psychologist Wilhelm Wundt, drew on this concept to develop his ideas on the structure of the mind, translating "Einfühlung" into English as "empathy." Moving to Cornell to establish a large program of psychology, Titchener continued to explore the different components of consciousness, highlighting introspection and description of qualities (rather than the reductive labeling), two aspects central to qualitative research. Description of qualities implies rich description; introspection involves self-observation and reflection that is fundamental to awareness of subjectivities.

The Anglo concept of empathy, coined by Titchener in 1909, was shaped by the intellectual context of aesthetic perception, at the end of the 19th century and early 20th century. The dominant positivistic and empiricist conception maintained that sense data constituted the fundamental basis for our investigation of the world. However, from a phenomenological perspective, our perceptual encounter with aesthetic objects (whether art or nature) and our appreciation of them as beautiful (or not) seem to be as direct as our perception of an object having a color or shape (Stueber, 2008). By appealing to the psychological mechanisms of empathy, philosophers aimed to provide an explanatory account of the phenomenological immediacy of our aesthetic appreciation of objects. Since our attention is perceptually focused on external objects, we experience qualities (e.g., beautiful, ugly) to exist in the object (Stueber, 2008) rather than in the interaction (or the self).

At the beginning of the 20th century, the focus on the experience of others became the core of the human sciences. Empathy understood as a non-theoretical method of grasping the content of other minds became closely associated with another German concept, *Verstehen*, interpretive understanding. German philosopher Wilhelm Dilthey (1833–1911) distinguished between the natural and human sciences, claiming that "we explain nature, but understand the life of the soul" (Dilthey, 1961, vol. 5, p. 144 in Stueber, 2008). Whereas the primary task of the natural sciences is to arrive at law-based explanations, Dilthey argued that the core task of the human sciences is the understanding of human and historical life. Understanding the meaning of a text, an action, or an artwork requires a mental act of "transposition," relating it to our own mental life

accessible through introspection. Dilthey introduced the notion of *Verstehen* into philosophy and the human (http://en.wikipedia.org/wiki/Human_sciences) sciences to describe putting oneself in the shoes of others to see and experience things from their perspective. Even though Dilthey himself did not use the word empathy, his ideas facilitated thinking about understanding as a form of empathy. The concepts of empathy and understanding were used almost interchangeably in order to delineate a supposed methodological distinction between the natural and the human sciences (Stueber, 2008; Makkreel, 2011).

In the first part of the 20th century the notion of empathy was generally criticized by philosophers as naïve, and was neglected, to be revived in the second half of the century by psychologists and anthropologists. Social psychologists regarded empathy as central to understanding human agency in ordinary contexts (Stueber, 2008). In contrast to mere emotional contagion à la Tolstoy (1898), genuine empathy presupposes the ability to differentiate between oneself and the other. Lipps's emphasis on the distinction between self and others is central in our current use of empathy (as the aforementioned reference to Greene, 2001, p. 102, indicates). Humanist psychologist Carl Rogers (1959), for instance, noted the importance of perceiving the internal frame of reference of another person with accuracy and with emotional components and meanings as if one were the person, but without ever losing the "as if" condition. Similarly, psychologists Decety and Jackson (2004) emphasized the sense of similarity in feelings experienced by the self and the other, without confusion between the two individuals.

Empathy has become central in cultural anthropology as both a tool and goal of qualitative research. Anthropologists who spend considerable time in the field with their participants have recognized the importance of connections and at the same time the dangers of being too close. Edward Hedican's (2008) recent entry on empathy in the *Sage Encyclopedia of Qualitative Research Methods*, for example, reflects the concern about the right distance in ethnographic research and the dangers of too close and too far:

> One of the possible difficulties of developing empathy with the subjects of qualitative research is that one's objectivity may diminish. Rapport with research participants helps to understand their attitudes, feelings, and lived experiences, but it also may lead to over-identification....Developing rapport and showing empathy for the subjects of research can lead to useful insights into the lived experiences of local peoples, but it can also lead to a diminished objective viewpoint that may hinder placing the results of one's research in a wider context. (p. 253)

The notion of empathy has entered various disciplines. In industrial design, for example, empathy is used in the context of identification with clients' emotions, in order to help design become more innovative (e.g., McDonagh & Thomas, 2010). In nursing, Michaelsen (in press) discusses empathy and sympathy in relation to work with difficult patients. Empathy in education is addressed by Australian Roslyn Arnold (2005), who examined empathic intelligence as the phenomenon of inter-subjective engagement.

Research Education and the Cultivation of Empathy Through Engagement with Art[10]

Given the importance of empathy in qualitative research, can empathy be taught? Research courses are often about the acquisition of a defined body of knowledge and set of skills, promoting an attitude of "doing it right" rather than gaining habits of mind (and heart). Students' ability to follow directions and learn traditions, though useful for research, can result in a "dutiful" rather than engaged mindset. However, duty can carry us only so far when it comes to the qualitative goals of interpretive, empathic understanding. Given the experiential nature of qualitative research in general, and empathic understanding in particular, I regard the research methodology course in which the activity described below occurs as an *occasion* rather than as a tool.[11]

My museum activity is conducted early in the semester, often on the first week after an overview of qualitative research, goals, assumptions, and main tools. The assignment builds a foundation for subsequent class activities and eventually fieldwork research.[12] Specifically, this assignment targets the skills of observation, contextualization, conceptualization, and generation of further inquiries. It seeks to support students/researchers in forming an intensified relationship with a case, getting beyond habitual, surface ways of seeing and hearing, in the same process they will need to activate in their own research projects. Towards that end, I structure a visit to the local art museum, asking students/researchers to choose two artworks. The choice of paintings, sculptures, or installations, compared to the ever-moving temporal world of music, drama, and dance, implies relative stability of qualities.[13] Here is a brief version of the assignment:

1. Choose two artworks, one that appeals to you and one that does not (either one that evokes aversion or one that leaves you neutral). Stay with each 30–40 minutes. Take field-notes to describe in detail what you see, noting time.

2. Identify themes and issues, reflecting on their significance.
3. What are you curious about? Generate a list of questions to expand your understanding (5–6 questions each) to:
 a. The artist.
 b. The curator.
 c. A person of your choice.
 Reflect on what it is that you would like to learn and how their perspectives will enhance your understanding of the artwork and your issue.
 d. Identify relevant contexts.

Indeed, artistic experiences offer important models for a connection within an analytic state. In his book *Move Closer: An Intimate Philosophy of Art*, John Armstrong (2000) identified five aspects of the process of perceptual contemplation of an artwork that, I believe, exemplify this relationship: (1) noticing detail, (2) seeing relations between parts, (3) seizing the whole as the whole, (4) the lingering caress, and (5) mutual absorption. Although these specific terms were generated in the area of art appreciation, I find them to apply powerfully to research.

The assignment of two artworks, one that students find appealing—that is, that they connect with easily—and another one that they don't, is meant to facilitate two types of journeys. The requirement to spend 30–40 minutes with each artwork, beyond habits and often comfort zone, parallels prolonged engagement (Lincoln & Guba, 1985) in both fieldwork and data analysis. This assignment, as I explain, is not meant to demonstrate knowledge in art history but is rather centered on deepening perception, interpretation, and openness to emerging themes and issues.

The list of questions addressed to individuals situated differently in relation to the artwork (e.g., the artist; the curator in the museum; the person who first bought the work) aims to explore perspectives of others situated within different relationships and distances to the artwork. This exercise serves as a prologue to a subsequent course activity where students practice the craft and art of interviewing. The identification of relevant contextual information, too, is aimed to expand horizons beyond the concrete, bounded case: What else would they need to know to better understand and relate to the artwork? Where will they search for this information? Here, students identify their wonderings and come up with queries to further their understanding and knowledge.

Individual Journeys in Cultivating Empathy

Below are excerpts from two (out of 32) papers of recent (Fall 2011) students in my qualitative class representing the explorations of distance and processes of inquiry that move them toward interpretive, empathic understanding. Shana focused on an artwork that she liked, Emily on an artwork that she did not; Shana chose a prominently placed outdoor sculpture, that in all the years that I have conducted the activity, she was the first to choose.[14] The artwork on which Emily focused drew the (independent) attention of six other women (out of the 24 females and the eight males. This was the only artwork chosen by more than one or two students at most).[15] The original papers were about 20 pages each, here reduced to a two-page excerpt.

Shana Riddick is a second-year doctoral student in the Department of Education Policy Organization and Leadership, with a background in performing arts. She positions her research within a social justice framework firmly rooted in her own racial background. The cultural understanding she presents in this piece was informed by her knowledge of student-led protests, in the 1970s, to remove her high school's former mascot—"The Warrior."

Shana Riddick: Welcoming and Honor

At 12:18 pm, I began my formal observations. I took time to simply stare at the piece, without writing, and then process what resonated. The same sentiments I had of the piece when I walked up to the statue, the previous day and that morning, became even clearer. I saw the piece as an instance of Native American inspired art. The piece manifested itself to me as a bird standing upright with its wings outstretched. The particular bird that this piece reminded me of was the thunderbird. I commonly see the thunderbird, a pinnacle creature of strength and spirituality in many indigenous tribal groups' cultures, presented one-dimensionally, allowing a viewer to see its stature, elaborate wings and thick tail all at one time. I saw a similar representation with this piece. From my perspective, I grounded the piece within a particular cultural context from which I further constructed my understanding. At 12:18 pm, I observed the piece from a bench roughly 24 feet in front of the statue's base. From this angle I took in the statue's grand size. It appeared very tall and regal to me. Its coloring and textural imprints were also reminiscent of design patterns present in indigenous artwork. At this distance I realized that I was taking in the piece as a whole, and what mostly stood out was its size.

At 12:25 pm I moved closer, I was then standing approximately 18 feet in front of the statue. From this place I noticed cylinder-shaped structures running up the middle of the piece that reminded me of a vertebrate or spine. The two pieces on either side of the statue, which I perceived as wings, seemed to envelop the structure. Their shape reminded me of an embrace. From this thought, I wondered if the piece was meant to connote welcoming or fellowship—that all patrons are welcomed into the embrace of the museum. From this depth, I also noticed "cut-outs" in the wings' overall structure giving them more depth and giving me the ability to imagine what they may have looked like in motion.

At 12:33 pm, I moved to about 12 feet in front of the statue. From this vantage what most clearly stood out to me were the imprints running through-out the piece and the statue having distinct sections. There seemed to be an order to the imprints, a possible meaning embedded in the imprints that I was unaware of—a language that I did not speak. I perceived the statue as broken up into three main bodily sections. There appeared to be a head that rested on the top of the statue, followed by a torso section with two sets of wings (one larger and one smaller), and the third section contained a tail with another set of smaller wings, both of which the thunderbird seemed to be perched upon.

At 12:43 pm I moved within 6 feet of the statue and from this perspective what most resonated was the design imprinted throughout the piece. I noticed more specific symbols and patterns, such as circular structures and images of the sun. There were both vertical and horizontal lines that ran singularly and in pairs throughout the piece. There was also an outline that appeared within the statue's different sections. I realized that my own movement towards the statue enhanced my perspective of the piece because it allowed me to witness the piece as a whole as well as in relation to its individual parts. I was able to see the artwork on multiple levels allowing for a richer understanding.

Two themes that resonated with me while I viewed the piece were representation and honor. While I observed this piece of art, which I took to personify the majesty of the thunderbird, I could not help but juxtapose this representation of Native American culture with the university's representative mascot—the Chief. I was actually shocked when I came to this school and realized that the university's fallen mascot (abandoned only because of NCAA regulations) was a primitive one-dimensional caricature of Native American culture. In both instances ideas regarding Native American culture and history are used to introduce a general public to a given space—either the museum or the university. From my historical and cultural understanding, I do not perceive the Chief to be a constructive representation which made me initially view the Thunderbird and the Chief as oppositional figures. However, as I thought about it further I could find similarities between the two images.

As stated both pieces are used as representation, but also some may argue that both images are used to honor the spaces they are associated with. Honor was the second theme that resonated with me as I reflected upon the statue. The Chief and the thunderbird definitely differ in terms of how I perceive them and the meaning I attach to them. However, as a qualitative researcher I know that there are multiple truths that must be examined, and through an appreciation of those truths one learns to empathize with others' experiences. There is a clear alumni and student body at the university that perceives the Chief as a constructive image. This may be because they grew up with the image and it holds a great familiarity for them. It is what they know, and therefore, for them that makes it correct or positive. I come to the Chief as an outsider. I am not from this space and carry with me my own experiencing that challenges this type of caricature portrayal of human beings. Yet, I have heard students talk about the Chief as the school's attempt to honor and show pride in local Native American cultures. They understand it to be a cultural privilege for Native Americans to be represented by the university in this public fashion. Depending upon who one asks, both the museum's thunderbird and the Chief can embody honorary status to particular viewing publics.

Some of the questions I had when observing the Krannert piece were directed at the artists, buyer, and museum's designers. I wondered if the piece was designed for the space. I know that through my observations I am attaching a lot of my own ideas to the piece based off my own experiences and perspectives. I wondered, if the piece was not designed for the space what meaning is lost since it would currently be viewed outside of its original context? How was the piece chosen to act as a representative image, ushering individuals into the museum? I wanted to know who made it and who bought it? I was curious to know how the artist understood their creation and the meaning he or she attached to it. Since this piece did not have any type of identification card I wanted to leave this observation session with some idea regarding the origins of the piece.

Beginning with the guard in the lobby I was ushered through three different museum personnel until I was introduced to a curator who was able to provide me with some historical context for the piece. The curator printed me an information card that noted the artist as Marko. He was an Italian artist, who constructed the piece in 1961. It was also purchased by the Krannert family in 1961 to be a part of the museum's initial installation when it opened. The curator was under the impression that the piece was created for the space. If this is the case, I wonder what the conversation between buyer and artist was like. Did the Krannerts help inform Marko's creation, or was he free to produce a piece of art of his own choosing? I thought that it was interesting that at the artwork's installation in 1961 it shared representative duties on campus with the Chief. The two images, therefore, have a long shared history on the University of Illinois campus.

This assignment helped to usher me back into the mindset needed to complete observations in qualitative inquiries. It made me conscious of some of the skills I will need to possess when entering a research site.

Shana experiments with physical distance, experimentation facilitated by the size of the sculpture and the outdoor space around it. Each vantage point enables her to note different aspects of the sculpture, capturing nuanced details and complex relationships. Her conceptualization of the themes of representation and honor (the sculpture had no title or artist's name) and her ability to abstract and transfer beyond the specific sculpture lead her to bridge what has been in the past few years a chasm of camps at the University of Illinois—the Chief symbolizing for many campus faculty and students a blatant manifestation of racism. The paper reflects Shana's ability to get beyond her commitments and identifications to bring a measure of empathic understanding to Chief supporters. This does not mean, of course, that she becomes a supporter of the Chief but that she is able to understand the position of those who are. Her questions regarding contexts lead to important issues about artistic processes, as well as aesthetic and sociological ones, including the role of the arts in society in representation, and creators of identity.

The second example is by Emily Dorsey. This is Emily's third year of a PhD in Special Education with a focus on policy issues, following several years working as a consultant for young students with disabilities. This excerpt focuses on an artwork that initially evoked a negative response.

Emily Dorsey: *A Thousand Pities III*

The first work I chose was by Sam Jury, a British artist born in 1974. The title was A Thousand Pities III; it was created in 2007–2008. I found the painting to be very disturbing, but the context in which it hung was equally troubling....

Although the picture intimidated me, I did my best to stare straight at it. The picture is on a freestanding gray wall in the middle of the room. The artwork is centered, placed at the bottom half of the wall. The background of the picture is teal. It reminds me of the sea but with an eerie glow. In the center of the painting is the face of a very sad woman. She is also centered in the bottom half of the painting, mirroring the painting's placement on the wall. The woman's distinguishing features are her sad eyes. They draw me in. The woman appears ragged, exhausted, hopeless, and incredibly lonely. There are dark shadows under her eyes. Her lips are red but the color is smudged. The top of her head is black. Perhaps this is a cap or her hair is pulled back. Her eyebrows are sparse. The light seems to hit her from the front and from below, lighting certain features, and casting sharp shadows.

Staring at the artwork, I first noticed details which I used to construct a narrative. At first I think she is abandoned, possibly kidnapped or raped, and that she is homeless. She lives on the streets and belongs to no one and her life is not anchored in a home or community. I notice that there is not even a tag next to the picture. I think that even the artist has left her. (This theory turned out to be wrong when a museum assistant showed me the tag on the opposite side of the wall.) What could have happened to her to make her so sad? It couldn't have been just one thing. And where is the woman living now? Is she on a street corner, or near a body of water, maybe in an underpass on the highway?

As I write more details, I realize that my initial theory is likely wrong. She has light hitting her from several angles. She must be somewhere in public. The other details I begin to notice are the smudged colors on her face. There is a deep mauve on her eyelids, spread out to the sides. Under her eyes are black smudges. Parts of her lips are shiny red, but the other parts are bland neutral. I think that she had recently applied make up and now it is all rubbing off. I don't think she lives alone, homeless, anymore. I think she lives in a real world, with real people. Others see her and see this pain. She is isolated, but it is not physical.

Curiosities for the artist: The artist was born in 1974, just four years before me. I have close friends his age, and I feel a connection to him. I have had deep sadness and grief in my own life, yet the feeling he creates is foreign to me.

Questions for the artist:
1. What happened in your life that made you understand such deep sadness?
2. How do you want people to feel when they see this painting?
3. Does this woman represent a real person that you know, or is she an imaginary vehicle used to convey emotion?
4. What does the title mean? Does the woman feel a thousand pities, or do a thousand others feel pity for her? Or are both of those interpretations too literal?
5. What is the narrative that accompanies the woman in this painting? Or do you purposely not want the audience to know that narrative? Does she have a narrative at all?
6. How long did it take you to paint this? Did its creation have an impact on your life?
7. Do you know where this art hangs now? Do you intend to follow this painting if it travels to other locations?

Lingering Caress and Mutual Absorption: In the reading for class, Bresler describes Armstrong's five aspects of contemplating artwork. The first three (noticing detail, seeing relations between parts, and seizing the whole as a whole), I understood, felt I could do, but I do not agree on the order. For me, seizing the whole as a

whole came first. There is a life to the picture that drew me in. The picture spoke for itself and was already a complete entity. This initial impression was when I felt a sense of empathy; it was when I most related to Stout's reference to what Radar calls "a living presence that calls to the beholder." After I sensed that living presence and that wholeness, I noticed details and relationships among parts, which changed my notions of the whole. These steps were a cycle that created understanding, and they were much the same as the steps I take in getting to know a person. There is an initial impression, an acknowledgment of details and relationships among parts, and then an adjustment of my initial impression.

I felt this way as I viewed A Thousand Pities, III. *The look in the woman's eyes drew me in. Because I had an assignment to notice detail, I began to describe her and her surroundings. I looked for a narrative and for ways to confirm or disprove that narrative, and eventually I looked away. When I looked back at the whole, it struck me differently. My feelings changed from fear to pity....*

Mutual absorption is also a hard concept for me to understand. I believe this refers to the idea that my mind is absorbed in the art, and that my body and mind absorb the art as well. I think I did experience mutual absorption during my time with A Thousand Pities, III. *My interaction with the art impacted me, and those impacts will stay with me. I have developed strong associations, memories, and feelings about this work through my observations, conversations with classmates, and the writing of this paper. In some ways, I have changed. While I am not yet sure of the significance of these changes, there are certainly changes.*

While each of the seven women who chose this artwork referred to sadness and pain, each of them had a somewhat different response, typically relating to the personal narrative of the individual students. For example, a student who chose it as her positive picture was reminded of a 19-year-old friend who died of cancer. Another was reminded of a depressed sister. Like Emily, all students moved beyond the immediate personal response and initial story to identifying the integrity and details of the particular image. The questions to artist, curator, and other visitors opened up the possibility of multiple relationships and interpretations. The use of archival information (information on the artist and his biography and credo as well as his other artwork) added the perspective of the creator, opening to further inquiries. The sustained immersion with the image triggering negative response took the viewers to new places, since most don't linger with negative images and therefore don't have the opportunities to deepen perceptions and interpretations. Many noted that the prolonged engagement with an artwork that was difficult typically made their discoveries more interesting, taking the observers to the "places that scare us," and beyond.

Cultivating Empathic Understanding: From Art to Qualitative Research

The dialogue with the artwork generated progressive seeing and understanding and the recognition that meanings change and deepen. The prolonged engagement is a requisite to experimentation with distance: farther, closer, different angles, searching for information and exploring multiple perspectives to gain a deepened complexity. The lingering, often occurring outside the museum, physically far from the artwork, was introspective, taking students to their inner selves. Inner selves are often too close to note. The free associative place of lingering caress facilitated a dialogue between student and artwork that made the strange familiar, reducing the initial distance. From their free associations, students could wonder about the artist's intent, providing a path toward empathic understanding. At the same time, the interplay of outside and inside enabled students to see more clearly their own subjectivities, values, and responses. The free associative period that they were able to access within themselves after some time with the piece of art led them to wonder in an empathic stance with the artist. As the artwork became familiar, the inner self, typically too close for attention, became visible. The specific assignments to observe from an emotional distance implied by the focus on meticulous observations—describe details, note relationships with an inquiring mind—supported a space of non-attachment.

An important aspect of the experience is the exploration of different encounters with the artwork. Initially, the encounter was one-to-one, the student with the artwork, sometimes once, often with repeat visits. Later on, the encounter involved consideration of third parties—invoking the artist, the first buyer, the curator, each of them situated within a different perspective. Still another kind of distance was created by the requirement to communicate observations, thoughts and feelings to others. This sharing was done with the whole class, each student presenting as well as listening to others. A third type of processing and engagement occurred through transferring field-notes and data records (which they used for sharing with others) to create a (graded) paper of 8–20 pages. Image and experiences, physical, emotional, and cognitive, were transposed into words, first orally communicated, then written and composed as a paper. Thus, this experience was not only prolonged, but was also one that involved a range of distances. The prolonged engagement was not only "in the field," with the artwork, but also with oneself (the researcher as the key instrument), through writing.

This exercise is a beginning for qualitative research, a space to cultivate a mindset. The use of museums supports the cultivation of an observation that is

also participatory, moving closer to an unfamiliar artwork, and gaining enough distance from ourselves to gain insight into our subjectivity. A week or so later, the next assignment, while building on similar guidelines, is focused on a temporal event, typically a festival, concert, or play in a communal space—a performing arts center or library. In addition to the temporal, ever-changing dimension, students need to negotiate the complex and demanding role of *participant*-observer (as compared to the more stable mindset in the museum of *observer*-participant). Students are asked to further develop the qualities they cultivated in the museum exercise in a situation resembling real life. A related, ongoing aspect of the course is reading scholarly works—some favorites include Barbara Myerhoff's *Number Our Days* (1978); Alma Gottlieb and Philip Graham's *Parallel Worlds* (1994); and Joe Tobin, Yeh Hsueh, and Mayumi Karasawa's *Preschool in Three Cultures Revisited* (2009)—to reflect on the ways that empathic understanding is achieved and communicated. Woven as part of educational experiences, theories and methods, we note how distance/objectivity and closeness/subjectivity—often perceived as opposing—operate in fact in tandem to create a richer empathic understanding. These ethnographic works provide yet another connection between the arts and qualitative research in exemplifying their functionality as "things of use, things of beauty" (the title of Barone's classic case study, 2001). Defying false dichotomies, qualitative experience can remind us that scholarship is at its best when the work is engaged and engaging, and when beauty meets usefulness in expanding knowledge and understanding.

NOTES

The chapter is dedicated to Bob Stake who introduced me to the concept of empathy in the context of qualitative research. I am indebted to Kelly Bradham, Betsy Hearne, Teija Löytönen, and Sue Stinson for reading early drafts of this chapter and for their insightful comments.

1. I would like to thank Boyd White for the suggestion that some advances have been made in research on empathy, for example see Lawrence, Shaw, Baker, Baron-Cohen, and David (2004).

2. In the Buddhist discussion of the four highest attitudes, the far enemy is the opposite quality, whereas the near enemy is a quality that can masquerade as the original, but is not the original. For example, the far enemy of compassion is cruelty, where its near enemy is pity. The far enemy of love is hatred, while its near enemy is attachment. (Insight Meditation Center, n.d.)

3. In contrast to a popular use of "the intuitive ability to become one with another" (Greene, 2001, p. 102).

4. Museums, as Elizabeth Ellsworth has pointed out, are regularly designed with explicit pedagogical intent (Ellsworth, 2005, p. 42).

5. For a broader discussion of the use of artwork in the teaching of qualitative research as part of cultivating students' skills of observations, interpretations, and conceptualization, see Bresler (2012).

6. Tracie Costantino suggested that a focus on wonder may provide an avenue for educators who believe in the ameliorative potential of art education to foster social change (Costantino, 2010, p. 64).
7. For a recent volume on aesthetic education, see Costantino and White, 2010.
8. For more recent, outstanding examples see Gottlieb and Graham, 1994;Stoller, 1989.
9. A point made by Dewey, who commented on our tendency to recognize rather than perceive (1934, p. 52).For an elaboration of this point, see Higgins, 2007.
10. I have referred to this assignment in a different course in Bresler, 2012, in a chapter focusing on teaching qualitative research methodology.
11. Here, I am paraphrasing Tom Barone (2001), who suggested that, when used for educational purposes, a text of qualitative inquiry is better viewed as an occasion rather than as a tool.
12. I like to schedule an observation of an event (e.g., a concert, a festival) the week after the museum observations.
13. Musicologist David Burrows has noted that where sight gives us physical entities, the heard world is phenomenally evanescent, relentlessly moving, ever changing (Burrows, 1990). For a discussion of temporality and stability in research, see Bresler, 2005.
14. In fact, though I have passed this sculpture many thousands of times in my 24 years at the University of Illinois, I have never seen it.
15. Initially, I considered focusing on these seven papers to note the similarities and differences in the empathic journeys, but opted to show different choices to provide a flavor of the diversity of artworks.

REFERENCES

Armstrong, J. (2000). *Move closer: An intimate philosophy of art.* New York: Farrar, Straus and Giroux.
Arnold, R. (2005). *Empathic intelligence: Teaching, learning, relating.* Sydney, Australia: UNSW Press.
Barone, T. (2001). *Touching eternity.* New York, NY: Teachers College Press.
Barrett, T. (2003). *Interpreting art: Reflecting, wondering, and responding.* New York, NY: McGraw-Hill.
Bresler, L. (2003). Out of the trenches: The joys (and risks) of cross-disciplinary collaborations. *Council of Research in Music Education, 152,* 17–39.
Bresler, L. (2005). What musicianship can teach educational research. *Music Education Research, 7*(2), 169–183.
Bresler, L. (2006). Toward connectedness: Aesthetically based research. *Studies in Art Education, 48*(1), 52–69.
Bresler, L. (2012). Experiential pedagogies in research education: Drawing on engagement with artworks. In C. Stout (Ed.), *Teaching and learning emergent research methodologies in art education.* Reston, VA: NAEA.
Burrows, D. (1990).*Sound, speech, and music.* Amherst, MA: University of Massachusetts Press.
Costantino, T. (2010). The critical relevance of aesthetic experience for 21st century art education: The role of wonder. In T. Costantino & B. White (Eds.), *Essays on aesthetic education for the 21st century* (pp. 63–77). Rotterdam, The Netherlands: Sense.
Costantino, T., & White, B. (Eds.). (2010). *Essays on aesthetic education for the 21st century.* Rotterdam, The Netherlands: Sense.
De Bolla, P. (2001). *Art matters.* Cambridge, MA: Harvard University Press.

Decety, J., & Jackson, P. L. (2004). The functional architecture of human empathy. *Behavioral and Cognitive Neuroscience Reviews, 3,* 71–100.

Dewey, J. (1934). *Art as experience.* New York: Minton, Balch & Company.

Ellsworth, E. (2005). *Places of learning: Media, architecture, pedagogy.* New York, NY: Routledge.

Gottlieb, A., & Graham, P. (1994). *Parallel worlds.* Chicago, IL: The University of Chicago Press.

Greene, M. (2001). *Variations on a blue guitar.* New York, NY: Teachers College Press.

Hedican, E. (2008). Empathy. In L. M. Given (Ed.), *The Sage encyclopedia of qualitative research methods* (Vol. 1, pp. 252–253). Thousand Oaks, CA: Sage.

Higgins, C. (2007). Interlude: Reflections on a line from Dewey. In L. Bresler (Ed.), *International handbook in research for art education* (pp. 389–394). Dordrecht, The Netherlands: Springer.

Insight Meditation Center. http://www.insightmeditationcenter.org/

Joost, J. M. (in press). Emotional distance to so-called difficult patients. *Scandinavian Journal of Caring Sciences.*

Lawrence, E. J., Shaw, P., Baker, D., Baron-Cohen, S., & David, A. S. (2004). Measuring empathy: Reliability and validity of the Empathy Quotient. *Psychological Medicine, 34,* 911–924.

Lincoln, Y., & Guba, E. (1985). *Naturalistic inquiry.* Thousand Oaks, CA: Sage.

Makkreel, R. (2011). Wilhelm Dilthey. In N. Zalta (Ed.), *The Stanford encyclopedia of philosophy (Spring 2011 edition).* Retrieved from http://plato.stanford.edu/archives/spr2011/entries/dilthey/

McDonagh, D., & Thomas, J. (2010). Rethinking design thinking: Empathy supporting innovation. *Australasian Medical Journal, Special Edition: Health and Design, 3*(8), 458–464.

Myerhoff, B. (1978). *Number our days.* New York, NY: Simon & Schuster.

Peshkin, A. (1988). In search of subjectivity—One's own. *Educational Researcher, 17*(7), 17–21.

Rogers, C. R. (1959). A theory of therapy, personality and interpersonal relationships, as developed in the client-centered framework. In S. Koch (Ed.), *Psychology: A study of science* (Vol. 3, pp. 210–211; 184–256). New York, NY: McGraw-Hill.

Spinosa, C., Flores, F., & Dreyfus, H. L. (1997). *Disclosing new worlds: Entrepreneurship, democratic action, and the cultivation of solidarity.* Cambridge, MA: MIT Press.

Stake, R. E. (2010). *Qualitati veresearch: Studying how things work.* New York, NY: Guilford.

Stern, D. N. (2010). *Forms of vitality: Exploring dynamic experience in psychology, the arts, psychotherapy, and development.* New York, NY: Oxford University Press.

Stoller, P. (1989). *The taste of ethnographic things: The senses in anthropology.* Philadelphia, PA: University of Philadelphia Press.

Stout, C. J. (1999). The art of empathy: Teaching students to care. *Art Education, 52*(2), 21–34.

Stueber, K. (2008). Empathy. In E. N. Zalta (Ed.), *The Stanford encyclopedia of philosophy (Fall 2008 Edition).* Retrieved from http://plato.stanford.edu/archives/fall2008/entries/empathy/

Tobin, J., Hsueh Y., & Karasawa, M. (2009). *Preschool in three cultures revisited: China, Japan, and the United States.* Chicago, IL: The University of Chicago Press.

Tolstoy, L. (1898/1969). *What is art?* London, England: Oxford University Press.

van Manen, M. (1990). *Researching lived experience: Human science for an action sensitive pedagogy.* Albany, N.Y.: State University of New York Press.

· 2 ·

Writing Towards Empathy

TERRY BARRETT

Hi, my name is Bart and I have second-hand Cancer.
I'm angry.
And I'm tired.
I'm angry that Cancer has interrupted my plans. I'm angry that Cancer has made Marcia depressed. And tired. And scared. And cranky. I'm angry that every time we think we've turned the corner, another long hallway is thrust in front of us. I'm angry that once the Cancer is treated, no one has any time or answers for all the "LITTLE" symptoms or side effects.

I'm angry because we can't make plans for next week, or next month, or next year because we don't know if we will be well enough to execute those plans. I'm angry because Cancer has made my kids afraid. Afraid for Marcia. Afraid for themselves.

I'm angry because sometimes I don't have enough patience for my kids. I'm angry because my kids have to be quiet in their own home. I'm angry because we have to wait until noon or later each day to know if we will be well enough to make plans for the day. I'm angry because once we know we can make plans for the day there isn't enough time to enjoy the plans.

I'm tired of doing EVERYTHING.

I'm tired of being a father, and a mother, and a husband, and a wife, and a mother-in-law. I'm tired of being a student, a psychiatrist, a nurse, a pharmacist, a

doctor, an advocate, a life coach, a friend. I'm tired of pretending everything is OK. I'm tired of answering the obligatory questions with answers that won't give anyone else second-hand Cancer. I'm tired of still answering those questions two-and-a-half years later. (Bart Dluhy)

The 24 lines above are the beginning of an 84-line monologue written in the same fashion. It is the text for a 'zine, that is, a small, illustrated magazine that is self-published for limited distribution. An undergraduate wrote it for an art writing course offered to future art teachers. The premise of the course is that art educators can become more effective writers by adopting the rationale of arts-based research: thinking like the artists that they are and conducting research through artistic lenses (Barone & Eisner, 1997). To aid us in our writing we read professional artistic authors (Newman, Cusick, & La Tourette, 2004) on topics such as writing short stories, novels, and poems, writing for television and radio, and writing for children.

It took courage for Bart to face his innermost thoughts and feelings and then more courage when he read his monologue to his classmates. The effect was palpable: Bart read in a deep, strong, resonant voice that sometimes trembled; his peers listened in awed silence.

Bart prefaced his public reading by saying that I, the professor, gave him "permission" to write personally and intimately about his life. Additionally, and most importantly, the "permission" to write about our personal lives came from Emily, a member of the class. In a brief, private written biographical introduction that I requested on the first day of class, Emily revealed many extreme physical challenges she was experiencing. "I have a pacemaker. I'm slowly dying of an aging illness and I'm doomed to live in a wheelchair. But I love my life and would not have it any other way." I did not know if she was being imaginative or factual. I invited Emily to talk with me. I wanted to know more about her ailments, specifically if they were actual or fictional. In this class I was intentionally blurring a hard distinction between fact and fiction, and no one in the class was in a wheelchair. Emily told me that her problems were both real and painful. She referred to herself as a "genetic mess." Two years prior, doctors found herniated disks and a cyst on her spine. Her spinal cord is fusing together, thus she will become unable to walk, she predicted, when she reaches her 30s. While doing procedures on her back a year later, doctors discovered a heart murmur, a low heart rate, and a blockage condition that is progressive. As a child, Emily had spontaneous bouts of paralysis, which required hospitalization (Barrett, 2009).

I suggested that Emily write about her life rather than follow the assignments given in class. After thought and conversation with her boyfriend and her mother, she agreed, and wrote a compelling first-person narrative about her travails. She cried during the reading and subsequently the class was crying with her.

Bart's narrative quoted above about his experience as a caregiver, and Emily's account of her damaged body, might serve as examples of Caring for Self, one of six categories of caring that Nel Noddings (2005) presented. Noddings argued that rather than measuring their academic achievement by the acquisition of knowledge assessed by test scores, "students should be given opportunities to learn how to care for themselves, for other human beings, for the natural and human-made worlds, and for the world of ideas" (p. xiii). In addition to Caring for Self, her other categories are: Caring in the Inner Circle; Caring for Strangers and Distant Others; Caring for Animals, Plants, and the Earth; Caring for the Human Made World; and Caring for Ideas. The six categories overlap. In her writing and reading aloud, Emily demonstrated care for herself as well as the inner circle of her class. Bart was caring for himself, and he also expressed care for the inner circle of his immediate family and his classmates.

What follows are short narratives, or excerpts from them, written by art education majors, and a discussion of these in relation to developing empathy through creative writing in an art education class. Noddings and Martha Nussbaum are two current philosophers concerned with fostering empathy in life through education, as they explain in their respective books: *The Challenge to Care in Schools* (Noddings, 2005) and *Cultivating Humanity* (Nussbaum, 1997). Although Noddings discussed *care*, and Nussbaum discussed *empathy* and *sympathy* interchangeably, their understanding of the concepts of *caring* and *empathy* may be understood as synonymous and overlapping. A related and overlapping concept is *compassion*.

Sogyal Rinpoche (2002) offered an ancient Buddhist view of compassion:

> What is compassion? It is not simply a sense of sympathy or caring for the person suffering, not simply a warmth of heart toward the person before you, or a sharp clarity of recognition of their needs and pain, it is also sustained and practical determination to do whatever is possible and necessary to help alleviate their suffering. . . . Compassion is not true compassion unless it is active. (p. 201)

I am using *empathy* in its ordinary sense of placing oneself in the shoes of another. The notion is both emotive and cognitive: We need to know about who or what we are in empathy with so that we may feel compassion. In Bart's and Emily's narratives, they share personal aspects of themselves, allowing us

to know aspects of their lives, which in turn allow us to feel empathically toward them, and to take action when appropriate. Self-disclosure can aid in garnering empathy. The more we reveal about ourselves the more others can think about and feel our experiences.

Noddings (2005) said that to know what someone is going through, and to feel compassionately, we must carefully apprehend: "When I care, I really hear, see, or feel what the other tries to convey" (p. 16). Jean Bolen (2007) made clear the demands and rewards of sharing and careful listening:

> For soul to be heard, the mind must be still. Then thoughts and feelings can arise as if from a deep well within us. Often these thoughts and feelings are not shared. When they are, the soul looks outward for a moment, and we hope that we can truly share the depth into which illness is taking us. We wonder if we should die, will our lives have been worthwhile? What do we regret doing or not having done? What do we still want time for? Do we matter? Do the people in our lives really matter to us? Is there a God? An afterlife? What unfinished business gnaws at us? What long-buried thoughts and memories are coming back to us now? What are our dreams saying? (p. 9)

The following is a self-revealing excerpt from a narrative written in the first-person by Andrew Copeland, one of six male friends home from college and out to enjoy a meal together at an IHOP pancake house on a summer night in Texas. Andrew writes:

> We were talking and laughing and didn't notice the people sitting at the table next to us until the woman looked over and said,
> "Hey boys, what are y'all up to?"
> "Hello, how are you doing tonight?" Dan said to the woman.
> "Oh, I'm pretty good. Just here with my husband and my son. Say, guys, where are your women?"
> Thomas, joking around, said, "Oh, we're all gay," even though this was not true.
> Trying to add to the humor, I remarked, "Oh yeah, we're all gay, and let me tell you, whoever decorated this place did a terrible job!" We all laughed, except for the woman and her son at the other table.
> "Y'all are gay? Well don't let my husband know that, he hates fags! He's a real beast."
> Our faces went blank. Did that just happen? We all looked down at our drinks, stirring our coffee and lemonade, trying to pretend we hadn't heard. A big man with burly arms, tattoos, and a mean look in his eyes walked over to the table next to us and sat down next to the woman. We tried to get our minds off what had just happened when we heard her say, "Oh, honey, look, they are all gay! What do you want to do about this?" I couldn't believe what I was hearing. The burly man, pointing at me, said, "Well that fag better not come near me, or I'll . . ."
> "Excuse me," I called to the waitress. "Can I cancel my order of waffles?"

My appetite disappeared along with my pride. The six of us just looked at each other, nothing to say. I could tell what was on my friends' minds. Even though I was the only one sitting at the table who is gay, nobody wanted to single me out. We all took the plunge to protect each other.

Andrew continues his narrative from the restaurant bathroom where he splashes cold water on his face. Writing internal dialogue he wonders about "why people are so quick to hate." His friends join him in the bathroom and offer condolence and support before they leave the restaurant without further incidence with the hostile man. Andrew concludes his narrative with this paragraph:

> I thought about going up and knocking on the window, and right as they looked over I'd scream, "Fuck you!" Then I realized that would solve nothing. Sure, it might make me feel better, but I have friends and family who love me and support me for who I am. If I did go and knock on the window and scream vulgar words to this man and his family, at the end of the day he would be the homophobic man, and I would be the delinquent teenager. I decided to walk away because I had the support I needed—all of my friends. (Andrew Copeland)

Andrew's story exemplifies empathy for different people in the narrative. He empathizes with himself, recalling an uncomfortable situation in a neutral environment that turns socially hostile through the rudeness and insensitivity of two customers in the restaurant. His expectation of a pleasant evening quickly turned sour by implied and actual threats because he openly admitted his sexual orientation as a gay male. Andrew empathizes with his friends who are not gay but who accept the false attribution out of solidarity with Andrew. Impressively, Andrew empathizes with the bullying man by understanding that to confront him hostilely would do no good and would likely add to hatred in the world.

Travis Oliver writes about his conflicted experiences while growing up in "a small town amidst cowboys and farmers" in Texas. "My brother is a cowboy and my mother has always been inclined to the country life. As a teen I rebelled against this lifestyle." Travis wanted a fast-paced life but worked in slow-paced Rockin L Trailers, while listening to a classic country radio station from a dusty radio that hung in the welding shop. Later, when he had become immersed in a faster pace in university life, art, and music, he began to miss his country home and its slower pace. "In hindsight, I just didn't understand the culture I came from." He ends his narrative this way:

> I had the idea for a new tattoo for myself that would perfectly sum up my love of art, tattoos, the country, and my family.

Almost all cowboy boot brands have a signature stitching pattern on the top of their boots, just behind the toe of the shoe. This symbol is iconic to me. My mother, being the lover of fashion that she is, collects cowboy boots, and my brother, a ranch hand and champion cutting horse rider, uses his boots as tools to help him get his work done. Two different views on how to use boots. I decided to add another for myself. I got a classic stitching pattern tattooed on the tops of my feet, where they would be on actual boots.

My mom doesn't like tattoos but has grown to love the way I interpreted the design into a personal meaning. My brother still thinks I'm from another planet, but every time I look down I think of my family and the culture they raised me in. I hope as an art teacher I can help students to realize their true loves, come to terms with different aspects of their lives, and incorporate them all into their art.

In his autobiographical sketch, Travis uses a permanent bodily symbol expressing to him his empathy for his mother, brother, and their western culture. The tattoo represents what Noddings (2005) called "caring in the inner circle" of Travis's family, and "caring for the human made world" of his culture.

Travis and Andrew provide their readers with knowledge about themselves and their self-realizations, and we get to know something about them. As Noddings (2005) said, "Caring is what characterizes our attention when we ask another (explicitly or implicitly) What are you going through?" (p. 15). As Nussbaum (1997) said, "Compassion involves the recognition that another person, in some ways similar to oneself, has suffered some significant pain or misfortune" (p. 90).

Both Nussbaum and Noddings argue that we ought to actively *teach* toward caring and empathy. For Nussbaum (1997), becoming a "world citizen" is the ultimate goal of education, and empathy is a prerequisite for achieving that goal. She reminded us that teaching children even the simple nursery rhyme "Twinkle, Twinkle Little Star, How I Wonder What You Are," "leads children to feel wonder—a sense of mystery that mingles curiosity with awe" (p. 89).

Noddings (2005) asserted, "Teachers have a responsibility to help their students develop a capacity to care" (p. 16). She further suggested that when we teach we ought specifically to explain the notion that we can all be "carers" and "cared-fors." She explained that the self is a "relational entity. We cannot care for ourselves in any meaningful way in isolation from others" (p. 90).

Nussbaum (1997) also asserted that we need to teach toward empathy. For her, it is "sympathetic imagination" that enables empathy:

we must cultivate in ourselves a capacity for sympathetic imagination that will enable us to comprehend the motives and choices of people different from ourselves, seeing them not as forbiddingly alien or other, but as sharing many problems and possibilities with us. (p. 85)

Through sympathetic imagination, Nussbaum (2006) advocated citizens who "cultivate their humanity," which entails citizens who see themselves "as human beings bound to all other human beings by ties of recognition and concern" (p. 6). One writing assignment I give overtly and explicitly cultivates sympathetic imagining as I ask students to construct fictional narratives about works of art. The assignment asks writers to choose something or someone in an artwork and enlighten readers about the artwork from that positional stance. The requirement is twofold: empathize and enlighten. The assignment meets Nussbaum's two criteria: to cultivate sympathetic imagination, and to contemplate the motives and choices of people and things different from ourselves.

Frederic S. Remington, *Rounded-Up*, 1901, oil on canvas, 25 x 48 inches. Sid Richardson Collection, Fort Worth, Texas. Courtesy of the Sid Richardson Museum.

As a class we chose to write about Frederic Remington's (1901) painting *Rounded-Up*. To prepare to write his story, Brent Hirak conducted research and found artifacts contemporaneous with the painting: a journal entry that was written at the time the painting was made and likely about the situation depicted in it, and a short letter written to a woman by a man who could well be in the painting. The research adds credibility to the imagined narrative that Brent wrote. These are the opening paragraphs of Brent's fictional letter he wrote on behalf of the seated soldier in the foreground:

Josiah Smith, Mormon. I write this letter and ask any civilized soul to return it to Samantha Keating, 815 Second Street, New York City.

> I joined this Unit as a way to seek forgiveness in the eyes of god and for you my love. And now i write this to profess my love. Our unit was ambushed about eight hours ago, just after dawn, about three miles from last nights camp. The comanche surrounded us with a group so large that it must be four or five camps. I have faith in god, my faith.

His concluding paragraph:

> Our captain remains calm now, as do the two Flathead scouts and the trapper who joined us one week ago. Is it God's choice to take us now? My mouth is dry even though i drink, and my skin turns white, and seems to glow brighter as the sun begins to go down. Perhaps it will continue to grow more and more white Samantha, until it gleams like i remember your beautiful white lace dress that you promised to wear every Sunday. I have made my peace with God, and now i ask you to forgive me too. I have been placing my finger inside my wound, the pain keeps me awake, I can feel something in there, i think it is the slug, or it is my bone, but i imagine it is our bond. so I place my blood print here for you, so that you will know how much i loved ya. Assist the corporal with his ammunition, for the grace of god. (Brent Hirak)

Bart also chose the imagined perspective of the wounded man in the middle ground who is wrapping his arm in a tourniquet, and imagined the man's longing for his lover.

> Oh how i've missed you Jane. Your long blonde hair with that lilac scent stays with me, 'specially in the hardest times. Whenever i get down i try to remember our Saturday nights at the square dance at the town hall: the silvery screech of the fiddle pushin' us back and forth, and the rapid fire of the banjo pluckin' our feet high in the air like a shootout at Murphy's Saloon. Sometimes i can smell the fresh cut Timothy, neatly tied in bales policin' the perimeter of the dance floor. How i long for a smoke rolled with Rusty's tobacco, like the ones i puff in the cool September air when we leave the dance on those nights when our feet won't let us break, even for one song. (Bart Dluhy)

The details of dialect that Brent and Bart include in their narratives enhance the credibility of their narratives. The artfulness of the writing enhances our ability to empathize with the characters in the painting, and perhaps with all dying soldiers.

Other students provided more perspectives. Chet chose to imaginatively be the downed horse, fulfilling Noddings' Care for Animals, Plants and the Earth, and imagined the horse recounting the poor decisions made by his rider. Angela imagined a character not depicted in the painting. She chose to be the wife of a soldier, fretting in a cabin far away about the long absence of her husband. To my surprise, no one chose to be an Indian among the war party who had circled the soldiers and their scouts. Everyone accepted the plight of the victims as depicted by Remington.

Katy Riley writes a short story inspired by different artworks: two photographic portraits made by Richard Avedon from the gritty collection entitled *In the American West*. One portrait, *Jesse Kleinsasser, pig man, Hutterite Colony, Harlowton, Montana, 6/23/83*, depicts a boy, about 12 years old, dressed in black clothes typical of the Hutterite community, which shares similarities with the Amish and Mennonite communities. The second portrait is of an elderly man holding two briefcases and wearing slacks and a long-sleeved shirt and leather string tie, an identification card hanging from his collar, a pocket full of pens and a case for reading glasses: *Emory J. Stovall, scientist, Los Alamos, New Mexico, 6/12/79*. Katy writes:

> Jesse Kleinsasser was a pig man. His daddy had been a pig man. His daddy's daddy had been a pig man. There wasn't a thing Jesse didn't know about the pig; what pigs ate, what parts of the pig were used for what, how to make piglets. You name it; he knew it. Jesse rarely thought about anything else in the world except pigs. Pigs, sun-up to sundown. Pick a time of day, it can be morning, noon, that little half-light when the sun starts going down, or right before bed. What will Jesse be thinking of? Pigs.
>
> One day, a man came to town. He wasn't like any man Jesse had ever seen. His skin was pale and there was no dirt beneath his nails. He wore a white shirt with no stains. He carried briefcases full of fiddly little gadgets with numbers and dials. His hair was thinning and whisked to the sides; it reminded Jesse of the fluffy tassel at the end of a pig's tail. He was an odd shaped man, big, but not big from throwing slop and lifting pigs. Big in a weird squishy sort of way, like an overstuffed rag doll. Except for his wispy hair, nothing about this man was familiar to Jesse.

Katy places the boy and the man in "a small general store that doubled as the local diner and bait shop." They both privately notice each other's differences and quietly wonder what it would be like to be the other. Jesse sees the man as "knowing nothing about pigs," but also as "someone new who he could talk to about something other than pigs," who he could show how to bait a fishhook and when to change the oil, someone who could be "the start of a whole new life for Jesse." Emory J. Stovall recognizes "an air of authority" in the boy "that smelled of meanness." He sees a grimy boy with ill-fitting clothes, muddy boots, a hat held up by his ears, and as someone who wouldn't hesitate to knock an old man down and steal his wallet. "The small kid across from him had taken on a much bigger and darker form." Jesse approaches Stovall's table, but with downcast eyes Stovall watches the boy's boots approach, pause, and then move on out the door. Stovall "finished his sandwich. He sat at the table and continued to stare at the plate, not allowing his eyes to wander to the boot tracks left in the dust on the floor or to the doorway through which the boots had left. He stood up, took his plate to the counter and placed it on top of the one left by Jesse."

Katy's narrative exemplifies what Noddings and Nussbaum characterized as empathy from a distance. Katy does not actually know the two characters in her story but learns of them and teaches about them through an imaginative reconstruction and insights inferred from the clothes and demeanor of the subjects and the titles of the photographs. Katy would not have known that Jesse Klein was a "pig man": he neither looks like a grown man nor like he has been working with pigs. Emory Stovall could belong to a number of white-collar professions. Not only are the two subjects distanced from Katy, she has chosen to pair two different photographs of two individuals who are seemingly distant from one another.

Katy empathizes with both Jesse and Mr. Stovall. She puts herself in the shoes of both individuals and imaginatively constructs a plausible narrative that gives us fictional entry into two different lives. Jesse is inquisitive, aware of his restricted experiences in the world, and imagines that Mr. Stovall could broaden his experiences. Jesse also believes he might teach Mr. Stovall some lessons learned in and around pig farms. In Mr. Stovall's shoes, however, stands an elderly man aware of his lack of physical defenses who sees the young and differen- looking Jesse as a threat to his wallet and his physical safety. We, as readers, through Katy's telling, grasp an understanding of two persons we do not know except through Avedon's photographs and Katy's imagination, and feel the loss of opportunity for what might have become an endearing friendship between a boy and an old man.

The capacity to imagine being someone or something in a stylistically realistic painting is aided by the suggested narrative prompts in the painting; but the strategy also works with abstract, non-objective works of art, such as Sean Scully's paintings. Scully paints large canvases using a limited visual vocabulary of vertical and horizontal rectangles in rich colors. Kathleen becomes an element in the painting and presents an informative justification for the element's role in the abstraction:

> I am the wide white stripe on the bottom left corner. I lie alone surrounded on three of my sides by black paint. I am the individual that stands alone, but I'm not lonely. I light up my corner of the world pushing darkness back. I know that there are others just like me in the world, giving light to their places and together we make our world brighter. (Kathleen)

Kathleen's writing about the Scully painting exemplifies Noddings's (2005) Care for Ideas.

These samplings of student writings seem consistent with the objectives of teaching toward empathy as advocated by Noddings and Nussbaum. The sam-

ples meet the categories of empathy identified by Nussbaum (Caring for Self; Caring for Strangers and Distant Others; Caring for Animals, Plants, and the Earth; Caring for the Human Made World; and Caring for Ideas). They are also answers to Nussbaum's concern for teaching for democratic citizenship by instilling empathy studies within the school curriculum. The students quoted demonstrate a capacity to care for self, others, and things, and moreover to achieve these ends by means of a careful study of works of art within an art curriculum that serves both learning towards empathy and learning about art. In the senses shown here, care, empathy, and art are intimately connected.

REFERENCES

Barone, T., & Eisner, E. (1997). Arts-based educational research. In R. M. Jaeger (Ed.), *Complementary methods for research in education* (2nd ed.) (pp. 73–116). Washington, DC: American Educational Research Association.

Barrett, T. (2009). Stories. *The International Journal of Art Education, 7*(2), 41–54.

Bolen, J. S. (2007). *Close to the bone: Life-threatening illness as a soul journey.* San Francisco, CA: Red Wheel/Weiser.

Newman, J., Cusick, E., & La Tourette, A. (Eds.). (2004). *The writer's workbook* (2nd ed.). London, England: Arnold.

Noddings, N. (2005). *The challenge to care in schools: An alternative approach to education* (2nd ed.). New York, NY: Teachers College Press.

Nussbaum, M. (2006, March). *Education for democratic citizenship.* Lecture at the Institute of Social Studies, The Hague, TheNetherlands. Retrieved from http://opc-prd.ubib.eur.nl:8080/DB=3/LNG=EN/PPN?PPN=293091765

Nussbaum, M. (1997). *Cultivating humanity.* Cambridge, MA: Harvard University Press.

Rinpoche, S. (2002).*The Tibetan book of living and dying.* San Francisco, CA: HarperCollins.

· 3 ·

Food for Thought

Idiom, Empathy, and Context in Lauren Greenfield's *THIN*

LAURA EVANS

Art has the potential to be idiomatic and contextual, an expression that can only be understood by audiences where it originated. But can we feel empathy without that context? More precisely, do viewers struggle to empathize with works of art that are created in a culture they are unfamiliar and uncomfortable with? How important is educational context to aesthetic empathy? This interplay between context and empathy informs this chapter and its topic: *THIN*, a powerful collection of documentary photographs from the renowned chronicler of girl culture, Lauren Greenfield (2006a,b). Using narrative inquiry and auto-ethnography as research methods (Bochner, 2000, 2001; Brady, 2005; Bridwell-Bowles, 1992; Davies, 2006; Denzin, 2002; Ellis & Bochner, 2000, 2002; Fraser, 2004; Goodall, 2000; Gubrium & Holstein, 2000; Josselson, 2006; Richardson, 2000), I look at whether or not these images are idiomatic. If so, can we only feel empathy for these women if we have experienced an eating disorder and thereby share this "culture"?

To test *THIN's* potentially idiomatic status, nine other women and myself (five of whom have had eating disorders and five of whom have not), each wrote narrative interpretations of three photographs from *THIN* as part of my dissertation research (Evans, 2011). Using the semiotic tools of denotation and connotation, we expressed what we saw versus what we knew by looking at the

photos, which were stripped of their explanatory labeling (Barrett, 2003, 2006; Barthes, 1964, 1977, 1982; Smith-Shank, 2004). The result was a blank photo, ripe for our own decoding. Through these narratives, I was able to explore how *THIN* was or was not an idiomatic exhibition and could generalize about how women empathize with the images. This research was a critical component of my dissertation (Evans, 2011) and is an ongoing area of study. As a woman, a professor in Art Education, a museum educator, and as someone who has recovered from anorexia, *THIN* held much personal and professional interest. From first introduction, I was invested in the exhibition and photographs, hopeful that it could add more value to the fight for eating disorder awareness.

For the purposes of this chapter, I have selected excerpts from eight narratives for detailed analysis (five of which were written by women without eating disorders, and three by women who have had eating disorders). These women were chosen purposely, or rather, the majority of them volunteered when they heard about the project and wanted to be involved. In this reincarnation of my research, I decided to have more women without eating disorders than with because I was trying to understand if there could be an empathetic connection, in spite of a lack of personal experience, with one specific image from *THIN*, rather than three, as in my previous work. Through these women's narratives, I am able to explore empathy, aesthetics, and, ultimately, how educators can enhance compassion through context.

Contextualizing Inspiration: *THIN*'s Background and My Objectives

THIN, the first exhibition of its kind, uniquely exposes the ugly underbelly of eating disorders to the public by way of large-scale portraits, documentary photographs, art, journals, interviews, video, and narratives from the show's subjects: in-patient eating disorder victims at the Renfrew Center, a Florida hospital dedicated solely to eating disorders. Greenfield became interested in photographing people with eating disorders both as an exercise in photojournalism with a social purpose and because of the semiotic appeal of eating disorders, where, in many cases, the subject's body is a sign, communicating one's illness through physical form. Greenfield and curator Trudy Wilner Stack began touring *THIN* in February of 2007 at The Women's Museum, an affiliate of the Smithsonian Institution, in Dallas, Texas. The exhibition traveled to university art museums until 2010, visiting the Smith College Museum of Art, the Snite Museum of Art at the University of Notre Dame, and the University of Missouri.

THIN, the exhibit, is gritty and emotional, stark and naked. It does not shy away from the disturbing and disconcerting world of eating disorders. Rather, it forces viewers to confront the abject behaviors and bodies of women with grave eating disorders—regardless of those viewers' relationships to food and eating. My own interest in Lauren Greenfield's *THIN* comes from being both a victim of, and an advocate against, eating disorders.

After viewing *THIN*, I wondered if the photographs and exhibit could be considered as an idiom. Would these images be confusing to the viewer who may not be "from" the culture (in this case, a culture of eating disorders) in which the works were created? If not of the culture, would the viewer feel as if he or she had missed the "point" of the artwork? Would they feel confused, frustrated, or ambivalent towards works of art that might seem irrelevant or empathetically impenetrable? Empathy for the work would be lost if idiomatic. The photographs of *THIN* are so heavily entrenched in a culture of eating disorders, of potential idiomaticity, that someone not of this "world" could get, as it were, lost in translation. Given this potential danger, I ask two primary questions in this chapter. First, are the photographs of *THIN* like an idiom, an empathetic puzzle that is inaccessible to viewers who do not have any experience with eating disorders? Second, if the images are accessible, as they were for my subjects, can one still interpret, understand, and empathize with the signs and signifiers of eating disorder culture, as shown in *THIN*, and not be of that "society"? (Barrett, 2003, 2006; Barthes, 1964, 1977, 1982; Danesi, 2007; Eco, 1984, 1992; Hall, 1997; Smith-Shank, 2004)

The Photograph and Interpretations

Having had Terry Barrett as an instructor and mentor while in graduate school, I witnessed how he teaches with a work of art; he does very little talking. He stirs conversation about as if it were a big cauldron, asking people questions here and there to keep discussion moving. Very occasionally, he will drop hints or give away selected pieces of information. It is as if he has handed you a hard candy as a nugget of knowledge; you hold it in your mouth and swirl it around on your tongue, waiting for it to dissolve and for the sweetness of its inside to wash over you. In this way, the information he gives you lets you explore your interpretation with more data in your arsenal. Does it strengthen what you thought or change it? It is like being a detective and having another clue to piece together the mystery.

In a similar fashion, I did not give my co-participants much information in their orientation to THIN. They knew these were photographs about eating disorders, and that was all. Their interpretations are based somewhat on this knowledge but mostly on their own experiences. Like Terry Barrett, I wanted to see what a little information would do, how far it would go. By presenting and analyzing my and my co-participants' narrative interpretations of one of THIN's photographs, I hope to examine the idiomatic nature of art and eating disorders, and what this might say about empathy in the face of these potential roadblocks to understanding. Below, I present one photograph from THIN and the eight interpretations, followed by my own analysis of the dynamics of empathy, idiom, and context.

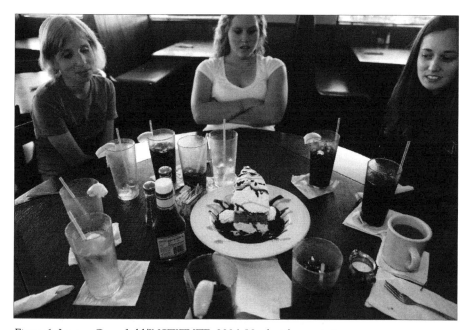

Figure 1. Lauren Greenfield/INSTITUTE. 2006. Used with permission.

1. Abby (who has never had an eating disorder)

"Just eat the dessert!" I want to shout. It looks really delicious, and it is making me question what desserts we have in the fridge. Nothing looks appetizing, so I grab a handful of miniature marshmallows. I wonder why these women don't want their dessert the same way I do. At first glance, this photo appears like a reminder of women's body issues. Maybe the women *want* to eat the

dessert but are too worried about calories or what such an act will do to their thighs. Perhaps the women are contemplating if a couple bites are worth it later on when they have to put on a swimsuit. I feel like the picture is meant to remind the viewer that no matter how appetizing this dessert might be, the women just aren't going to eat it. They have other things on their minds.

It's interesting that I would pass over this picture if it weren't in an exhibition about eating issues because this is such a familiar scene when a group of women gather. I can't tell you how many Junior League meetings I go to when there is something that looks fantastic to eat, but the majority of the women there feign uninterest like it's a badge of honor to *not* want dessert.

One time in college, I stress-ate a sleeve of Oreo cookies while creating a website with my friend Holly. She looked over at my demolished container of cookies and stated, "Wow. You have a really addictive personality." Holly would never know it, but her words really terrified me. If I really do have this terrible addictive personality that just can't put down that extra cookie (or the fourth handful of marshmallows that I'm nibbling on now), what does that say about my other impulses? Am I really addicted to everything the way an alcoholic is?

Deep down, I know these questions are all ridiculous. I know that Holly never even thought twice about her comment to me, and that she would feel terrible if she knew how much I still thought about it. But, logically, those women in the photograph know, too, that eating a bite of chocolate pie isn't going to ruin their worlds. Still, I doubt that any of them will be picking up a fork any time soon.

2. Crystal (who has had an eating disorder)

This is a "food challenge." Not the kind you see on silly reality shows. This is serious and frightening. The young women are in a treatment program for eating disorders, maybe nearing the end in the step-down program. They've come to this challenge to address fears of forbidden foods. For the woman on the left, I think she is in her twenties and recovering from anorexia nervosa. She looks down at the dessert with a look that says, "Of course, I knew this was coming." She'll do the challenge and hate it and love it and hate herself for loving it at all. She'll be terrified that she will go "out of control" having now tasted the forbidden "fruit."

The young woman in the middle, maybe 17 or 19, looks outright pissed. She crosses her arms in defense and in defiance, but she'll do the challenge because she is so close to being done and out of the program. It will awaken the desire

to binge though. This was one of the types of foods she used to binge and purge all the time.

I am not certain of the woman on the right. She is partially blocked from the camera so it is difficult to read her body language. Her face seems equally difficult for me to read. She isn't a "feeling person" and doesn't usually let others know what she is feeling either in words or gesture. I am guessing two of the two people not shown are facilitators. The one on the bottom right for sure. She is having coffee with cream.

We've done this—all of us who have been in treatment. Whether it was the Oreos or the mound of cream cheese, we've done it some way or other. We hated it, and we learned only that we could survive the terror but it never changed the name of terror. My heart aches for these women, at this snapshot of their pain, and the moments that come after.

3. Sophia (who has never had an eating disorder)

This picture suggests to me that these girls are staring at the cake debating whether or not they should eat it. They look slightly scared of the cake, the loss of control and gaining of calories it represents. The waters, coffee, and Diet Coke (I assume it's Diet Coke because that is what I drink) represent to me the way girls, or perhaps I, try to stave off hunger. The way we try to fill up on things that are not capable of feeding us.

For seven years, I took Adderall so that I didn't have to think about how I was feeling. I could get things done, and getting things done became a goal that I was constantly running towards, regardless of the friendships, joy, and growth that I was sacrificing along the way. To top it off, Adderall made me thin, very thin, and everyone complimented me, wanted to be as thin as me. Soon I found myself saying, "Well, I'm miserable, but I don't have to worry about gaining weight." And somehow, this became an acceptable standard of living: thin and miserable.

I've spent this last year trying to let go of all the things I use to mask my feelings and give myself some sort of edge, or push to be perfect. Some days, it feels truly impossible. Some days I think that if I could just take Adderall to lose some weight, then it would be easier to deal with the earth-shattering loss of confidence in my ability to get anything done without the drug. But, of course, nothing is going to fix the years of covering up emotions and trying to fit in— not drugs, not being thin—only painstaking honesty and radical changes in behavior and thought patterns.

I guess what I see in all these pictures is what I am starting to see in myself, which is a type of hatred for myself and a fear that if I can't control the world around me and my thoughts, I will fall apart. This hatred and fear seem present in these pictures and corrupt all [all women] our thoughts. Despite the fact that we know that starving ourselves, or taking drugs, or overeating, or trying to conform only makes the problem worse, we keep doing it in a vain hope that it will change how we feel.

4. Molly (who has had an eating disorder)

When I look at this image I see lemon wedges. First, they are yellow. Yellow is a cautionary, alerting color. But lemon is also a diuretic. Lemon in water, lemon in soda—perhaps I would not have noticed the lemon as much in the water, but it is also in the soda. I assume the sodas are diet sodas. The coffee is also a diuretic. So I immediately notice that the table has three diuretics and one apparently super-fattening dessert. I cannot help but notice that lemon. I used a lot of lemon in everything. Cucumber too. And vinegar.

The entire environment looks unappetizing to me. I feel like the table would be greasy, the air would smell fried. I feel like if I were to have gone to that restaurant during my "thin years" I would have struggled to find something I actually wanted to eat. I would have ordered a wilted salad. It would have been gross. I probably would have had to ask for no ham on it. Places like that are always putting ham cubes in salad.

I feel like I would be the girl on the right. But I can't see much of her and perhaps that is appropriate. I don't know 16-, 17-, 18-, 19-, 20-year-old me as well as I know 6-, 7-, 8-, 9-, 10-year-old me or 26-, 27-, 28-year-old me. That teenage girl is a stranger. When I look in the mirror I cannot remember her face. When I cycle back and try to put myself into her mindset I hit an opaque curtain. I cannot remember thoughts that she had like I can remember thoughts I had as a little girl. I was not thinking as a teenager. I was there but only so much as I had to be. I don't know why this is, exactly.

If it is me sitting there, looking at that food, I am thinking that I will not eat it. And I won't. I was very good at not eating things I didn't want to. I will be thinking about how I want to go for a run. I will be thinking about how I am cold even though I am wearing a sweatshirt and everyone else has on short sleeves. I am also in pain. I was constantly in pain during the "thin years." It was a non-specific pain. My legs hurt from running 3–5 miles a day. My stomach hurt from emptiness. My joints hurt because my body was burning muscle

fiber. My butt hurt because I was sitting on un-padded bones. I am also tired. I am also afraid. This is a free-floating fear of failure, and it manifests itself in the way I am looking at that food and steeling myself against it.

5. Amy (who has never had an eating disorder)

The three women seem like they are waiting for something. Are they waiting to sing "Happy Birthday"? Are they waiting for someone else to dive into the piece of pie first? My main question, being the dessert person that I am, is why the hell are six people sharing one piece of pie?! My gut reaction is that a group of women out to lunch are either not going to order dessert or only take a bite of a shared dessert because each of them is either on a diet of some sort or uncomfortable admitting that they want dessert. I realize the latter half of that statement is screaming "stereotype," but that tends to be my personal experience in addition to being a stereotype. It is the rare occasion when a female friend is not watching what she eats or cutting back on certain foods or food groups in order to lose a few pounds.

On the other hand, I continue to come back to the title of the exhibit from which the photos came. In light of that, and the focused or unsure expressions on each of the women's faces, I wonder if the piece of pie is an exercise for these women. Are they battling eating disorders or food issues and this is an exercise in overcoming that?

6. Laura (who has had an eating disorder)

From the expressions on the girls' faces, this piece of pie must be a freak in one of Barnum and Bailey's long-ago sideshows: the bearded lady, the strong man, the shortest person in the world. They look at it as if it cannot be believed, as if they stare at it long enough, it just might disappear. Or, as if they want it to disappear. They want it to be gone. The pie remains.

It is my guess that this is a "real world" experience that is designed for these eating-disordered women to eat food in a "real world" situation. Together, they are supposed to tackle the pie, but the army of three looks like they will be consumed by the pie rather than the other way around. The ironic thing is that I see this situation all the time. I have found myself in it more times than I would like to count. This could be any group of women, at any restaurant, of any age ranges, and with any food in the center of the table, though usually a dessert. Women seem to have a great fear of eating in public.

When do women ever eat? We never seem to do so in public unless it is picking at salads with dressing on the side. When I do see women scarfing down huge slabs of pizza or a doughnut gushing with Bavarian cream, I admit that I think to myself that they are probably going to be in the bathroom in five minutes, with fingers down their throats.

Linda Nochlin (1971) asked, many years ago, "Where are the great women artists?" Today, I look at this photo and I think about all of the situations I have been in where women have refused to consume and I ask, "Where are the great women eaters?" Where are the women who are not afraid to eat in public, to eat with gusto, to eat with an appetite not just for food, but also for life? What does our refusal to eat say about what we think that we deserve in life?

7. Shoshana (who has never had an eating disorder)

This could be one of those awkward moments when a server places an enormous portion of food on the table, and those sitting around are overwhelmed and even slightly embarrassed by what they have ordered. Not one of these women is moving towards the plate. No one has a fork in hand, no one is rubbing palms together in happy anticipation of a guilty pleasure. The women are thinking about the dessert. They aren't engaging one another as if to alleviate their worries about indulgence. No pathway through cups or glasses has been cleared to get at the sweet. Poor thing, it seems to be sitting there doomed to be left untouched, like a pretty but over-priced dress in a store-front window.

There is something rather obscene about the size of the cake, and its decoration. It reminds me of a Claes Oldenburg sculpture. It is just on that side of ugly. I realize the reason I am disconcerted by this photo. It has to do with eating in front of others. I tend to have a voracious appetite that, when alone, is indulged. (I've just now polished off a jar of peanut butter bought not too many days ago.) When no one is around, it is easy to eat and eat and eat. There is nothing as delightful as going to the grocery store, picking out a box of cookies and eating the entire box. This is, of course, not something I easily admit. My mind tells me this is a weakness. My growling stomach says, "What the hell." However, these urges are suppressed in public. When I eat with my husband, friends, or family I try to show restraint. I won't necessarily order salad and eat it without dressing, but then I won't order dessert or I will put off finishing everything on the plate in a (sometimes ludicrous) attempt to feign fullness. I will avoid the roll of bread, and if I do take a bite, I won't use the butter. These are all things I absolutely would do if I were by myself. And so, getting

back to the photograph of the women staring at the ridiculous cake on the plate in the middle of the table....If this image is about anything, to me it is a remark about how we as women feign restraint in front of these treats. It is about how we hold off eating with gusto in order to show a detachment to excess, clenching our teeth as someone inevitably comments, "A moment on the lips, a lifetime on the hips."

8. Anne Marie (who has never had an eating disorder)

Are they waiting for the birthday girl to arrive? Is the girl in the white shirt disgusted that it's whip cream from a can and hot fudge from a can instead of homemade? Could there be any more Diet Coke on the table? The longhaired girl on the right is looking at the dessert like she wants some. The woman in the pink shirt is looking past the dessert. She's not happy about it or seeming to want a bite. The girl in the white could just be full with her arms crossed over her belly...

This looks like it could be a youth group, high school class, or any collective of teen girls bored out of their minds and made to participate in something they do not wish to participate.

Revealing: Captions and Analysis

"Melissa, 23, Logan, 16, and Mary, 24, eat lunch at a nearby restaurant as part of a therapeutic excursion designed to help them overcome their fear of eating in public. Coconut Creek, Florida."—*THIN* exhibit caption for Figure 1.

Don't Be Shy

After sharing the above caption with my co-participants, I remember laughing when Abby remarked, "I think it's interesting that there is such a thing as a fear of eating in public." Was this fear of eating in public something that the other women, besides Abby, would not be able to relate to? Would this photograph be thus idiomatically inaccessible to women without eating disorders?

"Shy" eating is a relatively new term in the eating disorder lexicon and is used to describe this fear of eating in public. It is now considered to be a precursor to, or a well-established habit of, an eating disorder. Leslie Lipton, a one-time anorexic and "shy" eater, said of her preoccupation with not eating in public, "I assumed that everyone was watching everything that I put in my mouth, and everything that I ordered. They must be making judgments about

me, that I was too fat, or lazy, or a pig" (Dador, 2007). And so it goes with "shy" eaters who let their concerns over food, appearances, control, and a plethora of other issues control their social intake of food.

Greenfield's photograph is a document of confronting such "shy" eating as part of a treatment process. The photograph verifies that there is such a thing as a fear of eating in public, much to Abby's disbelief. In the photo, three women are engaging in a "therapeutic excursion" to help them overcome this phobia which, as eating disorder specialists recognize, is a possible signifier of an eating disorder. How did the other participants interpret this photograph? Did they see the fear in these women's eyes and empathize with their focus on the dessert? Or did they, like Abby, find the entire concept of that fear unusual and unrelatable? As women, what other possible interpretations of this photograph could we make, based on our experiences, our ability to empathize, and in unraveling this potential idiom?

Who or What Is the Subject? What Is the Message?

Our responses offered a variety of interpretations and narratives to explain the situation between the girls and the dessert, and most, but not all, of us were able to trace their connotative responses back to personal experience and empathy for the subjects. Further, we identified the women as the photo's subject, not the gargantuan dessert. Some read the unease on the subjects' faces and wrote about it, but were unsure as to the source of their anxiety. Shoshana, who has never had an eating disorder, recognized that there is tension in the room. Shoshana did not know exactly what has brought these women to the table, but she was certain that they have a connection in the look that all three direct at the dessert. Similarly, Abby and Sophia, both without eating disorders, noted the intent gazes of the women and their "purpose." Abby questioned the photograph as she wondered about why the women were there and what they were thinking. She focused in on their gazes and wrote about the dichotomy of both intensity and aversion.

Abby, like Shoshana, picked up on the focus of the women: the overwhelming dessert. She noticed the same tension that Shoshana wrote of, a balance of desire and detestation, focused on the pie. Abby speculated about whether or not their anxiety had something to do with calories and fat and weight.

Sophia also perceived their powerful gazes, filled with hatred, but wondered if this could not be somewhat self-directed. Sophia connected her present analysis to her past experience as an addict and as a woman who could empathize with the feelings of discomfort that she read in the photograph.

Molly, who has had an eating disorder, also put herself in the position of remembering. She took an embodied journey to reflect narratively upon what her reaction to the pie would be had she been in the image. Putting herself in the place of one of the women, Molly empathetically shared a stream-of-consciousness memory of what sort of thoughts would have been running through *her* head under such circumstances. She relived the horrors of her "thin years" and tried to put herself in the mental space of what is going on behind the gaze.

Like Shoshana and Sophia, Amy has never had an eating disorder, and wondered if this could not be a photo of some sort of celebration. But like Molly, she stepped into the space of eating disorders and tried to create empathy with the subjects through her knowledge of the exhibition's themes. Even though Amy is a "dessert person" and would be thrilled to consume a piece of pie among friends, she speculated that her feelings towards sweets are not shared by the women in the image. Amy's enthusiasm about dessert do not stop her from trying to step into the shoes of the women photographed. By reflecting upon the title of the exhibit, Amy wondered if the women are not engaged in an activity that challenges them to overcome their eating disorders. As a piece of semiotic detective work (Barrett, 2003, 2006; Barthes, 1964, 1977, 1982; Danesi, 2007; Eco, 1984, 1992; Hall, 1997; Smith-Shank, 2004), Amy moved close to Greenfield's caption.

Crystal wrote as if she has had to partake in such an experience. Wielding her experience, she wrote with authority about her knowledge of "food challenges" and how it must feel to the women in the photograph—serious and frightening. Crystal used eating disorder recovery language in her interpretation, slinging around the words "food challenge" and "step-down program" (which refers to the stages of an in-patient recovery program) as if she has lived it. And she has, of course. She came upon her knowledge by experience and she is "right," in the sense that she probably could have written Greenfield's caption. But I wonder, as I wonder about myself, at what price can we be right?

Noticeably different is the interpretation of Anne Marie, who wrote that the women's expressions could be explained by a birthday celebration, judgment over the industrial make of the pie, or simple fullness from consuming a meal before the photo was snapped. She had many questions to try to establish a reason for the women's tense faces, trying to create a narrative of explanation for their situation. Anne Marie described the woman in pink's expression as both disgusted and longing. She recognized that there is tension in the room but has not concluded that this photograph is anything other than a memento from some celebratory outing or an everyday lunch. Though Anne Marie is able to

sense that this photograph is about something more, she does not put herself on an empathetic path with these women. She questions their relationship to the pie but ultimately concludes that there isn't one. To her, there is not much to relate to and the photograph remains flat and benign.

Empathy and Experience

For all of the ambiguity of this photograph, almost every single woman, eating disordered or not, came close to understanding the motivations behind it. Each interpreter saw a sliver of fear in the faces of the women at the table. Some of my co-participants did not understand why someone would be looking at a slice of pie with such abhorrence. Others speculated that it could be an exercise in confronting food. Still others, those who have lived with such fears, were able to recognize the situation. Regardless though, this photograph had something that almost every woman seemed to be able to "read," and relate to. There is one noticeable exception to this empathetic unanimity, Anne Marie, who did not sympathize with the women in the image and their plight.

Until Anne Marie, I thought I had a tidy point to make about empathy and the non-idiomatic images of THIN. I began to think that THIN might have struck a universal chord with women and that all of us could relate and empathize with the images. By dint of our shared womanhood, I expected us to resonate uniformly with Greenfield's work, to see the dissatisfaction, the anxiety, and the obsession over form and figure. I expected there to be some correlation between women, some shared neuroticism about body image, and a strong line of empathy running through it all. I imagined that additional context would be unnecessary, superfluous.

But, as I realized through Anne Marie's narrative, this empathy is far from being universal. When I shared the caption of the image with my co-participants, Anne Marie wrote to me about the dessert photo, saying:

> Out of the context of her [Greenfield's] work, this image is benign. It doesn't tell me anything about eating disorders. The women appear bored, but healthy. No one appears skeletal, gaunt, or sickly. They look like teen girls. No one is overweight/obese, and they look normal. This work documents something so important and with the correct knowledge and insight, one understands what's going on. But, the image, on its own, does not tell us what I think she [Greenfield] intends to tell us.

I remember feeling stumped when I read Anne Marie's conclusions. My convenient hypothesis had been dashed by her honest words. Most of my co-participants could read and empathize with the language of body image

dissatisfaction in *THIN* without context but not all. This one person, Anne Marie, was enough for me to retrace my steps and to rethink what I had presumed would be the universality of this image. Certainly, I wasn't expecting for all of us in this project to have the same interpretation, but I anticipated that shared womanhood would transcend our connotations so that we would all be able to relate to the work of *THIN* and find it incredibly powerful and effective. Yet, Anne Marie was indifferent and unmoved by this image. Her words— "out of the context of her [Greenfield's] work this image is benign, it doesn't tell me anything"—made me think about the role of context in creating a relational empathy to this work of art.

In the end, as my data sat in front of me and stared me in the face, I could not deny that my original supposition was simply untrue. There was certainly a lot of reverberation among my compatriots, both eating disordered and not, but it was not as universal as I so tidily wanted. I could not refuse to recognize that one woman, Anne Marie, just could not relate to this image from *THIN*. With this understanding and emotional epiphany, I find that my acceptance of our differences as women, who are not universally anxious about our bodies, has allowed me to focus on other points about art, museums, context, and empathy—points that now mean more to me than they would have if things had worked out as seamlessly as I envisioned.

Contextualization and Conclusions

In this exercise, I consciously hid the caption of this photograph from my co-participants so that they might draw their own conclusions and so that I might determine their ability to empathize with the image without its context. As stated above, most of them were empathetic to Greenfield's original intentions. But one was not, and that was enough for me to conclude that this image, specifically, and *THIN*, in general, needs context in order for it to be fully understood and for Greenfield's message of the destructive nature of eating disorders to be comprehended. Perhaps context is not necessary for an empathetic connection, as is shown by the majority of the responses above. But, in the true spirit of post-modernism, context can and should be offered when available to assist in an empathetic relationship that might otherwise have fallen flat (Mayer, 1998, 2007). Furthermore, in such an exhibit as *THIN*, with a strong social agenda, Greenfield's message of eating disorder awareness can be lost without context.

Perhaps if Anne Marie had had more context, if she had seen this exhibit in the flesh, she would have had a different judgment of Greenfield's work. Maybe she would have come to understand that underneath the bored expressions and feigned indifference in THIN, beneath the crossed arms and blue eye shadow, there are fears and worries and debilitating concerns about bodies. Whether these concerns are legitimate or ridiculous is for the viewer to decide. But, with some context, that viewer has at least a more complete understanding and can make his or her judgments based more on knowledge and less on assumption. Empathy may be rooted more in context, in the case of THIN, and less in lived experience than I had originally expected when I set out in this project.

As THIN toured the country to various university art museums, it was bathed in context. At each site, the exhibit had explanatory labels, narrative panels written by the eating disorder sufferers in the images, a documentary on the same subject that was continuously showing on a video screen, lectures and panel presentations on eating disorders by counselors and curators alike, and, most importantly, a logbook where visitors could write down their thoughts and feelings.

In Part One of my dissertation (Evans, 2011), I analyzed these logbooks and, through the anonymous writings of visitors, I concluded that there was no lack of empathy or understanding for the women of THIN. The writings reflected an outpouring of pathos and emotional understanding between visitor and subject. Comparing the logbook entries of visitors who were surrounded by scaffolds of context (Buffington, 2007; Dierking, 2002; Falk & Dierking, 1992, 2000; Luke & Adams, 2007) to the narratives above, which had no context for interpretation, specifically, Anne Marie's, I can see that the accompanying materials of THIN moved the experience from merely seeing it into one of empathizing.

There might be other reasons for why Anne Marie was not able to enter into an empathic relationship with the images. Perhaps she was unwilling, resistant, to the work. She could represent the museum visitor who feels alienated, for whatever reason, from a certain exhibition or work of art and no amount of context or conversation will make the leap of empathy in this situation. Because Anne Marie specifically writes that the lack of context was what kept her from understanding Greenfield's image, I feel I can move forward, in this specific case, with the assumption that context is a strong basis for empathy.

My main question in this chapter was whether or not this photograph from THIN was idiomatic. I wondered if the image would be understood by and have meaning for women without eating disorders. Could my co-participants

empathize with this photograph without its context? In conclusion, this is an experiment in a lack of context, idiom, and empathy that I hope will never actually come to pass in an art museum setting. As an art and museum educator, I am a strong advocate of context as a tool for understanding more about a work of art (Carr, 2007; Dierking, 2002; Hooper-Greenhill, 2001; Luke & Adams, 2007). This project gives me another reason to insist on it as I go forward in my work in art and museum education. Though this experiment may have proved that idiomatic kinship is not a requirement to feel empathy for a work of art, Anne Marie's comments made me believe that added context can assist in creating a stronger bond between viewer and image; a relationship that might otherwise have gone to waste without a contextual framework, an aesthetic connection "doomed to be left untouched" like the pie in Greenfield's photograph.

REFERENCES

Barrett, T. (2003). *Interpreting art: Reflecting, wondering, and responding.* New York, NY: McGraw-Hill.

Barrett, T. (2006). *Criticizing photographs: An introduction to understanding images.* New York, NY: McGraw-Hill.

Barrett, T., Smith-Shank, D., & Stuhr, P. (2008). Three art educators in cancer world. *Journal of Cultural Research, 26,* 3–23.

Barthes, R. (1964). *Elements of semiology* (A. Lavers & C. Smith, Trans.). London, England: Jonathan Cape.

Barthes, R. (1977). "The death of the author" and "From work to text." In S. Heath (Trans.), *Roland Barthes, image-music-text.* New York, NY: Noonday Press.

Barthes, R. (1982). *Camera lucida: Reflections on photography.* New York, NY: Hill &Wang.

Bochner, A. (2000). "Criteria Against Ourselves." *Qualitative Inquiry, 6,* 266–272.

Bochner, A. (2001). Narratives' virtues. *Qualitative Inquiry, 7,* 131–157.

Brady, I. (2005). Poetics for a planet: Discourse on some problems of being-in-place. In N.K. Denzin & Y.S. Lincoln (Eds.), *The Sage handbook of qualitative research* (pp. 979–1026). Thousand Oaks, CA: Sage.

Bridwell-Bowles, L. (1992). Discourse and diversity: Experimental writing within the academy. *College Composition and Communication, 43*(3), 349–368.

Buffington, M. (2007). Six themes in the history of art museum education. In P. Villeneuve (Ed.), *From periphery to center: Art museum education in the 21st century* (pp. 12–20). Reston, VA: National Art Education Association.

Carr, D. (2007). A vocabulary for practice. In P. Villeneuve (Ed.), *From periphery to center: Art museum education in the 21st century* (pp. 222–231). Reston, VA: National Art Education Association.

Dador, D. (Producer). (2007, October 7). Sign of trouble? "Shy" eating may be a signal of anorexia, bulimia [Television Broadcast]. Los Angeles, CA: KABC-TV.

Danesi, M. (2007). *The quest for meaning: A guide to semiotic theory and practice.* Toronto, CA: University of Toronto Press.

Davies, C. (2000). *Reflexive ethnography: A guide to researching self and others.* New York, NY: Routledge.

Denzin, N. (2002). The interpretive process. In A. Huberman & M. Miles (Eds.), *The qualitative researcher's companion* (pp. 349–366). Thousand Oaks, CA: Sage.

Dierking, L.D. (2002). The role of context in children's learning from objects and experiences. In S. G. Paris (Ed.), *Perspectives on object-centered learning in museums* (pp. 3–19). Mahwah, NJ: Lawrence Erlbaum Associates.

Eco, U. (1976). *A theory of semiotics.* London, England: Macmillan.

Eco, U. (1984). *Semiotics and the philosophy of language.* Bloomington, IN: Indiana University Press.

Eco, U. (1992). *Interpretation and overinterpretation.* Cambridge, England: Cambridge niversity Press.

Ellis, C.,& Bochner, A. (2000). Autoethnography, personal narrative, reflexivity: Researcher as subject. In N.K. Denzin & Y.S. Lincoln (Eds.), *Handbook of qualitative research* (pp. 118–136). Thousand Oaks, CA: Sage.

Ellis, C., & Bochner, A. (2002). *Ethnographically speaking: Autoethnography, literature, and aesthetics.* Walnut Creek, CA: AltaMira Press.

Ellis, C. (2004). *The ethnographic I: A methodological novel about autoethnography.* Walnut Creek, CA: AltaMira Press.

Evans, L. (2011). *Eating our words: How museum visitors and a sample of women narratively react to and interpret Lauren Greenfield's THIN.* (Unpublished doctoral dissertation). Ohio State University, Columbus, Ohio. Retrieved from OhioLINK:ETD. (OSU Number: osu1299860725).

Falk, J.H., & Dierking, L.D. (1992). *The museum experience.* Washington, DC: Whalesback Books.

Falk, J.H., & Dierking, L.D. (2000). *Learning from museums: Visitor experience and the making of meaning.* Walnut Creek, CA: AltaMira Press.

Fraser, H. (2004). Doing narrative research. *Qualitative Social Work, 3*(4), 179–201.

Gardner, H. (1983). *Frames of mind.* New York, NY: Basic Books.

Goodall, B. (2000). *Writing the new ethnography.* Oxford, England: AltaMira Press.

Greenfield, L. (2002). *Girl culture.* San Francisco, CA: Chronicle Books.

Greenfield, L. (2006a). *THIN.* USA: HBO Video.

Greenfield, L. (2006b). *THIN.* San Francisco, CA: Chronicle Books.

Gubrium, J., & Holstein, J. (2000). *The self we live by: Narrative identity in a postmodern world.* New York, NY: Oxford University Press.

Hall, S. (1997). *Representation: Cultural representations and signifying practices.* London, England: Sage.

Hooper-Greenhill, E. (2001). Learning in art museums. In E. Hooper-Greenhill (Ed.), *The educational role of the art museum* (pp. 44–52). London, England: Routledge.

Josselson, R. (2006). Narrative research and the challenge of accumulating knowledge. *Narrative Inquiry, 16*(1), 3–10.

Luke, J., & Adams, M. (2007). What research says about learning in art museums. In P. Villeneuve (Ed.), *From periphery to center: Art museum education in the 21st century* (pp 68–73). Reston, VA: National Art Education Association.

Mayer, M. (1998). Can philosophical change take hold in the American art museum? *Art Education, 51*(2), 15–19.

Mayer, M. (2007). New art museum education(s). In P. Villeneuve (Ed.), *From periphery to center: Art museum education in the 21st century* (pp. 41–48). Reston, VA: National Art Education Association.

Nochlin, L. (1971). Why have there been no great women (http://en.wikipedia.org/wiki/Women_Artists) artists? *ARTnews*, January, 22–39, 67–71.

Richardson, L. (2000). Writing: A method of inquiry. In. N. K. Denzin & Y. S. Lincoln (Eds.), *Handbook of qualitative research, 2nd ed.* (pp. 923–949). Thousand Oaks, CA: Sage.

Shy eating: I'll pass, thanks: Fear of eating in front of others is a reality for an increasing number of girls [Television Broadcast]. (2007, September 22). New York, NY: ABC News.

Smith-Shank, D.L. (2003). The sheela-na-gig: A postmodern medieval mystery. In R. Irwin, K. Grauer, & E. Zimmerman (Eds.), *Women art educators V* (pp. 248–255). Vancouver, Canada: The Canadian Society for Education Through Art.

Smith-Shank, S. (2004). *Semiotics and visual culture: Sights, signs, and significance.* Reston, VA: National Art Education Association.

·SECTION II·

THE SELF AS
RESEARCH SUBJECT

· 4 ·

Art in the Expanded Field

Notions *of* Empathy, Aesthetic Consciousness,
and Implications for Education

In reflecting upon aesthetics, empathy, and education, semiotic squares (Krauss, 1979) beckoned. In assessing both constructivist and oppositional relationships, empathy is depicted as dependent upon consciousness. The convergence of aesthetics and consciousness appears to yield a pathway to achieve empathy in education.

Consciousness is an awareness of the mind-body connection in relation to its external environment. Aesthetics seems dependent upon consciousness; without consciousness, humans experience automation, flow, reverie, and dreaming. These altered states evoke imagery and provide a necessary rest for the mind, but elude beauty, awareness, or meaning-making.

A haven is a safe space, perhaps a sacred one. The ball is a visual symbol of the mind looking at itself beyond the body. I have defined a haven ball to be a concept of consciousness. Haven balls are also reflective spheres depicted in artwork, such as Vermeer's (1670) *The Allegory of Faith*. The reflective glass orb in the painting is symbolic of heaven, and the subject is gazing upwards at it. These spheres symbolize a reflection of the self. They are spiritual symbols that unlock peace, beauty, and consciousness. In utilizing semiotic grids and haven ball drawings, this paper will examine the triangulation of aesthetics, empathy, and consciousness, and their implications for education.

The image above (Figure 1)[1] serves to visualize a model of the haven ball bursting like mercury beads. Each bead contains a slightly different moment or snapshot of self-reflection.

These self-conscious moments emerge, some looming larger than others, some repeated, others shifting slightly and adhering to others. In this way the visualization model above is the aesthetic consciousness of one individual, and if it were to be extrapolated, would bead infinitely like the cosmos.

To utilize a molecular model, these diverse consciousness beads would aggregate, disperse, and have dipolar moments of attraction and repulsion. If only we could harness and harvest these beads and connect them in meaningful ways, we could achieve a shared sustainable understanding of the evolving self. The act of drawing is a self-conscious recording of an observation. In this instance it was in response to a sampling of the figure in the landscape in which Gardner's (2006) ideas of integrative thinking are at play. The self is drawing itself drawing and contextualizing the act of self-portraiture. A self-portrait is a complex expression, which doesn't end with a representation of a figure but in some way hints at those relationships it depends upon. Each small bead in Figure 1 is a different self-portrait.

If our future is dependent upon interdependence then there exists real potential for empathy to be utilized as a catalyst for social transformation. In an attempt to understand individual transformation towards interdependence, Robert Kegan (1982) charted psychological developmental stages. Kegan aspired to a fifth stage of psychological development whereby the egocentric "I" gives way to understanding the self as an integrated whole that isn't jeopardized by community interdependence. Gardner (2006), in *Five Minds for the Future*, postulated that our very existence is predicated upon an integrative understanding of interdependence both globally and locally.

The computational model of cognitive science likened the mind to an information-processing machine or a computer. Bruner (1990, 1996) rejected this model and argued that socio-cultural contexts need to be taken into account in order to understand the construction of meaning by the human mind. If the computational model of the mind as an information processing machine is ineffective (Bruner, 1990; Cacioppo, Hawkley, Rickett, & Masi, 2005) then perhaps it is interesting to think how cybernetic relationships have evolved with the advent of social media. Cybernetics, a systems approach to thinking about the human-computer interface (HCI), laid the foundation for cognitive science. It was about being human in a technological world, and it continues to focus on the human-computer interface (HCI), which Manovich (2001) described as the most important cultural zone for the foreseeable future. The Macy Conferences

(1946–53), which birthed cybernetics, were a serious endeavor that theorized the workings of the human mind and HCI design. Norbert Weiner, the grandfather of cybernetics, was instrumental in modeling a feedback-systems approach to the HCI, which was then extrapolated to models of social engineering. This group was interdisciplinary and humanist in its quest but gave way to the computer age and a shift toward the computer as model.

A unitary computer is an unsatisfactory model even for a computer. Computational models have evolved within networks where packets of data are exchanged in all directions. It is perhaps more interesting to look at the model of the mind in reference to a Web 2.0 model of collaborative end-user-generated content based on peer-to-peer interaction across computer networks. And even more interesting could be the fusion of virtual and physical realities via Web 3.0 technologies that project a fully integrated and embedded computational model where all objects "talk" to the "cloud" (Internet) through a transparent interface. In terms of cybernetics, the machine does tell us about ourselves by mediating our interactions with one another. Perhaps this is because the boundaries at the HCI are blurring, or because computer networks serve as an abstraction of how we may think. It is obvious that one's mind is not a solitary "do-it-yourself" agent, but that true consciousness involves interaction and interdependence. And this is a part of Bruner's (1990) rebuttal of a computer- or information-based model of cognitive science. He advocated the situated narrative that is culturally reflected and discovered through storytelling. You can't take technology out of being human in the digital age, but reality construction is a lot more than computation. It's the story being told at the HCI.

The engine of social transformation has been, and will continue to be, education, both formal and informal (Dewey, 1916). What implications does empathy have for education? Aesthetic empathy has an established history, but Verducci (2000) argued that aesthetic empathy doesn't account for judgment. She discriminated between art forms on the basis of status established by art historians. In this regard, I believe she is utilizing a rather conservative rubric for evaluating art. Popular culture is as relevant to aesthetic empathy as is Mozart or Pollock. Rather than relying on reified evaluations of what qualifies as art, let's frame this inquiry as one that is concerned with an aesthetic experience. The aesthetic experience is corporeal, conscious, and resonates with the back-story of an individual or cohort within a cultural context. One may have enough knowledge to fully appreciate Mozart or be a part of a niche group that prefers Kraftwerk or Lady Gaga. The important thing here is that an object—visual art, film, music, dance, literature, and so forth—enables an aesthetic experience that is transformative.

In Lacanian terms a viewer projects onto the art object and vice versa. This empathetic exchange is both imaginative and projective (Greene, 2000) and facilitates the union and harmony that Vischer (1876) described (in Verducci, 2000, p. 69). Essentially, it comes down to the eternal struggle of the human in the landscape and crisis of separation and sameness. The individual cannot persist under the auspices of the Western ideal of individualism, which amounts to, in the capitalist model, owning an iPod with special picks of music, images, and movies (thanks to artist Millree Hughes here, 2004).[2] Our "i" life is riddled with social alienation, network exhibitionism, and myopia, which raises the question: Is anyone paying attention at all?

How can aesthetic consciousness be utilized to foster empathy in education? The inquiry then expands toward how aesthetic consciousness and empathy can be strategized to build meaning-making in education. If it can be argued that aesthetic empathy exists and that the aesthetic experience is a conscious and transformative one, then perhaps it is useful to take a visual symbol such as the "haven ball" as a signifier of aesthetic consciousness. The haven ball is a reflective sphere representing the mind seeing into itself, within the context of the physical environment, and serves as an interesting representation of the evolving self. These spheres, historically, symbolize heaven—a depiction of the soul or the mind connecting beyond the body, as consciousness, as in Vermeer's (1670) *The Allegory of Faith*. Haven balls are the antithesis of empty abstraction. Rather, they are deliberate image constructions of the mind, body, and soul, as situated and reflected within environment. These images conjure up deep interiors and should prove useful in depicting the triangular relationship between empathy, aesthetic consciousness, and education. This discussion aims to build a framework that helps clarify this relationship and implications for education.

Art in the Expanded Field

In tackling art in the expanded fields of empathy, aesthetic consciousness, and education, I applied a Greimasian semiotic grid (Davis, 2011) (see Figure 2). Within art history there exists a strategy for mapping oppositional relationships in a grid that then constructs new hybrid relationships (Davis, 2011; Krauss, 1979). In the application below, the relationship between aesthetic and consciousness is pitted against its opposites—unaesthetic and unconsciousness. It was a deliberate choice to select aesthetic, rather than art, for the top axis. In order to avoid narrowing the field to only art objects that have met high art canon criteria, I chose aesthetic to include those polysensate experiences that

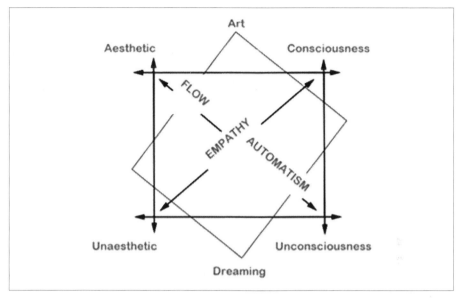

Figure 2. Art in the Expanded Field: Aesthetic and Consciousness, © 2011, Dr. Sherry Mayo.

move us viscerally. An aesthetic experience could be a Gerhard Richter painting or, equally, a walk in the woods. However, art must be both conscious and yield an aesthetic experience, and so the top axis constructs a relationship that may produce art. In this model, art could include any form, from museum-grade fine arts, to popular culture. Art is produced deliberately and cannot be produced without critical consciousness or the objective of producing an aesthetic experience. Whether it is Lady Gaga's (2008) *Poker Face* or a Russian polka that makes one groove is of no consequence. Taste is not a factor in this discussion.

The lower axis refers to experiences that are non-transformational and involuntary. This would include any experience that occurs without our being cognizant of it, and, while it could include images and sound, it would not produce an art object or meaning-making. The diagonal axis between aesthetic and unconsciousness represents a new category of experience. These nonsensical experiences would emerge from the Freudian id and run their neurological script in the background, such as: dreaming, automation, and reverie. While these phenomena are important to human consciousness, they do not produce art, or concrete meaning-making. Nor do they induce empathy.

In order to create an empathetic response one can follow the diagonal between consciousnesses and unaesthetic. Empathy is a conscious phenomenon, whereby one projects oneself and relates to another in a way that evokes an

emotional response. Walking in another's shoes or feeling someone else's pain are typical empathetic clichés. What occurs is a subject that relates to an object and projects itself onto that object while observing the situational experience. The projection of finding oneself in that situation evokes an emotional response, positive or negative. But, the experience still remains a fantasy—of one's own psychological response to a similar situation. The object that is evoking the empathetic response is acting as a signifier or trigger of a larger concept. For example, a hungry, impoverished child on TV is depicted and causes me to feel sad. In fact, I could cry or get sick to my stomach.

The information that is provided in combination with the imagery of a human in a desperate situation evokes emotion. It could be because I have children and I fantasize how it would make me feel if this were my child. Or, if I were a child, I might project myself as being born in that location as opposed to my own country. The larger framework is the social injustice of disenfranchised children in the world. Experiencing this harsh reality through mediation doesn't allow for true exchange. Rather, this falls into the category of aesthetic empathy (Verducci, 2000). In this type of empathy the object is not able to receive from the subject. It is a one-way interaction, not truly reciprocal (Enzensberger, 1974).

With the help of the semiotic grid, new relationships are constructed and clarified. These result in an aesthetic consciousness that is able to facilitate art production. Empathy requires consciousness; in opposition there exists dreaming, reverie, flow, and so on. When oppositional relationships are eliminated, there remains: aesthetic consciousness, art, and empathy, and these constructivist relationships are depicted in a triangulation schema (Figure 3).

This triangular configuration takes into account the constructivist relationships between aesthetics and consciousness and consciousness and empathy and creates a relationship between aesthetic and empathy. Aesthetic empathy provides an opportunity to engage education, particularly art education. Art education makes natural use of art objects and rich media in curricula, and

Figure 3.

these materials may be utilized to foster aesthetic empathy. That is, there exists potential to formulate critical consciousness within students and collaborative meaning-making between them. To this end, art in the expanded field becomes a useful exercise that opens up new hybrid constructivist possibilities, while scaffolding upon older theories and existing resources. There exist many pathways towards empathy amongst one another. Perchance in a laugh there may exist compassion, sympathy, empathy, and understanding.

Notions of Empathy

An (inside) joke (one pathway to empathy). "However spontaneous it seems, laughter always implies a kind of secret freemasonry or even complicity, with other laughers, real or imaginary" (Higgie, 2007, p. 24). The moment someone lets you in on a joke, you're given real access to "get it." Freud (1905, in Strachey, 1960) also described a good joke as a viral phenomenon, akin to Dawkins' (1976) "meme," or Gladwell's (2002) "tipping point." Freud (1905) observed that a joke traverses cultural borders, including language, due to the universality of being human (Strachey, 1960, p. 30). Jokes, or any type of memes, are tools that can elicit an empathetic emotive response such as laughter or tears. Not only is laughter good for you (see laughter clubs, http://www.laughteryoga.org/), Daniel Pink (2003), in *A Whole New Mind*, argued that humor is a key attribute needed in future leaders.

Nancy D. Bell (2007), investigator of sociological aspects of cross-cultural communication through humor, stated: "Joke competence is a somewhat dynamic construct—that understanding can be partial and that lack of full understanding need not preclude appreciation" (p. 367). Comedy is consumed the most, grossing more money than any other category (24% of the U.S. market share (retrieved from http://www.the-numbers.com/market/Genres/). The appetite for comedy speaks to Bell's (2007) notion that partial understanding does not preclude appreciation. It is our desire to laugh with one another that makes partial comprehension good enough for empathy.

Social interaction beyond humor. Cacioppo et al. (2005) investigated invisible forces such as perception of loneliness and its impact on physical health. Their assertion was that "invisible forces" such as sociality, spirituality, and meaning-making do have physiological impact that can be studied by the "hard" sciences. Their study evaluated social connectedness by having subjects self-evaluate their feelings of connectedness versus separateness and found that "sociality has profound effects on physiological functioning and sleep" (Cacioppo et al.,

2005, p. 152). Being human demands understanding, and this need is sated through empathy facilitated by social connectivity. This is but one recent study that attempted to find "hard" evidence or measurable effects for ephemeral phenomena such as feelings, emotions, and beliefs. This is the realm of empathy whereby the individual identifies with others and resonates with their experiences.

Interdependence. It is this level of interrelatedness that needs to be sustained in the experience of being human. This digital age, or "conceptual age," as Gardner (2006) and Pink (2005) have coined it, has clearly identified our current and future lives as dependent upon collaborative meaning-making or the formation of a collective consciousness. Our understanding of being interrelated and interdependent is integral to the success of global sustainability. NPR (National Public Radio Broadcast, 2011) has announced that the euro is in jeopardy, and described the serious dilemma that wealthy nations face regarding further investment or the problems connected with turning back to older economic models. It appears that the crisis of separation and sameness is looming ever larger. Can we accept the risk of walking alone? Is American isolationism or Western individualism a viable option? What is the cumulative impact of ignoring interdependence if individuals experience malaise from loneliness? Our success at achieving sustainability is within each individual accepting the need for collaboration, shared responsibility, and interdependence. This requires empathy.

Daniel Bell (1973) described an expanded intellectual class that does not separate art and life and engages in a post-industrial information-based economy in which economics is the regulatory factor in social control.

> Society itself becomes a Web of consciousness, a form of imagination to be realized as a social construction. Inevitably, a post-industrial society gives rise to a new Utopianism, both engineering and psychedelic. Men can be remade or released, their behavior conditioned or their consciousness altered. (p. 488)

In this social forecast, a relationship with technology privileges the professional class with the skills to profit from a tech-based economy. Bell (1973) also pointed out that technology widens the gap between the haves and have-nots, or, in his view, the professional and service classes. Education is identified as being the gateway of entry into the techno-driven professional class. Other possible downsides with the onset of our cyberselves include increased alienation, real or perceived, and mental illness.

The half-full view points towards social networking and digital infrastructure increasing consciousness and connectivity. Our future will depend upon how educational technology penetrates our current systems and infrastructure. This

forecast relies upon education as the entry ramp to the "having-more" highway, and technology integration can do as much to foil social connectivity and empathy as it can enhance. If the HCI serves as a buffer zone from human contact instead of a dynamic interactive cultural interface (Manovich, 2001), then humanity will fail. In part, Bell's (1973) projection is a challenge to revise his forecast. Social media provide potential to parry him and defeat the unitary computational model of the mind. In Cacioppo et al.'s (2005) study, they concluded that today's advancements in technology provide better models of the mind, but technology alone cannot achieve human empathy. These models are abstract and rely too much upon the machine to inform us about ourselves.

My Story

While putting a picture up on Facebook may make one seem more human, it is more like adding flair to one's wait-staff uniform. It's the story behind the image that solicits empathy. Otherwise the image remains empty decoration, like the faux photos of people that come with new frames. Tenkasi and Boland (1993) rejected the computer model/metaphor of the mind and have argued for a narrative model for understanding human cognition. As in Bruner (1990, 1996), it's the story that constructs the reality of oneself. The failure of Web 2.0 lies within social interaction. If the experience isn't interactive, one remains only an avatar. "It is a process of narrativizing our experience in a way that makes it believable and livable within the canons of signification, legitimation and domination that is our culture" (Tenkasi & Boland, 1993, p. 21). Whether this interaction is physical or virtual, it necessitates understanding generated between one another. One could put one's entire life up on YouTube without generating any meaning about that life. It is through interaction with others that stories are made.

Tenkasi and Boland's (1993) investigation into organizational change put the spotlight on storytelling and cited Mitroff and Kilmann (1976) in connecting the age-old habit of storytelling to meaning-making (p. 22). Rushdie (1980) painted the eternal struggle of the figure in the landscape in his epic *Midnight's Children* and asserted that no one can tell the story of a man without telling all the stories of every man before him. Human social connectedness is essential to survival because without it empathy cannot exist.

Returning to the argument that Facebook is more humanized than the faux-people photos in the frames, the layers of the technology in the experience unfold. On Facebook, one's image has metadata, information about the individual and those connected to her. The more one interacts with other images and metadata, the richer the experience. However, online socializing doesn't suffice.

It needs to lead to that cup of coffee. Facebook is one's advertisement agency for oneself in virtual reality. It doesn't socialize on one's behalf. According to Tenkasi and Boland (1993), it is through storytelling that we write our narratives and make meaning of our life experience. These narratives are fluid, meaning that we revise our stories over time with reflection and interaction with others. It's not enough to tell our stories to ourselves, we must tell them to others and, more so, we need to hear other people's stories in order to make meaning of our own. This would infer that meaning-making is dependent upon empathy. Bruner (1990) is an earlier supporting source for a narrative model of cognition: "The typical form of framing experience (and our memory of it) is in narrative form, and Jean Mandler has done us the service of drawing together the evidence showing that what does not get structured narratively suffers loss in memory" (p. 56). For me, memory does work with the computational metaphor; it is akin to surfing my hard drive (mind) for images throughout my memory bank. It works a little differently from what Bruner (1990) described, in that, typically, I see or hear something that triggers other images, and then pull a narrative file that's attached to it. But it is also true that retrieval occurs situationally, and that many moments and pictures are lost without a story being attached to them.

As I experience the phenomena of remembering, it is a process of searching for images and sound bites that are incomplete and then reassembling them in a way that fits to make meaning or to tell my story. Perhaps a blended model of a physically embedded Internet that's portable and personable, such as is projected by Web 3.0 enthusiasts, makes a better model.[3] The "cloud" that may be accessed through any surface/interface radically transforms our daily habits and interaction with people and machines. This integrates the abstraction of the computer model of the brain and blends virtual reality (VR) and real life (RL) to help one make meaning. The human-computer-interface (HCI) becomes seamless and transparent in the next phase of technology development. But will this be enough to facilitate empathy and ensure human connectivity and global sustainability? After all, a love affair with a computer interface has some limitations, even if it can anticipate what I want.

Can empathy be achieved by going to someone's website, viewing her headshot, slideshow, and reading her story? Is it enough to swap URLs to connect with someone? Would a video do it, or does empathy require texting and video conferencing? What was missing in the flatland of Web 1.0 was the lack of socialization. Web 2.0 brought broadband to support images and video, but that was only enough to get the masses to buy into cyberspace. It's more than that. The "live" real-time interactivity is the fix we crave; images are eye-candy.

SMS (Short Message Service) is a prime example of how little interface is necessary to make one take the psychological leap. The device is of little consequence. It's the interactivity, the speed, and the feedback that closes the communication loop and allows one to feel with another.

If one reflects on the experience of birth, of becoming other from one's mother, it is the physical separation that is the original trauma of coming into selfhood. The primary sensation and mode of communication for infants is tactile. They yearn to feel touch and proximity to their mothers, and as this distance increases, the crisis of separation and sameness emerges. Empathy closes the gap on the space in between.

Aesthetic Empathy

Figure 4. Untitled (climb), 83/8 x 71/2, ink, acrylic on paper, © 2011, artist Matt Ferranto. Used with permission.

Art as Reflection

Matt Ferranto (Figure 4) solicits the viewer to empathize with try, try again. The isolated clunky figure is in an uphill battle. The Sisyphean character is a stand-in for the viewer and meets up with blunder and catastrophe. The folly and frustration of life's journey and one's dreams are inscribed in Ferranto's clumsy, gimpy character, both feeble and heroic. Ferranto lives and works in Pleasantville, New York, and evokes empathy within the human condition (for more information about the artist, Matt Ferranto, see spareroom.org). This is an example of an artist who viscerally moves me towards aesthetic empathy.

Freedberg and Gallese (2007) understand images and visual art to be connected with visceral responses in the body and postulate that an empathetic response is one that is physiologically felt and neurologically evident. The audience or spectator viscerally experiences artworks, across media, and claims to experience transformative bodily sensations. This physiological impact is only recently being tackled as a scientifically measurable entity. Previously, aesthetic empathizers focused on human mimicry of an artistic experience and the implied bodily motion left as a result of the artistic process. Freedberg and Gallese (2007) discussed several works of visual arts, but Jackson Pollock is the most salient example of an artist whose work implies the bodily action of the artist (p. 199). Gesture or mark-making is the trace of the artist that demands the viewer know "I" was here. That's what mark-making is about, the record of one's existence. A Pollock cannot really be described without hand waving through the air (Freedberg & Gallese, 2007, p. 202). An engaged viewer will involuntarily start to use hand-gestures when describing a work of art to repeat her experience as a spectator for the benefit of others. The hand gestures used during the recap do not function as informational for the secondary listener but are residue of the primary viewer imagining or empathizing with the artist's original action in making. This reconnects with Bruner's (1990) understanding of cognitive meaning-making through narrative that is situationally constructed.

Aesthetic empathy plays out as emotive, visceral, and polysensual responses to artworks (Freedberg & Gallese, 2007, p. 199). These phenomena can be evoked from images but not necessarily from all. Spectatorship is sort of like dating—not all art will evoke such a response. An aesthetic experience is predicated upon the subjective response between the viewer and the object. Verducci (2000) described aesthetic empathy as a projective, imaginative process that fuses subject and object. In the case of the art object, an empathetic aesthetic moment is akin to Narcissus and the looking glass. Something of the self resonates and

identifies itself in the object of *cathexion*. Empathy can occur beyond the realm of aesthetics, but aesthetics can be a powerful trigger or effective device for stimulating an empathetic response.

Greene (2000) asserted the role of the imagination in cultivating an empathetic response, and pointed out the role the arts play as being vital in soliciting the latter. "And we are comforted by this perception of sameness, this strategy for reducing anything foreign in either time or space, to what we already know and are" (Krauss, 1979, p. 30). The potential value of aesthetic experiences to education, according to Verducci (2000), is in facilitating empathy and closing the gaps that separate the spaces between us. Again, the crisis of the individual and one's struggle to achieve a feeling of sameness persists within aesthetic empathy. A feeling of harmony or pleasure eases the stress of otherness, and is achieved through empathy and often found within the aesthetic experience.

Aesthetic Consciousness

Haven Ball

In returning to the expanded computational model of the brain that connects it to a multitude of other brains connected like nodes on a network, the question remains: Does this model suffice and does it represent consciousness? Is it enough to have access to the HCI through smart phones and Wi-Fi to be socially connected and critically conscious? What role does the aesthetic experience have in consciousness and, more so, in formulating a collective consciousness?

The orb in Christian artworks normally conveyed the spiritual world, for example in the *Book of Hours* (1420–1430), fragment 22, with Christ enthroned while holding an orb (Hesius, 2002). Sometimes, monarchs are depicted with an orb with a cross, symbolizing their dominion on earth through God. These glass spheres were often depicted in hand, or as a terrestrial globe underfoot, as shown underneath the figure of faith in Vermeer's (1670) *The Allegory of Faith*. Vermeer's allegorical constructions were inspired by Cesare Ripa's book, *Iconologia*. Ripa took from Egyptian and Greek symbolism and invented his own, describing the various virtues and vices that populate two volumes. Vermeer also interpreted and invented his own symbology. Ripa's figure of Faith (figure #235, in Richardson, 1779) varies greatly from Vermeer's in that she gazes at a chalice and holds a cross while perched on a pedestal (See Tempest, 2011). Vermeer's stiff, statue-like Faith is a cross between the Madonna as a matron, and Bernini's St. Teresa. She clasps her heart in *agape*, while penitently gazing at the glass

sphere suspended above her by a blue satin ribbon. This pictorial convention is due to Vermeer's compassion, or perhaps empathy, for the individual in everyday life. Walter Liedtke et al. (2001) asserted that,

> if the Delft painter's use of symbols is generally less obvious than in other artists' works it is because of his sympathy for human nature, his instinctive reticence, and his practice of subordinating incidentals to the overall impression and mood. (p. 162)[4]

The suspended glass sphere is most directly referenced from the Jesuit Willem Hesius in his *Emblemata Sacra* (Hesius, 2002, p. 88). Vermeer, a converted Catholic living in a Catholic district of the Delft, had access to Jesuits. However, Vermeer's suspended sphere also bears reference to a much more contemporary source, *Vanitas Still Life* by Jacques de Gheyn II (1603). In this vanitas painting a large bubble is suspended over a skull. Bubbles were often depicted in vanitas paintings to remind the viewer of the transience of life as well as for their reflective optics. The glass sphere in *The Allegory of Faith* (1670) is established as depicting man's faith in God (Wheelock, 1997). However, I'd rather suggest that the glass sphere was of Vermeer's own re-invention, a reminder of consciousness and our ephemerality. I refer to his visual construction as a "haven ball."

Haven balls such as depicted in Vermeer's (1670) *The Allegory of Faith*, and more recently in John Currin's (2009) *The Women of Franklin Street*, contain a possible model for aesthetic consciousness. The haven ball in Currin's Caligula-esque fantasy seems to pop out of Vermeer's *The Allegory of Faith* (1670) and most likely did. These glass spheres wrap the room around their reflective surface and symbolize "the human mind and its capacity both to reflect and to contain infinity" (Cant, 2009, p. 144). Referencing heaven above or the mind's ability to conceptualize faith, the haven ball is a part of Renaissance iconography (Olms, 2002, p. 88). Seemingly blasphemous in Currin's paintings, the haven ball's religious overtones might fall sway to a kaleidoscopic mirroring of visual culture, Americanism, and hedonism found in one's own reflection. Perhaps these spheres serve as a good model of consciousness: the internal self-reflective, cognitive process that unpacks the evolving self as contextualized by its environment.

Somewhat like a cybernetic system, external environmental feedback swirls around the individual, and the conscious looks back or reflects an image of the self depicted in this landscape. The understanding of the self shifts over time and, while this may be a solo internal process, it doesn't get very far without external context and feedback. In order to see the self looking back at

itself, there needs to exist a larger vista within which it can embed its vision. The haven ball as an aesthetic device possibly serves as a good model for this. Perhaps it is best described in Hesius' *Emblemata Sacra* (1636) (see Figure 5, #3) as faith, or the mind's ability to believe in what it cannot apprehend (in Hesius, 2002, p. 88).

Figure 5. #1., 2., 4., Self-Portraits While Drawing a Haven Ball, © 2011, artist Dr. Sherry Mayo.#3., "Capit Quod Non Capit" illustration from *Emblemata Sacra* (Hesius, G., 2002, Georg Olms Verlag AG, p. 88). Used with permission.

Implications for Education

The value of the haven ball model is in visualizing our consciousness evolve, complicate, and populate. As in Figure 1, you can see the cameraman off to the left of the central ball. It is, in fact, his point-of-view that creates the photo that documents the artist's self-reflection during the act of self-portraiture. In Figure 5, #1, the drawing includes another young artist towards the right of the sphere. It is not just a unitary self or consciousness here, after all, but one that is interacting with the external environment and others while formulating one's own understanding. This, of course, shifts moment to moment like those beads of mercury, producing more and more beads of understanding of oneself through each situation. Now, imagine an infinite number of these haven balls or beads of consciousness created by individuals as they formulate their own perspectives in response to external stimuli and interaction with others.

All of a sudden we begin to appear in other folks' haven balls, and this is an opportunity for altruism and empathy. This is also an opportunity to envision Bruner's (1990) "folk psychology," a self that is socially and culturally understood through narrative construction. WIIFM (What's in it for Me?) becomes crystallized as understanding that "I" don't exist without being present in others' consciousness. The social connectivity that creates a concept for self does more than this. It establishes the mores or rules required in transactions or within a "negotiated reality." People need to abide by conditions that are encoded in social interaction and cultural sign systems in order to be visible or, in Bruner's (1990) terms, to be present in narrative, "the folk psychology of ordinary people is not just a set of self-assuaging illusions but the culture's beliefs and working hypotheses about what makes it possible and fulfilling for people to live together, even with great personal sacrifice" (p. 32).

Time is important in narrative construction and aids in the telling of our story. In every story there is a beginning, middle, end, and with that a plot, agenda, climax, and resolution. The telling of a story is always in the present or contemporary. Whether the story is from the past or prophesying the future, it is told in the present (Bruner, 1990). In this way, time is not relevant but rather is a means to organize our story. This provides an opportunity to reconstruct, revise our past, our "history." Our understanding of ourselves, our culture, is shared and transformable. However, in order to change history within a shared construction, it is necessary to convince others that our story is the right one.

This leads to a great opportunity and risk to reconstruct the self through rewriting the narrative script that runs the mind. In this way it is through cre-

ating new meaning for ourselves that we obtain access to new levels of consciousness and behavioral change. This change in our story, or pattern recognition of the self in the mirror, occurs situationally within cultural contextualization and through social interaction. The figure codes "I" and "Not I" through the miasma or landscape that reflects and curls around its haven ball.

Verducci's (2000) complaint against aesthetic empathy is that it does not lead to moral action. For her, sympathy with the protagonist in a docudrama isn't enough. I understand Verducci's desire for moral action to result from education, but I think the failure is within curricula design rather than aesthetic empathy's lack of utility. Resonating with others through art is an incredibly powerful and effective means of soliciting self-identity, empathy, and understanding. Meaningful outcomes happen through post-experience reflection. Do teachers just take on spectatorship, or follow-up with a discussion-reflection or a paper, or construct a project? Too much of the rubric behind education is based on individual assessment through paper-writing or testing. Facilitating a collaborative model for constructing a project based on exposure to a consciousness-raising topic might be a more effective way towards scaffolding upon aesthetic empathy. This could take the form of a laboratory experiment, field research, qualitative interviews, filmmaking, or a play. Disciplines that implement constructivist strategies in their teaching create more opportunity for action following initial meaning-making.

To make a computational analogy, teachers are human programmers. This is a position of power that has long-term impact on the development of human consciousness. In our current plight there exists a real gap between pedagogical theory and philosophy or "praxis" and teaching practice in our schools. In an applied setting there exist possibilities to facilitate collaborative constructivist projects. Individual assessment aside, peer-to-peer learning in a group is rapid and provides social interaction or a way to construct "my story." The pathway toward a collective consciousness is one that honors McLuhan's (1964) "tribe," whereby individuals are socially, emotionally, psychologically connected in one contiguous story. This, perhaps, is the failure of the American experiment.

America is a sociological experiment that proved that diversity equates with creativity. From the big beautiful cars of the 1950s through Abstract Expressionism and small businesses, people from every corner collaborated on the American Dream. The way to solve problems is to surround them with great variance in perspectives. However, the American model has also sought to disconnect individuals from their origins to avoid conflict of allegiance. The suffering induced by Diaspora is the suffering of the loss of tribe or separation from

sameness. America's creation of an acme umbrella to suffice for cultural heritage is painful. Somewhere between MacDonalds, Wal-Mart, American cheese, and ketchup, being human is short-changed. American cheese is a product that states, "I'm bland enough that everyone, regardless of background, will be satisfied enough with it." The lack of distinction makes it generally acceptable, but doesn't suffice or fulfill the need to delight the palate.

> For the evolution of the hominid—call it culturalism. For the evolution of the hominid mind is linked to the development of a way of life where "reality" is represented by symbolism shared by members of a cultural community in which a technical–social way of life is both organized and construed in terms of that symbolism. (Bruner, 1996, p. 3)

Given that knowledge is constructed socially, and that in order to make meaning between people, a cohort needs to share cultural symbolism, we might want to rethink our investment in arts education. The American strategy is to build loyal consumers to support corporate brands that support our economy. In achieving this we have failed to honor the ingredients of our "special sauce," or who we are. The richness and diversity of our collective cultural heritage, which should yield a kaleidoscopic tapestry of beauty, possibility, and empathy, have been denied. Instead America's representation of cultural diversity looks like a Motel 8 bedspread, the tacky kind, with mold spores and bedbugs, which you don't want to touch your skin. The lack of investment in the arts for the masses in this country might have been strategic in cultivating brand loyalty and avoiding the distraction of competing nationalisms. However, it aggravates the crisis of separation and sameness and produces side effects such as racism. This is the kind of ailment that defeats the American project of harnessing the creative potential of a diverse people.

This is not exclusively an American problem, but one that is spreading virally around the globe through increased migration, mediation, and democracy. The empty abstraction of corporate brand identity that sells a homogenous lifestyle of consumerism combined with historical, decontextualized educational teaching practices that remain bereft of cultural heritage, is placing the human race at peril. If we accept the need for interdependence as essential to our sustainability as a species, then the facilitation of empathy through education is essential. The proliferation of tattoos, in recent years, reflects Gibson's (in Parsons, 2010) theory that humans will begin to display all their beliefs and desires through their fashion. The construction of personal symbols and reading of sign systems in the world creates our "reality code."

From observing a young adult female waiting in line at the Carvel ice cream store recently, I marveled at how much people yearn for symbols that validate the self. In this instance, the young woman had tattooed her name across the base of her neck like a label on a shirt. Why would anyone tattoo his or her own name? Are they afraid to forget it? The placement was for the viewer behind the figure, so what purpose would the tattoo serve? I peered closer and there was a little oval symbol painted in red, green, and white. This seemed to signify that Amelia was an angel of Italian descent. Does cursive text of the name combined with the halo in the colors of the Italian flag reinforce the unique identity of the girl, or was it that she felt lost in the miasma of the acme hyphenated American culture and was seeking to stick a label on it?

Figuring out who we are involves finding out who others are. This process needs to be shaped through meaning-making. Art education is in a unique position to foster self-investigation, empathy among students, meaning-making through constructivist project-based curricula, celebration of diverse perspectives, and an environment that is interdependent. At the core of artistic practice is the self-portrait, and that intense practice then develops into a portfolio of the world as seen by the artist. In multimedia practices such as film, theater, and new media, students understand how artists co-create and construct versions of reality. This is the kind of curricular strategy that needs to be undertaken by all students, not just a select few who go on to amuse the elite consumer. I would argue that art education has the potential to go from being an optional fringe frivolity in our schools to its core.

"Art has a socially critical role to play in the survival and evolution of the American democratic experiment, currently weakened by unrestrained capitalism and the threat of terrorism" (Ernesto Pujol in Madoff, 2009, p. 8). In fact Ernesto Pujol asserted that, "art schools should be the conscience of the art world" (in Madoff, 2009, p. 8). I think this is too modest, and that art education could serve to construct our collective cultural consciousness across education. Art education is not just in service of vocational trades or decorating other disciplines but has a critical role to play in cultivating empathy through aesthetic consciousness. This requires investing time and money for all of our students to study culture, the arts, and aesthetics. The haven balls of our youth need to be morally self- conscious and richly reflective of their environment, understanding of their culture, and vastly populated with other others. This increased appetite for culture, history, and arts will generate a mutual coexisting, co-creating community.

"The horizons of the artist's self continuously expand to take in the incremental unraveling of what the artist still desires to inscribe on his or her

consciousness and the attention of the world" (Raqs Media Collective in Madoff, 2009, p. 74). Artists know and benefit from the formation of an aesthetic consciousness. It provides them with an enhanced ability to empathize with others and experience the human condition. But should this privilege be restricted to cultural producers? Doesn't the current millennial climate demand that we widen our circle of empathy, and perhaps through this need, demand that society offer art education at all levels throughout our democracy?

> How do we convince the public that neither complexity nor difficulty in art—in thinking about and responding to art—is a formula for estrangement but an invitation to imagine solutions to seemingly intractable problems and predicaments in contemporary life? To teach persons to make art is to teach them to resist the commodification of their wills and desires, to use flexibility and ingenuity in the face of adversarial forces, to build a capacity for the attention and response to that which is not like them or belongs to them. (Lauterbach in Madoff, 2009, p. 96)

The teaching of arts is a "dangerous business" according to Roy Ascott (Alexenberg, 2008, p. 49). Consciousness theory is central to Ascott's strategy of fusing arts, technology, and biology. It is true that the constructivist, interdisciplinary nature and permeability of arts education ruptures boundaries and challenges perceptions. An art education is constructivist, transdisciplinary, and transformative, and it is because of these attributes that it provides a special opportunity in today's converging media-driven mash-up culture. Artist-teachers and artist-scholars are free-range thinkers. This cohort is in an optimum position to work between the lines, and the most likely to do so.

"Connectivity is at the root of cultural coherence. Where there is dissatisfaction with materialist culture and reductionist thought, new paradigms are arising in science which may correlate to the emergence of new pathways to the spiritual in art" (Roy Ascott, in Alexenberg, 2008, p. 58). I refer the reader to Gerhard Richter's (2007) installation of pixilated stained glass[5] in Köln, Germany. At the time of the initial presentation of this work, devout Catholics were outraged at the secularity and irreverence of this design. For me, nothing depicted more hope than Richter's intersection of art, digital technology, and spirituality. Art education's cultivation of aesthetic consciousness, and fostering of empathy among students provides hope that educators may continue to promise students that they have a real chance at success within the democratic system.

NOTES

1. I hung a small silver holiday ornament from my ceiling and studied it until I could draw what was reflected in it. It became a drawing of myself drawing what was in a sphere. After I made the drawings, I made photos by setting up a camera behind me on a tripod. I had been attracted to spherical surfaces, drawing them as I spied them in restaurants, museums, and so on. Later, I saw the piece in the Metropolitan Museum by Vermeer and afterwards came upon Currin's show at Gagosian Gallery in New York City (www.gagosian.com), and made the connection.
2. My thanks go to artist Millree Hughes for this point, interview 2004.
3. Retrieved from http://computer.howstuffworks.com/web-30.htm
4. Special thanks to Una Shih, Westchester Community College Research Librarian, for assistance with this section.
5. See http://www.spiegel.de/international/zeitgeist/gerhard-richter-s-symphony-of-light-cologne-cathedral-gets-new-stained-glass-window-a-502271.html

REFERENCES

Alexenberg, M. (2008). *Educating artists for the future: Learning at the intersections of art, science, technology, and culture*, Chicago, IL: University of Chicago Press.

Bell, D. (1973). *The coming of post-industrial society: A venture in social forecasting*. New York, NY: Basic Books.

Bell, N. (2007). Humor comprehension: Lessons learned from cross-cultural interaction. *Humor, International Journal of Humor Research*, 20(4), 367–387.

Bruner, J. (1990). *Acts of meaning*. Cambridge, MA: Harvard University Press.

Bruner, J. (1996). *The culture of education*. Cambridge, MA: Harvard University Press.

Cacioppo, J., Hawkley, L., Rickett, E., & Masi, C. (2005). Sociality, spirituality, and meaning-making: Chicago health, aging, and social relations study. *Review of General Psychology*, 9(2), 143–155.

Cant, S. (2009). *Vermeer and his world, 1632–1675*. London, England: Quercus.

Davis, B. (2011). Social media art in the expanded field. *Artnet Magazine*. Retrieved from http://www.artnet.com/magazineus/reviews/davis/art-and-social-media8-4-10.asp

Dawkins, R. (1976) *The selfish gene*. Oxford, England: Oxford University Press.

Dewey, J. (1916). *Democracy and education*. New York, NY: The Macmillan Company.

Enzensberger, H. (1974). *The consciousness industry: On literature, politics and the media*. New York, NY: Seabury Press.

Freedberg, D., & Gallese, V. (2007).Motion, emotion and empathy in esthetic experience. *Trends in Cognitive Science*, 11(5), 197–203.

Gardner, H. (2006). *Five minds for the future*. Cambridge, MA: Harvard Business School Press.

Gladwell, M. (2002). *The tipping point: How little things can make a big difference*. Boston, MA: Little Brown.

Greene, M. (2000). *Releasing the imagination: Essays on education, the arts, and social change*. San Francisco, CA: Jossey-Bass.

Hesius, G. (2002). *Emblemata sacra: De fide, spe, charitate*. Hidesheim, Germany: Georg Olms Verlag.

Higgie, J. (2007). *The artist's joke*. Cambridge, MA: MIT Press.

Kegan, R. (1982). *The evolving self: Problem and process in human development*. Cambridge, MA: Harvard University Press.

Krauss, R. (Spring, 1979). Sculpture in the expanded field. *October, 8*, 30–44.

Liedtke, W., Plomp, M., & Ruger, A. (2001). *Vermeer and the Delft school*. New Haven, CT: Yale University Press.

Madoff, S. (2009). *Art school (propositions for the 21st century)*. Cambridge, MA: MIT Press.

Manovich, L. (2001). *The language of new media*. Cambridge, MA: MIT Press.

McLuhan, M. (1964). *Understanding media: The extensions of man*. Cambridge, MA: MIT Press.

National Public Radio (NPR) (2011). Despite Crisis, Do Countries Benefit From Eurozone? Retrieved from http://www.npr.org/2011/09/15/140490521/does-the-eurzone-still-make-sense

Parsons, M. (Oct. 13, 2010). Interview: Wired meets William Gibson, *Wired*. Retrieved from http://www.wired.co.uk/news/archive/2010-10/13/william-gibson-interview

Pink, D. (2005). *A whole new mind: Why right-brainers will rule the future*. New York, NY: Penguin Group.

Ripa, C. *Iconologia* (1593). Retrieved from http://emblem.libraries.psu.edu/Ripa/Images/ripa00i.htm

Rushdie, S. (1980). *Midnight's children*. New York, NY: Penguin Group.

Strachey, J. (1960). *Sigmund Freud: Jokes and their relation to the unconscious*. New York, NY: W.W. Norton.

Tempest, P. (2011). Iconologia, or moral emblems. Charleston, South Carolina: Nabu Press.

Tenkasi, R., & Boland, R. (November, 1993). *Locating meaning in organizational learning: The narrative basis of cognition*. Center for Effective Organizations, Marshall School of Business, University of Southern California. Retrieved from http://ceo.usc.edu/pdf/T9317237.pdf

Unknown (1420–1430). *Book of hours (fragment)*. (Folio# fol.062r). Manuscripts and Early Printed Books, Bodleian Library, Oxford University, England.

Verducci, S. (Winter, 2000). A conceptual history of empathy and a question it raises for moral education. *Educational Theory, 50*(1), 63–80.

Wheelock, A. (1997). *Vermeer: The complete works*. New York, NY: Harry N. Abrams.

· 5 ·
Expanding Empathy Through Dance

INDRANI MARGOLIN

This chapter reveals how aesthetics and empathy intertwine through move-
ment. I highlight the power of movement invoked from within to cultivate
empathy in adolescent female relationships. I present a qualitative dance
inquiry with a small group of adolescent girls centered on girls dancing in rela-
tion with one another. Through narrative and poetic renderings, I reveal that
a curriculum through the body, focused on seeing and being seen in the vul-
nerable act of creation, can foster meaningful empathic connections sometimes
lacking in girls' peer relationships.

Beginning with Myself

Dance has woven her way in and out of my life since childhood. At four, she
helped me spin around my house. At eight, she taught me to communicate and
play with friends. At 13, she came to me through jazz in a studio class. I felt
incredibly alive. At the same time, I became painfully conscious of the size dif-
ference between my body and the others in the class. I felt left out of what
appeared to be a *skinny club*, and quit studio dance for 11 years. The world
around me, at school, in magazines, and on television, conveyed that embod-
ied feminine beauty requires slenderness with straight lines, not curvy hips or

muscular thighs and arms. I began to weigh the virtue of my body, not in regard to reaching past physical limitations, as I did with pride and joy in gymnastic tricks, but in a constant comparative analysis with other girls on their relative thinness. This is a thought pattern I still work to eradicate and replace with more compassionate notions about myself and other women.

That same Grade 8 year, as a girlfriend confided in me that her father physically abused her, I remembered, in a flash, I had been molested as a child. These events had gone underground, out of my consciousness, for two years. Embodied resonance with my friend's feelings allowed me the safety and space to remember. This sudden memory was subsequent to classes in dancing I had attended earlier that year, during which I had felt great joy. Only now did this forgotten shame erupt. Until this moment I had simply felt a general embarrassment about my body while in the changing room of the studio. Bertherat and Bernstein (1977) have explained that body cells store emotions and memories in nonlinear ways.

Bearing witness to my own and others' emotional suffering inspired an inner calling to serve humanity in its quest for emotional balance and healing. I developed a special passion throughout my postsecondary education to help adolescent women tune into their bodies at a time when they have often already learned to subvert their bodily wisdom in favour of so-called expert knowledge from external sources. Upon completion of a graduate social work program, I became a Youth and Family Counsellor, where I worked with adolescents and co-facilitated self-esteem groups for girls. As I healed, I transformed my childhood trauma into one aspect of my past that did not need to define me. Dance came back into my life to further my therapeutic journey, which included my doctoral dissertation process and a choreographic piece, entitled *Jai*.[1] Only a poetic rendering can capture how dance transfigures my worldview.

Soaring in Dance
Dance is freedom. Surrender to now, to movement, to breath,
To the rhythm of silence, to the music of space.
Thinking moves out of my brain and into my body.
My body awakens to air and to earth. A meeting, choreographed.
She lifts me into ascent and throws me into descent.
Caressing to cleanse.
Dance, my Beloved Spirit ~ lures and loves me back into undivided tranquillity.
—DANCER, HUMAN AND COSMIC (MARGOLIN, 2009).

Because dance transcended my shame and transformed it into deep compassion for my bodily self, and because in my previous counselling work I observed a

deep longing in girls to be heard, I chose to work with dance as my life work: to invite, reach, and teach girls to turn their attention back in on themselves—not on their external bodies but their inner ones.

Inquiry Details

Framed within a qualitative arts-based research design, I worked with girls aged 16–18 in a Canadian urban public high school. I invited participation at one urban school that had a dance space and welcomed my involvement. I spoke with three dance classes from Grade 10–12 and provided a flyer that resulted in five participants initially, with four completing the workshop. I crafted a series of 10 after-school movement workshops to meditate, dance, and reflectively converse with girls about their dance and bodily experiences. Reflective conversations doubled as semi-structured group interviews after dancing segments and provided a main source of the data outlined in this chapter. We met for three months, one day per week, in the dance studio of their school. I employed Performative Inquiry (PI), which views the creative act as transformative because an essential aspect of self becomes temporarily visible and available for reflection and conscious integration (Fels, 2008; Phelan, 1993). I worked with girls in a small group setting because their relationships with themselves are often intertwined with their relationships with their peers. Before describing my dance inquiry, I will define a few terms.

Aesthetics

My definition of aesthetics evolves out of the lived experience described above. The aesthetic of an artistic process or product connects to the depth of feeling evoked in the artist (Knill, 2005). Aesthetic response originates in the body as something that moves us emotionally. Where other writers on aesthetics focus on beauty as technical craft of form and content, I concern myself with the beauty that arises in the harmony between artistic experience and the transformative insight that creative process offers for the artist, which can be enhanced by one who bears witness to it.

The creative process, through its symbolic expression, can invite and safely contain feelings while simultaneously integrating personal narratives and illuminating one's connection to the external world. The expression of self that occurs in a safe, accepting atmosphere invites others to open themselves, and

holds great promise for female students to move out of isolation and into connection with one another through their shared experiences.

Empathy

Carl Rogers (1980) defined empathy as:

> Entering the private perceptual world of the other and becoming thoroughly at home in it. It involves being sensitive, moment by moment, to the changing felt meanings which flow in this other person....It means temporarily living in the other's life, moving about in it delicately without making judgments. (p. 137)

The capacity to imaginatively enter the life of another other is, according to neurobiologists, inborn. We are neurologically predisposed to empathically relate to one another (Berrol, 2006). When a dancer is seen leaping, the same neurons, called mirror neurons, are activated in the observer as if the observer were leaping herself (Gallese, 2004). Another way to describe this process is through the concept of kinaesthetic empathy (Harris, 2007). The kinaesthetic qualifier signifies the importance of the body where empathic understanding is both experienced and conducted through bodily awareness and movement. Empathy dances between girls as they express their feelings and images in response to one another. They weave in and out of each other's embodied creations with compassionate play.

Girls and Creative Movement

Many North American adolescent girls live under the surveillance of oppressive gendered discourses that control the way they navigate through peer relationships, perceive their bodies and sexualities in the tumultuous changes of puberty, and become objectified by others (Belenky, Clinchy, Goldberger, & Tarule, 1986; Blood, 2005). Girls' initiation into adolescence revolves around silencing their opinions, ideas, and feelings (Taylor, Gilligan, & Sullivan, 1995). They are explicitly and subtly told to quiet their voices and feelings by family members, peers, and teachers. In Grade 7, many girls start saying "I don't know" when only a year earlier they unequivocally did know (Gilligan, 2006). They face a psychological disconnection, where they are in danger of losing their relationships if they speak freely, and yet if they do not, they are alone. Unfortunately, they often choose other over self, beginning to relegate their former embodied knowing as *stupid* and *crazy* (Gilligan, 2006). In addition, they learn that their bodies mostly, if not solely, exist to attract

others, most often males, and that their success in life as women revolves around maintaining and remaining preoccupied with their body shape, size, and diet regime. These discourses are institutionalized and incorporated into varying developmental stages of a girl's life, shaping how girls relate to themselves and to one another.

Creative movement (CM), as a contesting discourse, encourages inner impulses to take form. Dancers are the choreographers of the emerging dance that arises from their creative cores (Laban, 1963). The deep body-psyche connection causes feelings to flow before we can consciously censor what is happening (Whitehouse, 1999). This physical and emotional articulation of the bodyself allows a girl to realize an unused, new quality of movement, and when she does, she experiences a new feeling to parallel the new posture.

Two fundamental components of CM are: caring for the body and trusting the self as authority. These are important considerations because it is precisely in adolescence that girls begin to divorce thought from emotion, knowledge from the body, and self from relationship (Gilligan, 2006). Creative dance, done in relation with others, fosters empathy through the kinaesthetic emotional attunement required to engage in the process. The objective is to perpetually and spontaneously attune to feeling sensations and desires without interpretive or critical thought as they manifest in bodily movement. At a time when girls learn that the critical thinking they acquire through schooling is apparently more highly valued than the immediate apprehension and insight they gleaned from their bodies in preadolescence only years prior, creative dance education can assist girls to resist the pervasive notion that logic supersedes embodied understanding. Critical reflection, while invaluable when directed toward cultural, institutional, family, and peer group contexts, cannot replace embodied tacit knowledge for girls to move through this world.

To give voice to the silenced bodies of girls, I apply the term bodyself throughout this chapter (Snowber, 2008). I adopt this term as a reminder to turn inward toward the sensual, emotional, and spiritual understanding that awaits recognition. The self pulsates and thinks throughout every cell of the body. The bodyself term signifies that a person's core and her body are one. I interchange the term bodyself with bodysoul, as the self to which I witnessed being moved in this work seemed synonymous with the soul. Drawing on both Emerson (1990) and Sen (2005/2007), the soul is the individualized integrating consciousness through which the universal consciousness flows. Attuned awareness of bodyself sensations and feelings alerts girls to inner distress and danger as well as safety and delight.

First Finding Compassion for Self

Before my participants could dance together, they needed to feel their own inner impulses, to experience a supportive space to move, imagine, and sense their own bodyselves in the presence of their peers who were taking the same risks. Without awareness of our own body boundaries and feelings, holistically attuning to others' bodily experiences is nearly impossible. Rogers (1980) spoke to the possibility of a transcendent connection where profound growth and healing are present when first we are in touch with our own core. Thus, I directed my participants to dance alone with their eyes closed, guided by themes of energy, space, time, and motion to explore bodily possibilities (Laban, 1963). This was a way to shut out the possibilities of peer rejection or pressure to dance according to socially accepted forms and gestures. They learned through the touch of air, the weight of gravity, and the emptiness of space to voice what was once silenced and to move what was once halted.

Approximately one month into the study, I invited Olivia, Shirley, and Stacey to open their eyes—to see and be seen by each other unarmed in creation.[2] The continuous, concentrated practice of re-attuning to their own bodyself impulses provided a foundation to enter each other's space, not as a distraction, as in their day-to-day world, but as a joyful addition. I detail their collective work now.

Mirror Dance

In duets they stood face to face, palm to palm, leaving a small space between their hands. One moved her hands slowly while the other reflected back a mirror image as closely as possible. When the impulse came, the follower took the lead. To give and take the lead fluidly to the point of indistinguishable leadership, they needed to tune into each other's body movement and respond.

Here is a piece of movement poetry I wrote to describe what I saw and reveal how I felt as I watched the student dancers mirror one another.

Seeing Other ~ Feeling Self
She sees in the eyes of the other a reflection of her own soul.
As a shadow, her reflection moves.
Is she inside looking out or outside looking in?
Wrapping arms hold close sacredness.
Embraced by a reflection of herself in the other,
Embraced by beauty
—(MARGOLIN, 2009)

Bridging Paradoxes in Relationship

After our mirror dances, laughter, and wonder filled our conversations. Shirley explained:

> We just understood what the other was doing. Without words we had to meet each other in our bodies—reach deep down into our childhoods where everything was alive. Get that out-of-body experience where your mind just leaves.

Mirroring is particularly conducive to the development of kinaesthetic empathy in the experience of reciprocal interplay and most clearly resembles physically aligning with others (Harris, 2007). It encourages attentiveness and intimate interaction. Communication is sensed and felt throughout the bodysoul with each response in the meeting of two individuals (Whitehouse, 1999). This dialogue stretches beyond words and daily interactions where concern for being right, polite, and liked causes automated responses and a lack of meaningful relationships among students in general but impacts girls' relationships in unique ways. Gilligan (2006) wrote of "a paradoxical sacrifice of relationship for the sake of having 'relationships'" (p. 56). Girls know this sacrifice is psychologically incoherent, but the cultural context makes it nearly impossible to resist.

Mirroring in creative dance provided a context and an open invitation for girls to explicitly resist personal sacrifice and genuinely be with one another. Empathic relating can grow into a deep resonance of being with and reflecting back one another's movements and thus, intentions and emotions, without judgement. Stacey pronounced:

> Eventually, I didn't even have to look at her arms anymore. I never felt that before with another person where you just know what's next. It feels like you are touching but you are not. It was the most amazing feeling ever.

Empathy opens the possibility for a mutual metamorphosis (Rogers, 1980). In synonymous sensing, Stacey and Shirley harmonized themselves with their own and each others' bodysouls in a seemingly cyclical process. They slipped beneath fear and doubt, and their relationship transcended into something releasing and healing for them both. The need to follow social requirements for being generous and appearing *cool* melted away.

In dancing mirrors, Olivia, Stacey, and Shirley learned to rely on their in-the-moment process. By authentically dancing together, they jointly created an element in which they each could dwell in a space receptive to who they are (Whitehouse, 1999). They no longer needed to internally pre-approve, analyze, or reason their movement ahead of time. In an urban high school context,

where girls are consistently reinforced to manoeuvre around and between social norms through sanctions of ostracism and ridicule, this took great courage (Garner, Bootcheck, Lorr, & Rauch, 2006).

Seeing and Being Seen

The underlying idea of the psyche proves it to be a half bodily, half spiritual substance...a hermaphroditic being capable of uniting the opposites but who is never complete in the individual unless related to another individual. The unrelated human being lacks wholeness, for [s]he can achieve wholeness only through the soul, and the soul cannot exist without its other side, which is always found in a "You." (Jung, 1954, p. 243)

We first develop a sense of self in infancy by being truly seen by our primary caregivers (Adler, 1999). We internalize that seeing and begin to see ourselves in the same light. Being seen equates to being loved, and the emergence of empathy is cognitively rooted in this love. This drive to be seen and see authentically in relationships continues throughout development by mirroring actions and emotions and engaging empathically.

In a self-directed bodily movement practice called authentic movement (AM), which is related to creative dance, an external witness watches a mover to contain, balance, and bring calm to a mover's initial fears and chaos of movement (Whitehouse, 1999). Witnessing in AM replicates aspects of the kinaesthetic attunement inherent in the caregiver-infant bond where the witness holds a receptive consciousness within herself to see and feel the nonverbal experience of the mover. I felt an extraordinary embodied resonance to Stacey, Olivia, and Shirley's bodyself worlds as they danced before me. I saw imagery that was clearly influenced by their intentions and desires. I felt utterly transfigured as I watched them move from within. I saw goddesses in motion. It demanded that I too move in dance/life with a wide-open heart, vulnerable and unapologetic for my presence.

Travel into uncharted feelings and sensations, which creative movement inspires, can be frightening. To address the girls' apprehensions, we developed guidelines to work together on the first day and revisited those guidelines with each new dance introduced. To help the girls swing between their own inner impulses and allow others to influence their movement, I used an *eyes half closed half open* method. Travelling back and forth between inner and outer forms further fostered a process of learning to include one another in the relationship, where they experientially began to blur sharp distinctions between self and other. Olivia illustrates this point.

This dancing opened us up so we could really see each other. It was different. It was strong. Immediate. Raw. We were [on] a different level of a connection because we were vulnerable to each other and we allowed ourselves to be so open. It felt like our souls were exposed with very little armor around us. Unlike when you are a kid or with friends, we were both giving something completely. And we could have embarrassed the heck out of ourselves but we decided to do it anyway. It was free happiness without restraint.

Girls seek to know and express the core of who they are and have others accept that core (Margolin, Pierce, & Wiley, 2011). This process is made easier by the presence of another who can absorb overwhelming emotions and reflect them back to the individual in a more digestible form (Wyman-McGinty, 2007). Creative dance offers an aesthetic path through bodily awareness, where female students can both empathize and feel deeply understood on a visceral level as they witness and attune to one another's bodily expressions of inner feelings.

Energy Ball Power

After the solo and duet work, I invited Olivia, Shirley, and Stacey to move together as a group. Here is what I witnessed:

Hands awaken with outstretched fingers ~ reaching, grasping, lifting.
Movements affect one another and former separate dances intertwine.
Shirley and Stacey spontaneously pass something between them.
Olivia enters. Laughter, as she moves among them.
Opposition and balance.
Movements become frenetic, matching the frantic feeling of new music.
Sharp angles, bent legs, and flying hair capture a villainous scene.
They group together like spies eyeing their secret and keeping it close.
I suggest let go of the ball. A shift.
Bodies supported by breath. Chests expand and lift into sky absorption.
Twist and flow, melting into each other. Borders between bodies become fuzzy.
A unified field where molecules in the air bounce between them.
An ocean-like invitation to dive in.
In visceral reverence, these newly acquainted friends teach each other to move, to breathe, and to dance, together (Margolin, 2009)

Being Self with Other

The girls said they felt utterly rejuvenated from dancing together. They discussed the story of their dance where the power of a ball that connected them seeped inside them, and when they finished dancing they were transported by it. Shirley imagined that their movement created energy that became trapped

and accumulated in their hands as they passed the ball. By the time the ball was destroyed, they were so filled up that they could "dance and dance and dance with energy ball power" (Stacey, Olivia, & Shirley simultaneously). From then on, that is how we referred to this dance.

> Sometimes, there comes a wonderful moment in which a spontaneous rhythm or dynamic intensity gradually catch[es] all the members of the group, lifting them into a leaderless whole....From the outside, it has a quality of unpremeditated choreography. From the inside, it is an experience of participating in a totality made up of more than the sum of its parts but including each part equally. (Whitehouse, 1999, p. 62)

Each of the girls was inspired and awed by abilities to think and act distinctly from each other while simultaneously allowing each to be influenced by one another. They not only maintained a connection but expanded into a deeper relation by embracing their unique dance forms simultaneously, which reportedly was previously experienced as a self/other paradox. They wove another's movements into their own, providing symmetry and balance as well as dissonance and chaos. Wyman-McGinty (2007) conceptualized this relational process as merging and differentiating, where merging refers to an inclination to unite, and differentiating refers to experiencing separateness and distinction from another. Merging and differentiating describe polarities on a continuum in which humans are constantly engaged as they negotiate relationships. Shirley illuminates how this process transpired in Energy Ball Power.

> We didn't plan. We just did it. And we fed off each other. If Stacey threw her arm up, my arm would go up afterwards. We weren't copying each other. We were totally doing our own stuff but still intertwined. We were so close that we couldn't help but all do it the same yet differently at the same time.

Shirley spoke of the immediate emotional connectedness she felt with Olivia and Stacey without "really hanging out or knowing their history." Not only did kinaesthetic empathy occur during Energy Ball Power, where mirror neurons were at work, but afterward the girls shared intimate details of their lives and personal thoughts they formerly kept private, hidden, especially from peers. Significantly, they felt recognized and empathized with one another's tribulations. Their merging dance experience facilitated empathic conversation. The ability to feel kinaesthetic empathy while also maintaining self-other differentiation is a concept not easily bridged in girls' daily relationships with one another. Emotional support is usually marked by agreement, and attempts made at disagreement can lead to being branded by hurtful labels, such as *self-ish* or *bitch*, that do not fall within an acceptable concept of femininity.

Seeing Self Anew: Stretching the Feminine

Of particular importance is Olivia's narrative. Olivia moved 11 times throughout her life, making it difficult to root herself in one place. She suffered enormously from body-image issues and from being bullied by her peers. In Grade 6, she was dragged by a group of girls into a ravine and physically assaulted. At age 12, Olivia was diagnosed with clinical depression and sleep apnea. Thus, for Olivia to feel authentically seen and accepted for who she was in her moving bodyself by female peers who are "popular and pretty" was a victory in her life. She not only experienced being supported for dancing differently than Shirley and Stacey but encouraged and liked for exaggerating her differences. Olivia articulated:

> I don't think that I could be as graceful and as light as they were being. It looked like they were almost touching their feet to their head! But it's okay. I decided I'll just be whatever I'm gonna be. I felt like I should be stabbing my elbows out. It got deeper and deeper and more and more into myself. They were above me, I went low. If I did feel myself moving away then suddenly I'd be surrounding them again, like herding sheep. They were helping me exaggerate my movements and I tried to exaggerate theirs. I could see them smiling and I was accepted. It was good. I was happy 'cuz I wasn't cast out. I was still connected and accepted even though I was doing something differently than everyone else.

As girls feel connected emotionally and kinaesthetically, they develop mutual trust and respect for one another. Olivia felt supported, even admired, for her uniqueness. This connectedness is only possible when girls recognize each other as equal to themselves and recognize themselves as equal to others. In a state of conscious gesture and passion, the students broke out of their habitual anxiety in peer relationships and saw one another empathically. This type of relating is uncommon in their daily urban schooling, where girls often scapegoat one another and become "haters" of those who do not conform sufficiently to group norms and values. *Haters* are girls who spread rumours to purposely sabotage other girls at Shirley, Olivia, and Stacey's school. Garner, Bootcheck, Lorr, and Rauch (2006) stated that peer groups in urban schools reflect and exaggerate adult culture but use ridicule and ostracism as the major form of sanction in place of formal punishment.

Notions of femininity also restrict adolescent girls when they are seeking to discover their actual impulses to move through this world. Fraleigh (2004) referred to a dance piece that explores a feminine archetype, "Unadmitted ugliness and untapped beauty, the two sides of our original face, are held uneasily together…not knowing which way to turn; a third interpretation stirs" (p. 45). Olivia permitted herself to put on display what she perceived as *ugly* in herself. With the assistance of uncritical popular peers, she embraced previously rejected

body parts and provoked expanded ways of being feminine. Olivia offered her insight into how this occurred.

> I'm a little bigger than some people here and I don't feel that I can do pretty move-
> ments without my stomach rolling so I'm hard on myself. If I didn't go "hey you're gain-
> ing weight," I could be like a billion pounds by now. If I'm thinking this, they might
> be thinking this as well. Then I thought, for the first time I think, "Maybe I should-
> n't put my insecurities on them." I can't go on some massive diet and look pretty just
> before this class. So I'm here. I'm in spandex and I'm going to do whatever my body
> feels comfortable with. Maybe if I was skinnier I would be able to jump higher or
> bounce better. Or maybe I would still be growling and clawing at people.

Olivia realized for possibly the first time since Grade 5 that others may not respond to her appearance in the same negative light as she does. A strong and secure bodyself-image is indicative of individuals' abilities to relate with oth-ers (Wyman-McGinty, 2007). When a girl can accept her own body appear-ance and experience, she can let go of body comparison with peers. She can *differentiate* from others in a healthy manner and sustain a strong interpersonal self. Rather than a central concern of competition and mental flagellation, rela-tionships can be marked by a capacity to accept diversity. This example demon-strates the potential of creative dance to qualitatively change a girl's relationship with her bodyself when dancing in relation with empathic peers.

Expanding Empathy Beyond Dance Studio Walls Into Everyday Halls

> One thing that's positive about being a woman is that there are other women out there
> and we're really good for each other. I see women can be really strong. They have flaws
> like everyone and they still just act. (Shirley)

Shirley voiced her insight near the end of our dance work together, which evolved out of participants sharing personal pains in movement and conver-sation. It stands in marked contrast to Shirley's school experiences with female peers the previous year. She recounted:

> Last year I spent my whole life not being a slut. A guy made up this huge lie about me
> how I was on E [the drug Ecstasy]...and I had sex with him for a ride. A group of girls
> came up to me and surrounded me. I was scared shitless they were going to beat me
> up. I carried mace on me for the next two weeks. The rumours went on for months.
> Girls talk so much and they don't realize the kind of name that we're all getting.

Tanenbaum (1999) espoused that *slut-bashing* provides girls an opportunity to wield power that cuts across racial and class boundaries. Though this behaviour reinforces repressive discourses concerning female sexuality in general, girls in high school are not exposed enough to feminist ideas to reflect more critically on their behaviour. Thus, they instead revolt against each other rather than against the complex overarching Judeo-Christian system, which, set in place centuries ago, links a girl's character with her sexual choices, and controls women (Pagels, 1988). Male-privileging institutionalized practices continue to shape thought patterns and behaviour. Participants in my study unanimously agreed, "If they don't like you, they'll call you a whore or a slut," referring especially to their female counterparts. The high school context seems to breed comparison, insecurity, ridicule, and devastation to the self-esteem of many girls. Thus, the kinaesthetic empathy often fostered in creative dance becomes an essential pedagogical tool to teach respect for diversity, compassion for self, and the power of aesthetics to lift students and teachers out of complacency and into bodyself awareness.

I used my knowledge as a counsellor to mentor growth-promoting attitudes toward self, which permeated the participants' ways of relating to each other. Participants internalized my active listening. They learned to listen closely to their muscles and nerves to hear their desires and needs. Olivia, Shirley, and Stacey began to broaden their beliefs about their capacities as creators and young women. They repeatedly commented that "after dancing with one another, they felt more comfortable in their own skin" and felt compelled to inspire others to feel the same. Empathy began to surge beyond our dance studio walls. Olivia disclosed:

> When I was outside of this room I would watch people more, the way people acted with each other. I would try and put more of an effort not to judge people. If I'm in a group or classroom, I'll make people feel comfortable. I'll try to make people feel like being an individual and feel good about it.

After a student dancer internalizes being authentically seen by others, she transcends the need to be seen (Adler, 1999).

> The deepest longing now has shifted from being seen as I am by another to seeing another as she is....And so the cycle continues to recreate itself, each time expanding consciousness. Increasingly, the concern is about seeing and loving. (p. 154)

Like Olivia, Stacey was also ostracized. Peers, teachers, and family members racially discriminated against her throughout her schooling. Stacey shared painful childhood stories. Her Caucasian grandfather, who lovingly raised her, consistently used racial slurs against African Canadians. A Grade 4 math teacher

failed her and discreetly told her she was not intelligent enough, as a person of colour, to understand math. Peers ridiculed her for her hair type since first grade. Stacey grew up feeling "in between" her Caucasian and African Canadian friends. She lost a sense of hope in Grade 9, the year prior to this dance inquiry, when she dropped out of school and drank excessively by herself. Eventually, she found the courage to come back to school through dance. During this dance inquiry, not by coincidence, Stacey embarked on a political mission for the first time, to run for student council, and won. We rejoiced as she articulated:

> Dance is the best thing that ever happened to me. I've become more myself. I've learned to escape from trying to impress people and trying to fit in with certain crowds. I realize when I reveal myself to the people around me, they also take down those walls and stop judging themselves. They feel more comfortable. For example, one friend Nadine is a Goth....She used to try and hide it from me. Then I said Nadine "You don't change who you are because you wear different clothes." So she's comfortable around me now. We went out and she got all dressed up. I was SO happy.

Shirley also alluded to a shift in consciousness to empathize with and uplift others.

> I learned to care for things a lot more. I don't want to put anyone down. I would way rather try and make them smile than make anybody feel bad, even when they've tried to make me feel bad. All these things were a part of me but I wasn't as aware of them as I am now. This workshop has actually made me think about it. I made the conscious decision I don't want to litter anymore. I've learned how to listen to my body and how to do things that make me feel good....I didn't really listen to that before. Now if I'm worried, I'll actually listen to myself instead of just listening to the popular demand.

Shirley's new-found bodyself attunement stretches beyond jumping into a hip-hop circle without regard for other's criticisms or staying home on a Friday night when she feels like relaxing. Her bodyself awareness and internalized compassion reportedly led to a courageous act of beginning to break away from a violent dating relationship.

Adolescent girls' socialization often causes them to feel they have to choose between self and others' acceptance. Problematically, they often choose acceptance over authenticity. This results in a false self they reveal publicly while leaving their authentic thoughts and feelings to the realm of the private—hidden and protected from ridicule and eventually from self. The consequences of ignoring bodyself wisdom are grave. Girls live in friendships where they sacrifice themselves and, additionally, can miss important inner warning signs when their bodies sense physical, emotional, or sexual danger. The mirror and energy ball power dances, however, inspired Olivia, Stacey, and Shirley to feel the bodysoul

of themselves and each other. Although their socio-historical contexts and unique perspectives led them to varied life experiences, they realized they all felt lament and they all felt elation. Together they experienced comfort, acceptance, and even ecstasy. Gordon's (2005) stages of empathy—awareness of self, understanding of emotions, ability to attribute emotions to others, and take the perspective of another person—were all present in our dance work together. The girls that participated in this research learned to be fully present, equal, dynamic, unique, and united all at the same time. This embodied curriculum of deeply attuning to one another's movements, intentions, and feelings reconciled the inner battle between following self and other by sensing and seeing the same energy move each of them individually and collectively. When these girls felt genuinely seen and accepted, self-compassion and the desire to empathically relate to others followed.

> Whoever wishes to quickly rescue [her]self and another,
> should practice the supreme mystery:
> the exchanging of Self and other
> —(8TH-CENTURY POET, CITED IN GIMMELLO, 1983, P. 69).

NOTES

1. Jai means victory in Sanskrit.
2. Participants chose these pseudonyms.

REFERENCES

Adler, J. (1999). Who is the witness? A description of authentic movement. In P. Pallaro (Ed.), *Authentic movement: Essays by Mary Starks Whitehouse, Janet Adler, and Joan Chodorow* (pp. 141–159). Philadelphia, PA: Jessica Kingsley.

Belenky, M. F., Clinchy, B. M., Goldberger, N., & Tarule, J. (1986). *Women's ways of knowing: The development of self, voice, and mind.* New York, NY: Basic Books.

Berrol, C. (2006). Neuroscience meets dance/movement therapy: Mirror neurons, the therapeutic process and empathy. *The Arts in Psychotherapy, 33,* 302–315.

Bertherat, T., & Bernstein, C. (1977).*The body has its reasons: Anti-exercises and self-awareness.* New York, NY: Pantheon Books.

Blood, S. K. (2005). *Body work: The social construction of women's body image.* New York, NY: Routledge.

Emerson, R. W. (1990). In R.D. Richardson (Ed.), *Ralph Waldo Emerson: Selected essays, lectures, and poems.* New York, NY: Bantam Books.

Fels, L. (2008). *Exploring curriculum: Performative inquiry, role drama, and learning.* Vancouver, Canada: Pacific Educational Press.

Fraleigh, S. (2004). *Dancing identity: Metaphysics in motion.* Pittsburgh, PA: University of Pittsburgh Press.

Gallese, V. (2004). *Intentional attunement. The mirror neuron system and its role in interpersonal relations* (pp. 4–13). Retrieved from http://www.interdisciplines.org/medias/confs/archives/archive_8.pdf

Garner, R., Bootcheck, J., Lorr, M., & Rauch, K. (2006). The adolescent society revisited: Cultures, crowds, climates, and status structures in seven secondary schools. *Journal of Youth and Adolescence, 35*(6), 1023–1035. doi:10.1007/s10964–006–9060–7

Gilligan, C. (2006). When the mind leaves the body...and returns. *Daedalus, 135*(3), 55–66. doi:10.1162/daed.2006.135.3.55

Gimmello, R. M. (1983). Mysticism in its contexts. In S. Katz (Ed.), *Mysticism and religious traditions* (pp. 61–88). Oxford, England: Oxford University Press.

Gordon, M. (2005). *Roots of empathy: Changing the world child by child.* Toronto, Canada: Thomas Allen.

Harris, D. A. (2007). Pathways to embodied empathy and reconciliation after atrocity: Former boy soldiers in a dance/movement therapy group in Sierra Leone. *Intervention, 5*(3), 203–231. doi:10.1097/WTF.0b013e3282f211c8

Jung, C. G. (1954). *Psychology of the transference* (Vol. 16). London, England: Routledge & Kegan Paul.

Knill, P. (2005). Foundations for a theory of practice, Part III: The theory of practice. In P. J. Knill, E.G. Levine, & S. K. Levine (Eds.), *Principles and practice of expressive arts therapy: Toward a therapeutic aesthetics* (pp. 93–169). Philadelphia, PA: Jessica Kingsley Press.

Laban, R. (1963). *Modern educational dance.* London, England: MacDonald & Evans.

Margolin, I. (2009). *Beyond words: Girls bodyself* (Unpublished doctoral dissertation). Ontario Institute for Studies in Education at the University of Toronto, Ontario, Canada.

Margolin, I., Pierce, J., & Wiley, A. (2011). Wellness through a creative lens: Meditation and visualization. *Journal of Religion & Spirituality in Social Work: Social Thought, 30*(3), 234–252. doi:10.1080/15426432.2011.587385

Pagels, E. (1988). *Adam, Eve, and the serpent.* New York, NY: Random House.

Phelan, P. (1993). *Unmarked: The politics of performance.* London, England: Routledge.

Rogers, C. (1980). *A way of being.* Boston, MA: Houghton Mifflin.

Sen, T. (2005/2007).*Ancient secrets of success for today's world: The four eternal principles revealed.* Toronto, Canada: Omnilux Communications.

Snowber, C. (2008). The soul moves: Dance and spirituality in educative practice. In L. Bresler (Ed.), *International handbook of research in arts education* (pp. 1449–1456). Dordrecht, The Netherlands: Springer.

Tanenbaum, L. (1999). *Slut! Growing up female with a bad reputation.* Toronto, Canada: Seven Stories Press, Hushion House.

Taylor, J., Gilligan, C., & Sullivan, A. (1995). *Between voice and silence: Women and girls, race and relationship.* Boston, MA: Harvard University Press.

Whitehouse, M. S. (1999). Reflections on a metamorphosis. In P. Pallaro (Ed.), *Authentic movement* (pp. 58–62). Philadelphia, PA: Jessica Kingsley.

Wyman-McGinty, W. (2007). Merging and differentiating. In P. Pallaro (Ed.), *Authentic movement: Moving the body, moving the self, being moved: A collection of essays, volume 2* (pp. 154–175). Philadelphia, PA: Jessica Kingsley.

· 6 ·

Pay Attention,
Pay Attention,
Pay Attention

BOYD WHITE

In February 2011, during an already long and wearying winter, a ray of warmth arrived one Sunday afternoon in the form of a radio interview with the American novelist Richard Ford.[1] A substantial part of the interview focused on his 2006 novel, *The Lay of the Land*, which he described as a political novel. For Ford, politics goes beyond deciding which side of the political spectrum one sits on; it's more about living each moment to its fullest potential. Borrowing a line from the poet Randall Jarrell,[2] Ford worried: "The way we miss our lives is life." But Ford argued that life is worthy of attention. He said, in the interview, "Live in the present. Realize what you're doing when you do it. Pay attention, pay attention, pay attention."

Attention, for Ford, enfolds others, objects, and ideas. He claims that a key purpose of the arts—literature in his case—is to "realign conventional wisdom." For Ford, that realignment follows in the footsteps of the ancient Greek quest for happiness, albeit in a contemporary setting. Ford's writing—droll, pensive, and profound—celebrates his capacity to embrace life in all its complexities, and in full awareness of its ultimate tragic nature. That embrace begins and endures through attention. So too, in the following paragraphs, I will argue that attention is essential to, even synonymous with, acts of aesthetic experience,

empathy, and education, and of course, research. I find the symmetry between Ford's repetition and the three foci of our text pleasing. And to bring Ford more directly into an educational context, it is probably also fair to say that his "attention" is akin to Greene's (1977) "wide awakeness"[3] or Smith's (2006) "percipience."[4]

In what follows, I divide the chapter into three largely theory-oriented sections that correspond to the triple foci in the text's title. I then attempt to provide a concrete example, in the form of a poem, of how the three foci can interact. Poetic responses to artworks are the focus of my current research in art education. Thus I conclude with a discussion of the implications of such interactions for education and research.

I. Aesthetics

Roger Scruton (*Britannica Online Encyclopedia*, n.d.) cited three main approaches to the study of aesthetics under the following headings: (a) aesthetic concepts (such as theories of beauty, or psychical distance); (b) aesthetic experience (such as Dewey's notion of a unified consummation of *an* experience); (c) aesthetic objects (such as artworks, but also a myriad of objects that exist outside the artworld). Here, I will confine my discussion to Scruton's second orientation, that is, the study of experiences that people undergo that they acknowledge to be aesthetically oriented. As Scruton argued, "It is, after all, to experience that we must turn if we are to understand the value of the aesthetic realm—our reason for engaging with it, studying it, and adding to it" (p. 2). Such understanding is essential if one is going to make an argument for the place of aesthetics in education, as we are doing in this text. More particularly, I am interested in responses to encounters with artworks and what such experiences have to offer to education. Inevitably, some of those responses address or imply concern for definitions of art, whether art has to be beautiful, and so forth; but those are topics for another paper.

A Brief Overview of General Characteristics[5]

A focus on the experiential component of aesthetics dates back to the early Greek use of the verb *aisthanomai*, to perceive. Readers of English are likely to note how the related term *aisthetikos* (sometimes spelled *aisthitikos*) tranforms into "aesthetics" (*Concise Oxford Dictionary, 7th ed.*).[6] Susan Buck-Morss (1992) elaborated on the topic: "*Aisthisis* is the sensory experience of perception.…It is a form of cognition, achieved through taste, touch, hearing, seeing

and smell—the whole corporeal sensorium" (p. 6). While I endorse Buck-Morss's attention to corporeality, I note as well her reference to perception as cognition. Aesthetically oriented cognition involves imagination. By "imagination" I mean a capacity to make connections. These acts may range from the mundane to the ingenious. The former might include recognition of objects or events as belonging to particular categories; the latter, to creative invention. In other words, in the context of aesthetic experience, it is imagination that enables one to link an act of seeing with an earlier one, to understand possible connections between the two (or more) and thus to create meaning out of ongoing experiences. Without this capability, each act of seeing would remain isolated, incapable of comparing one moment to another, incapable of meaning-making. In short, just as perception is more than the mechanical act of vision, aesthetics is more than sensuous. One's understanding of the world derives from participation in it, the more holistic that participation, the more aesthetic. To have an aesthetic experience is to be viscerally, cognitively, imaginatively, and emotionally attentive. Art educators know this intuitively, although they don't necessarily have a uniform concept of aesthetic experience.

For example, Eaton and Moore (2002) noted that, within education, aesthetic experience, as generally understood, "refers to three frames of attention and receptiveness" (p. 13). In the first of these "the term 'experience' implies an accumulation of lived response, rather than some one moment of inspiration" (p. 13). The second points to a specific moment, a spontaneous, "isolated, specific transformation of awareness…[during which we] are *moved* by what we find" (p. 14). Third, "the term is…attached to *whatever* states of mind occur…when observers focus their awareness on such perceptual features of a thing as its design and its sensible patterns" (p. 14).

More recently, David Burton (2011) suggested that there are five categories for the study of aesthetics that emerge in art classrooms.[7] His first and fourth categories are philosophically oriented, addressing the nature of art and axiological potential, respectively. I will turn to the topic of values later in this chapter. Burton's second category addresses aesthetic experience specifically, and in that respect corresponds with Eaton and Moore's overview; but where Eaton and Moore refer to types of experience, Burton focuses on the nature of the viewer, on one's capacity for "aesthetic predisposition." Such an orientation might be said to parallel Eaton and Moore's first frame insofar as a predisposition would depend on accumulated lived responses. But here I want to draw attention to Burton's closely related third category where he raises the question: How does art mean? This is implied rather than explicitly stated in Eaton and

Moore's article, but it is an important question and an essential contribution to any argument for the inclusion of the arts in general education. For surely one facet of education shared across the curriculum is a concern for meaning-making. Indeed, one could argue that education broadly defined is about meaning-making. But, as Eaton and Moore suggest, where one of the characteristics of aesthetic experience is a direct and spontaneous grasp, meaning is usually associated with discursive construction. Thus one might be justified in seeing conflicting educational goals in aesthetic education—immediate grasp versus constructed learning. As Parsons (2002) insisted, however: "The grasp of aesthetic qualities is built up over time in a cyclical process of discursive learning and immediate grasping, where what is grasped responds each time to what is learned...the two [actions] are...closely related and mutually dependent" (p. 31).

To summarize this section, I have provided a brief historical account of the origins of the term "aesthetic" and pointed to some literature that addresses educational perspectives on the topic. These perspectives provide a general account of the place of aesthetic experience in teaching and research. Mark Johnson (2007) captured the sense of such a generalized view succinctly: "aesthetics becomes the study of everything that goes into the human capacity to make and experience meaning" (p. x). The generality expressed in such a broad statement is both useful and problematic, as the next section will demonstrate.

From the General to the Particular: Problems and Possibilities

Johnson is influenced by Dewey's notion of aesthetic experience. In *Art as Experience* (1934/58) Dewey differentiated between everyday, perhaps useful, but unremarkable experiences, and *an* experience, which is remarkable for its sense of unity, completion and fulfillment: "it is a consummation and not a cessation" (p. 35). And just as Johnson's "everything" suggests, Dewey too argued that aesthetic experiences are possible in almost any situation (p. 34). But if every activity or perception is potentially aesthetic, this raises the question of how we recognize the real McCoy. What, for example, demarcates a cessation from a consummation, or an intense but non-aesthetic experience from an aesthetic one? Conscious avoidance of a near-accident could well be intense, complete, and even unified in terms of one's awareness of all the contributing moments of the event; but would it qualify as aesthetic? Could the end of a love affair be aesthetic as well as a cessation?

Eaton and Moore (2002) explored some attempts to address such questions. Thus, for example, they cited the work of Monroe Beardsley, for whom the key

characteristic of aesthetic experience is gratification. Beardsley, like Dewey, also insisted on there being a sense of unity to the experience, and gratification. Gratification, for Beardsley, means pleasure. But, as Eaton and Moore pointed out, Beardsley's criteria raise more problems than they resolve. Is aesthetic experience always pleasurable, for example? Dewey and Beardsley do not move the discussion beyond the realm of the generalize-able.

Carroll (2001) attempted to do so. He began by discussing four theories of aesthetic experience. I have discussed Carroll's account in more detail elsewhere.[8] Here, I will simply note that the first three theories point to influences from Kant (disinterested intrinsic pleasure), Dewey's pragmatism, Marxism, and finally, Carroll's own "deflationary" account, in which he draws attention to: (a) design appreciation—e.g. shape, colour; and (b) *aesthesis*, or "expressive quality"—e.g., elegance. By narrowing his focus, Carroll does avoid accusations of generalization, but as Eaton and Moore (2002) asked, "Is this enough?"

Shusterman (2002) appeared to need something more. Like Carroll, Shusterman also relies on just two foci; in his case, surface and depth. His attention to "surface" appears similar to Carroll's "design" emphasis. Shusterman's second focus, depth, however, moves in a quite different direction from Carroll's qualitative account. Shusterman's "depth" is contextually oriented. For Shusterman, aesthetic experience is inclusive of:

> underlying cultural traditions, social structures, and economic forces whose constellation and transformations provide the framework that enables the work to be created and understood as having the kind of artistic identity and features we ascribe to it. (p. 2)

Through his attention to context, Shusterman enlarges the definition of aesthetic experience beyond Carroll's account; and if Dewey and Johnson's "everything" may be assumed to include contextual considerations, then Shusterman's account lends some credence to Johnson's claim. Eaton and Moore (2002) appeared to support the general tenor of such a claim. Then too, in drawing attention to the perceptual features, Eaton and Moore reinforced Carroll's "design" focus and Shusterman's "surface." The "states of mind" emphasis would seem to correspond to Carroll's *aesthesis*.

This is beginning to sound like aesthetic experience is maybe a little of this, maybe a little of that; an awkward philosophical position to maintain unless another model suggests itself. Eaton and Moore find such a model in Ralph Smith's work. They called it *Smith's composite view* (p. 15). They noted:

> Smith agrees with Beardsley's later view that the several criteria of aesthetic experience should be understood as jointly sufficient, but individually non-necessary

(p. 15)...in the end, we are left with the Beardsleyan idea that "aesthetic experience" must be a cluster concept, a collection of ingredients that is emendable, corrigible, and inherently loose in that none of the ingredients is essential to its realization. (p. 16)

Eaton and Moore concluded that aesthetic experience is a cumulative one, what they call a "*sorites* phenomenon...it comes into being when a number of contributory elements add up to a sufficient sum" (p. 16). This is similar to Arnold Berleant's (2002) notion of an *aesthetic field*, in which it is possible to encounter a number of responses to a given situation, and these responses would, together, qualify as aesthetic, yet a different set of responses would be called for in different circumstances.

Smith's and Berleant's accounts strike me as practical and philosophically sound. They enable one to acknowledge those features that predominate on any one occasion without necessitating feelings of having somehow missed the boat because some other feature is missing. It is possible, therefore, to have a predominantly intellectual, contextually oriented, aesthetic response that doesn't include a sense of spiritual uplift or deeply emotional response. Conversely, one may be spontaneously emotionally aroused but have little contextual background. Both occasions, however, could well qualify as aesthetic experiences. This is not to say that one couldn't pursue additional responses on successive occasions and thus enlarge the experience. That is, just as art is sometimes thought of as deserving the designation "Art" and sometimes merely "art," so too there are undoubtedly major and minor aesthetic experiences.

Empathy

Dictionaries vary somewhat in their versions of the etymological roots of empathy. All agree, however, that the word derives from the Greek *empátheia*, variously translated as "passion" (from *en* "in" + *pathos* "feeling"(Online Etymology Dictionary). Another dictionary suggests "affection," "*path*" being the base of *páschein*, to suffer (Dictionary.com). All agree that the German philosopher Rudolph Lotze (1817–81) adopted the concept in 1858 with his use of the word *Einfühlung* (from *ein* "in" + *Fühlung* "feeling"). Suffice to say that the emphasis so far is on feeling. If that were the end of the matter it would be difficult to differentiate between empathy and sympathy. Indeed, a number of web sites I checked seem to use the terms interchangeably, and their examples are not helpful. There is another side to the phenomenon, however. In a move beyond the etymological roots of the term, Dictionary.com defines empathy as:

1. The intellectual identification with or vicarious experiencing of the feelings, thoughts, or attitudes of another.
2. The imaginative ascribing to an object, as a natural object or work of art, feelings or attitudes present in oneself: *By means of empathy, a great painting becomes a mirror of the self.*

The capacity for mirroring (in #2) is an interesting phenomenon, one I will return to shortly. For the moment I will concentrate on the first part of the first definition. Here the key phrase is "intellectual identification." That is, empathy is not a purely affective state.

David Swanger[9] (1990), taking the Oxford dictionary as his point of reference, elaborated on the notion of empathic knowledge, that is, "what is learned or comprehended by empathy....The emphasis of empathic knowledge is on outward projection, 'projecting one's personality into the object of contemplation,' whereas terms like 'feeling' or 'intuition' emphasize bringing what is perceived into our psychophysical organic state" (p. 77). In short, the emphasis on outward versus inward projection provides the essential difference between empathy and sympathy.

An example may help to illustrate the point.[10] If a medical doctor were to immerse himself in sympathy for a seriously ill patient, his attention would be self-oriented, to his own emotional responses. In such a scenario, the doctor's capacity for medically addressing the situation might well be compromised. A doctor needs not just to walk in a patient's shoes, as the expression goes, but also to decide on the best course of action to take to address the problem at hand. That focus on the patient's well- being, rather than on his own feelings, is empathy. Of course, one may well experience both sympathy and empathy simultaneously and in varying degrees, but it is important to recognize the difference. I will return to this point in the section on education.

The second phrase in the above definition that I want to draw attention to is "vicarious experiencing." The definition makes clear that the authors have in mind an ability to enter into the mental life of other individuals. Clearly, this is an essential capacity if one is to interact fully with any of the representational arts, whether visual or literary. If one cannot identify with the character in a novel, the work fails in that regard. Of course, such a failure raises the question as to whether this is the fault of the author or the reader, or, conceivably, both. That is, vicarious experience involves a reciprocal relationship. On my computer mouse pad is an image of Velasquez's *Las Meninas.* The extent to which I can enter into the mind of the young princess, Velasquez himself, or any other

member of the group, depends on my willingness to enter into the drama. At the same time, the figures are invitational. It has happened that, during a gallery visit, I have heard a person say, "That painting doesn't speak to me." On such occasions, for that individual, the invitation is not apparent. The issue of reciprocity is an important one, to which I will return in another section. For the moment, I will conclude this commentary on vicarious experience by reminding the reader of the practical nature of the phenomenon. To put the matter simply, vicarious experience enables one to squeeze many lives into one's own, thus enlarging and enriching one's life through the experiencing of multiple perspectives.

My reference to *Las Meninas* in the foregoing paragraph introduces a variation on attention to individuals that the first definition addresses. That is, while the painting depicts individuals, it is also an object and represents the artist's ideas about art and his place in the world. Empathy here requires a move beyond attention to people. This is why the dictionary introduces a second definition for empathy; one may have empathy not only for individuals but for objects and ideas as well. But the capacity to empathize with an object perhaps requires a heightened awareness of oneself and how some personal characteristic is reflected in the object or idea. This is why the definition makes reference to a painting becoming a mirror of the self. That possibility permits me to tell my students in a course on aesthetics and art criticism that the course is really about them. That is, one perceives through the lens of one's own past experiences and understanding. Thus, interactions with an unfamiliar artwork are inevitably filtered through that lens.

Education

all aware human beings care
(Noddings, 1992, p. 18).

I turn now to the third entity in our text's title, namely, education. I will limit my comments to a narrow focus but one that has wide-ranging implications.

Noddings (1992) stated: "if the school has one main goal...it should be to promote the growth of students as healthy, competent, moral people" (p. 18). For Noddings, the route to such an end is the act of caring. Noddings described in detail the reciprocal relation of the carer and cared-for. While I appreciate the need for such reciprocity, I suggest that, for the educator, a further distinction must be made. That is, earlier I discussed the difference between sympathy and empathy, both of which may be considered to be

forms of caring. But caring in education must be empathic. My own pre-service teachers sometimes raise this point. That is, to my initial consternation, some have suggested that caring can be taken too far. They don't want to be emotional sponges soaking up their students' problems. At first I thought that these teachers were reacting with fear—fear of being considered soft, losing control, becoming too involved in their students' lives. Perhaps there was some of that. If so, that is unfortunate. Fear is self-centered. But on further reflection, I realized that most of my pre-service teachers are not fearful. They crave engagement. Instinctively, they know that one should temper sympathy with empathy. People, by and large, don't want sympathy; students want successful resolutions of whatever learning difficulties or life problems they are experiencing. Resolutions are achieved through empathic response.

In a more recent work Noddings (2003) made a different distinction that is pertinent to this discussion. I have suggested that a common goal across the curriculum is the pursuit of meaning-making. But as Noddings has made clear, educators need to distinguish between goals and aims. Goals are tied to courses; aims reach beyond the concerns of individual courses. As a former student of mine succinctly put it: Goals pertain to classroom results; aims focus beyond the classroom, to what we want to be as human beings. I raise the issue of the difference between aims and goals because I am persuaded by Swanger's (1990) declaration: "The epistemology of art is empathy" (p. 76). But empathy is not a goal. It is not content based. Empathy is an attitude, one that operates on the basis of belief in the worth of others as well as objects and ideas (Agne, 1999). Thus, while art classes certainly contain content, mastery of such content is a goal. However, arguably the most important component of art classes—empathy—is more a matter of inculcation on the part of the teacher and positive response on the part of the students. In short, goal-oriented meaning-making is a rather different matter from an aim-oriented, empathy-funded quest for meaning, the latter being an evolving realization of what it means to be a human being.

Noddings's and Agne's emphasis on the caring relationship brings to mind an earlier work, Martin Buber's (1958) influential *I and Thou*. To Buber, there are two ways of being. One consists of an *I-Thou* relationship; the other, *I-It*. The former is an encounter or meeting, a dialogue. The relationship bespeaks a unity, a mutual holistic existence without boundaries. People truly in love might be the perfect example, the carer and cared-for as a single entity. The reciprocal, empathic nature of the encounter is apparent, as is, no doubt, the rather ideal nature of the phenomenon.

The *I-It* relation, on the other hand, is our much more common way of being. It is a pursuit, even a confrontation, rather than an encounter. It is instrumentally oriented, a means to an end. It is therefore not a dialogue; rather, it is a monologue—inward-looking and self-oriented. It is the antithesis of empathy.

I raise the issues of caring, of empathy versus sympathy, dialogue versus monologue, encounter rather than pursuit, because they seem to me to be at the core of what education should be promoting. Students cannot be argued or coerced into caring, for an artwork or for anything else. They must see it for themselves. Students gain that capacity by mirroring their teachers' behaviors (Agne, 1999). That is, one cannot force a student to see an artwork as the teacher sees it. The mutual seeing can only emerge as a shared response, Buber's "meeting"; one adopts the values of the other. In turn, those values come to the fore as one interacts with an artwork. This is where the idea of art mirroring the self emerges; or, in Buber's terms, the two become a unity. The meanings one derives from any interaction are filtered through the prism of one's ever-present personal, cultural, and societal values. Education is ultimately a values-based exercise in meaning-making.

Aesthetic experience appears to embody the features I have been lauding. I have suggested that aesthetic encounters may provide differing levels of experience. Jones (1979) depicted aesthetic experience like a bull's eye or dartboard divided into intrinsic and extrinsic, cognitive and affective opposing quadrants. (See Figure 1). The closer one is to the center, the more integrated one's various responses and the stronger the experience; the further away from the center, the less aesthetic. Thus, a highly centered experience might equate to a life-changing, Buberian *I-Thou* epiphany. Experience that is represented on the outer edges of the diagram would, of necessity, be less unified and might therefore be more of an *I-it* exchange—perhaps attention to how a painterly effect is achieved or a concentration on one's emotional state. Regardless of the degree of the experience, requirements are the same—a reciprocal interaction or dialogue, an open-mindedness and self-awareness of the nature and range of one's responses to the occasion—corporeal, affective, and intellectual. Pay attention, pay attention, pay attention.

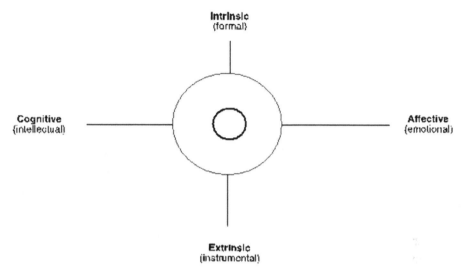

Figure 1. Jones's Model of Phenomenological Balance.

From Theory to Practice

I turn now to an example that I hope illustrates the foregoing. It is a specific focus of my research and teaching. One course I teach involves introducing my preservice teachers to aesthetic practice, and ultimately to commentary on their responses to encounters with art. These responses become art criticism, which, in turn, can take a variety of forms. What consumes my research and teaching interests lately is criticism in the form of ekphrasis. Here, I provide an example of my own attempt at ekphrasis, on the premise that I have to be able to demonstrate what I'd like my students to attempt.

The early Greeks coined the term *ekphrasis*: a "speaking out" or "telling in full" (Heffernan, 1993). The Greek tradition continues. Heffernan provided a contemporary definition: "*ekphrasis is the verbal representation of visual representation*" [italics in the original](p. 3). This suggests that response can take the form of prose or poetry. Here, I concentrate on the latter. As Cheeke (2008) observed, there seems to be a surge of interest in poetic ekphrasis in recent years. Cheeke quoted Hollander: "Poems addressed to silent works of art, questioning them; describing them as they could never describe—but merely represent—themselves; speaking for them; making them speak out or speak up" (p. 24). Notable examples from the twentieth century include

W. H. Auden's (1938) *Landscape with the Fall of Icarus*, and on the same topic, William Carlos Williams' (1962) *Pictures From Breughel*; more recently, Pat Adams's (1986) *With a Poet's Eye: A Tate Gallery Anthology*, and Paul Durcan's (1991) *Crazy about Women*.

Lest Heffernan's definition appear to prompt merely a verbal imitation of the visual work, I stress the point that the poetry I have in mind, while obviously prompted by encounters with an image, is an extension and enlargement upon the initial viewing experience. At the same time it is an exercise in creative exchange—rather than a treatise upon difference—between the two media. It is more of a Buber-ian meeting. That is, fidelity to the image is not the issue; rather, the issue is the viewer/writer's experience "and the pressure of that experience on his or her interpretation of the work of art" (Heffernan, 1993, p. 183). Thus, ekphrasis is not simply an attempt to translate the non-verbal (image) into the verbal—an endeavor doomed to failure. Ekphrasis is an elaboration upon the viewer's experience and a creative endeavor in its own right. Thus, a poem may take a number of directions, only one of which is a specific reference to discrete features of an artwork. Others could be: an emulation of the work's structure to evoke a similar mood; a commentary or philosophic stance that reflects the viewer's response to the work in terms of its personal and social significance; or combinations of these foci—what Fischer (2006) referred to as "an interplay of complicity and provocation" (p. 3).

Due to my emphasis on a subjective response to artworks, some may question the educational credibility of the exercise. Would not such a focus encourage a self-centeredness and lack of perspective on exterior matters? Why not strive towards objectivity? In response, I refer to Husserl's (1954) notion of radical subjectivity, which, in brief, posits the idea that all experience of the external world begins with the self. That is, the external world is always understood in relation to the self. One defines the self in relation to the world and vice versa. Inevitably, such definitional exercises draw attention to experience. Poetry strives towards a grasp of that which is unique in our individual experiences and at the same time invites a shared commonality.

To demonstrate that possibility, I turn now to a poem-in-progress that is (so far) my response to Feininger's (1918) *Yellow Street II*. My premise is that I have to be able to demonstrate what I'd like my students to attempt.

Figure 2. *Yellow Street II* (1918). Acquisition No: 1971.35. Lyonel Feininger, American, 1871–1956. Oil on canvas 95 x 86,1 cm. Coll. The Montreal Museum of Fine Arts. © The Lyonel Feininger Family LLC / SODRAC (2012). Photo: The Montreal Museum of Fine Arts, Richard-Max Tremblay.

Feininger Moments

I
Neighbours idle in the village square.
Autumn sun swirls and
Bounces off house walls, chasing
Breezes, flipping coattails.
The old woman, in white
Skirts sailing 'round her cane,
Muses:

Getting about's not as easy
As it used to be.
In fact, nothing is.
I move slowly now
Often not sure
Where or why
In a world no longer mine.

No birds sing
In the bare-branched trees.
No one talks.
The young flaunt their frippery and
Eye each other furtively
Beneath barren windows
While the wind chafes and
A chill settles in the bones.

II
But then again, how playful.
Cubist echoes, but colour all your own
No Picasso-esque browns or greys for you.
Prismatic planes jostle,
Mostly yellows and blues,
Some red and green bracketing,
Black punctuations, contrapuntal lines.
One by one
Figures join in chorus,
A yellow-themed fugue
Rising; shapes merging, shifting, circling.
A curve in the lower center,
Bridges two figures, bow-like;
Vibrato throbbings
Vibrate skyward
And down again.

III
The Belgian flag is a nice touch,
Though a puzzling one in a Bavarian village.
Were you just being mischievous—or wistful—
Caught up in events
foreshadowing worse to come?
The Nazis took your paintings.[11]

Discussion

Why write a poem? Justification requires a brief comment about art criticism, which is a pedagogically essential step beyond aesthetic experience (Shusterman, 2003; Barrett, 2003). That is, the initial experience is essentially a private interaction between viewer and artwork. Confirmation or enlargement upon that experience generally requires dialogue. In the context of aesthetic education, dialogue becomes art criticism, of which there are two forms—evaluative and interpretive (Barrett, 1990). Professionals such as art curators usually employ the former. Since educators don't aspire to curatorial expertise, interpretive critiques offer a more appropriate pedagogical strategy. That is, the role of educators is not to pass definitive judgment upon the worth of a particular artwork; rather, it is to provide opportunities for sharing individuals' interpretations.

Galvin and Todres (2009) made an interesting observation about individual experience. They noted: "experience is both unique and shared, and thus can never be understood exclusively from a first person or third person position" (p. 314). Ekphrasis has the capacity to move between those perspectives or, as Fischer (2006) framed the move, "between charisma and critique" (p. 19). In so doing ekphrasis offers art educators a rich potential for individual efforts at meaning-making and shared experience.

My poem is my attempt to share my empathic responses to Feininger's painting and to demonstrate my attention to the individual moments of encounters over an extended period. I believe the poem also demonstrates the reciprocal nature of the encounters and the possibility for multi-faceted responses that constitute aesthetic experience. I hope it also shows my capacity to pay attention. There is no ultimate correct response to the Feininger work, but in my interactions with the work I do come to some understanding of my meaning-making as a reflection of the world as I see it.

Looking back at Eaton and Moore's three modes of aesthetic experience, I find that I have participated in all three. That is, certainly my various responses are due to my accumulated lived experiences (first mode). In terms

of an emotionally funded specific moment of transformation, I think verses I and III demonstrate that. The whole poem exemplifies Eaton and Moore's third mode, that is, attention to my specific moments of experience.

In terms of research, authors such as Cahnmann (2003), Percer (2002), Piirto (2002), and Sullivan (2000, 2005) address possibilities for the use of poetry as a research tool. A glance through Prendergast, Leggo, and Sameshima's (2009) text shows the breadth of poetic application to arts-based research—from introduction into educational research methods courses, to nursing, sociology, language arts, and more. Prendergast (2009) provided statistics on the number of poetry-oriented citations in peer-reviewed social science journals appearing between 2006–2008—234 citations. To my knowledge, however, none of the articles addresses the use of poetry, specifically ekphrasis, within art education. I argue that ekphrasis is a legitimate form of art criticism, indeed one of ancient lineage as well as contemporary usage. And in terms of aesthetic experience, ekphrasis provides a dual mode encounter—visual and literary—and the opportunity to play imaginatively between the two.

Today we attempt to give credence to the individual experiences and voices of our students. Experience and understanding of art are not exclusive to museum curators. At the same time, the sharing of the experiential nature of one's encounters with art makes some form of evocative writing highly desirable. Ekphrasis fulfills that criterion.

NOTES

1. C.B.C. Radio 1; *Writers and Company*, hosted by Eleanor Wachtel. Sunday, February 6, 2011. Interview with Richard Ford.
2. American poet Randall Jarrell (1914–1965). *A Girl in a Library*. Line 92.
3. Greene comments: "I am embarrassed by 'Abstract words such as glory, honor, courage, or hallow....' Wide-awakeness has a concreteness; it is related...to being in the world." Within the single quotation marks, Greene is quoting Hemingway in *A Farewell to Arms*.
4. Percipience is a key concept that Smith borrows from Harold Osborne. The notion of percipience suggests a highly attuned perception, one that combines an innate intelligence, informed awareness in terms of some capacities for the making of comparisons (a looking *for* as well as a looking *at*), and a sensate and affective sensitivity.
5. My discussion is, of necessity, brief. For a more extensive study of aesthetic experience I recommend Shusterman, R., & Tomlin, A. (Eds.) (2008). *Aesthetic Experience*. New York, NY, & London, England: Routledge.
6. Aiththetikos: Having to do with perception.
7. The five categories are: (1) The art object and its nature; (2) Aesthetic experience; (3) Art in society and culture; (4) The function of art (its value); (5) Art as spiritual experience. As one can see, only #2 addresses aesthetic experience specifically, although it could be argued that #5 addresses a particular form of experience.
8. White, B. (2011). Private perceptions, public reflections: Aesthetic encounters as vehicles

for shared meaning making. *International Journal of Education and the Arts,12*(2), 1–25.
9. I owe David for influencing me in the direction of this current exercise. His 1991 text, *Essays on Aesthetic Education*, persuaded me years ago of the importance of empathy to the whole educational enterprise.
10. I seem to recall reading this example somewhere. If so, I have lost the reference.
11. I had originally included another verse, one devoted to memory, which was part of my interactions with the painting. I deleted that verse in the interests of making the poem stronger.

REFERENCES

Agne, K. (1999) Caring: The way of the master teacher. In. R. Lipka & T. Brinshaupt (Eds.), *The role of self in teacher development* (pp. 165–188). New York, NY: State University of New York.

Ashbery, J. (1985). Self-portrait in a convex mirror. In *Selected poems* (pp. 188–204). New York, NY: Viking Penguin.

Barrett, T. (1990). Fewer pinch pots and more talk: Art criticism, schools, and the future. *Canadian Review of Art Education, 17*(2), 91–101.

Barrett, T. (2003). *Interpreting art: Reflecting, wondering, and responding.* New York, NY: McGraw-Hill.

Beardsley, M. (1969). Aesthetic experience regained. *Journal of Aesthetics and Art Criticism, 28*(1), 3–11.

Berleant, A. (2002) *The aesthetic field* (2nd ed.). Christchurch, New Zealand: Cybereditions Corporation.

Buber, M. (1958). *I and thou* (2nd ed.). New York, NY: Scribner.

Buck-Morss, S. (1992). Aesthetics and anaesthetics: Walter Benjamin's artwork essay reconsidered. *October, 62,* 3–41.

Burton, D. (2011). *Five aesthetic questions.* Address given at the 2011 AERA Conference in New Orleans, LA, USA.

Cahnmann, M. (2003). The craft, practice, and possibility of poetry in educational research. *Educational Researcher, 32*(3), 29–36.

Carroll, N. (2001). *Beyond aesthetics: Philosophical essays.* Cambridge, England: Cambridge University Press.

Cheeke, S. (2008).*Writing for art: The aesthetics of ekphrasis.* Manchester, England, & New York, NY: Manchester University Press.

Dewey, J. (1934/58). *Art as experience.* New York, NY: Capricorn Books.

Dictionary.com. http://www.etymonline.com/index.php?term=empathy

Eaton, M. M., & Moore, R. (2002). Aesthetic experience: Its revival and its relevance to aesthetic education. *Journal of Aesthetic Education, 36*(2), 9–23.

Fischer, B. K. (2006). *Museum mediations: Reframing ekphrasis in contemporary American poetry.* New York, NY & London, England: Routledge.

Ford, R. (2006). *The lay of the land.* New York, NY: Random House.

Ford, R. (2011, February 6). Richard Ford interview with host Eleanor Wachtel. CBC, *Writers and company.* Retrieved from http://www.cbc.ca/writersandcompany/episode/2011/02/06/richard-ford-interview/

Galvin, K., & Todres, L. (2009). Poetic inquiry and phenomenological research: The practice of embodied interpretation. In M. Prendergast, C. Leggo, & P. Sameshima (Eds.), *Poetic*

inquiry: Vibrant voices in the social sciences (pp. 307–316). Rotterdam, The Netherlands: Sense.

Greene, M. (1977). Toward wide-awakeness: An argument for the arts and humanities in education. Teachers College Record, 79(1), 119–125.

Heffernan, J. (1993). Museum of words: The poetics of ekphrasis from Homer to Ashbery. Chicago, IL, & London, England: University of Chicago Press.

Husserl, E. (1954). The crisis of European sciences and transcendental phenomenology. Evanston, IL: Northwestern University Press.

Johnson, M. (2007). The meaning of the body: Aesthetics of human understanding. Chicago, IL, & London, England: University of Chicago Press.

Jones, R. L. (1979). Phenomenological balance and aesthetic response. Journal of Aesthetic Education, 13(1), 93–106.

Noddings, N. (1992). The challenge to care in schools: An alternative approach to education. New York, NY: Teachers College Press.

Noddings, N. (2003). Happiness and education. Cambridge, England: Cambridge University Press.

Online etymology dictionary. Retrieved from http://www.etymonline.com/index.php?term= empathy

Parsons, D. (2002) Aesthetic experience and the construction of meanings The Journal of Aesthetic Education. 36, 2, 24 – 37.

Percer, L. H. (2002). Going beyond the demonstrable range in educational scholarship: Exploring the intersections of poetry and research. The Qualitative Report, 2002, 7(2). Retrieved from http://www.nova.edu/ssss/QR/QR7–2/hayespercer.html

Piirto, J. (2002). The question of quality and qualifications: Writing inferior poems as qualitative research. International Journal of Qualitative Studies in Education, 15(4), 431–445.

Prendergast, M., Leggo, C., & Sameshima, P. (Eds.) (2009), Poetic inquiry: Vibrant voices in the social sciences. Rotterdam, The Netherlands: Sense.

Prendergast, M. (2009). Introduction: The phenomena of poetry in research. In Prendergast, M., Leggo, C., & Sameshima, P. (Eds.), Poetic inquiry: Vibrant voices in the social sciences (pp. xix–xlii). Rotterdam, The Netherlands: Sense.

Scruton, R. (n.d.) Aesthetics. Britannica online encyclopedia. Retrieved from http://www.britannica.com/EBchecked/topic/7484/aesthetics/11683/medieval-aesthetics

Shusterman, R. (2002). Surface and depth: Dialectics of criticism and culture. Ithaca, NY: Cornell University Press.

Shusterman, R. (2003) Pragmatism between aesthetic experience and aesthetic education: A response to David Granger. Studies in Philosophy and Education, 22, 403–412.

Smith, R. (2006). Culture and the arts in education. New York, NY, & London, England: Teachers College Press.

Sullivan, A. M. (2000). Voices inside schools: Notes from a marine biologist's daughter: On the art and science of attention. Harvard Educational Review, 70, 2, 211–227.

Sullivan, A. M. (2005). Lessons from the Anhinga trail: Poetry and teaching. New Directions for Adult and Continuing Education, 107, 23–32.

Swanger, D. (1990). Essays in aesthetic education. San Francisco, CA: ETM Text.

· 7 ·

Notes on
Empathy in Poetry

DAVID SWANGER

This is a personal essay on theory and practice in poetry. My theory of poetry (poetics) is based on the writings of Wordsworth and Coleridge, and then moves from what is included in their poetics to what is left out—the role of empathy in poetry. My account of varieties of empathy in poetry makes reference to other writers and to Plato, as well as really causing me to examine and re-examine my own poetry to understand fully how empathy is manifest in poetry. This is rather like wading into a long-familiar meadow and seeing anew cornflowers, which have been there all along, profuse, lovely, and varied, among thickets of grass.

1. Poetics Pertaining to Persons

First, I confess an aversion to the poetics of "ism"—structuralism, deconstructivism, subjectivism, and their ilk. Such poetics can be useful to our reading of poetry, especially if boundaries between them are permeable and their application is nuanced. But I find it vexing that these poetics more often than not diminish the poet in his or her own work or even banish the poet from the poem by contortions of cleverness that portray him or her as unwitting or superfluous. Poets are persons, not potted plants to be shelved away from the garden.

And once we take seriously that poets are persons responsible for poems, we may also seriously consider that readers are persons responsible for the poem's life beyond its maker. Readers are persons who, by their interest in the poem, show themselves to have rather more in common with the poet than less.

Having made this somewhat obvious point, that readers are persons, I will venture a less obvious one: the purpose of literary study, and here, the study of poetry, is not ultimately to teach us to read; rather, it is to teach us to live. This chapter will attempt to show how a proper *study of poetry* does exactly that—teaches us to live. Note my emphasis is on "study of poetry." I am not saying that poetry itself has a didactic function—I'd rather not attribute any particular function or purpose to poetry.[1] But the study of poetry is another matter, and necessarily didactic: as we study poetry and enter it more and more fully, and become more and more active as readers, we are, I dare say, learning how to live more fully.

II. Poetics: Emotion, Order, and Mystery

In this spirit, let us consider two poets whose poetics inspire, inform, and perspicaciously describe the poet in the act of writing, and by implication include the reader in the act of reading as an actor of co-creation: Samuel Taylor Coleridge, in *Biographia Literaria*, and William Wordsworth, in "Preface" to *Lyrical Ballads*.

Empyrean poets, Wordsworth and Coleridge earn, in my view, equal stature for the poetics they enunciate and refine through discussion with each other. Furthermore, Wordsworth and Coleridge are progressives; their poetics shape a new poetry for modernity. They do not look backward for critical authority, unlike, for example, T. S. Eliot, in his elevation of Metaphysical and Augustan poets.[2] Our examination will discover, also, that despite differences between them, Coleridge's and Wordsworth's poetics complement each other.

Coleridge describes the poet as one who brings his "whole soul" into activity, creating art that fuses opposites, among them "a more than usual state of emotion with more than usual order."[3] Coleridge's concept of opposing forces united through poetry is exactly right (and bears on our conception of metaphor: think of the remarkable fusion of several opposites in *Ulysses* when Buck Mulligan describes the "snot-green sea" to Stephen Dedalus).[4] An array of opposites is enumerated in *Biographia Literaria* that coalesces in a poem. But this is the basic one, and the one on which I will concentrate: the fusion of the feeling that impels the poem with the formal structure that gives it shape. I want not only to show that this fusion occurs in the making of a poem, but also to elucidate in talking about Wordsworth the prior conditions that enable fusion in poems to occur.

Wordsworth announces the state of mind in which creation of the poem can happen when he says that poetry "takes its origin from emotion recollected in tranquility."[5] This assertion serves not only to describe when the poem can come into being but also illuminates how the poet's rational and emotional selves combine to achieve the artistic fusion Coleridge says is poetry's core.

As I understand his poetics, Wordsworth's "recollected" doesn't simply mean remembered. Rather, "recollected" means reconstructed and transformed: in short, given form. And while "tranquility" may initially be a state of quietude, it is more than that. The tranquility of which Wordsworth speaks is also a kind of reverie, the occasion when an emotion or action from the past is vivified and made malleable as it never was before.

Combined, Coleridge and Wordsworth take us a long way toward understanding how poems emerge from intense feeling not simply remembered, but reconstructed, and reconstructed synthetically to have form. This is the fusion that enables the poem to become itself as art.

I suggest there is another fusion implicit in the poetics of Coleridge and Wordsworth: a fusion of the reader's and the poet's perceptions. When we read, comprehend, and are moved by a poem, it is because the poem draws us into its world, its way of seeing the world. Put another way, we become lively inhabitants of the world of the poem; put yet another way, through reconstructing the poem's metaphors in our own imagination, we join our perception with that of the poet. A shared vision comes into being.[6] To return to the "snot green sea,"[7] if this metaphor is effective, it propels our intellect and imagination into the world of Homer—he of the wine-dark sea—and his protagonist, Ulysses, probably the cleverest seafarer in literary history. This awareness we graft onto the modern Dublin of Joyce's protagonists—the Dublin of earthy images and candid talk about sex and body functions.

We are now actively co-creating Joyce's metaphor; and we go further as we think of the literal sea: Homer's, dark as red wine; Joyce's, green as snot. Can the sea be both elegantly and vulgarly described; and can a tale take place simultaneously in the 5th century B.C. and the 20th century A.D.? Yes!—in our imaginations, through metaphor created by the poet, and co-created by the reader, as I maintain here. [8]

However, in setting forth these poetics rapidly and for the most part, abstractly, I may overstate their capability. Let me proceed to poems themselves, while acknowledging that ideas of fusion, recollection, and tranquility are unlikely to tell the entire story of a poem's creation.

To take the last point first: for many, me included, it is an article of faith

that poetry's ability to enthrall will forever elude complete explication (as will all art). We are not, after all, discussing a toaster, a computer, or a bicycle, the totality of whose parts and their function can be identified and schematized, repaired if broken, replaced if necessary, and identically reproduced by someone other than the original maker.

Or, it to put it another way, as Roger Rosenblatt observed, "all writers are mystery writers."[9] Rosenblatt was initially speaking of the writers of mystery novels, but in the broader sense, he developed an argument for *writing itself* as mystery—the mystery of its making probed, if you will, though not solved, by the writer. In like manner, the reader, in constructing and exploring the way the poem is made—its poetics—may delve deep but won't solve what is ultimately the same mystery.

III. Practical Poetics: "Scar."

As an example, consider this poem:

Scar
The truth is never enough
But I'll tell it anyway:
this scar was once a blue
bird with a forked tail,
applied by the staccato
prick of a tattooist's
electric needle behind
the dusty glass off Broad
Street in Newark, N. J.,
on a day when peace marchers
and pickpockets shuffled
toward police barriers.

This blue bird with its
forked tail was the reason
you left me and my biceps,
my upper arm flexor which
made the bird fly or hover
and stoop from the flesh-colored sky my arms supported
above your body before
you enrolled in Language
Studies at Princeton, where
your maiden name could speak
after its pronounced silence.

This reason was the abrasive
wheel in the doctor's office
among the aquariums full of dying
fish where my skin was flayed
(having found an ad, "Tattoos
Removed," in the Yellow Pages),
flying off me like soft sparks,
blood, ink and flesh in the air;
I left with a clumsy bandage and
the old man's promise there
would be no evidence
of all these fallen feathers.

The scar is because I'm black
the doctor said to my white
face while his fish watched.
"Black people form more keloid
tissue; it's not my fault.": OK,
I don't mind being black, but
this is a big scar, something
like a blue bird with a forked
tail, and my bicep makes the scar
fly toward an apparition
of a pale bird just visible
inside the shape of itself.

Which is why I probably am
too hard on both of us,
creating these collisions now,
like the bird who comes down
the chimney into our lives
and bangs its life out against
the window even though we try
to save it, and tells us
something as we pick up
the weightless body, the irrational
broken neck and the single bead
of blood losing its luster.[10]

This is a far cry from, let's say, Wordsworth's "Ode: On Intimations of
Immortality from Recollections from Early Childhood," which begins:

There was a time when meadow, grove, and stream,
The earth, and every common sight

To me did seem
Appareled in celestial light,
The glory and the freshness of a dream.[11]

Yet both poems are born of "emotion recollected in tranquility." The "Ode" even uses the word, "Recollections," in its title; and begins, "There was a time." "Scar" starts up by telling us there is a truth to be told. Both, in short, are explicitly stories, and, further, stories impelled by recollection, to recreate— as art—intense feelings previously experienced. It's hard to imagine a more intense awakening to the world than finding it, "Appareled in celestial light,/The glory and the freshness of a dream." [12]

It may take *chutzpah* to compare my poem with Wordsworth's; yet having written the poem, "Scar," and others like it are what I unblushingly call a miracle—similar in kind, though of lesser magnitude than Wordsworth's poem— which embodies the fusion of opposites: in each case, more than usual emotion and more than usual order, a fusion that is also the invention of metaphor. "Scar" originates in, or is initially embedded in, chaotic emotions of distress and loss. That these are transformed into a stately, contained, engaging, and comprehensible (up to the point of poem as mystery) work of art is an amazement for me. The dominant metaphor of the poem is the tattoo's voluntary, masochistic, and brutal removal, fused with the speaker's involuntary and despairing loss of love. Each—tattoo and love—is now gone but not entirely gone: within the poem, and the making of the poem, is the poet's comprehension, through metaphor, of the recollection of both events: the tattoo's removal and the break-up of a love affair. One more thing about recollection—it is both of the past and not: as Faulkner reminds us, the past is never past.[13]

I have come to realize that the writing of this and almost all of my poems may begin with emotion recollected in tranquility; but the act of writing not only *recollects*, as Wordsworth has it, but also *transforms*, through the fusion of more than usual feeling and more than usual order set forth by Coleridge. And, often, there is another element involved in the transformation.

IV. The Missing Element: Empathy

All insight I owe to Wordsworth and Coleridge notwithstanding, my poetic exemplars leave out something no less important to the understanding of poetry than their dicta: empathy, of which I will speak now, expanding both Coleridge's notion of "more than usual feeling" and Wordsworth's idea of emotion recollected.

Mine is the most common, basic definition of empathy: "the intellectual identification with or vicarious experiencing of the feelings, thoughts, or attitudes of another."[14] In this sense, empathy is all over poetry. Or, to be more precise, there are at least three ways poetry enacts empathy.

First, poetry enables, if not requires, empathy between the reader and the point of view of the persona or speaking voice. The reader may not have had a tattoo, much less flagellated himself with its removal; but for the poem, "Scar," to succeed, the reader needs to be able to empathize with the persona's situation—loss of love, need for erasure, and so forth.

And if this empathic connection seems in any way challenging, imagine a male reader coming upon the line "Every woman adores a fascist," in Sylvia Plath's poem, "Daddy."[15] What kind of empathic connection could this line (admittedly out of context here) effect? I think empathy in this case would be inspired by shared emotions about the attraction and repulsion (fused!) of brute power. For "Daddy" to succeed, it must establish an empathic transmission between the feelings expressed by its persona as voice and its readers as persons; for the poem to be truly powerful, this empathy must be engendered (pun intended) in men as well as women. Compared to the modern poems, "Scar" and "Daddy," empathic connection between persona and reader in Wordsworth may be more easily accomplished. Across centuries, people share longing for their youth (however idealized), and for a vision of an uncorrupted earlier time (however simplified).

The empathy I am describing, then, is between the attitude or viewpoint of the poem expressed by its persona, and that of the reader, regardless of sex, era, or even, when a poem is translated, language. I should note that empathy between persona and reader, if it does not exist apart from, or prior to, experiencing the poem, can be created by the poem if the poem succeeds as art. For example, a reader may have events in her or his life that readily, painfully connect him or her to the persona of "Daddy." Or, the reader may be fortunate enough not to have such personal history, but the poem itself can enable the reader to realize empathic connection as awareness—or revelation!—of the seductiveness and vulgarity of brutal power as envisioned in the poem.

The second kind of empathy abetted by poetry connects a person portrayed in a poem, a literary character, to its reader. For obvious reasons, this empathic link seems more readily available in narrative and epic poetry (and in novels) than in other literary forms, such as lyric poetry; and one of the earliest and most illustrious examples of empathic connection to a character in Western literature occurs with the character of Odysseus, in Homer's poem, *The Odyssey*.[16]

Odysseus endures terrible trials on his 20-year journey from Ithaca to Troy. He is portrayed as an epic hero who survives these trials even though he experiences despair and other less-than-heroic emotions, and his predicament at these moments is poignant. He can be afraid—"Odysseus was still fearful, and he said in his heart, 'Ah me!, what is to befall me now?'" and he can cry—"The heart of Odysseus melted within him and tears fell down his cheeks"; and he can be angry at the gods—"The gods have given me more woes than man can speak of."[17] If we weren't moved to empathize with Odysseus, his bravery and sorrow would diminish in affect. His valor and ingenuity are awesome; his fear and despair are intimate.

Yet when we read about Odysseus in Plato's *The Republic*, we see that while empathy created by poetry is recognized, it is not appreciated. In Book X of *The Republic*, Plato, speaking for Socrates, worries that *The Odyssey* will bring out the "womanish" in Greek youth if they read of Odysseus weeping and railing against fate. Plato's (i.e., Socrates') famous dictum that Homer, Hesiod, and all poets must be banished from the Republic is based on a fear of certain emotions and the empathic power of poetry to engender them in those who listen to poets.[18]

Similar fears have infected "official" views of poetry well beyond Plato's criticism of *The Odyssey*. Repressive regimes abroad are notorious for banning or imprisoning poets, because the authorities fear citizens might empathize with characters in their poems, or with the persona's point of view. In our own country, examples of poets censored (though not imprisoned) for similar reasons include Walt Whitman, "The Leaves of Grass"; Gwendolyn Brooks, "We Real Cool"; Allen Ginsberg, "Howl"; and Shel Silverstein, "Where the Sidewalk Ends," (as well as other poems). While profanity and explicit sex are often given as reasons for censorship, history suggests that a more fundamental reason is the one given first in Western culture by Plato in the *Republic*: poetry's empathic power is at once acknowledged and feared.

V. Empathy in Writing Poetry

There is another manifestation of empathy in poetry that I discovered as a poet: the poet himself (speaking of myself) will often develop empathy as he writes. I have written poems that envision the lives of residents in an old-age home ("Assisted Living"), of a father as cuckold ("Secrets"), of Virginia Woolf ("Spoken Wading In"), and of a piano tuner ("The Piano Tuner Talks"), among various personae. I have been none of these, and in each instance, I needed to empathize

with the subject of my poem if I were to write movingly and authentically about him or her.[19] But, "Wayne's College of Beauty," is the poem that has caused me to realize most vividly how writing a poem *in itself* can create empathy.[20]

Here is how it happened. In Santa Cruz, California, where I live, there was for many years a hairdressing school called "Wayne's College of Beauty." The school was situated on a street I walked often, and images of students and their clients took possession of my consciousness, memory, and imagination.

The students were young women in their late teens or early 20s who typically wore heavy make-up and elaborate hair styles and lounged outside the school during breaks, most of them smoking while they chatted. At the risk of belaboring the earlier tattoo motif, let me say that even though the young women wore unrevealing pink smocks, tattoos typically made an appearance on ankles and forearms, promising an elaboration of butterfly, dragon, cherub, or tribal design. Between lipstick and lacquered hair, cigarettes and tattoos, the young women appeared to me as superficial in thought and rough in demeanor.

Those who had their hair done by these student hairdressers were almost exclusively elderly women. Although some men and younger women must have come into Wayne's College of Beauty, I can't remember ever seeing them.

Wayne's College of Beauty seemed an eminent candidate for satire. Its name used a common gimmick, calling a place a "college" in order to accrue undeserved status and cash flow: cf. "Animal Behavior College"—dog grooming, "Kepler College of Astrological Education"—what's your sign?, "Utah College of Massage"—hands-on learning. These "colleges" are not my invention! And Wayne's College of Beauty students, visible both through plate glass windows and when taking breaks on the sidewalk, could not have appeared less collegiate. There were no books anywhere. Alas, the clientele seemed to be gullible old women prey to false advertising, inept scissors, and suspect chemicals.

So I conceived a snarky poem, which began, "We have dropped out of the other schools/to enroll here where no one fails." Maybe it was the persona I chose, the inclusive "we;" or, just as likely, a cause I can't identify—but something happened during the writing of the poem that changed my, and its, point of view entirely.

Instead of dripping sarcasm and condescension, the speaker set well apart and above his subjects, my persona in this poem found himself among the denizens of Wayne's and humanely connected to them.

Wayne's College of Beauty
 I know what wages beauty gives

 —YEATS

We have dropped out of the other schools
to enroll here where no one fails; everything
is fixed, fluffed, teased into its temporary best
at cut-rate prices because we are all novices
in the art of making beauty, learning that beauty
is not so hard. Beauty is not so hard we learn,

because it is not chemicals or varieties of fashion.
Our scissors and combs, our libraries of lotions,
our bright mirrors assure the timorous or imperious
elderly they have come at last to the right place.
Wayne's is not the Heartbreak Hotel, and when they
leave beautiful, it is because they are briefly unlonely.

We have said, "How are you?," "How would you
like your hair?," and we have touched them not cruelly,
and with more than our hands. When it is over
we swivel their chairs so they can see themselves
carefully from several angles while we hover silent
just above their doubts, a calculation that provides
two faces in the mirror, ours smiling at both of us.

Sarcasm and condescension are transformed into empathy—and empathy in the world of Wayne's College of Beauty means that the students who "have dropped out of the other schools" are kind and reassuring of the "timorous or imperious elderly"; that beauty is created, not just, or even mostly, by hair styling, but by the caring, which causes the elderly to be "briefly unlonely." And so forth: in short, "Wayne's" becomes a metaphor, a fusion of the banal and loving into a vision shared in the mirror by student beautician and her client.

The empathy evinced by the poem's persona, and by apprentice beauticians, is the story within the poem. Within *the poet* came the startling creation of empathy in the act of writing a poem that began not only with no such feeling but with, in fact, its antithesis.

VI. Poetry and the Education of Empathy

Earlier, my point was that the *study* of poetry is the study of how to live. Let me circle back this idea now. Who would say we know how to live if we do not

understand and feel a connection with our fellow men and women? Who would say we know how to be humane—kind, respectful, caring—if we do not understand and feel this connection? And the connection, I have maintained throughout this study, is enabled by empathy.

Not that empathy isn't approached through other means other than poetry. I remember reading some years ago that a medical school had their doctors-in-training wear glasses smeared with Vaseline to experience and empathize with elderly patients whose vision was failing. Medical students were also asked to go about their day in wheelchairs, walk with pebbles in their shoes, and have their arm in a splint (but not all at once).[21]

In schools, empathy in students is a growing concern, impelled most recently by publicized incidents of bullying, some of which ended in tragedy. To cite a couple of prominent educators' efforts: *Kids Health* advocates curricula of role playing, presenting hypothetical and actual situations, and a variety of exercises that afford opportunities for children to respond empathically[22]; and one author among scores who promotes teaching empathy and their curriculum to do so is David A. Levine (2005), who spoke of "creating a bully free school culture," and is the author of *Teaching Empathy: A Blue Print for Caring, Compassion, and Community*.[23]

A more rigorously intellectual approach to understanding and enacting empathy can be found in *The Age of Empathy* and *The Empathic Civilization*.[24] These have become top sellers nationally, their prominence abetted by *New York Times* columnist David Brooks (2011), who took the authors to task for aggrandizing the importance of empathy in ethical behavior.[25]

As Steven Pinker (2011) said in *The Better Angels of Our Nature*, "we are living in the middle of an empathy craze."[26] In the educational establishment and our culture generally, the empathy stew bubbles but doesn't provide that much nourishment. Amid educational concerns and curricula, and national concerns and debate, it remains unclear that the parties understand empathy similarly, that empathy can in fact be taught,[27] that having empathy leads to compassion and helping behavior, and that empathy is a prime factor in a civilized world—as compared, let's say, with the moral codes of religions, the military, social groupings or organizations, or philosophical tenets.[28]

With the poetics discussed here, I propose that we have ventured, not so much into the field of the current fray among educators, etc., but into another arena. The ideas and tenets set forth in our work on empathy in poetry establish—if that's not too decisive a word—an education in empathy by indirection. In reading and studying poetry, in the connection we make between us

and the voice that speaks the poem, the persons who are actors in it, the emo-
tions vivified by it, and the mystery of it, all of which we discussed earlier, we
enact our own education in empathy. And when we teach poetry to others so
that they too can experience these connections, we are teaching empathy.

As for education by indirection, in empathy or any important matter, con-
sider this poem by Emily Dickinson:

> **Tell All the Truth but Tell It Slant**
> Tell all the truth but tell it slant—
> Success in Circuit lies
> Too bright for our infirm Delight
> The Truth's superb surprise
>
> As Lightning to the Children eased
> With explanation kind
> The Truth must dazzle gradually
> Or every man be blind—

VII. Fillip

Aside from quoting this little gem by Dickinson, I may have dwelt overlong on
my poetry as example. As counter-balance, I will conclude with a poem by Ellen
Bass, which I consider an accomplished vision of empathy, enacted both by the
poet in writing the poem, and by the persona, the "I," within it. The poem,
"Phone Therapy," tells a story from the past, and, I suggest, manifests
Wordsworth's "emotion recollected in tranquility." It also satisfies Coleridge's
desire for "fusion of opposites," which I have called metaphor. I think it is
metaphor that most measures the poem's empathic achievement: the "cord that
connected us," is both a wire "under the dirty streets," and the persona's abil-
ity to "match my breath with his . . ."

> **Phone Therapy**
> I was relief, once, for a doctor on vacation
> and got a call from a man on a window sill.
> This was New York, a dozen stories up.
> He was going to kill himself, he said.
> I said everything I could think of.
> And when nothing worked, when the guy
> was still determined to slide out that window
> and smash his delicate skull

on the indifferent sidewalk, "Do you think,"
I asked, "you could just postpone it
until Monday, when Dr. Lewis gets back?"

The cord that connected us—strung
under the dirty streets, the pizza parlors, taxis,
women in sneakers carrying their high heels,
drunks lying in piss—that thick coiled wire
waited for the waves of sound.

In the silence I could feel the air slip
in and out of his lungs and the moment
when the motion reversed, like a goldfish
making the turn at the glass end of its tank.
I matched my breath to his, slid
into the water and swam with him.
"Okay," he agreed.[29]

NOTES

1. I am not the "art for art's sake" proponent that Oscar Wilde is when he says all art is like a flower, its purpose solely to be a flower; but I am wary, generally, of trapping poetry inside a purpose. We might say, *contra* Wilde, that flowers have many purposes, which depend not only on the kind of flower, but on who's picking them.
2. T. S. Eliot, *Tradition and the Individual Talent*, 1919. Eliot's modernism could not dampen his enthusiasm for the past: for tradition, authoritarianism, anti-Semitism, and the frozen "now." (DS)
3. Samuel Taylor Coleridge, *Biographia Literaria*, 1817.
4. James Joyce, Episode 1, Telemachus, *Ulysses*, 1922.
5. William Wordsworth, Preface to *Lyrical Ballads*, 1800.
6. To put it in altogether different terms, we enact "a willing suspension of disbelief," this concept is another of Coleridge's contributions to poetics. He speaks here of the reader's or viewer's entry into the worlds and visions created by Shakespeare's plays. *Biographia Literaria*, op. cit.
7. Although the metaphor comes from a novel, rather than a poem, I use it because I am inordinately fond of it, or, more cogently, because any and all metaphors bespeak poetry.
8. Lest I be misunderstood: I am not saying the reader *is* the poet. It is the poet who creates—in the manner I've laid out and will soon describe in greater detail—and the reader who is inspired by the poem to become, him- or herself, a co-creator, subordinate to the poet; and engaged in thought, feeling, and imagination that is similar, though not identical.
9. Roger Rosenblatt, "The Writer as Detective," *New York Times Book Review*, July 10, 2011.
10. David Swanger, "Scar," *The Georgia Review*, No. 1, Spring 1985. Reprinted in *Wayne's College of Beauty*, BkMk Press, 2006.
11. William Wordsworth, "Ode: On Intimations of Immortality from Recollections of Early Childhood," *The Oxford Book of English Verse*, Ed. Arthur Quiller-Couch, 1919.

12. "Ode: On Intimations" also contains the luminous, deeply felt lament, one phrase of which has been become part of popular American culture:
Though nothing can bring back the hour
Of *splendour in the grass*, of glory in the flower (emphasis added)

13. William Faulkner, *Requiem for a Nun*, 1951.

14. Dictionary.com

15. Sylvia Plath, "Daddy," in *Ariel*, 1962.

16. *The Odyssey*, Trans. Robert Fagles, 1996.

17. *The Odyssey*, op. cit.

18. Cf. David Swanger, Ideology and Aesthetic Education, *The Journal of Aesthetic Education*, Vol. 15, No. 2, 1981, pp. 33–44. Also, Morriss Henry Partee, "Plato's Banishment of Poetry," *The Journal of Aesthetics and Art Criticism*, Vol. 29, No. 2 (Winter, 1970), pp. 209–222.

19. David Swanger, *Wayne's College of Beauty*, op. cit.

20. This revelation moved me to instate "Wayne's College of Beauty" as the title poem of the volume, *Wayne's College of Beauty*.

21. Duke University Medical School. A more complete account of teaching empathy to medical students can be found at the John A. Hartford Foundation's website: jhartfound.org

22. Kidshealth.org/classroom/3t05/personal/growing/empathy.pdf

23. Solution Tree Press, 2005.

24. Frans de Waal, *The Age of Empathy*, Three Rivers Press, 2009; Jeremy Rifkin, *The Empathic Civilization*, the Penguin Group, 2009.

25. David Brooks, "The Limits of Empathy," *The New York Times*, September 29, 2011.

26. Steven Pinker, *The Better Angels of Our Nature*, Viking, 2011.

27. Cf. "What Is Empathy, and Can Empathy Be Taught?" Carol J. Davis. *The Journal of Physical Therapy*, 70, 1990. pp. 707–715.

28. These last are among David Brooks' caveats. Brooks, *New York Times*, op. cit.

29. Ellen Bass, "Phone Therapy," *Mules of Love*, Boa Editions Ltd., 2002. Reprinted with the author's permission.

REFERENCES

Bass, E. (2002). Phone therapy. In *Mules of Love*. Rochester, NY: BOA Editions.

Brooks, D. (2011, September 29). The limits of empathy. *The New York Times*, A25.

Coleridge, S.T. (1817; reprint 1971). *Biographia Literaria*, London, England: Dent; New York, NY: Dutton.

Davis, C. J. (1990). What is empathy, and can empathy be taught? *The Journal of Physical Therapy, 70*, 707–715.

de Waal, F. (2009). *The age of empathy*. New York, NY: Three Rivers Press.

Eliot, T.S. (1950).Tradition and the individual talent. In *The sacred wood: Essays on poetry and criticism* (7th ed.). London, England: Methuen.

Faulkner, W. (1951). *Requiem for a nun*. New York, NY: Random House.

Homer. (1996). In R. Fagles (Trans.), *The Odyssey*. New York, NY: Penguin Books.

Joyce, J. (1922). Episode 1, Telemachus. In *Ulysses*. Paris, France: Orchises Press.

Levine, D. A. (2005). *Teaching empathy: A blue print for caring, compassion and community*. Bloomington, IN: Solution Tree Press.

Partee, M. H. (1970). Plato's Banishment of Poetry. *The Journal of Aesthetics and Art Criticism*, 29(2), 209–222.

Pinker, S. (2011).*The better angels of our nature*. New York, NY: Viking.

Plath, S. (1965). Daddy. In *Ariel: The restored edition* (2004). New York, NY: Harper Collins.

Rifkin, J. (2009). *The empathic civilization*. New York, NY: Penguin Books.

Rosenblatt, R. (2011, July 10).The writer as detective. *New York Times Sunday Book Review*, BR 27.

Swanger, D. (1981). Ideology and aesthetic education. *The Journal of Aesthetic Education*, 15(2), 33–44.

Swanger, D. (2006). Scar. *The Georgia Review*, 1, Spring 1985. (Reprinted in *Wayne's college of beauty*. Kansas City, MO: BkMk Press)

Wordsworth, W. (1800). Preface to *lyrical ballads*. Prefaces and prologues. Vol. XXXIX. In *The Harvard classics*. New York, NY: P.F. Collier & Son. Bartleby.com.

Wordsworth, W. (1919). Ode: On intimations of immortality from recollections of early childhood. In A. Quiller-Couch (Ed.), *The Oxford book of English verse*, Oxford, England: Clarendon; New York, NY: Bartleby.com.

TWO ALTERNATIVE PHILOSOPHICAL PERSPECTIVES

· 8 ·

Aesthetic/Empathetic Punctures Through Poetry

A Lacanian Slip *into* Something Other Than Education

SEAN WIEBE

In this chapter I argue that to practice poetry, or to live poetically, is an art-making process where the self has an aesthetic/empathetic sense of being in the world. I utilize Lacanian theory to explain how artmaking processes of aesthetics/empathy (1) *resist* the long-standing traditions of modernist education, and (2) *create* worlds of desire where desire is not hidden or disciplined in a social form. Tightly coupled, perhaps even functioning as a singular concept, aesthetic and empathetic artmaking processes can create distortions and disruptions to overly familiarized aesthetic norms, not only for personal meaning, but also for relating to others who share those same experiences as human beings. Rather than call for more artmaking in education, I contend that an aesthetic/empathetic orientation to pedagogy might be so different from current, modernistic educational practices that it would be more publically valuable and viable for young people to participate in *something other* than education as a means to attain the social objectives that having an education implies.

Introduction: A *Something Other* Education

In his recent essay, "Postmodern Education and the Concept of Power," Rømer (2011) argued that public education, as it was conceived and is currently

practiced, is a modernist system, and so endless postmodern critique of what is modernist in design faces difficulty from the outset, as the words "'postmodern' and 'education'" are problematic when treated together (p. 755). When scholars engage in critique, Rømer's challenge to them is to "come up with *something other* [emphasis added] than education" (p. 755). While calls for structural and conceptual change are not new, I think that Rømer's framing of scholarly critique provides an opening for arts-informed scholars to address this "something other" that ought not to be called education but yet is understood as publically valuable and viable for young people to participate in as a means to social improvement.

In this regard, our editors, White and Costantino, have timed this collection well: Aesthetics, empathy, and—taking up Rømer's (2011) challenge— imagining *something other*. In this chapter I will explore ways that poetic practices, or living poetically, are simultaneously aesthetic and empathetic. While the exemplars to illustrate this are drawn from poetry and poetic prose, I call the above processes "artmaking" so that the aesthetic/empathetic construct is not applied too narrowly to poetry alone. With this in mind, I utilize Lacanian theory to enrich our understanding of the *monstrous mutations* necessarily complicit in beauty and of how denying this complicity is a denial of self and one's receptiveness of and to others. I then look at the pervasiveness of rationality in education as foundational to denying self and others, explaining how subverting such a reason-fantasy is an important puncture to two dominant motifs in modernist education: (1) the luxurious privileging of ignorance and (2) the persistent pursuit of perfection. As the chapter draws near its conclusion, I consider some practical ways aesthetics/empathy can be part of the *something other* activities that young people might be involved in, what past centuries have called education. By exploring the differing and complicated ways poets combine aesthetics/empathy, perhaps there is something hopeful to counter the power-imbued processes of a techno-centric and globalized world.

Understanding the Connection of Aesthetics and Empathy Through Poetry

Working poetically within the context of qualitative inquiry is a means of appreciating the depth and complexity of human knowing: As an aesthetic engagement, poets (and their poems) are continuing to, and continually, represent our world—everything from the hundreds of shades of green in Prince Edward Island (MacLean, 2009) to the deep and soulful experiences of loss (Guiney

Yallop, 2010). There is a poem for whatever can be sensed, or felt, or thought, or dreamed. Thus, to practice poetry, which is quite often more than simply the writing and reading of poems, is to have an aesthetic sense of being in the world, to be concerned with day-to-day lived experiences and how/why one comes to understand and value them, not only for personal meaning, but also in relation to others who share those same experiences as human beings.

As human beings, our ongoing aesthetic ways of being and becoming are intimately and rhizomatically intertwined with our feelings and performances of empathy. In particular, a poetic way of being, what Leggo (2004) called "living poetically," explores the relational interactions of a becoming, and always-shifting, self, while simultaneously nurturing empathetic connections. Daily poetic encounters of our lives need not be named as poetic. Leggo pointed to something more basic, more natural, more fecund: He said, "poetry invites me to breathe, to attend, to slow down, to embrace the healing of body and spirit and imagination" (para. 1). Breathing in and breathing out, where an incoming breath might signify the heartful/soulful attentiveness to one's experience, and an outgoing breath might be the creating and meaning-making that happens as a result of such deep attentiveness. I speak metaphorically; the reverse is just as apt, the point being that living poetically comingles an aesthetic/empathetic response to experience. By way of example, I offer the poem, "Night Light":

Night Light
Her summer was scented
with balsam fir curled
tightly into a lollipop
over decades swirled
with darkened evenings
in the sunroom slowly
slumbering to the pat pat
pat of Charlottetown
rain: it falls to set
contemplation, as if
they might catch a glimpse
of who they are before night
fall. She buttons
her flannel against the late
hour, tightens the collar
around her neck, he smells
like baby powder, shadows,
bruises deep under his eyes,
and pushes a stray lock

from her cheek. Together
they watch the rain aimlessly
all night, barely believing
its silence, as in a fine
gallery, they view their seasons
piece by piece, the body
landscape framed with subtle
strains of light passing through
who they are becoming.

In "Night Light," the speaker is trying to express a way of feeling, not so much what he feels, but the experience of time felt like this, time felt in relation to another. The social world created in the poem is an empathetic interaction remembered through aesthetic nuances as the speaker ponders feelings and values of shared significance.

As "Night Light" implies, empathetic education might be understood as processes (shared significations) by which one comes to understand *receptions of the other*. Foregrounding the receptive processes that might be involved in receiving the other is not so much a cognitive exercise but an aesthetic one. For this reason, aesthetic processes, with their connections to what is deeply human, depend on a "something other" orientation to education. The careers of influential theorists Freire and Rancière underscore this point: As proponents of the transformation of culture, Freire (1971, 1985, 1994, 1997, 1998) and Rancière (1991, 1999, 2004, 2006, 2009) have variously described education in ways that hardly resemble what takes place in today's schools. As Wong noted (2009) "Education characterize[s] ideal students as rational and in control of their thinking and actions. The good student is often described as intentional, cognitive, metacognitive, critical, and reflective....[This] tradition is deeply rooted in...the story of Western civilization" (p. 192).

Tightly coupled, perhaps even functioning as a singular concept, aesthetics and empathy resist the long-standing tradition of *logocentric* education. Decoupled, an aesthetic education in the humanities has typically been an interpretive experience, while empathetic education has rarely found itself part of any official curriculum. Not surprisingly, poets themselves underscore this point by resisting the logocentric interpretive act on a poem. Consider former U.S. Poet Laureate Collins' (1988) wish for what students might do when they encounter a poem: "press an ear against its hive" or "walk inside the poem's room" (lines 4,7). His hope for a non-rational encounter with a poem is rebuffed by students' desires to "tie the poem to a chair with rope / and torture a con-

fession out of it" (lines 13–14). How is it that students are so well versed in the interpretative act that, even when advised not to, they still give "special sta-tus for human reason and control in the pursuit of knowledge, beauty, and morality" (Wong, 2009, p. 193)?

An Aesthetic/Empathetic Reception of the (Monster Self) Other

I have suggested above that *receiving the other* might be an orientation for understanding how aesthetics and empathy can together be educative without becoming logocentric. What might ordinarily follow at this point in the chap-ter is a definition of the blended aesthetic/empathy concept I'm proposing. The authorial ease by which a writer invokes reason and control to explain a new concept is precisely (or perhaps not so precisely) what an aesthetic/empathic approach might resist. Proceeding without definition is not the no-win scenario so often assumed but more a deconstruction of the fantasy scenario that defi-nition offers clarity (Aoki, 2000). Thus, what follows is an aesthetic/empathetic reception of *the other* that begins with exploring what it is that students (and teachers) desire.

Following the overly ambitious road to clarity, traditionalists narrowly define aesthetics as an appreciation of, or an increased valuation of, beauty.[1] But as Lacan (1977) argued, with our sense of beauty also comes our desire, our fascination with what is more than beautiful. Desire is the excess of what can-not be contained in a signifier/signified relationship; desire is what pulls us toward emotions like terror, awe, deviation, monstrosity, and so forth; even chil-dren's fairy tales reveal that within desire is that link between a lover's beauty and a banished inner ugliness. Understanding beauty/ugliness as inwardly linked rather than as empirically opposite provides a helpful context for receiv-ing the other via a blended aesthetics/empathy construct.

What I'm proposing is that beauty's outward form of being (aesthetics) has an inner discourse of desire (empathy), which can't remain only inside, and can't be acknowledged as only one's own. Practically speaking, in nourishing empathy, poets live/create worlds of desire where desire is not hidden or disci-plined in a social form; they live/create distortions and disruptions to overly familiarized aesthetic norms; they live/create metaphor with a view to *catachre-sis*, what Derrida (in Kearney, 2004) described as "monstrous mutation" within the normative or privileged tradition (p. 154). Implicit in words themselves are

disruptions to any secure signifying reference. Poets exploit this. To do so, argued Derrida, is "an openness towards the other" (p. 155).

Making a similar argument via imagery, Beasley (2007), in his poem "Towards a Poetics of Monstrosity," wrote, "The monstrance is the jeweled container that holds aloft the consecrated Host" (para. 7). Here is the interplay of aesthetics and empathy, where what is most beautiful of all, a monster (monstrance), holds that which cannot be named. Lacan (1977) called that which cannot be named a *missing* signifier. It is permanently missing, dwelling in that realm of the unconscious that he called the imaginary (p. 65). Articulating the possibility of a missing signifier is noticing that there is more to the possible reality of a concept than what a word implies. Such articulation is empathy (what I will later call aesthetic/empathetic punctures), that which notices loss, failure, monstrosity, and understands how all these are central to social values and ideals.

Mary Cornish (2000), in her poem "Numbers," employs a particularly insightful empathetic critique to the more normative tendency to count and value only that which can be measured. For all those who have fallen below the cut line, received a zero or two, or become the more deviant part of a standard deviation, Cornish locates the missing signifier in counting: "Even subtraction is never loss / just addition somewhere else: / five sparrows take away two, / the two in someone else's / garden now" (para. 4). In weaving loss with life, Cornish's generosity in imagining another garden for the equation at hand is a textured empathy that helps us feel whole.

Creating Artmaking to Subvert the Reason-Fantasy

Working with Derrida's premise that *catachresis* is an openness to the other, for a "something other" education, students and teachers would create (as poets have) aesthetic/empathetic articulations of the missing signifiers in our world. Their purpose would be to disrupt what I'm calling the *reason fantasy*, or reason's limitless power to "understand both God and the workings of the universe" (Wong, 2009, p. 194). Such a task need not be any more expansive than artmaking, that process by which the creative artist relates meaningfully (externalizes outwardly) her or his inner experience in relation to another. The relation (the process of relaying the incomprehensible inner desire) to another exists in the tension that stretches between inexpressibility and representation. Because our self/other relations and relationships are fraught with evasions (those peremptory self-performances that prescript the reason-fantasy), a first

step toward aesthetic/empathetic articulation is a puncture through the façade of what makes common sense common.

By way of example, Addonizio's (2011) "Whack Report" is an aesthetic/empathic struggle in the text, a creative artmaking that is also an intentional catachrestic tactic to subvert the reason-fantasy:

Whack Report

A woman at the gym today said to her friend, *Most people are whack.*
Whack meaning crazy, displeasing, undesirable, stupid, of poor quality,
appalling, masturbatory, laid off, weird, or dead.
Most poets, as it turns out, are generally pretty whack
as in mentally ill. Anne Sexton, for example. Robert Lowell, also quite whack.
I myself am whack about sixty-seven percent of the time,
not counting nights and weekends, when it's more like eighty-two percent.
But let us focus on the beautiful wine glass, eighteen percent full
of sane, delightful, and intelligent fruit and acid. A whiff of rose petals.
Black cherry, pomegranate, cassis, devil's food cake. And limestone. Drink me
and taste my ooids, my hot buttered toast. For we must be ceaselessly whack
as in deranged said another whack poet who became a whack gun runner.
Guns are whack. Much of the world population experiences the whack factor
ninety-nine percent of the time, which can cause excessive thirst, diarrhea, death
and other side-effects. After a while, if you keep saying a word, it kind of loses
its meaning. Whack. Whack. Here come the weed whackers, beheading the grass.[2]

Leggo's (2011) insightful confessions of love and fear give texture to Addonizio's whack report. Representing himself as a poet/scholar, Leggo asked: "Who am I? Who am I in relation to the world? How should I live? What are the responsibilities of a human being in the contemporary world?"(p. 115). Surveying a career spent writing about love and situating love as a reply to the deeply felt inner questions of human relations, Leggo then said:

> Now I wonder if I write so much about love and hope because I am actually so fearful. I am growing old, and the past suddenly seems extraordinarily expansive while the future has grown brief and uncertain. I live a life full of privileges, but when I reflect on my past, I am most steadily struck by the memory of wanting something, always something more. (p. 117)

Leggo's Lacanian turn—that inside the professed beauty of love is the monstrous fear of desire—is a poet's tactic that stymies the rationalist discourse. Leggo's wanting of something more cannot be separated from his opening questions of "who am I?" and "how should I live?" To employ Addonizio (2011) here, Leggo is demonstratively whack. And why shouldn't he be? "*Most people are whack. /*

Whack meaning crazy, displeasing, undesirable, stupid, of poor quality, /appalling, masturbatory, laid off, weird, or dead" (lines 1–3). Some, when presented with their wackiness, or whackfullness, are taken aback. Why? Perhaps because in the promise of understanding the workings of the universe (the reason-fantasy), the implied who(ness) of who can take on such a role is an altogether more self-satisfying description of who I am (and might be) than the "stupid" and "appalling self" with which Addonizio confronts me. So, even when, as Addonizio notes, "Much of the world population experiences the whack factor / ninety-nine percent of the time" (lines 13–14), I feel compelled to deny it. Regarding the existential self question—Who am I?—it is not easy to explain the human tendency to deny what seems to be quite broadly apparent. Perhaps even more difficult to explain is the nature of human denial in a related, second, existential question: Given my who(ness), how should I then live? Using myself (and, by extension, Leggo and Addonizio) as an example, if I am a whacker, then how do I live with other whackers? As Addonizio insightfully explains, "we *must* [emphasis added] be ceaselessly whack" (line 11). What is it about living (and teaching) that depends on, is perhaps even a moral imperative, being ceaselessly whack with one another? In addition to being a moral and existential question, it is an aesthetic and empathetic question, as it is concerned with our reception of the other.

In the following section, I consider Lacan's theories on desire as a means to query these troubling questions of human denial.

The Necessary Denial to Preserve a Satisfying Self-Image

As noted above, Lacan theorizes desire as the excess of a signifier/signified relationship. The "reason-fantasy" would have us control or subdue this excess. Wong (2009) wrote: "[T]he ability to be rational and in control of oneself has become an important quality of the motivated learner" (p. 197). Leggo (2011) is concerned that in his entire career of love-writing he may not have (as yet) earnestly struggled with the inner desire. Perhaps, as Aoki (2002) noted, the price of love-teaching/love-writing (in the rationalist discourse) is the denial of excess. In a similar aesthetic/empathic tactic to Leggo's, Aoki addressed that price by elaborating on the following irony in human relations:

> Consider how people in love claim that their partners are, to them, the sexiest and most beautiful creatures on the planet, when a quick glance at said partners would suggest,

to even the benevolent observer, that this is probably not the case....That is, compared with the one we love, there is always someone else who is much smarter, kinder, more loyal, more loving. For all of us, with only the rarest exceptions, there is not just one superior alternative to our partner, but many, many such others. (p. 23)

Before making the application to teaching, Aoki asks, "Why does it remain necessary for us to believe our partners are the sexiest and most beautiful creatures in the world?" (p. 24). Why the imperative to maintain denial, to keep the ugly truths beyond our typical frames of reference? Aoki's most direct address of this question comes in his text when he says, "In this situation, objective truth and subjective contradiction somehow co-exist simultaneously and peaceably in our minds" (p. 24). We do not acknowledge the contradiction so "we can become and remain who we are, or at least, who we mistake ourselves to be" (p. 25). In other words, *in this refusal* of some knowledge (our *whackfulness*) a substitution of preferred knowledge (our beauty, our rationality) becomes our working hypothesis of who we really are (mistake ourselves to be). This *reason fantasy* provides a version of the self that is much more autonomous and capable of glory, and education is the process by which we come to believe so strongly in the fantasy of our greatness. Looking back in history to illustrate the reason-fantasy at work, Milton's (1694) famously humble (arrogant) invocation to "justify the ways of God to man" (p. 4), might more aptly be understood as justifying the ways of men *to men who think of themselves as gods.*

Education is the Persistent and Insistent Luxury of Privileging Ignorance

In *A Few Good Men* (Brown & Reiner, 1992), Jack Nicholson, playing the part of Colonel Jessup, thunders forth a famous line which is the climax of the movie: "You can't handle the truth." Stringing a few of Nicholson's phrases together and changing the context to education reveals something of the nature of why fantasies are so persistent: (1) "We live in a world that has walls, and those walls have to be guarded"; (2) "You have the luxury of not knowing what I know"; (3) "My existence [is] grotesque and incomprehensible to you"; (4) "Deep down in places you don't talk about at parties;" (5) "You use them as a punch line." The walls, by extension, are the boundaries marking curriculum, and what is behind those walls is knowledge that must be ignored. The existence of that knowledge is so deeply felt in human experience that it needs to occasionally rise to the surface in talk at parties but only in jest.

The luxury of love (and teaching) is in not knowing. Den Heyer and Conrad (2011) argued convincingly that education is a learned ignorance. What we learn to not see, what we learn to ignore, is what they call a "privileged ignorance" (p. 9). The purpose of their paper is to put forward a case for teaching social justice. To do so, part of their aesthetic/empathic tactic is to disrupt the reason-fantasy, acknowledging that for a privileged majority it is imperative to ignore social injustice lest its acknowledgment bring too close to home ongoing Canadian colonialism. The Faustian price teachers consent to pay (from their place of luxury) is to deny entry to their influence, to foreclose on the possibility of being too good a teacher. Were teaching to genuinely approach a transformational possibility, the public majority might have to seriously acknowledge what has previously been approached only in jest. The outcry would be immense (we can't handle the truth). In the world of reason-fantasy, teachers willingly consent to propagating innocuous lessons because they lessen the potential danger of ugly truths escaping from the unconscious.

Very quickly we have moved from a funny party joke—50% of us are uglier than average (Aoki, 2002, p. 24)—to the seriousness of learned impediments to social justice. Theorized as an aesthetic/empathetic construct, I believe art-making quickens the pace of identifying the missing signifiers in the fantasy worlds of narcissistic investment. Artmaking can poke fun and pokes seriously (and everything in between) with the intent of puncturing/rupturing the surface of Narcissus' gaze. Artmaking as aesthetic/empathic processes would be a "something other" education because the openings created are an openness to and for the other. In other words, articulations of the missing signifier identify excess (desire), that something more than reason's limits can acknowledge. Martin Buber (1998) explained why this is so important to empathy: "Genuine conversation, and therefore every actual fulfillment and relation between men [sic], means acceptance of otherness" (p. 59). Buber is whack. His pedagogy would respond to the other as a whole person (particularly acknowledging the sacred inner person within the monstrance). Buber's pedagogy would be a kind of presence to others, which does not assume understanding (the reason-fantasy). Buber is advocating listening for what is not said and what inner excesses are being repressed. This, perhaps, is putting one's ear against the hive (Collins, 1988).

Three Aesthetic/Empathetic Punctures to Perfection (and Perfect Teachers)

In *Gattaca* (DeVito & Niccol, 1997), Jude Law, playing the part of Jerome Morrow, is the perfect human specimen. After all, in this future world of genetic engineering, he was designed to be perfect. As the subplot, Jerome's story is easy to miss alongside the more substantial pursuit of the American Dream in the character of Vincent Freeman, who, conceived naturally (i.e., without the geneticist), must overcome incredible odds to eventually be selected for space travel. What I find moving about this movie is Jerome's suffering in the face of his perfection. Designed to be better, he is destined to a world of underperforming. The *underperformance tragedy* is the seldom spoken-about burden of perfection. Much more prominent in our lives as human beings is the seduction of a better version of ourselves. In the same movie, consider Blair Underwood's compelling portrayal of the geneticist, who, speaking to worried parents about the moral dilemma of a designer baby, says, "You want to give your child the best possible start. Believe me, we have enough imperfection built in already. Your child doesn't need any additional burdens." Underscoring the point, in the comment section below a YouTube clip of this movie, four of the five who contribute posts on the topic write that they would like a designer baby. Extending the notion of the reason-fantasy, I find that much of what might be called *good work* in education imagines it as a system that, in the words of this geneticist, "eradicates any potentially prejudicial conditions," such as a "propensity to violence" or "obesity." School programs aimed at decreasing bullying or promoting nutrition and a healthy lifestyle are important (Craig, Bell, & Leschied, 2011), but what I find curious is a growing sense that I cannot measure up to a socially manufactured version of me, which people prefer, and, in some cases, require.

Typically, as the chief promoters of the reason-fantasy, educators often concern themselves with rules, with the rulers that draw straight lines, and with colouring within the lines. Such concerns are aesthetic and empathetic. During a time when I was working out ways of being with my students as a poet, and what that might mean for how I would approach what is typically called classroom management, I had the opportunity to be "straightened" out, as my crooked experimentation (think poetic) of letting the students search for poetry outside the classroom walls was identified as slack, or lack, or whack. My straightening included a lecture from Mike[3] on how a teacher needs to be firm, fair, and friendly, and a subsequent promise on my part to more carefully read

the 900-page staff handbook that outlined the proper duties of a teacher in that school. Referring again to *Gattaca* (1997), I find it interesting that as part of setting an epistemological mode for his audience, the director/writer (Andrew Niccol) has an approximately two-second shot of this quotation: "Who can straighten what He has made crooked?" (Ecclesiastes 7.13, NIV). Whack. Considered wisdom literature, I am curious about the suggested wisdom in Ecclesiastes that leads us to accepting crookedness, brokenness, or failure as part of perfection, as part of beauty, as part of an ethic of relations with one another?

Lydia Davis (2009), American short-story writer and poet, is another who aesthetically/empathetically punctures the surface meaning of human efforts *to perfect* our world:

> She hated a *mown lawn*. Maybe that was because *mow* was the reverse of *wom*, the beginning of the name of what she was—a *woman*. A *mown lawn* had a sad sound to it, like a *long moan*. From her, a *mown lawn* made a *long moan*. *Lawn* had some of the letters of *man*, though the reverse of *man* would be *Nam*, a bad war. A *raw war*. *Lawn* also contained the letters of *law*. In fact, *lawn* was a contraction of *lawman*. Certainly a *lawman* could and did *mow* a *lawn*. *Law and order* could be seen as starting from *lawn order*, valued by so many Americans. *More lawn* could be made using a *lawn mower*. A *lawn mower* did make *more lawn*. *More lawn* was a contraction of *more lawmen*. Did *more lawn* in America make *more lawmen* in America? Did *more lawn* make *more Nam*? *More mown lawn* made *more long moan*, from her. Or a *lawn mourn*. So often, she said, Americans wanted *more mown lawn*. All of America might be one *long mown lawn*. A *lawn* not *mown* grows *long*, she said: better a *long lawn*. Better a *long lawn* and a *mole*. Let the *lawman* have the *mown lawn*, she said. Or the *moron*, the *lawn moron*. (p. 314)[4]

Barbara Kingsolver (1998) offered a similar aesthetic/empathetic puncture. In *The Poisonwood Bible*, the main character, Nathan Price, is a missionary who has traveled to Kilanga to offer the good news that Jesus is beloved (*bangala*). Not unlike Davis' law man, Price's first order of business is to clear every local weed (in his mind) and plant a proper American garden; that is, he brings order and beauty to a place where it was not. In a related miscue, Price also stumbles in learning the local language and continually mispronounces the Lingala word *bangala*, saying it too quickly. Thinking he is saying "Jesus is beloved" he says instead "Jesus is a poisonous plant."

The Statue of Liberty as Monstrous Mutation

Implying that Kingsolver (1998), Davis (2009), and Addonizio (2011) do resonate with one another, what I think emerges in their work is a generative pro-

vision of empathetic pedagogical orientations for teachers and students: How might aesthetic/empathetic processes be utilized to bring greater teacher recognition to the normative power of the reason-fantasy? Or, more personally expressed, how might a teacher come to confess that s/he is a "lawman" who "whacks" children with a "poisonous" curriculum in order to motivate their pursuit toward a better version of themselves, irrespective of how impossible that version is to attain? A surprising admission/question? Perhaps. As Granger (2010) noted, it is an important undertaking to reflect on "the strange surprise of theories and processes that paradoxically uncover what we seem to be using them to conceal" (p. 219).

As discussed above, much of the difficulty lies in the human preference for believing we are more beautiful than we are. Any process that provides "missing signifiers" to contest the reality-fantasy is apt to cause some friction—we can't handle the truth—whack—sometimes these processes are demonstratively public and political (counter hegemonic practices), and sometimes these processes are more private and psychoanalytical (therapeutic practices). The trouble with schools is that they have tended to be neither political nor personal, neither public nor private. Symbolically, they have evaded the Statue of Liberty and embraced a narcissistic statue of puberty.[5]

French philosopher Alain Badiou is helpful here. He uses an auditory explanation to get beyond the signifying dilemma of the subject's gaze on her/himself. When we think of teachers as *becoming teachers* and students as *becoming students*, Badiou helps draw our attention to the materiality of time and place. That is, teacher and student do exist together in time and space. How that space is constructed as reality often reveals more about the fantasies educators hold than any "reality" that might be taking place. Hence Badiou's turn from the gaze to a listening posture: When we listen to others for their otherness, what is it that we hear? In the layers, in the patterns that emerge, do we hear how our lives have been patterned, even predicated by power? As we listen, do we hear the intersections that privilege ignorance and promote fantasy? As den Heyer (2010) explained, Badiou argued for "material traces" of a "becoming subject" (p. 153), pointing to the ever-ongoing processes and situated nature of our knowing. Den Heyer draws our attention to the possible "fidelity" between a becoming subject and the instigating events of time and place that make up our encounters with the world. As I (with Snowber, 2011) described elsewhere, this is where our aesthetic/empathetic articulations become embodied—what we ascribe becomes inscribed materially/physically in time and place as our sense-making sensuality in the world.

Schecter and Bayley (2002) described the intersection of a becoming sub-ject and the world as a "perpetual process of being differently positioned, and positioning differently" (p. 51), carefully noting that we cannot understand any move to action without understanding the structures of power that subject the subject. What Schecter and Bayley add to our understanding is how power ori-ents the becoming subject. I contend that tightly coupled aesthetic/empa-thetic processes resist the powerful positioning of the reason-fantasies that create consent around a better (preferred) version of myself. Understood as art-making, resistances that are articulations puncture normative discourse, acknowledging the signifier/signified gap where the excess of desire cannot be held. Expressed as a theoretical possibility, the living and lived poetic (artmak-ing) processes that would make up an aesthetic/empathetic articulation would, one hopes, create significant shared experiences with others while simultane-ously acknowledging the inner discourses of passion (desires) that are inevitably part of the becoming subject's reception of the other. Expressed practically, a *something other* education would be a process of relational interactions by which the becoming subject shares (inwardly and outwardly) the quest of "who is my monstrous mutation?" and "what is my relation to other mutants?"

ACKNOWLEDGMENTS

This article was funded in part by a grant from the Canadian Centre for Ethics in Public Affairs.

I would like to thank Liz Townsend, Erin Casey, and the editors for their helpful comments and suggestions.

NOTES

1. While beauty continues to be one consideration of aesthetics, today aesthetics is much more broadly understood.
2. Used with permission from the author.
3. Pseudonym.
4. Used with permission from the author.
5. The notion of a statue of puberty is from Wayne Johnston's A World Elsewhere.

REFERENCES

Addonizio, K. (2011). Whack Report. New Letters, 77(2), 112.
Aoki, D. S. (2000). The thing never speaks for itself: Lacan and the politics of clarity. Harvard Educational Review, 70, 347–369.
Aoki, D. S. (2002). The price of teaching: Love, evasion and the subordination of knowledge. Journal of Curriculum Theorizing, 18(1), 21–39.

Beasley, B. (2007). Toward a poetics of monstrosity. Retrieved from http://www.poetrynet.org/month/archive/beasley/intro.html

Brown, D. (Producer) & Reiner, R. (Director). (1992). *A few good men* [DVD]. United States: Castle Rock Entertainment. Retrieved from http://www.youtube.com/watch?v=8hGv QtumNAY

Buber, M. (1998). *Knowledge of man: Selected essays*. New York, NY: Humanity Books.

Collins, B. (1988). An introduction to poetry. In B. Collins, *The apple that astonished Paris*. Fayetteville, AK: University of Arkansas Press. Retrieved fromhttp://www.loc.gov/poetry/180/001.html

Cornish, M. (2000). Numbers. *Poetry*. CLXXVI(3), Retrieved from http://www.loc.gov/poetry/180/008.html

Craig, K., Bell, D., & Leschied, A. (2011). Pre-service teachers' knowledge and attitudes regarding school-based bullying. *Canadian Journal of Education, 34*(2), 21–33.

Davis, L. (2009). A mown lawn. In L. Davis, *The collected stories of Lydia Davis*, (p. 314). New York, NY: Farrar, Straus and Giroux.

den Heyer, K. (2010). Alain Badiou: A becoming subject to education. *Educational Philosophy and Theory. 42*(2), 152–158.

den Heyer, K., & Conrad, D. (2011). Using Alain Badiou's ethic of truths to support an "eventful" social justice teacher education program. *Journal of Curriculum Theorizing, 27*(1), 7–19.

DeVito, D. (Producer) & Niccol, A. (Director). (1997). *Gattaca* [DVD]. United States. Columbia Pictures. Retrieved from http://www.youtube.com/watch?v=lP1cCjBkWZU

Freire, P. (1971). *Pedagogy of the oppressed*. New York, NY: Herder & Herder.

Freire, P. (1985). *The politics of education: Culture, power, and liberation*. (D. Macedo, Trans.). Hadley, MA: Bergin & Garvey.

Freire, P., & Freire, A.M.A. (1994). *Pedagogy of hope: Reliving pedagogy of the oppressed*. (R.R. Barr, Trans.). New York, NY: Continuum.

Freire, P., & Freire, A.M.A. (1997). *Pedagogy of the heart*. (D. Macedo & A. Oliveira, Trans.). New York, NY: Continuum.

Freire, P. (1998). *Pedagogy of freedom: Ethics, democracy, and civic courage*. (P. Clarke, Trans.). Lanham, MD: Rowman & Littlefield.

Granger, C. (2010). The split-off narrator: Coming to symptoms in stories of learning to teach. *Teachers and Teaching: Theory and Practice, 16*(2), 219–232.

Guiney Yallop, J. J. (2010). *Notes to my prostate*. Toronto, Canada: Sixth Floor Press.

Johnston, W. (2011). *A world elsewhere*. Toronto, Canada: Random House.

Kearney, R. (2004). *Debates in continental philosophy: Conversations with contemporary thinkers*. New York, NY: Fordham University Press.

Kingsolver, B. (1998). *The poisonwood bible*. New York, NY: Harper.

Lacan, J. (1977 [1966]). On a question preliminary to any possible treatment of psychosis. In *Écrits: A Selection* (A. Sheridan, Trans.). New York, NY: Norton.

Leggo, C. (2004). Living poetry: Five ruminations. *Language & Literacy, 6*(2). Retrieved from http://www.langandlit.ualberta.ca/Fall2004/Leggo.html

Leggo, C. (2011). Living love: Confessions of a fearful teacher. *Journal of the Canadian Association for Curriculum Studies, 9*(2), 115–144.

MacLean, B. (2009). *Shades of green*. Charlottetown, Canada: Acorn Press.

Milton, J. (1694). *Paradise lost* (2nd ed.). London, England: S. Simmons.

Rancière, J. (1991). *The ignorant schoolmaster: Five lessons in intellectual emancipation*. Stanford, CT: University of Stanford Press.

Rancière, J. (1999). *Disagreement: Politics and philosophy*. Minneapolis, MN: University of Minnesota Press.

Rancière, J. (2004). *The philosopher and his poor*. Durham, NC: Duke University Press.

Rancière, J. (2006). *The politics of aesthetics*. London, England: Continuum.

Rancière, J. (2009). *Aesthetics and its discontents*. New York, NY: Polity Press.

Rømer, T.A. (2011). Postmodern education and the concept of power. *Educational Philosophy and Theory, 43*(7), 755–772.

Schecter, S., & Bayley, R. (2002). *Language as cultural practice: Mexicanos en el norte*. Mahwah, NJ: Lawrence Erlbaum.

Wiebe, S. & Snowber, C. (2011). The visceral imagination: A fertile space for non-textual knowing. *Journal of Curriculum Theorizing, 27*(2), 101–113.

Wong, D. (2009). Beyond control and rationality: Dewey, aesthetics, motivation, and educative experiences. *Teachers College Record, 109*(1), 192–220.

· 9 ·

Johnson, Levinas, and Sensibility

An Aesthetic Avenue to Ethics?

DONALD BLUMENFELD-JONES

The title of the present book is *Aesthetics, Empathy, and Education*. I must begin with two demurrals about the project of this chapter that come in the form of ironies. First, I will claim that in Emmanuel Levinas' work he rejects the notion of "empathy" as a basis for ethical life (see Sharon Todd's work on Levinas) and will present a précis of Levinas to show why this is so. This does not mean that aesthetics has nothing to do with ethics, only that empathy may be the wrong idea to put into play. Second, and equally ironic, Levinas, at some points in his work, actively rejects the arts (and by extension, therefore, aesthetics) as being able to contribute to ethical life. I will be arguing that he does not see in his own work the hidden potential of aesthetic experience for fostering an ethical consciousness. These two ironies (one going against the grain of the present book and the other against the explicit grain of Levinas) make this chapter both a foil to, and extension of, the project of this book.

I begin by establishing the place of imagination in moral awareness and consciousness, using Mark Johnson's work in this area. Johnson has done a great deal of work on the relation between the structure of language and consciousness (*Metaphors We Live By*, with the linguist George Lakoff, 2003) and the relation of language to bodily states (*Body in Mind*). This work connects to Levinas, as Levinas uses a structuralist analysis of language, coupled with

a phenomenological account of the development of the self, as a central basis for his ethics. Thus, Johnson's thinking is a more or less natural fit for thinking about Levinas, whose work I elaborate in the second section of this chapter. In the last section I link imagination and the Levinasian position to posit an education for ethical life through art experience.

Moral Imagination

Mark Johnson, in his 1994 book *The Moral Imagination*, began by rejecting what he called "misguided views" of ethics, those of moral absolutism and moral relativism. He wrote:

> Moral absolutism asserts the existence of universally binding, absolute moral laws that can tell us which acts are right and which are wrong. It assumes that imagination is "merely" subjective…[with] no place in a morality of laws. (p. 3)

He found that moral absolutism asserts that we: "think and act as though we possess a universal, disembodied reason that generates absolute rules, decision-making procedures, and universal or categorical laws by which we can tell right from wrong in any situation we encounter" (p. 5). He stated that he did "not mean to deny the existence or usefulness of very general moral principles," but this approach "misses most what really matters in morality…be[ing] morally sensitive and fully responsible to other people" (p. 5). In this chapter, I shall assert that Levinas would agree with this point of view and makes a call for a kind of ethics in line with the development of imagination.

Johnson is equally critical of moral relativism as he writes that it:

> argues either that there are no moral laws of any sort, or else that if there are moral laws, they could have force only relative to a particular cultural group and within a particular historical context.…If moral relativists embrace imagination, they do so only because they regard it as entirely unconstrained, as opposed to reason, and as undermining…moral universals. (p. 3)

Over against such views of morality and mind, Johnson wrote that imagination is "neither subjective, unconstrained, nor irrational" (p. 3). Further, he wrote:

> Humans are fundamentally imaginative creatures whose understanding of experience is built up with the imaginative materials of cognition…[which] make it possible for us to envision the probable consequences of a proposed course of action, such as how other people are likely to be affected, how it might change our relationships, and what new possibilities it might open up (or close off) concerning how we can grow. (p. 3)

When Johnson writes that using imagination yields "alternative viewpoints and concepts" for evaluating "the merits of a particular moral position" he is focused on moral imagination providing information useful to our thinking and obtainable in no other way except through imaginative practices. As we shall see, Levinas makes it clear that knowledge (epistemology) is not ethics and does not lead us toward ethics, so we will have to be careful how we read Johnson's work.

Johnson based his thinking about imagination on cognitive psychology as he set out what he called the "Moral Law Folk Theory." He claimed that the usual way of thinking about "how to be ethical" is through the use of reason to parse situations and make decisions based on moral or ethical principles. Certain undergirding assumptions are needed in order to make this construal likely. If a moral law is to apply directly to a situation, then our conceptualization of the situation must match exactly the concepts in terms of which the moral law is stated (p. 7). This, in turn, requires that the needed conceptualization must be unique, univocal, and literal in order for it to be applied to the situation (p. 8). An exact match of a situation is impossible to attain as we can never "know" the whole of the situation, thus our conceptualization will always be found wanting. As for the notion of unique, and so forth—if it is unique then it cannot lead toward a law that is to apply to any situation beyond this specific situation. Thus, wrote Johnson, "Moral Law theory can never give us the laws it promises" (p. 12). In its place, Johnson argued that "narrative is a fundamental mode of understanding....Narrative is not just an explanatory device, but is actually constitutive of the way we experience things" (p. 9). Asserting narrative as the fundamental "way we experience things" contradicts our folk theory of moral reasoning, demanding a view of moral reasoning as imaginative through and through (p. 11). In arguing for imagination, Johnson is really asserting that we come to understand morally through imagination and aesthetic processes to deliberate about moral decisions. There are no moral laws, except in the most obvious cases, whereby the law wasn't really necessary in the first place.

Johnson contended that the folk theory has "very little to do with actual human deliberation" (pp. 79–80). "[M]oral deliberation [is] expansive, imaginative inquiry into possibilities for enhancing the quality of our communally shared experience" (p. 80). Human beings are not objective moral agents who subsume everything to practical reason and have a self "defined prior to its ends and independent of the contexts it comes to inhabit," but we are,

> socially constituted...historically situated...changeable...defined not only by...biological makeup...but also by its ends, its interpersonal relationships, its cultural traditions, its institutional commitments and its historical context. (p. 151)

In a similar fashion, as we shall see shortly, Levinas would agree, to the degree that we are always in a state of becoming someone rather than being a fixed being who acts out of the same set of pre-ordained conditions. Johnson continued:

> The "self" develops…by inhabiting characters embedded within socially shared roles and by creatively appropriating those roles, even to the point of coauthoring new ones. I stress coauthoring, because all of this imaginative exploration…is carried on in and through complex social interactions in which practices and forms of relationship are communally constructed….I can only come to know who I am…by an ongoing process that is never complete during my lifetime or beyond. I am not reducible to the roles I internalize, but neither do I have an identity utterly independent of those roles. (p. 153)

We shall find echoes of this in Levinas when Levinas insists upon an image of the self being built out of interpersonal relationships. As we shall see shortly, "inhabiting characters embedded in socially shared roles and…creatively appropriating those roles" parallel Levinas' s phenomenological account of how the self initially comes to be, although it is not the ground for an ethical life.

Given all this, what exactly is "moral imagination"? Johnson described it as grounded in prototypes of experience that we use to frame ongoing experience. These frames "involve a broad range of imaginative structures, such as image schemas, various types of prototype structure, metonymy, and metaphor" (p. 192). Johnson claimed that "knowing about the imaginative character of frames…is crucial" as these frames are "inherit[ed] from our moral tradition and apply to situations…if we are to be at all aware of the prejudgments we bring to situations" we can only do so through such knowledge (p. 192). Johnson is particularly interested in the metaphoric character of moral imagination, writing that it has "radical implications" by providing "insights" for moral understanding. Some of these insights are, when we consider the idea that our language is filled with metaphors, which we do not notice, for the most part, as they have become such common knowledge that they have become "true." This means that our moral understanding is also structured through the metaphoric character of language.

It behooves us, according to Johnson, to recognize what specific metaphors are populating our particular moral perspectives. Enter the body as one source of metaphors: "Are certain source domains based on universal bodily experience? If so, when they are used to understand a target domain that appears in every culture (e.g., community), they may well present experientially based cognitive universals" (p. 193). Metaphors take a "target" as the "thing" to be "explained" in the metaphor and bring the target into close proximity with

something quite different. In this interaction between two very different "things" something happens to the target domain such that new facets of it become illuminated and/or exposed that were previously hidden from us. Thus, if there is a common universal bodily experience that pertains to understanding community in a particular way, we may feel some confidence that community, understood in this way, is a common feature of many cultures, even if it "sounds as if" it is not. Over against this, "we can discern where cultural variation is most likely to enter into a given level of metaphorical structure" (p. 194). Thus, metaphors enable us to examine what is common to all human experience, what are specific to specific situations, and, thus, begin to build across cultures understandings that could eventuate in better cross-cultural understanding and, thus, better relationships that would lead to a better life for all.

Near the end of Johnson's book, he leads on toward the topic at hand: the relationship between aesthetics and moral imagination. He offers, in the place of moral reasoning, the metaphor, "morality as art," noting that "moral reasoning is a certain type of skillful imaginative activity" (p. 210). He is interested in "examining how far [moral imagination] is like aesthetic discrimination and artistic creation," which may yield certain salient understandings of our ability to make moral decisions (p. 210). He wrote that certain characteristics of artistic activity are important for moral imagination. These are discernment, expression, investigation, creativity, and skill (pp. 210–212).

Discernment, he noted, is the ability to "frame" a situation in terms of what is important for that situation, to "notice what we do not [ordinarily] see, to imagine possibilities we have not imagined, and to feel in ways we might, but are not now, feeling," all of this for the purpose of "opening up to us new dimensions of our world" (p. 210). For art and moral imagination "there is no predetermined method (or algorithmic procedure), yet they are 'assisted' by general principles and constrained by the nature of our bodily, interpersonal, and cultural interactions" (p. 211). Expression, as a characteristic of both art-making and moral imagination, denotes the giving of "definition, individuality, and clarity to emotions, images, and desires" (p. 211). Art (and moral imagination) becomes "a form of self-disclosure and self-knowledge" (p. 211). In a parallel and related fashion, in regard to the characteristic of investigation, both art and moral imagination are a form of knowledge as we come to know features of our world better and in new ways. Both the artist and the moral imaginer explore "various framings of situations, inquire into the motives and intentions of others, and explore possibilities for constructive interaction that are latent within situations" (p. 212).

Lastly, there are creativity and skill. Imagination expressed through the active making of things is central to both art and moral imagining. In both, "we mold, shape, give form to, compose, harmonize, balance, disrupt, organize, re-form, construct, delineate, portray, and use other forms of imaginative making" (p. 212). Johnson noted that:

> Certain people are particularly good at this sort of imaginative exploration and cre-ation...as [they] appear to break the established rules of morality or law or propriety, going beyond canonical forms and practices to show us new ways of thinking, relat-ing, and acting. (p. 213)

In order to successfully negotiate such creativity, skill is needed, which means:

> the deliberate application of human intelligence to some part of the world, yielding some control over...chance or contingency...the person who lives by [skill] does not come to each new experience without foresight or resource. He possesses some sort of systematic grasp, some way of ordering the subject matter, that will take him to the new situation well prepared, removed from blind dependence on what happens. (Nussbaum in Johnson, p. 214)

Johnson goes on to write that skills are acquired through practice and, most importantly, that skill is not "merely knowledge of effective means" but rather, an ability to interact,

> with materials, forms, and ideas in which something determinate begins to take shape through the process of working with the materials of the art. One's conception evolves and grows by skillfully working the material..."the art activities themselves constitute the end." (Nussbaum in Johnson, p. 214)

This last point seems crucial, that "'the art activities themselves constitute the end.'" I will argue, soon, that for aesthetic experiences to be viable grounds for developing ethical consciousness, the act of art-making must be focused on making quality art, focused on following through on thinking as an artist does, even if the more important point is to develop an ethical sensibility. Only through a thorough art experience can the arts contribute to developing an eth-ical consciousness, for only through such an experience can we leverage the kind of awareness available through the arts. But this runs ahead of the argu-ment. In the next section I briefly explore Levinasian ethics.

Levinasian Ethics

In this section I will rehearse Levinasian ethics in an abbreviated form and then look to that part of Levinas' work that, in my estimation, lends itself to think-ing aesthetically.

Sharon Todd (2003) has persuasively argued that Levinasian ethics is not about being in empathy with another person. She asserts that a focus upon empathy requires, in part, that "[t]he self...be in the place of the other" and that the students are to be brought "face to face with a 'representation'...of one who has suffered, setting up an encounter whereby students are expected to identify by 'taking in' the injustice and thereby sharing another's pain" (p. 45). This runs counter to Levinas' account of the ethical relationship, which is predicated on the notion that an ethical relationship is always and only between two people, whereby one person comes to understand that s/he cannot capture, control, or know the life or meaning of another nor feel the other empathically. This state of "ignorance" is utterly necessary for the ethical relationship to be ethical in the first place. We shall see that it is not actually "ignorance" but, rather, recognizing the complete separateness of the other from me. I use "ignorance" at the moment to move away from the idea that the ethical relationship is based on knowledge. Let us see how Levinas attempts to establish this notion of ethics.

In *Totality and Infinity*, Levinas phenomenologically traced the development of a self who discovers her/his responsibility for another in the world. This journey begins in what Levinas termed "Metaphysical Desire" (1969, p. 33). He wrote:

> The other metaphysically desired is not "other" like the bread I eat, the land in which I dwell, the landscape I contemplate, like sometimes, myself for myself, this "I," that "other." I can "feed" on these realities and to a very great extent satisfy myself....Their *alterity* is thereby reabsorbed into my own identity as a thinker or a possessor. The metaphysical desire tends toward *something else entirely*, toward the *absolutely other*. (1969, p. 33)

He means by this that there is a desire to "know" something beyond myself, something that is radically not me, is fundamentally unreachable but is yet "knowable" in my yearning for it. More than merely knowing, this desire may be understood as the desire to be connected to something beyond me. He writes that this metaphysical desire cannot be filled by bringing the desired closer but, in fact, is predicated on "remoteness."

> This remoteness is radical only if desire is not the possibility of anticipating the desirable, if it does not think it beforehand, if it goes toward it aimlessly, that is, as toward an absolute, unanticipatable alterity, as one goes forth unto death. Invisibility [of the metaphysically desired] does not denote an absence of relation; it implies relations with what is not given, of which there is no idea. (1969, p. 33)

This is what is meant by "not knowing," for how can you know that of which you have "no idea"?

As I sally forth into the world around me in order to craft a self, I treat what is in the world as resources that bring me what I need to be a self. I gather them in as I gather in bread and dwelling places. One primary resource for such in-gathering is language: I use language to label and make sense of all experiences, fitting into my growing understanding of myself. This move, however, is a matter of taking what is other than me and making "other same." That is, I must transform something outside myself into something that fits the categories I use to make sense of my experience if I am to use it. This, however, defeats the desire to be connected with something outside myself as I have transformed the outside into me. It may bring some small difference to me, but overwhelmingly it is a matter of "more of the same." Importantly, I notice that the things of the world are not entirely malleable to my designs and, in varying degrees, resist my use of them. I must transform and perform "work-arounds" to use them.

Levinas informs us that there is one "thing" of the world which entirely resists my use of it and that "thing" is an Other, a being (like myself, crafting a self) who will not be subsumed by the language categories that I use to make sense of "it." Levinas used the image of "face" to develop this notion. Levinas described this encounter as follows: "The face resists possession, resists my powers. In its epiphany, in expression, the sensible, still graspable, turns into total resistance to the grasp…the resistance to the grasp is not produced in an insurmountable resistance" (1969, p. 197).

Levinas (1969) meant here that the Other resists being grasped by the Self that would treat the Other as just an other that is available, as a resource, to the self. But the Other's resistance is "not…insurmountable," does not put up a wall that cannot be scaled or breached. He wrote, "[T]he face speaks to me and thereby invites me to a relation commensurate with a power exercised, be it in enjoyment or knowledge….The face…is…still…exposed to powers" (p. 198) even as it is the instigator of its own power over the Self. Nevertheless:

> [T]he depth that opens in this sensibility modifies the very nature of power, which henceforth can no longer take, but can kill. Murder still aims at a sensible datum, and yet it finds itself before a datum whose being cannot be *suspended* by an appropriation. It finds itself before a datum absolutely non-neutralizable….Neither the destruction of things, nor the hunt, nor the extermination of living beings aims at the face, which is not of the world….To kill is not to dominate but to annihilate….Murder exercises a power over what escapes power…the face rends sensible. The alterity that is expressed in the face provides the unique "matter" possible for total negation. I can wish to kill only an existence absolutely independent, which exceeds my powers infinitely, and therefore does not oppose them but paralyzes the very power of power. (p. 198)

Despite this possibility, in the end, this is the Desire that has been sought, the Desire of something wholly Other, wholly outside myself, wholly to be connected to. Levinas wrote:

> There is here a relation…with something absolutely *other*: the resistance of what has no resistance—the ethical resistance. The epiphany of the face brings forth the possibility of gauging the infinity of the temptation to murder, not only as a temptation to total destruction, but also as the purely ethical impossibility of this temptation and attempt. If the resistance to murder were not ethical but real, we would have a *perception* of it, with all that reverts to the subjective in perception….The struggle this face can threaten *presupposes* the transcendence of expression. The face threatens the eventuality of a struggle, but this threat does not exhaust the epiphany of infinity, does not formulate its first word. War presupposes peace, the antecedent and non-allergic presence of the Other; it does not represent the first event of the encounter. (p. 199)

The moment I notice that this "thing" is not a "thing" like other things, it transcends its "thingness" and becomes the being to which I wished to connect: it becomes "radically Other" (that "alterity" that I cannot absorb into myself); it escapes my attempts to control and understand; it escapes my categories. Whereas, prior to this, I was able to "totalize" the world (Levinas' notion for speaking about the world as if I understood it in its totality and have spoken for it in its entirety), this being over against me becomes infinite to me, beyond all categories I might apply.

In this moment of the face, my responsibility for the Other is born and, so, ethics is born; I notice the fragility and tenderness of this Other I was, but a moment ago, attempting to totalize, and could at this moment destroy. But I do not. I become aware that the fragility and innocence that is infinity calls to me to take care of "it," to, as Levinas argued, master the world on its behalf, create the conditions for its protection and thriving. This is what Levinas means by ethics. Prior to there being knowledge (language), prior to there being Being (crafting myself, ontology) there is the Other (ethics) who was always there although I did not recognize this Other, this being who needs me.

If ethics is born outside of, or before, categories entering the scene, and if language, the ultimate categorizer, is such a powerful mediator of reality that it intervenes prior to our being aware of what we "know," then how are we to arrive at ethics? In multiple ways, Levinas presents us with the notion that just before our categories congeal into language, into labels, into what we already know, just before the signifier becomes signified, just before we know that we know, there is a moment when all the personhood and infinity of the person are available to us. In that unknowable moment, we can "know" the Other for his/her infinity.

I cannot explain this better than that. This knowing is upon us before we notice it, but we must notice it for the learning to occur. Please be clear: the "noticing" precedes the "knowing" but the knowing occurs "because of" the "noticing," and yet the "real" knowing is in the noticing, not the knowing through categories. This dialectical irony tinges the ethics that ensues.

Levinas' phenomenological edifice is built upon dyads in which both terms are dialectically and necessarily connected, are necessary to the making of a self and a life and, simultaneously, are antithetical to each other: Signifier and signified, totality and infinity, self and other, and, among these dyads, "sense" and "sensibility." In each case one term of the dyad is clearly privileged and more powerful than the other, having a materiality not possessed by the opposing term. Signifier is the concrete, material symbol publicly shared; the signified, "existing" as it does only within the interpreter of the signified's mind, exists only in the private "space" of the person interpreting the signifier. Totality takes material existence and sorts it into material categories useful to the self; infinity is a concept that constantly escapes our being able to comprehend it (the very nature of the infinite is to transcend boundaries). The self is something I can know concretely as it is in my possession; other is something I, ultimately, cannot know, precisely because it exists outside the self. The dyad upon which I wish to focus is presented by Levinas (1998) in his follow-up text to *Totality and Infinity: Otherwise Than Being*. In this book he presents the dyad of "sense" and "sensibility" similarly: the senses are concrete experiences that are, through language, brought into existence to be shared with others (we all see the "red" wall); sensibility is that openness to experience of the "red" wall before it becomes the "red" wall. In each of these dyads, just prior to the world congealing into something cognizable, it "exists" in this "infinite" "space" that "contains" "pure potential."[1]

The "sense" and "sensibility" dyad will be the focus of the rest of this chapter as it is, in my estimation, most pertinent to the intersection of aesthetics and ethics. "Sense" and "sensibility" are clearly steeped in the body. In this dyad, "sense" means the senses we have and that we know and can identify; "sensibility" is that moment just before we congeal into knowing the sense being accessed or enlivened. As just noted, before I know "red" there is something of infinite potential in that pre-knowing that is beyond "red" as a category, even beyond "color" as a category, that connects me to this universe of possibility. "Red" is the sensed, known quality and quantity, "pre-sensed sensibility" is the potential of "knowing" before it is "known." It is in this "state" of "sensibility" that face becomes momentarily infinite and Other the ground of ethics.

Aesthetics and Ethics: A Confluence of Possibilities

This portion of the chapter may, I worry, appear to the reader as "mystical" or beyond credibility. It does not rely on the kind of rationality that marks what I have written so far (if you take what I have presented as being rational). In Sam Harris' recent book, *The Moral Landscape* (2010), he asserted that moral life can only be predicated on human consciousness. Further, he asserted that the faculty of reason is the only sensible (pun intended) court of judgment for determining human values, and that all values point toward improvement of the human wellbeing. I will not argue with these assertions but I will assert that the notion of reason as the only proper venue for determining value is misguided and incorrect. Clearly, from what I have presented so far, I see that the centrality and stand-alone value of reason for the establishment of an ethical life are, at best, limited and, at worst, misleading. (See Nussbaum, 1990, cited in Johnson, 1994, for more on this.)

That said, I will argue that while what I have been presenting is not "empirical" in the usual sense of that word, it is empirical in being grounded in bodily experience. What is meant, usually, by empirical, is sense data made sense of through external measures that remove the person's concerns and desires from the moments of understanding. As I discuss the potential of aesthetic experience for cultivating an encounter with the Face of the Other, it will be through an account of placing the Levinasian notions as dispositions within action, becoming consciously available to them as a "presence." "Disposition" is used deliberately: to be disposed to something is not to mandate its existence but rather to lean in the direction of that something, to be more alert to its possibility than the possibility of another experience. The *Oxford English Dictionary* presents "disposition" as a "natural tendency or bent of the mind, esp. in relation to moral or social qualities; mental constitution or temperament; turn of mind" and a "physical aptitude, tendency, or inclination (to something, or to do something)" (on-line OED, n.d.). This indicates, I think, an openness to be ready for something (to incline toward it).

It seems to me that aesthetic experience as experienced in the making of art is a venue for cultivating the kind of "pre-knowing" suggested by Levinas, coupled with the inclination to "know" in an innocent way that does not pre-dispose the object of our knowing into already known categories. What do I mean by this? Nicolaides (1975), in *The Natural Way to Draw*, informs us that often when a person attempts to draw an apple, for instance, s/he tends to draw the apple s/he thinks they see rather than the apple that is there. He created a series of exercises designed to help the artist really see *this* apple in all its specificity,

in its unique presence in the world at this moment. While this is still in the arena of categories (a specific shape, a specific color, specific markings, etc.), it does help us orient ourselves to be present to the moment, rather than use filters to automatically place the moment within a library of previous moments and, thus, sort it into the already known (making other same). What can be said for drawing might be said for being bodily present to another human being prior to the moment of "knowing" that person to be a woman or man, a person of a certain age and a certain body and a certain affect and so forth. It might be a matter of "remembering" that who we think we know before us is someone we don't know, is a "face" before there is a "face" we recognize. It is standing before the other and "seeing" the other without preconceptions of who is the other and seeing the preconceptions fall away. It is asking the self, "If I know nothing of this other what will I know before I know this other?"

I hazard that we have all had experiences of encountering another person in such a way that the other, at first, surprises us with our not knowing and, in the state of not knowing, feeling a connection that opens the space between the other and I such that I feel the connection by "realizing" the not knowing.

The first example involves a first grade classroom in NC. The teacher and principal were speaking by the door, backs to the room. Suddenly there was a noise from behind them. The teacher turned quickly, pointed at Henry, a small-boned Black boy and, gesturing with a sweeping motion, commanded, "Out in the hall now. We'll speak in a moment." But just before that judgment, the teacher saw Henry's face, his eyes staring at her as the infinitely possible human being before acting ("I could do this or I could do that"). She felt that pang of vulnerability, responsibility for his life in her care. The moment passed, she ordered him to the hall. The second example involves driving in Arizona during August (one of the most dangerous heat months of the year in Arizona, my part of the world) from Flagstaff to Phoenix, south along the interstate. Along the route I saw many cars stranded on the shoulders of the highway, likely from overheating. For the most part I felt that people had been inattentive to the situation, had run their car air conditioning when they should have "suffered" through a stretch of heat in order to have their cars not break down. There was a particular car on the shoulder, with a family outside the car with a young woman standing in what little shade was afforded by the vehicle, holding a baby, in the searing heat. Unlike the other people standing by other vehicles for whom I had not much thought, I suddenly had the feeling of responsibility for this young woman and her baby, this sudden upwelling of concern and care. I might have judged the family: Hispanic, prob-

JOHNSON, LEVINAS, AND SENSIBILITY 163

ably poor or at least not wealthy judging by their car, and so forth. I might have judged them as typically careless—too bad, but really! Yet, here was this moment when the categories disappeared. Here was this woman who wasn't Hispanic, or poor, or woman, even, but person with small, vulnerable person in her arms. I felt the vulnerability of both. The moment passed; I noticed men were on cell phones, likely getting help from friends. I didn't suggest to my family that we pull over and take care of this woman. But there was this instant when I felt what Levinas suggested is the "experience" of the vulnerability and fragility of the Other, in which responsibility is born. This incident took place years before I read Levinas or even knew of the existence of his work. And yet, that moment has stayed with me as Levinas might expect it would. Such moments, while brief and evanescent, mark us forever, and change us if only we are available to them.

What does art have to do with this? It is my suggestion that a more conscious cultivation of practicing presence or the possibility of presence through making art begins in being present to the immediacy of the object being encountered (tree, person, plate, apple, even idea). It is steeped in what Johnson suggested the artist practices (the various capacities of the artist to pay attention and use discernment and judgment to make the art). This practice may prepare us for the ethical encounter/moment. It is important to note that I am arguing for the salience of the artistic *process* of presence and noticing that is of importance; it is not the making of an art product that produces ethical consciousness. However, ironically, unless I move through to the making of the art product, act as if I am making art, I will likely not be available to this ethical encounter. Only in the state of "thinking like an artist" can I come to the possibility of this presence and be available to it. Or as Ansel Adams stated, quoting Vince Lombardi, the great Green Bay Packers coach, "Success happens when opportunity meets preparation." (http://jonphotoj.blogspot.com/2011/09/reading-responses.html). Some attribute this to the Roman philosopher Seneca who stated, similarly, that Luck is where the crossroads of opportunity and preparation meet (http://wiki.answers.com/Q/Who_said_luck_is_when_opportunity_meets_preparation). In either case, unless we are already disposed to the possibility of the ethical moment we will not experience it, but if we do not already know something of what it means to be available to an other, how can we be available when the opportunity arises?

We cannot manufacture the ethical moment; Levinas makes that clear. It will arise, does arise, more or less "naturally," but if we are not aware of it as a possibility, then we will likely never notice that it came to pass, and did pass.

This argument proposes a use of the arts that is not about making art and does not pretend that artists are, somehow, more likely to be ethical than others. Not all art is practiced as I have described the process. Not all artists are interested in the process as an availability state. It is not art, per se, that I am referencing, but a certain disposition toward art that, I am asserting, provides one possibility for living an ethical life. If this contributes anything, it is, hopefully, the beginning of wisdom that knows we know nothing and that is a good state of affairs.

NOTE

1. I place these terms in quotations not because Levinas does so but, rather, to convey the experience of them as provisional "place holders" in a situation that has no "place," otherwise it would not be infinite but would be confined and knowable as belonging to a specific, locatable category that shears off all that cannot be known by that category.

REFERENCES

Adams, Ansel (n. d.) *Jonathon Stephanoff photoblog*. Retrieved from (http://jonphotoj.blogspot.com/2011/09/reading-responses.html).

Harris, S. (2010). *The moral landscape*. Detroit, MI: Free Press.

Johnson, M. (1994). *The moral imagination: Implications of cognitive science for ethics*. Chicago, IL: University of Chicago Press.

Lakoff, G. & Johnson, M. (2003). *Metaphors we live by*. Chicago: University of Chicago Press. First published in 1980.

Levinas, E. (1969). *Totality and infinity: An essay in exteriority* (A. Lingis, Trans.). Pittsburgh, PA: Duquesne University Press.

Levinas, E. (1998). *Otherwise than being or beyond essence* (A. Lingis, Trans.). Pittsburgh, PA: Duquesne University Press.

Nicolaides, K. (1975). *The natural way to draw: A working plan for art study*. New York, NY: Houghton Mifflin.

Seneca (n. d.) *Answers*. Retrieved from (http://wiki.answers.com/Q/Who_said_luck_is_when_opportunity_meets_preparation

Todd, S. (2003). *Learning from the Other: Levinas, psychoanalysis, and ethical possibilities in education*. Albany, NY: SUNY Press.

· SECTION IV ·

FROM THEORY
TO PRACTICE

· 1 0 ·
Multisensory Aesthetic Experiences and the Development of Empathy

The Big Bad Wolf's Not So Bad After All

JULI KRAMER

Philosophers, from Socrates, Plato, and Aristotle, to Hegel and Kant, have elevated sight and sound over the other senses as they relate to aesthetics. Taste, touch, and movement have been deemed as the "lesser" senses, incapable of eliciting an aesthetic event, although this perspective continues to face challenges (Brady, 2005; Korsmeyer, 1999; Montero, 2006). Supporting these challenges is recent neuroscience research that adds a physiological element to the debate, entreating us to see the holistic nature of sensory experiences. From this physiological perspective, all sensory input contributes to neurological processes and functioning. Additionally, the more fully an experience integrates all of the senses, the more the brain generates neuronal connections and synthesizes an experience into a complete whole (Gallace & Spence, 2009; Smith, 2005; Spinella, 2002). To address this growing recognition that the senses operate in concert with each other, a broader, more open conception of aesthetic situations will better inform how to use such experiences to facilitate the development of student empathy. To that end, I draw upon L. Arnaud Reid's (2008) conceptualization of an aesthetic situation, which holds that "we have an aesthetic situation wherever we apprehend and in some sense enjoy meaning immediately embodied in something; in some way unified and integrated: feeling, hearing,

touching, imagining" (p. 295). This view opens up the opportunity for all senses, not just seeing and hearing, to inform an aesthetic experience.

A barrier to the potential of fashioning multisensory aesthetic experiences arises from the fact that as children move through traditional educational systems, each year they spend more of their time in anaesthetic situations that dull, versus enliven, the senses and the desire to learn (Dewey, 1934). Dewey did not advocate only having aesthetic experiences, but he held that interacting with the world through the senses had value and that eliminating such experiences from students' education hindered their learning. It "becomes out of order at a certain stage in education to go on paying attention to sensuous forms for their own sake...and instead [students learn] merely by stereotypes, signs, symbols, abstractions" (Reid, 2008, p. 299). Typically, students have little opportunity to engage with the sensuous nature of human experience. Perhaps this tendency stems from the teachers themselves, the academics who've succeeded without necessarily connecting to the physical world. Ken Robinson (2006) argued that people in control of schooling emphasize teaching from the neck up because that reflects their comfort with living in a world of ideas. Reid (2008) echoed this sentiment, stating that "the one-sided academic often has a sort of gaucherie and awkwardness which he needs to be released from, and I think if he understands the importance of the physical more, perhaps it would help" (p. 300). If we are to fashion enriching multisensory aesthetic situations to help students develop empathy, we must recognize these hurdles and work to overcome them.

Research on empathy further supports a multisensory approach. Studies have linked the activation of motor-sensory processes in the brain to the development of empathy (Decety, 2011a; Iacoboni, 2009; Phillips, 2004; Spinella, 2002). In fact, "empathic processes occur rapidly, at the millisecond timescale" within the brain, and researchers are moving ever closer to determining the complex networks that activate when people experience empathy (Mar, 2011, p. 114). Decety (2011b) shared that "cognitive, sensorimotor, and somatovisceral mechanisms are intimately connected, as stressed by embodied cognition and simulation models" (p. 43), a finding that supports developing more complex multisensory aesthetic experiences to activate empathy. The interconnectedness of sensory experiences emerges in a study on tactile memory as well. Gallace and Spence (2009) identified that:

> the representation of tactile information interacts with information about other sensory attributes (e.g., visual, auditory, and kinesthetic) of objects/events that people perceive. This fact suggests that at least part of the neural network involved in the memory for touch might be shared among different sensory modalities. (p. 380)

Further support comes from an intriguing study by Spinella (2002) in which he determined that the "emotional component of empathy (feeling another's emotions) correlated with smell, whereas a cognitive component (comprehending another's emotions) did not" (p. 605). The areas of the brain within the limbic system, stimulated in the smell study, are those same centers that produce powerful, long-term memories (Willander & Larsson, 2007; Yeshurun, Lapid, Dudai, & Sobel, 2009). By processing intricate sensory data, "The aesthetic response occurs very rapidly, beneath the level of the conscious mind...[and] lies at the core of human mentality" (Smith, 2005, p. 17).

The physiological evidence serves to support the notion that empathy is a complex phenomenon. Human empathy, while rooted in mirror neurons and rapid neurological processes, goes beyond empathy as experienced in other animals (Iacoboni, 2009; Phillips, 2004). The collective activities of the human brain comprise the ability to imagine the feelings and experiences of others. "Imagination is what, above all, makes empathy possible. It is what enables us to cross the empty spaces between ourselves and [others]" (Greene, 1995, p. 3), or as Daniel Pink (2006) wrote, "Empathy is a stunning act of imaginative derring-do, the ultimate virtual reality—climbing into another's mind to experience the world from that person's perspective" (p. 159). Moving away from species-centric notions of other, empathy can and should be expanded to include animals and plants, as well as inanimate objects that, when acted upon, affect the health of living beings.[1] Drawing upon knowledge of how the mind works, how it takes in data from the external world to craft aesthetic experiences, enables us to purposefully fashion situations in which our students can strengthen their imaginations and ability to empathize.

Crafting Multisensory Aesthetic Situations to Develop Empathy: A Four-Stage Process

This section offers four stages of curricular and instructional planning that can guide teachers in developing multisensory aesthetic situations aimed at strengthening student empathy. Stage 1 asks questions to help identify teachers' goals and means of assessment; Stage 2 emphasizes the brainstorming process needed to plan multisensory aesthetic experiences; Stage 3 provides information on how to help students embrace and get the most out of the planned multisensory opportunities; and Stage 4 discusses ways to help students process and make meaning in order to use what they've experienced to accomplish identified

educational goals. I first elaborate on the framework for each of the four stages, examining key variables to consider. I then include a narrative, based on my role as a participant observer co-teaching five high school freshmen, to bring the theoretical constructs to life.

Stage 1: Setting Goals and Means of Assessment

Identifying goals.

After establishing that multisensory aesthetic experiences designed to nurture empathy make up the foundation for one's planning, the teacher must decide how striving to develop empathy fits within the overall curriculum. For example, in language arts, is the focus on empathy in order to help students connect to characters and concepts within literature, poetry, and other narratives, or to give depth to students' writing, whether essay or the more typically creative forms? In the sciences, social studies, and even mathematics, is the goal to help students feel empathy for the plight of animals and people affected by global warming, pollution, or increased levels of toxins in the foods they consume? Is the goal to have students grasp social justice concerns in the past and present at an empathetic level, versus a simple cognitive grasp of the issues? Should students find meaning behind statistics about population growth, the spread of HIV, or homelessness, versus simply learning about statistics in a vacuum? These topics reflect the notion of ecology, or the interrelatedness of phenomena, outside the classroom as well as between subject areas. These connections grow increasingly apparent when looking at how to engender student empathy. Students begin to see how what they learn in school connects and applies to the real world. They also develop a sense of purpose and the ability to act based on what they learn. The age and developmental stages of students dictate which direction teachers should follow when setting goals for cultivating student empathy. Younger students might grapple with the same issues but at appropriate levels of difficulty and intensity.

If fortunate enough to work in an educational setting that values empathy and social action as topics of study for their intrinsic worth, teachers should also identify extrinsic values to help students achieve through greater empathy. Topics and projects might relate to curriculum content or stand on their own. Some examples include working with students to combat child slavery, and supporting programs that feed those in need, or raising awareness of mankind's impact on the natural world. Engaging in these types of broader goals goes beyond increasing knowledge and helps students gain greater awareness of how their choices and actions affect others and enhances their self-concept and

self-esteem by connecting them to caring and compassionate aspects of themselves. Addressing needs in their school or broader community deepens students' level of commitment and motivation.

Thinking about assessment.

The next question to ask is: How will one know if one has succeeded? How will students be different after the experience? What can be seen in their writing that indicates students empathize with characters, or that empathy informs an argumentative essay? In science and social studies, will empathy for other animals or humans come out in class discussions, multimedia presentations, or essays? Would a student-led petition to gather signatures in support of recycling in their community or writing grants to fund solar power at their school serve as evidence? Would students taking initiative to bring in Holocaust survivors or refugees from war-torn parts of the world indicate a greater sense of empathy for others? In mathematics, would the students describe "aha" moments when encountering the "golden rule" in the daily course of events? Would they identify with the people and the planet behind the statistics and show evidence of a connection by changing their habits or maximizing food production and efficient food distribution? Perhaps one might choose to simply debrief the experience to help students make connections. The serendipitous moments that might occur, unplanned for and beautiful in their spontaneity, could take a class in directions not previously imagined. Allowing students to abide in these moments without deliberately aiming for a bigger purpose could become one's objective for the day. If teachers remain open to these possibilities the above questions and answers can impact the curricular and instructional choices made.

Stage 2: Identifying and Planning for Multisensory Aesthetic Situations

The intention in this stage is to examine possible goals and distinguish which types of multisensory experiences contain the potential for aesthetic moments, ones in which students "apprehend and in some sense enjoy meaning immediately embodied in something; in some way unified and integrated: feeling, hearing, touching, imagining" (Reid, 2008, p. 295). Teachers might be able to plan for these situations within the classroom, or broader school building, but getting beyond school walls, permeating the essence of life in the world, can increase the potential for encountering the aesthetic moment. By doing so, teachers increase the likelihood of exposing students to circumstances that engage their senses and enable them to apprehend meaning.

This type of planning requires thinking and acting creatively, stretching one's thinking to identify encounters that support the above elements. Teachers need to allow time to brainstorm possibilities without restrictions, writing down every idea, no matter how far-fetched. While teachers might not have the luxury of traveling with students to Africa to help doctors teach youth about AIDS through soccer,[2] drawing upon that idea might help shape experiences closer to home that have a similar quality about them. Writing a short narrative or listing out bullet points helps draw attention to the sensory opportunities inherent in each potential situation. For example, if a teacher has identified the goal of creating awareness of the impact of toxins in food production, the class might visit traditional and organic farms near their community, where students could see, touch, and smell the soil, fertilizers used (are they even allowed to come in contact with the artificial fertilizers?), and food produced on the farms (taste would be another great sense to add to interact with the food). They could also listen to people's narratives about the choice of agricultural methods used. The purpose is to place students in situations that stimulate multiple senses to help them integrate the experience and find meaning.

Brainstorming often feels uncomfortable or unfamiliar, but going through this process is a valuable tool that enables teachers to model problem solving processes for their students. The following methods to enhance creative brainstorming draw upon current brain and creativity research. The methods aim to break entrenched patterns of thought that often act as barriers to new ideas. The first finding is that teachers should use others as a sounding board or at least draw upon inspiration from outside sources (Csikszentmihalyi, 2003; Moran & John-Steiner, 2003; Sternberg, 2003). Teachers should enlist a colleague, family member, or a few students in the brainstorming process. Utilizing resources on the Internet, internationally, nationally, and locally, serves as another source of inspiration, as does poring through magazines, novels, movies, plays, or textbooks to see what jogs the imagination.

Asking "What if?" questions that allow for the impossible or improbable can further break down limiting patterns of thinking. The purpose is to create a mindset, a personal environment that is "congenial" to creativity (Csikszentmihalyi, 1996). Teachers should start with warm-up questions not necessarily related to the topic, such as "What if the sky were pink?" "What if fire were cold?" "What if food quenched thirst and water satiated hunger?" By writing down answers to these questions, teachers allow themselves to engage in the playfulness associated with creativity, priming them to address "What if?" questions related to their goals. For example, instead of hitting a wall when asking, "What if my students

could solve world hunger?" teachers continue to apply creative thinking and are able to ask, "What would have to happen?" They can generate multiple answers to the question, which, in turn, enable them to then identify enriching multisensory aesthetic experiences that lead to desired outcomes.

Taking into account the students themselves grounds the process and leads to enhanced effectiveness. What passions have they exhibited that could strengthen the connections? What level of maturity and readiness needs to be present for them to take in the moment? A broader range of experiences over time will ensure that the needs and interests of more students are addressed, as not all encounters will resonate for everyone. Developing empathy through aesthetic moments is not a perfect path either. Students will connect in fits and starts along the way. Some will evidence progress and then regress; others will not show any response until years later, forcing teachers to tolerate uncertainty about whether or not they've attained their goals. The word "authentic" is bandied about a great deal, but "authentic" situations, ones that matter to the students and to which they can relate, will facilitate the process. As a math teacher, and close colleague, observed, "Kids think about important stuff" (personal communication, McKinney, 2011), which suggests that teachers need to enlist students' inherent interests and worries.

At this point, teachers get into the nuts and bolts of arranging the experience, drawing on the same organizational and planning skills used for classes every day. The only variance is the need to reach out to people in the community, coordinate logistics such as transportation, and any other factors that arise unique to the experience. Teachers must stay mindful of their goals and sensory expectations, not letting them get lost as they finalize the details.

Stage 3: Facilitating the Aesthetic Experience

Advanced preparation.

Placing students into an encounter without any framing might prove sufficient depending on identified goals. However, laying the groundwork for where they are going, understanding the importance from a theoretical perspective, can prove helpful. It allows students to go in with a sense of confidence versus insecurity when they arrive at the setting. They know what to expect, why they are there, which helps them move beyond feelings of anxiety to those almost akin to "ownership." Teachers need to move forward with thought and purpose. If surprise and awe are essential, advanced preparation might prove limiting. If the students will gain more once they understand key facts, they should prepare accordingly.

Additionally, in advance of field experiences, teachers should prime and help students attune to their senses through varied activities. Examples of different ways teachers can engage the senses include the following: 1) having students close their eyes and reach into bags of assorted materials and describe what they feel; 2) allowing students to smell distinct odors, such as chocolate-chip cookies, lemons, oranges, old leather, seashells, a dirty sponge, wet dirt, etc., and relate these odors to memories called to mind; 3) providing students the opportunity to use their vestibular and kinesthetic senses by first spinning around and then having to perform a task, followed by a brief discussion of how they felt; and 4) taking students outside and asking them to describe the temperature, whether or not there is a breeze, the feel of the sun on their skin, or the cool shadow of the clouds. Having students participate in these activities, among others, in advance of the experience, gives them a level of sensitivity to and comfort with paying attention to their senses.

Facilitating in the moment.
During Stage 3, teachers need to help students process the experience in the moment, purposefully directing them to attend to the sensuous aspects of the endeavor, helping them make connections, watching for the moments where students apprehend the whole, and drawing these moments to their attention.

Because students live in a fast-paced, visually dominant world, teachers need to help them to slow down and make careful observations. This step seems simple, but students released from school for the first time in ages[3] often do not know how to respond to the freedom. They race around from place to place or ignore what's around them because they've lost, or never developed, the skill to fully occupy themselves in the moment. Teachers need to act as guides. Often, to justify a field experience, teachers require students to complete worksheets, journal, or record every detail, fearful that the students won't learn without these tools. These requirements actually draw students away from what is going on around them and activate parts of the brain more distant from sensing and responding. They might also close students off from their own interpretations and meaning-making if too structured and directed. Teachers should engage the students in conversation or facilitate them talking with each other to help pay attention to and process what they experience. Giving the students digital cameras and having them shoot at least three different angles of a particular object also help students look at things from different perspectives. To ensure key elements are not missed, in addition to discussion, teachers could develop scavenger hunts—visual, auditory, and tactile—that guide students with their explorations.

Teachers should watch students apprehend the moment, listen to what they say, and notice their expressions and their bodies, looking for and promoting opportunities for students to bond over the encounter. If together they endured the foul odors of a wastewater treatment plant, the teacher can use the experience to draw them into discussions related to larger goals. If they overcame physical trials when climbing a mountain, the teacher should bring their attention to how the students feel collectively as a result. The key point is for teachers to draw upon what the students say about the experience, positive and negative, and echo back what they say, in order to help them consolidate their learning.

Stage 4: Reflection

During this stage students need to reflect in a more formal way on what they experienced. The ways in which they can reflect are limited only by the imagination. They might write postcards, decorating one side with images and the other with text portraying the four key components described below. The teachers might lead a discussion asking students to share their thoughts. They might write poems, choreograph dances, or put together multimedia presentations that address the components of the reflection. This stage helps students reflect on what they experienced in order to achieve the goals identified in Stage 1.

Regardless of the method of reflection, four key components will facilitate the ease with which they connect to and attribute meaning, helping them tap into feelings of empathy made possible by the experience. 1) Any reflection should call attention to *sensory experiences*, grounding students first in their bodies. Teachers should push for vivid depiction, whether through words, images, sound, or movement. Allowing for multisensory ways in which to relate the information will often assist students in processing their ideas. 2) The method should provide students the opportunity to describe *"aha" moments* that suggest integration and embodied meaning. They should also have permission to share if they didn't have any such moments. If that was the case, the method must provide a mechanism to assess why. Were there external factors affecting the experience, such as feeling ill, being afraid, worrying about what their friends would think, a crisis at home, etc.? Metacognition about how internal thoughts and worries affect their ability to relate to an activity increases self-awareness and perhaps even self-empathy. 3) Students should address how *being with their peers* enhanced or hindered the experience. Do they feel closer to their classmates? How? Why or why not? 4) Lastly, if relevant to the goals, students should have an opportunity to express if and how *they think, or feel, about the topic being*

studied, or the issue addressed, *as a result* of this experience. They will most likely need help fleshing out their thoughts and feelings, since this type of reflection is not something usually called upon in traditional learning situations.

Case Study: Putting Theory into Practice

In my role as principal and teacher at a new high school last year, I had the charge from the parents and broader community to facilitate the development of student empathy, in addition to implementing more traditional curricular aspects of the school's college preparatory curriculum. The unique charge stems in part from the school being rooted in Modern Orthodox Jewish values. This fact alone does not account for the mission, since other similar schools choose to focus on text-based skills to the exclusion of much else. What makes this situation conducive to empathy is the community emphasis not only on rigorous academics but also on creating caring, Torah-observant leaders. Within the structure of this directive, I had great freedom in designing the programs and methods to work towards attaining this goal. Working from my previous research and interests in enhancing students' empathy, caring, and positive identity development, I engaged in the four stages outlined above to begin to fulfill the mission.

Stage 1: Laying the Foundation

Realizing that I had four years in which to nurture the students to become the leaders that the parents and community desired, I stepped back and identified successive goals. The most critical step for this first year was to connect students to the bigger picture of the world. I wanted them to see how people's actions affect others in both positive and negative ways. I wanted students to gain exposure to both the wide variety of ways in which people dedicate their time and energy to helping effect change as well as to consequences that arise when people engage in behaviors that cause harm. I wanted to plan a variety of experiences that would help students feel what it is like to make a difference in the world, not just in a theoretical way through discussion but holistically, where they could actually feel the impact of people's commitment and dedication.

Assessment methods varied as I sought ways in which to enhance student metacognition about what it means to have empathy and to take action based on those feelings. Discussions during the moment, presentations to their peers and the broader community, journals, formal debriefing back in school, newspaper articles, and letters to themselves supported self-reflection and also allowed them to see that they had important insights to share and could begin

to take on leadership roles by informing their community on important issues. These methods revealed the fits and starts of feeling empathy and taking action, helping me and the rest of the faculty to identify next steps needed.

Stage 2: Brainstorming the Experiences

During this stage, I drew upon my own advice to enlist others to identify varied experiences that would help students begin to develop empathy. I clearly expressed my premise that multisensory aesthetic experiences must drive the planning and why. Enabling exciting possibilities to work from this premise is the unique mission of the school, which allocated funding for extended classroom experiences on a weekly basis, in addition to two six to ten-day trips in both the fall and spring. The longer trips are called immersions because the students study the area they will visit one week prior to the experience and then immerse themselves in the setting for 6–10 days. The narrative in Stage 3 focuses on specific experiences from the fall immersion.

My faculty and I brainstormed possible fall immersion opportunities. We asked ourselves: What locations and experiences would connect our students to different natural experiences? Where could we volunteer our time in varied and meaningful ways? What organizations would allow us to spend time with adults who dedicate their time and energy to care for others? We wanted an immersion that took students out into nature, something they rarely experienced, and included volunteer opportunities that pushed them out of their comfort zones. We connected with outside experts in our area, who have over 30 years of experience planning youth wilderness trips, and collaborated to develop a program that met our goals.

Stage 3: Embracing Multisensory Aesthetic Experiences

What follows is a description of one part of our fall immersion trip to southern Colorado. Three male students, two female students (all students were 14 years old), one male science teacher, one male volunteer, one female guide, and I, another female teacher, made up the traveling team.

The howling of wolves.

After driving for five-and-a-half hours, winding down switchback after switchback, snow-covered hills banking our way, the students exclaimed at something lying just off the side of the road. Our guide, having been to the wolf sanctuary before, felt comfortable driving over to take a look. Stretching their

legs and arms upon disembarking the car, the students ambled closer to the dark object. "Gross!" "Eew!!!" "What is that?" "It's a dead horse!" "How did it die?" "Why's it here?" Disgust eventually gave way to curiosity as the students bent closer to examine the flesh, bones, muscles, and teeth. The chaperones exhibited awe versus disgust, purposefully modeling for the students how to open themselves up to learning. The guide answered their questions, sharing that the wolves at the sanctuary had to eat fresh meat, and that ranchers in the area donated horses that had recently died. Rapid-fire questions about how the horses died, how volunteers slaughtered and selected what parts to feed the wolves, and how the remainder of the carcass was dealt with, shot forth from the students. They continued to move closer, talking about how cool it was that people fed and cared for the wolves and how the ranchers helped.

Their curiosity piqued, we continued to drive up a dirt road to get to the sanctuary. Dressed for the bitter cold, we stepped out to meet the wolves. "What's that sound?" "That's so cool!" "What is it?" "Let's go see!" The sound of 35 wolves howling across 30 acres of enclosures drew the students into the moment. They clamored to see the wolves, to meet them face to face. The first of many volunteers met us and went over safety precautions, sharing that they were for the wolves equally, if not more so, than for the humans. The wolves continued to howl, a soft eerie sound that reverberated in the air and in our bodies. Following the volunteer, students gathered bowls of food for the wolves and headed up the hill to a far enclosure. Along the way, the students met each wolf and heard the story of how it came to the sanctuary. Over and over they heard tales of humans drawn by the allure of wolves or wolf-dogs as pets, only to realize that wolves do not bend to human expectations.

Students each fed the wolves in turn, smiles extending across their faces. "I can't believe I'm feeding a wolf!" "She's so beautiful!" The volunteer continued to share stories about the wolves. The students expressed worry over wolves that had suffered physical damage and had visible scars, such as a missing eye or leg. They talked about how sad it was that the wolves had endured such hardships, and that humans callously tossed them aside. They began to ask questions about the wolves' habits, how the volunteers came to the sanctuary, and what they loved most about working with the animals. Safety rules prohibited petting the wolves through the fence, and the students asked hopefully if they would be allowed in an enclosure to interact more directly with the wolves. Patience had to reign as the sun began to set and we had to leave for the day. Anticipation of working more closely with the wolves the next day set in as we drove away.

The morning started cold but sunny, snow clouds far off to the west. The silent cold of morning highlighted the students' breath but could not inhibit their drive to help and interact with the wolves. The first task was to prepare food for the wolves. Some students recoiled from the smell of the raw meat that they combined with hard kibble. Others expressed surprise at having to add vitamins and oils to the dish, nodding appreciatively when they learned that being in captivity and having controlled access to food causes different stresses than wolves experience in the wild, making the supplements necessary. All of them worked diligently, anticipating the walk up to the enclosures where they would once again be near the wolves. Their faces beamed and quiet laughter (so as not to startle the wolves) expressed delight. Washing the dishes once the wolves finished eating caused several students to squirm, holding the sponges tentatively between their fingers, afraid to scrub away the remnants of meat. "This smells!" "This feels so gross!" "It's so disgusting!" These expressions provided an opportunity to talk about how important it is for the wolves to have clean dishes and how the volunteers perform this task several times a day. A feeling of appreciation and admiration for what the volunteers have to do permeated the conversation.

After a challenging hike with some of the volunteers, their dogs, and one of the wolf-dogs, the time had come for all of us to meet some of the wolves close up. We learned that wolves needed to encounter us as they would each other, nose-to-nose while calmly gazing into each other's eyes. We had to meet them on their terms, respectful of their ways of being. The students literally bounced with joy, while at the same time trying to keep their body motions and voices subdued to respect the wolves. Large, soft snowflakes began to fall from a bright gray sky, lightly blanketing the wolves' fur. Several wolves started to howl, followed by others, as the volunteers led us into one of the enclosures.

The first wolf came near as we sat on logs along the fence, waiting patiently to see if we'd be worthy of interaction. The students tried to follow instructions, but the urge to reach out, to pet the wolf, proved irresistible. The wolf shied away, its paws barely lighting down as it ran rapidly up the hill. Some of the students chided their peers for "ruining" the opportunity, and the volunteer drew upon wolf interactions to help them see how being negative hindered their relationships with each other and the wolves.

We stepped into another enclosure, the sun peeking through the clouds while snowflakes continued to flutter around us. The wolf-dog came close to one of the students; the student stayed calm, put his nose to the wolf's, and gazed intently into his eyes. Everyone else looked on with amazement, clasping hands over their mouths, eyes wide with wonder, trying to hold onto this precious moment. The young man petted the wolf; the wolf then continued to choose others with whom to interact. It was visibly difficult for the students to wait patiently for the wolf to make a choice; they each wanted an opportunity to interact.

The volunteer then presented the students with the opportunity to go one at a time against the fence to see if the wolf in the next enclosure would come up to them. Their words, pleading faces, and body language oozed the depth of their desire to interact with this more elusive wolf. When the wolf chose to be near them and be petted through the fence, they could scarcely contain their delight as they turned to face the rest of the group, cheeks aching from grinning so widely. They could not get enough and used words associated with pain when finally having to leave the enclosure.

That night, by the campfire, the founder of the sanctuary and its educational programs spoke to the students. The same respect afforded the wolves infused this encounter. Sitting around the bright orange, dancing flames of the fire, beneath a dark black sky filled with countless stars, the students listened with their whole bodies as he told them what wolves taught humans about how to live. They heard about how he had dedicated his life to combat misinforma-

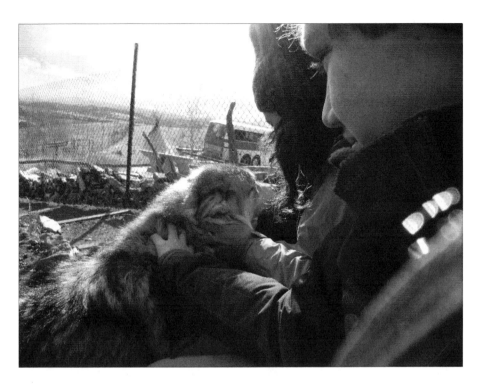

tion and create better lives for wolves. As if on cue, the wolves howled agreement with his words of wisdom. The students' chatter after leaving the wolf sanctuary focused solely on what they'd learned, how they felt, and how inspired they were by the work being done by the founder and volunteers. Again and again the students revisited the moment they stared into the eyes of one of the wolves and were able to touch and pet him.

Stage 4: Making Meaning—Identifying Empathy

The remainder of the immersion included further experiences in nature at a national park as well as time working for an organization that serves a large population of people who are needy or homeless, living in a rural farming community. Each of these encounters exposed the students to varied multisensory aesthetic situations that strengthened their budding empathy, expanding to include the natural world and people as well. Their experiences were as vivid as that described for the wolves. To bring meaning and clarity about how they were feeling as a result of these experiences, we debriefed each evening. On the way home, we stopped by a river to write letters to ourselves about what we'd learned,

how we felt, and how we had changed. We collected these letters, which remained private and were mailed back to each trip participant six months later.

To help students refine their awareness of how the experiences impacted them, they wrote reflection papers. To meet our goal of nurturing leadership, some of the students refashioned papers into newspaper articles. One article was published, and the outpouring of support and pride from the community overwhelmed not just that student but everyone at the school. To provide a sense of how the experience supported the development of empathy, I share the conclusion of his article:

> There are many types of inspiration and we experienced almost every one. The silent inspiration of marveling at the beauty of nature; feeling a connection to another creature, and seeing its strength and beauty; watching volunteers work tirelessly for others; feeling a powerful connection to G-d while thanking Him for the blessings that you have just begun to realize and appreciate; seeing people's resilience even in the hardest situation; and, for me, looking into the eyes of a nine-year-old who has experienced more hardship than anyone should ever have to in a lifetime and seeing her smile at me. That is inspiration.

Conclusion

Students need opportunities to engage with the world in physical and meaningful ways. Several of our students fought us every step of the way for not allowing technology, the young man who wrote the article being one of the most fervent in his protests. Students expressed feeling most frustrated by giving up their cell phones and constant access to friends not on the trip. They also stated initially that they could "not survive" without their computer games, something more easily overcome than the lack of cell phone access. Students did ultimately acknowledge truly enjoying their time talking with and getting to know each other, especially on the long car rides. Staying rooted and secure in our goals, we believed in the growth that would come from connecting them to others through sensuous experiences outside themselves, and the students rose to the occasion. More simple programs that facilitate multisensory aesthetic experiences can have a significant impact; programs such as the one described have the potential for even greater change. Regardless, establishing a commitment to developing student empathy provides hope and a path for growth and change. By setting goals and assessments (Stage 1), brainstorming about and planning multisensory aesthetic situations to attain these goals (Stage 2), help-

ing students embrace and get the most possible out of these situations (Stage 3), and setting up ways to debrief and process experiences to gain insights and meaning (Stage 4), we can help students in their development as empathetic, caring, and action-oriented individuals.

NOTES

Photographs in this chapter by Juli Kramer.
1. When referring to "others" in the remainder of the chapter, the broader conceptualization of the term is implied.
2. See, for example, http://www.grassrootsoccer.org/
3. During elementary school, many students go on at least one field trip a year. By middle and high school, they're lucky if they do so. Being in a classroom even one month, let alone year after year, without being in the field leads to uncertainty on one end of the spectrum, to wildness on the other.

REFERENCES

Brady, E. (2005). Sniffing and savoring: The aesthetics of smells and tastes. In A. Light and J. M. Smith (Eds.), *The aesthetics of everyday life* (pp. 177–193). New York, NY: Columbia University Press.

Csikszentmihalyi, M. (1996). *Creativity: Flow and the psychology of discovery and invention*. New York, NY: HarperCollins.

Csikszentmihalyi, M. (2003). Key issues in creativity and development. In R.K. Sawyer, V. John-Steiner, S. Moran, R.J. Sternberg, D.H. Feldman, J. Nakamura, & M. Csikszentmihalyi, *Creativity and development* (p. 223). New York, NY: Oxford University Press.

Decety, J. (2011a). Dissecting the neural mechanisms mediating empathy. *Emotion Review, 3*(1), 92–108.

Decety, J. (2011b). The neurorevolution of empathy. *Annals of the New York Academy of Science, 1231*, 35–45.

Dewey, J. (1934). *Art as experience*. New York, NY: Perigee.

Gallace, A., & Spence, C. (2009). The cognitive and neural correlates of tactile memory. *Psychology Bulletin, 135*(3), 380–406.

Greene, M. (1995). *Releasing the imagination*. San Francisco, CA: Jossey-Bass.

Iacoboni, M. (2009). Imitation, empathy, and mirror neurons. *Annual Review of Psychology, 60*, 653–670.

Korsmeyer, C. (1999). *Making sense of taste: Food and philosophy*. New York, NY: Cornell University Press.

Mar, R. (2011). Deconstructing empathy. *Emotion Review, 3*(1), 113–114.

Montero, B. (2006). Proprioception as an aesthetic sense. *The Journal of Aesthetics and Art Criticism, 6*(2), 231–242.

Moran, S., & John-Steiner, V. (2003). Creativity in the making: Vygotsky's contemporary contribution to the dialectic of development and creativity. In R.K. Sawyer, V. John-Steiner, S. Moran, R.J. Sternberg, D.H. Feldman, J. Nakamura, & M. Csikszentmihalyi, *Creativity and development* (pp. 61–90). New York, NY: Oxford University Press.

Phillips, H. (2004). Is empathy an animal quality? *New Scientist, 182*(2444), 15.

Pink, D. (2006). *A whole new mind: Why right-brainers will rule the future*. New York, NY: Penguin.

Reid, L.A. (2008). Aesthetics and education. *Research in Dance Education, 9*(3), 295–304.

Robinson, K. (2006). Do schools kill creativity? [Video]. Retrieved from http://www.ted.com/index.php/talks/ken_robinson_says_schools_kill_creativity.html

Smith, C.U.M. (2005). Evolutionary neurobiology and aesthetics. *Perspective in Biology and Medicine, 48*(1), 17–30.

Spinella, M. (2002). A relationship between smell identification and empathy. *International Journal of Neuroscience, 112*, 605–612.

Sternberg, R.J. (2003). The development of creativity as a decision-making process. In R.K. Sawyer, V. John-Steiner, S. Moran, R.J. Sternberg, D.H. Feldman, J. Nakamura, & M. Csikszentmihalyi, *Creativity and development* (pp. 91–138). New York, NY: Oxford University Press.

Willander, J.,& Larsson, M. (2007). Olfaction and emotion: The case of autobiographical memory. *Memory & Cognition, 35*(7), 1659–1663.

Yeshurun, Y., Lapid, H., Dudai, Y., & Sobel, N. (2009). The privileged brain representation of first olfactory associations. *Current Biology, 19*(21), 1869–1874.

· 1 1 ·

Earth Education

Interbeing and Empathy
for Mother Earth

Tom Anderson & Anniina Suominen Guyas

What's the Problem?

Arguably the biggest issue before humankind right now is environmental degradation (Hanh, 2008; Kahn, 2010; Louv, 2011, 2008; Speth, 2008). There are hundreds of dead zones on land and at sea. Climate change is causing some of the most extreme weather on record in the form of droughts, hurricanes, heat, floods, and more. The oceans are rising due to polar ice melt and may flood entire countries. There is very little debate about these things. We know intellectually they are true. Still, we humans are very slow to change our ways; slow to reduce our consumption, re-use our material goods, or recycle what can't be reused. Somehow we cannot integrate and actually use the information that we desperately need to reduce our production of greenhouse gases or all is lost. We intellectually grasp the issues as they present themselves, but it seems that we don't really *feel* the full import of the crisis. We suggest in this chapter feelingful disconnection—lack of empathy—is a core issue in addressing climate change and environmental degradation. After making that case we explore solutions for feelingfully engaging the Earth and the ecosystems that sustain us, through art and education, toward the goal of ecological balance.

Reflection: Anniina

I wake up smelling smoke.
Controlled fires: the season has begun.
A sensual spell cast in late summer in the sweaty armpit of Florida,
A sensory fusion of heat and humidity in ever-changing compositions.
It's time. Early morning.
The windows are open.
How I have waited for it to be cool enough to smell outside.
Humidity of the night still mists my skin.
Mist turns to sweat as hot air—the blaze of a rising sun—erupts across my face
and arms. I am simultaneously cold and sweating, like a fever.
It's toad and frog mating season.
Their loud ritual continues night after night.
A few unfortunates fall into the pool and their bodies harden as chlorine
swells them up. Like rubber duckies they float lifeless until I pick them up.
Cicadas' voices begin to fade as the birds take over: a symphony so complex and
layered that at first my ears only pick out the high key solos.
Still tasting my morning coffee, my consciousness starts to meld with place. I begin
to float with the rising and fading interludes into a meditative space only acces-
sible in attunement to my surroundings. Body rhythms, heartbeat, breathing, feel-
ings and meaning emerge from the relationality of my existence.

Tom's Story

As with many people my age, I spent many of the free days of my childhood
lost in contented wandering, outside, in the natural world. I remember being
about five years old, wandering down the path at a camp in Idaho, just look-
ing at things that caught my eye. Feeling someone looking at me, I turned and
saw a lynx watching me through the brush. We made eye contact and held it
for a few brief seconds. Then we both got scared and ran in opposite directions.
I didn't have the words to describe it at that time, but I knew I had encoun-
tered a fellow sentient being.

I also remember being in junior high school, wandering from my home in
Great Falls through town to the Missouri River. I'd clamber down the cliffs
below the dam and follow the river, looking at rocks, scrub pines, wondering
who made the little path (probably the Indians, I guessed, or maybe deer, or
maybe it was even wolves!). I really had no agenda: no goal but to just wan-
der. Often I would end up at Giant Springs, which flows out at the river's edge,

and which supports a different set of flora and fauna than the actual river. That fascinated me. I'd sit and look into the water at the fish and the plants, all the way through the clear water to the bottom. Then I'd gaze out at the mighty Missouri, at the cliffs on the other side, and wonder how I could get across the river and see what was there. Or, I'd watch the white pelicans who made a permanent home on this spot of river, which was kept from freezing in the winter by the cold spring water. I wondered about that too. Sometimes I'd wade into the spring if it was a particularly warm day. I was literally enchanted by the natural world around me. I drew inspiration and solace from it. When I got hungry or when it got dark, I'd wander back up the path along the cliffs and through town to my home, sometimes eight or ten hours after I'd first gone out the door. My mom might ask what I'd been doing. "Nothing much," I'd say. I didn't think to tell her I'd been playing in the holy water.

I don't think wading in Giant Springs was illicit at the time, but I went back a few years ago and the manicured park, the paved parking area, and the "no wading" signs made it abundantly clear that the rules had changed. I looked for my old path along the cliffs and couldn't find it, but I did find a Lewis and Clark exhibition and information center. The railroad tracks along the river are now a bike path. Not that I object to Great Falls dressing up its assets. But given all these prescribed activities—upgrades—it was interesting to me that I was one of the few people there. And none of the others was a kid.

I Can't Hear You! (Fingers in Our Ears)

Research indicates that most kids don't now have the kind of undirected experience with nature Tom had (Louv, 2011; 2008). As a culture, our emotional and psychological separation from nature is widening and deepening. We aren't even looking at how to get to the banks across the river. And that's a problem. It may be, in fact, that the world is increasingly out of balance precisely because we are out of touch with it (Anderson & Suominen Guyas, in press; Wilson, 1998). It's not like nature isn't trying to tell us that we are abusing her; we're getting plenty of warnings. Species are disappearing a thousand times faster than before the industrial revolution (Kahn, 2010), and, in fact, 40 percent of all the species on Earth became extinct between 1970 and 2000 according to a United Nations survey (Speth, 2008)! MIT professor Stephen Meyer (Speth, 2008) believes this species die-out is of such a magnitude as to set the course of life on Earth for the next several million years. And natural disasters are being reported with ever-greater frequency and intensity. Events

such as Hurricane Kate, which destroyed the United States Gulf Coast in 1985, the 2009 wildfires in Australia and California, and the 2011 heat wave in North America, are thought by many to be the result of an Earth out of balance, trying to adjust itself (Gibson, 2009). Earth is talking to us. She's telling us that our dominance of her is "an evolutionary dead end. It will kill us" (Casey, 1998, p. 115). But we're not listening. We seem to have little or no empathy for the Earth's or our own self-inflicted wounds.

Nature, Relationship, and Empathy

The *Encarta World English Dictionary* (2011) identifies empathy as "the ability to identify with and understand another person's feelings or difficulties" (n.p.). We note this definition restricts empathy only to people. That's a narrow focus and a critical gap if we are to feelingfully address the larger biosphere in which we live. Focusing only on people ignores our critically important relationships with nature, implicitly relegating the rest of sentient (and non-sentient) life to the status object, not subject. It's an attitude built into our very language, the language that speaks to us and defines us (Lacan, 1968). The Strunk and White style handbook (2000), for example, suggests that animals other than us be referred to as "it" rather than the emotionally closer "he" or "she." The spellchecker on our computers suggested that we use the word "that" instead of "who" in referring to the pelicans in Tom's story above. These and many other linguistic conventions objectify, distance, and make our fellow sentient beings more distant and less significant than *Homo sapiens*.

Because contemporary culture discourages feelingful relationships for the Earth, we are largely disconnected from the natural world and therefore from the biosphere—the web of plants and animals and rocks and air and water and earth—that sustains us. We have objectified the earth's bounty as merely resources called beef, veal, timber, and minerals, not sentient beings and ecosystems with souls and a right to exist. And with objectification, since trees and calves and oil are simply products, we need have little concern for ethics or empathy in our relations with them. The relationship is I-it, not I-thou (Buber, 1970). In short, we can treat the Earth badly because we don't feel badly about doing so. We feel we are privileged to have dominion and do as we please.

This disconnection is relatively new in the two-million-year history of people. It really took hold only in the time of the industrial revolution a couple of hundred years ago (Jackson, 1994). Before the modern era most people in

most cultures had the sort of integral consciousness (McIntosh, 2007) in which they took for granted that they were embedded in cultures and their cultures were embedded in a sense of place. The natural evolutionary connection to the living world was a natural part of consciousness (Wilson, 1998). To have any chance to halt the current environmental degradation, people have to get that connection to their place—to the Earth—back again.

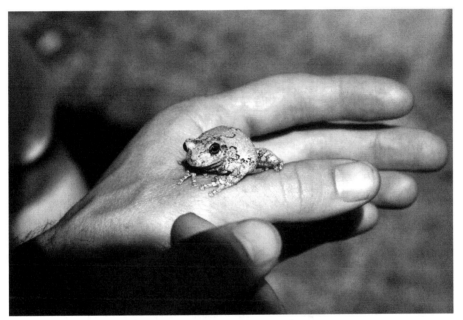

Photo by Anniina Suominen Guyas

The New Paradigm

We believe a fundamental feelingful, embodied reconnection must be made with the Earth, and at the heart of this reconnection must be empathetic connection to the other living beings on the planet. As Louv (2011) put it, "in the twenty-first century, our survival—or thrival—will require a transformative framework for that relationship, a reunion of humans with the rest of nature" (p. 3), a framework in which we have empathy not only for other human beings, but for all sentient beings and for the larger biosphere that supports us all. We are proposing in this context an alternative cultural archetype of empathetic interbeing (Hanh, 2008), further suggesting that art, as the consummate instrument of values transmission in human culture (R. Anderson, 2008;

Dissanayake, 2000), and art education are primary tools for this paradigm shift since they are "primary levers of social progress" (McIntosh, 2007, p. 1).

To address the problem of environmental degradation through art and education, we suggest a paradigm shift from a predominantly intellectual, individualist, dualistic orientation to a connectively oriented sense of *self-realization* (Naess, 2008) *as interbeing* (Hanh, 2008) that is *within*, not above, outside of, or separate from, place, community, and the greater interconnected biosphere of planet Earth (Anderson & Suominen Guyas, in press).[1] Reflecting the philosophical stance called *deep ecology* (Devall & Sessions, 1985; Ecology Journal, 2008; Milton, 2002; Naess, 2008; Sessions, 1995), we question an anthropomorphic view of being that centers on humans and positions them over everything and everyone else and instead propose a model embracing humankind as an integral part of the larger web of life. Aligning ourselves with an increasing number of artists, scientists, sociologists, educators, cultural researchers, and economists, we promote a pedagogical approach built on the recognition that to counteract environmental injustice we need to take action against global techno-capitalism and begin to acknowledge the interconnectedness of social justice and environmental issues (Bookchin, 2005; Kahn, 2010; Orr, 2009; Shiva, 2005; Speth, 2008; Weil, 2004). Employing an environmentalist E*arth* Education perspective, we advocate deep ecology and the paradigm of interbeing as a praxis-based philosophy for developing an individual and extended sense of place, which may serve as a foundation for reconnecting us and achieving a sense of balance with the natural environment.

We also believe a prime cause of environmental degradation is capitalism and its culture of overconsumption (Anderson & Suominen Guyas, in press). Psychologists tell us that material goods do not guarantee happiness beyond a certain, very moderate level (Leonard, 2010; Louv, 2011, 2008), but we continue to consume amounts inordinate with our needs. Research indicates that such consumption is engaged due in large part to corporate advertising interests preying on our egos, insecurities, hopes, and fears (Speth, 2008). We are substituting material goods for spiritual wellbeing. So if overconsumption isn't making us happy and is in fact endangering the biosphere, we need to define a new non-consumptive paradigm of wellbeing that would benefit both people and the Earth.

The new paradigm requires decentering the current consumerist *to-have* model, replacing it with a *to-be or being* model of wellbeing, which sees the value of life as central, reciprocity (between living systems and beings) as key, and a commitment to future generations of all species as inherent. And in the *being* model, ethics trumps technology, in that we should consider first what values

inhere in making the bomb or stripping the mountaintop for its coal; that is, we should not make the bomb just because we can (de Silva, 1990; Hanh, 2008; Weil, 2004), but empathetically should consider the ramifications, not just for ourselves but for the whole living Earth.

The new paradigm would be non-acquisitive/non-consumerist and non-hierarchical. It would focus on our close and extended relationships, our sense of self, of place, and of community (Anderson & Milbrandt, 2005). It would engender a deep understanding of what it means to *belong*: individually, communally, and environmentally (hooks, 2009). Such a paradigm would see all life as sacred and interrelated, not simply as resources to be exploited (Henning, 2002). It would be Earth-based and relational, as opposed to detached, objective, and metaphysical (Hanh, 2008; Jackson, 1994; Kahn, 2010; Weil, 2004). It would recognize that we belong to the Earth, rather than it belonging to us (Halifax, 1990). It would recognize self-actualization and searching for connectedness as valid research and ideally would result in conscious love and care for the planet (Milton, 2002; Sardello, 2001). This stance, which rests firmly on an empathetic relationship to all of life, is called *interbeing* (Hanh, 2008).

Interbeing

Abram (1996) suggested: "Humans are tuned for relationship. The eyes, the skin, the tongue, ears, and nostrils—are all gates where our body receives the nourishment of otherness" (Abram, 1996, p. ix), and argued in this context that "direct sensuous reality…[is] the solid touchstone for an experiential world" (p. 10). He asserted that the Western separation of body and soul has separated us from this direct connection to the experiential world, so having lost our intimate body-and-spirit connection to the rest of the living Earth, we frame it as "Other," outside of us, beyond us, not us. And yet there are breakthroughs that show us we are one with other beings.

Wandering in a field following the death of her sister, Louise Erdrich's (2005) character, Faye, reflects:

> Perception saved me. I saw that the spiders were just substance. Not bad, not good. We were all made of the same stuff. I saw how we spurted out of creation in different shapes. How for a time I would inhabit this shape but then I'd be the lace on my sister's shoe.…I saw the endless exchanging of shapes. The grass growing all around me, now, would one day be the cow, the milk, the flesh of the calf, then me. (p. 94)

Faye found her way, at least temporarily, to interbeing. Likewise Anniina, after being separated from her connection with the Earth by the cultural conventions of well-meaning adults, explained her reconnection through mark-making, through art. She said:

> with renewed energy and relief, unguarded, I restored the more familiar and original relationship I once experienced daily with my surroundings. The layered, fantastical, spirited, animate environment that once was so vividly part of who I was, so alive in me, resurfaced on those markings and in my speech. I was taught to believe that my imagination was too lively and intense for reality and I was repeatedly encouraged to learn to control them. So I shied away from the shadows of the animated world until years later when the connection was rekindled through my camera. Forests, fields, water, especially with embedded shadows and darkness still continue to animate, structure, and justify my thinking, experiences, and feelings. Captured in my speech, writing, and art, they frame my existence in the complexity inaccessible to pure intellect. In this open, limitless sense of time, space, place, that I find a sense of self in my photography. For a moment I am attuned to the sensibilities of my body that attend to the patterns of my surroundings in ways that are never the same, never exactly repeated and only exist in the complex, temporal, and corporeal relationality. One might consider this experience a momentary access to life-world, an awareness not limited by language and logic.

Anniina's experience, too, is interbeing. Interbeing centers the Earth Education model of art education that we describe later in this chapter. In Earth Education we seek a "reenchantment with nature and…a balanced relationship with it" (Barry, 1999, p. 17). We promote the idea of human beings as a part of the larger web of life. We foster an understanding that no one is above or beyond the natural world, and that we all (microbes, algae, giraffes, pelicans, people) have an intrinsic right to our place in the system.

Interbeing suggests we are all one (de Silva, 1990; Hanh, 2008; Henning 2002). Collectively, we—all living things—are the life force of the planet. Framed this way, interbeing requires a collective shift of consciousness in which the self is fully realized, not through consuming, but through transpersonal relationships (Naess, 2008). We are of nature, having evolved on Earth, and it is in our nature to be in relationship to the ecosystems that shape us (Lane, 2009). Our brains, eyes, lungs, our ability to run, eat, and think, as well as our emotions, have co-evolved with the "physical regularities and principles of the physical world" (Levitin, 2008, p. 146). We are, naturally, in a state of interbeing with the natural world.

Manatees Embracing. Wakulla Springs, Florida. Photo by Tom Anderson

Pollan's (2002) useful example of this is how we have been and continue to be engaged in an ancient co-evolutionary relationship with plants. Pollan described how plants attract us with their beauty and sweetness, and intoxicate us, to serve their own ends of propagation and continuity. From a plant's-eye view, he suggested that the flower introduced beauty to the world as an evolutionary survival strategy, that the flower cultivates us, not vice versa, as do marijuana, grapes, and tobacco. From a plant's-eye view, human consciousness, which people see as being an advanced feature of being, is merely a tool plants use for their own purposes. Such species as corn and wheat and rice, as well as dogs, cats, horses, and many other species, have "linked their destinies" to our own through "complex reciprocal relationships" (Pollan, 2002, p. xvi) and their success and ours are irrevocably tied. This intrinsic reciprocity between plants and human beings is a sort of inter-consciousness.

Interbeing relies totally on recognizing and instituting our feelingful consciousness of being within the larger web of life. Lane (2009) defined "consciousness as the awareness of self embedded in the world" (p. 234) He argued that consciousness depends on *recognizing our feelings* (a computer or a robot in this sense are not conscious). He made the case that emotions are more powerful for what we know and do than intellect and are actually the foundation

of our intellect. So we are not conscious until we feel and know our feelings. "Consciousness, then, is...a map of how feelings relate to the world: a map that drapes our perceptions with values" (p. 245). So feelings come from our experience in the world, and it is in that context that they have meaning and give direction to future experience. They are a survival strategy, a code that has developed over millions of years, and we ignore them at our own peril—especially, we would argue, our feelings of alienation from nature. These feelings (that have evolved in nature, and that, if we are sensitive to nature, connect us to it) are trying to tell us something very important.

Support for this conception comes from E. O. Wilson (1984), who developed a theory called *Biophilia*, borrowing a term first used by psychologist Erich Fromm, referring to love of life or living systems. Wilson used the term to describe people's biologically rooted desire to connect with the rest of life, which is a product of our evolution in the larger context of all life. Our current *exemptionalist* (Wilson, 1998) culture exists apart from and has dominion over the natural world. That culture believes in the idea of (technological) progress, regrets the loss of habitat and species, but sees it as the price of progress. A second *naturalist* position, which Wilson sees as the correct stance, exists in a primate's body that is biologically adapted to a razor thin, finely balanced biosphere, who has huge emotional and intellectual potential, and is "easily shut down by trace toxins and transit of pea-sized projectiles, [is] short-lived and emotionally fragile, dependent in body and mind on other earthbound organisms...[and] is starting to regret deeply the loss of Nature and all those other species" (p. 305).

Recognizing our naturalist position on the Earth is in a very real sense *coming home*. This entails not piecemeal changes but systemic changes in economics (particularly in reining in the currently almost totally unconstrained capitalist economy), philosophy, ethics, as well as the arts and sciences (Wilson, 1998). Stand-by schemes, such as developing algae farms for fuel or planting fast-growing nitrogen-fixing trees, are only prosthetics and will only enable our current inappropriate use of the Earth's resources leading to collapse, because the fundamental problems of economics and overpopulations have not been addressed. According to Wilson, "the only way to save [the biosphere] with existing knowledge is to maintain its natural ecosystems" (p. 324). In this way we save both the Earth and ourselves. Wilson called this *consilience*.

Given the critical state of the environment, given how important are people's emotional and spiritual connections to nature, and given that interbeing has been our natural state of being until recently, it would seem that there would be no question about our recentering the natural Earth in our lives. But that

just isn't happening. Earlier in this chapter we suggested the reason we aren't reconnecting is that we understand the issue intellectually but are just not feeling it. Feelingfully engaging things that count is the realm of the arts.

The Role of the Arts and Ritual in Constructing Belief

In her novel *The Painted Drum*, Erdrich (2005) described the drum as "the universe" (p. 42) and continued, saying:

> The people who take their place at each side represent the spirits who sit at the four directions. A painted drum, especially, is considered a living thing and must be fed as the spirits are fed, with tobacco and a glass of water set nearby, sometimes a plate of food. A drum is never to be placed on the ground, or left alone, and it is always to be covered with a blanket or a quilt. Drums are known to cure and known to kill. They become one with their keeper. They are made for serious reasons by people who dream the details of their construction. No two are alike but every drum is related to every other drum. They speak to one another and give their songs to humans. (pp. 42–43)

That drum the author describes is from the Ojibwe people, but they are hardly alone in ascribing essential power to the arts. The Navajo people believe that through aesthetic rituals called *sings* they balance the universe (R. Anderson, 2008). West Africans create abundant harvests by dancing and singing while wearing special clothing and accoutrements (Thompson, 1984). Inuit hunters convince the whale to give up his/her life for them to live because of the power they invest in carved whale figurines (R. Anderson, 2008). Catholics, wearing special robes while engaged in a baptism ritual, are doused in sacred waters from a baptismal fountain, to become one with the son of God. These and a multitude of other examples illustrate how the arts in the context of ritual center and confirm human beings and their cultures.

Facilitating feelingful understanding, objectifying subjective experience and giving it form so we can understand it (Langer, 1980), and personifying our values, embodying our human spirit: those are the roles of the arts. As Casey (1998) put it, there's a world of difference between having an insight and giving it power. She said, "We only possess the power of insight when we give it expression....Knowledge is converted to power through artful, ritualistic expression" (p. 118). In short, it is through the arts that we give power to our insights.

Dissanayake (2000, 1988) has described the bioevolutionary role of the arts in human culture as being one that helps us recognize and integrate the val-

ues, viewpoints, and mores we hold in common through their integration into rituals that bind us in our beliefs. One of the most important ways human beings affirm what is important to them is through ritual (Dissanayake, 2000). Certainly, for many thousands of years—maybe even a million or more—people have engaged in rituals to confirm belief. Innumerable examples are still in practice today: Kwanzaa, Christmas, Ramadan, the Gelede festival, Labor Day, Halloween, even the January white sale, the spring fashion shows in Paris and New York, and many more. The mutuality that allows us to function collectively (Dissanayake, 2000, 1988), that defines our success as a species, depends on these symbolic activities for mutual confirmation.

The arts are intrinsic to these rituals. Through ritualized, elaborated, skillfully rendered form, they create special forms that cause us to pay attention, making the values referenced by the forms also special. Examples include special songs (hymns and chants and even *Sweet Home Alabama*) and dances—from polkas to ballet—ritual clothing (yarmulkes, cowry beads), visual symbols (yin/yang, gang tattoos, crosses, and swastikas), and artifacts (menorahs, stained-glass windows, and Tibetan sand mandalas). Arts-embedded rituals work on us at both a conscious and a deep level, and the meanings of ritual are integrated deeply since the unconscious cannot tell the difference between a real act and a symbolic one. This manner of human functioning makes the symbolic act very literally real in meaning and significance. It is in this context of the power of symbol and ritual that we suggest a role for art and art education in reconnecting to an empathetic vision of human beings as an integral part of the biosphere of a living Earth. And in using the arts as an instrument to reconnect with nature we look to nature itself as a guide.

In that context, Wilson (1998) suggested the arts "might be understood [through] knowledge of the biologically evolved epigenetic rules that guide them" (p. 233), rules that rise from natural selection in a "biotically rich environment" (p. 243). Thus they attend to the "universal traits that unite humanity" (p. 234). He argued that metaphor is the primary tool of creative thought in this framing of human knowing, from which archetypes of belief arise. He believes, with Dissanayake (2000, 1988), that in this way the arts foster the things we value and believe in. Further, Wilson argued that these values, mores, ways of being and doing, arise from our human nature, which has evolved for millions of years in the larger natural environment. The lesson in this, we believe, is to look to our natural selves in seeking principles and practices for an art education that seeks to reconnect us with the natural world. These are principles and practices we have articulated in the paradigm we call Earth Education.

Ea*rt*h Education:
Art and Ritual for the Living Earth

Elsewhere (Anderson and Suominen Guyas, in press), we have articulated a set of principles that focus on a paradigm we call Ea*rt*h Education.[2] In the remainder of this chapter we explore those principles of Ea*rt*h Education most directly related to art and ritual that support an empathetic relationship centered on interbeing on the Earth. It is important to understand that, in referring to ritual, we are including the informal, the small, the casual, the intimate, as well as full-blown social and cultural events. What we mean by ritual is a conscious and deliberate way of seeing, being, and valuing that contributes to a new or renewed understanding of our place on the Earth.

Ea*rt*h Education principle one, *awakening the senses and radical amazement*, suggests a number of implied ritual attitudes and activities. To become in touch with the world and promote understanding through awareness, we suggest meditation, mindfully watching snails and flowers, listening to rain or waves, and creating art based on senses other than vision. Careful observational drawing in nature is an excellent way to slow students down and get them to really look and wonder. Visual and written journals are another strategy, focusing students on a place of solace, a place to be preserved, or a local animal or plant. Another activity is Miksang photography (Society for Contemplative Photography, 2010), with its attention to vivid, non-conceptual experiencing.

Principle two, *positive emotional investment*, is both a product of, and a means of, promoting radical amazement and opening of the senses to the wonders of the natural world. Attention to the ordinary makes it extraordinary and cultivates the key emotion of empathy. And because empathy is about relationship, we cannot be happy when we desecrate the environment or hurt our fellow sentient beings. Thus, centering emotions and emotional bonding are vital in helping learners to connect to their environments and cultures, and ultimately, to transform or realign their thinking, meaning, and values (Louv, 2008; Mantere, 1995; Noddings, 2005; van Boeckel, 2010, 2009). So, engaging emotions, we focus on the wonder, power, complexity, color, subtlety, and interdependency of nature, in addition to acknowledging environmental problems. Instead of numbing our senses and imaginations by focusing on the negative effects we have wrought on the planet, we choose to frame interbeing through art as a positive experience, because fear does not foster love and care.

Principle three, *embodying our experience*, is critical to re-engaging our relationship with the natural world. hooks (1994) argued that in essence all

knowing is embodied, that we feel and know with our bodies. Playing with sand and other materials, wondering and walking with and without purpose, and engaging in physical work, are activities that support immediate and embodied experiencing and knowing, as is making art (Jokela, 2008; 2007; Neperud, 2007). Immediate experiencing, being open to its unpredictability, and incorporating sensual knowing, are key to reestablishing body knowledge as a valid form of knowing.

Principle four, *working with metaphors*, is critical in seeking to construct and institute a paradigm shift toward an Earth-centered understanding of being. If we want to promote a paradigm other than the current materialist, Earth-dominating archetype, we must integrate new metaphors. Tied to this idea is principle five, in which we seek to *connect critical awareness and emotion with actions*. When students address ecological issues intellectually, we want them to also address the challenges of social inequality and misuse of power, and ultimately to be moved to do something about it.

Although all the principles support the project of Earth Education, perhaps principle six, *relational learning—recontextualizing self as interbeing*, is most important for addressing the topic of developing empathy in our relations with the Earth. Humans gain a sense of purpose, belonging, and fulfillment through developing loving, caring, respectful, non-manipulative, non-acquisitive relationships with each other. But beyond human affairs these same types of relationships must be fostered with other sentient beings and the larger world. Not simply magnanimous or altruistic, such expanded relations are necessary to Earth Education and literally to self-preservation through preservation of the rest of the living world.

This sense of self as interdependent is what we mean by interbeing. Implicit in the notion of interbeing is the understanding that self-realization cannot be attained through heightened attention to the individual ego but must be achieved in relationship with other people, species, living organisms, and even with water, rocks, wind, and earth. We believe that interactive ritual with other human beings and with the forces of nature is a particularly effective strategy to develop this sense of interbeing; so we suggest people engage in collaborative and relational processes/projects with other artists and nonartists in the context of the natural world (Boldon, 2008; Bourriaud, 2002; The Green Museum, 2011; Jokela, 2008). Examples are Andy Goldsworthy, who works with rivers, tides, wind, and time, and Joseph Beuys, who planted 700 oak trees in Kassel, Germany.

Dissanayake (1988), hooks (2009), and Lippard (1998) all noted the impact of their childhood landscapes and geography on their evolving sense of belong-

ing and on their notions of humanity, knowledge, and scholarship. Such activity in art education entails collaboration between students, teachers, and community members in the largest sense. Helping learners return to key memories through art-based activity and to reconstruct them from a current relational perspective can enable new realizations about their relationships with the environment and with each other. Likewise, students are likely to find such connections in activities that promote conversation, sharing, journaling, and co-creation.

Interbeing promotes *place-based epistemology*, which is principle seven. Place-based epistemology acknowledges the environment as central to understanding one's place in the world (Anderson & Milbrandt, 2005). Attention to the specificity of place supports a sense of kinship, emotional bonding, empathy, and revitalized perception (Jokela, 2007). Lippard (1998) suggested that the lure of the local rises from our knowledge of it, thus our attachment to it.

All the other principles are animated and put into practice, of course, *using art knowledge and skills as a model for understanding nature*, which is principle eight. Not just an activity, art is an embodied way of doing and being that can engage us deeply and fully. As such, it potentially embodies deep relationships through one's senses, emotional investment, and prolonged engagement with materials within context and environment. Earth Education practitioners must experience and understand examples of artists engaging in the paradigm of interbeing and deep ecology, and be immersed into the relationship between the artists and their work as well as the emergent nature of that work. Figuring out "what the work needs or wants" (Boldon, 2008, p. 2) engages the sort of animated/lifeful relationship with the work and can serve as a model that extends to our work in the world. Boldon also addressed contemporary society's careless relationship with objects, suggesting that working with found objects can revitalize our relationship with rubbish that results from human consumption. Moreover, the way the artist merges with, and emerges out of, her/his work may serve as a model for how empathy and deep connection can bridge the gulf between us and the environment. In the same vein, Finno-Uric mythology has a strong animistic/shamanistic (Jokela, 2007) component that evokes an awareness of the natural world, and Walter De Maria's *The Lightening Field* is another example of the animation of the natural world through art. Students should study these and other examples as paradigms for their own such engagement to understand that through animating our art we can better understand an animated world.

Finally, principle nine suggests that *pedagogy be built on connectedness and engagement*. This requires that Earth Education—that is, interbeing toward deep ecology through the arts—is naturally interdisciplinary and socially and

politically engaged in nature as epistemology and pedagogy, interdisciplinary, and engaged in the guiding question: What is my instrumental relationship to this sub-ject/phenomenon/action? The answers we seek are political as well as aesthetic, instrumental in addition to beauty-based, remembering that the traditional social role of the arts has been to embody and remind us of those things that count in keeping us alive and keeping us centered in our lives in the real world.

Conclusion

"The great work of the twenty-first century will be to reconnect to the natural world as a source of meaning" (Louv, 2011, p. 245). It's a simple choice, whether we do this or not, but it has monumental consequences. Species that lose touch with their environment die—pure and simple. So re-establishing our relationship to the natural world is not just nice; it's necessary. Scholars and researchers from multiple disciplines have argued that emotions (empathy, the propensity for mutuality, and indeed the capacity to love) are innate in human beings (Dissanayake, 2000; Lane, 2009) and that these capacities have evolved with us as survival strategies (Dissanayake, 2000, 1988; Wilson, 1998). The arts and empathy then seem to be innately connected, both in their ori-gins and in human expression, at least in relation to other human beings.

But what about the greater realm of sentient beings and non-sentient exis-tences? What about the larger web of life? Do human beings have the capac-ity or inclination to emotionally connect with the larger world around us? We believe we do, but that our sense of connection has been dulled by cultural par-adigms that distance us from nature. We have argued here that it is the arts that connect us feelingfully to each other and the larger issues in society. And we suggest that it is the arts and art education that can lead us, through conscious, feelingful engagement, through artful ritual, to empathy with all sentient beings and the larger web of life. We believe this empathetic understanding is necessary for re-establishing balance in life on Earth.

NOTES

1. Some passages in this chapter are largely unchanged from a paper in press (Anderson & Suominen Guyas), called "Earth Education, Interbeing, and Deep Ecology," in *Studies in Art Education*.
2. These principles and practices are considerably more elaborated on in Anderson and Suominen Guyas (in press).

REFERENCES

Abram, D. (1996). *The spell of the sensuous: Perception and language in more-than-human world*. New York, NY: Vintage Books.

Anderson, R. (2008). *Calliope's sisters*. Upper Saddle River, NJ: Prentice Hall.

Anderson, T., & Milbrandt, M. (2005). *Art for life: Authentic instruction in art*. New York, NY: McGraw-Hill.

Anderson, T., & Suominen Guyas, A. (in press). Earth education, interbeing and deep ecology. *Studies in Art Education*.

Barry, J. (1999). *Rethinking green politics*. New York, NY: Routledge.

Boldon, A. (2008). Climate change—an aesthetic crisis? *Taidelehti*, 2, 1–8. Retrieved from http://www.naturearteducation.org/Articles/Climate%20Change%20An%20Aesthetic%20 Crisis.pdf

Bookchin, M. (2005). *The ecology of freedom: The emergence and dissolution of hierarchy*. Oakland, CA: AK Press.

Bourriaud, N. (2002). *Relational aesthetics*. Paris, France: Presses du reel.

Buber, M. (1970). *I and thou*. New York, NY: Touchstone Books.

Casey, C. (1998). *Making the gods work for you: The astrological language of the psyche*. New York, NY: Harmony.

de Silva, P. (1990). Buddhist environmental ethics. In A. Badiner (Ed.), *Dharma Gaia: A harvest of essays in Buddhism and ecology* (pp. 14–19). Berkeley, CA: Parallax Press.

Devall, B., & Sessions, G. (1985). *Deep ecology*. Layton, UT: Gibbs Smith.

Dissanayake, E. (1988). *What is art for?* Seattle, WA: University of Washington Press.

Dissanayake, E. (2000). *Art and intimacy: How the arts began*. Seattle, WA: University of Washington Press.

Ecology Journal. (n.d.). *Definition of deep ecology*. Retrieved from http://www.ecofirms.org/journal/definition-of-deep-ecology/

Encarta World English Dictionary. (2011). Retrieved from http://en.wikipedia.org/wiki/Encarta_Webster's_Dictionary

Erdrich, L. (2005). *The painted drum*. New York, NY: HarperCollins.

Gibson, W. (2009). *A reenchanted world: The quest for a new kinship with nature*. New York, NY: Metropolitan/Henry Holt and Company.

Green Museum (2011). Retrieved from http://greenmuseum.org/

Halifax, J. (1990). The third body: Buddhism, shamanism, and deep ecology. In A. Badiner (Ed.), *Dharma Gaia: A harvest of essays in Buddhism and ecology* (pp. 20–38). Berkeley, CA: Parallax Press.

Hanh, T. N. (2008). *The world we have: A Buddhist approach to peace and ecology*. Berkeley, CA: Parallax Press.

Henning, D. (2002). *Buddhism and deep ecology*. Bloomington, IN: Daniel H. Henning and 1st Books.

hooks, b. (1994). *Teaching to transgress: Education as the practice of freedom*. New York: Routledge.

hooks, b. (2009). *Belonging: A culture of place*. New York, NY: Routledge.

Jackson, W. (1994). *Becoming native to this place*. Lexington, KY: University Press of Kentucky.

Jokela, T. (2007). Close to nature: Marks of the forest. Retrieved from http://www.environmentalart.net/natur/close_to_natur.htm

Jokela, T. (2008). Wanderer in the landscape—reflections on the relationship between art and the northern environment. Retrieved from http://www.natureartteducation.org

Kahn, R. (2010). Critical pedagogy, ecoliteracy, and planetary crisis: The ecopedagogy movement. New York, NY: Peter Lang.

Lacan, J. (1968). The language of the self: The function of language in psychoanalysis. Baltimore, MD: The Johns Hopkins University Press.

Lane, N. (2009). Life ascending: Ten great inventions of evolution. New York, NY: Norton.

Langer. S. (1980). Philosophy in a new key. Cambridge, MA: Harvard University Press.

Leonard, A. (2010). The story of stuff. London, England: Constable.

Levitin, D. (2008). The world in six songs: How the musical brain created human nature. New York, NY: Plume/Penguin.

Lippard, L. (1998). The lure of the local. New York, NY: The New Press.

Louv, R. (2008). Last child in the woods: Saving our children from nature-deficit disorder. Chapel Hill, NC: Algonquin Books.

Louv, R. (2011). The nature principle: Human restoration and the end of nature-deficit disorder. Chapel Hill, NC: Algonquin Books.

Mantere, M-H. (Ed.).(1995). Maan kuva: Kirjoituksia taiteeseen perustuvasta ympäristökasvatuksesta [Images of the earth: Writing on art-based environmental education]. Helsinki, Finland: University of Art and Design Helsinki.

McIntosh, S. (2007). Integral consciousness and the future of evolution. St. Paul, MN: Paragon House.

Milton, K. (2002). Loving nature: Towards an ecology of emotion. New York, NY: Routledge.

Naess, A. (2008). In A. Drengson & B. Devall (Eds.),The ecology of wisdom: Writings by Arne Naess. Berkeley, CA: Counterpoint.

Neperud, R. (2007). Personal journey into participatory aesthetics of farming. Studies in Art Education, 48(4), 416–423.

Noddings, N. (2005). Caring in education.The encyclopedia of informal education. Retrieved from http://www.infed.org/biblio/noddings_caring_in_education.htm

Orr, D. (2009). Down to the wire: Confronting climate collapse. New York, NY: Oxford University Press.

Pollan, M. (2002). The botany of desire: A plant's-eye view of the world. New York, NY: Random House.

Sardello, R. (2001). Love and the world: A guide to conscious soul practice. Great Barrington, MA: Lindisfarne Books.

Sessions, G. (Ed.) (1995). Deep ecology for the twenty-first century. Boston. MA: Shambhala.

Shiva, V. (2005). Earth democracy justice, sustainability, and peace. Boston, MA: South End Press.

Society for Contemplative Photography. (2010). Miksang photography. Retrieved from http://www.miksang.org/m/index.html

Speth, J. (2008). The bridge at the edge of the world: Capitalism, the environment, and crossing from crisis to sustainability. New Haven, CT: Yale University Press.

Strunk, W., & White E. (2000). The elements of style (4th ed.). New York, NY: Pearson Longman.

Thompson, R. (1984) Flash of the spirit. New York, NY: Random House.

van Boeckel, J. (2009). Arts-based environmental education and the ecological crisis: Between opening the senses and coping with psychic numbing. In B. Drillsma-Milgron & L. Kristinä (Eds.), *Metamorphoses in children's literature and culture* (pp. 145–164). Turku, Finland: Enostone. Retrieved from www.naturearteducation.org

van Boeckel, J. (2010). Forget your botany: Developing children's sensibility to nature through arts-based environmental education. *The International Journal of the Arts in Society, 1*(5), 71–82.

Weil, Z. (2004). *The power and promise of humane education.* Gabriola Island, Canada: New Society Publishers.

Wilson, E. O. (1984). *Biophilia.* Cambridge, MA: Harvard University Press.

Wilson, E.O. (1998). *Consilience: The unity of knowledge.* New York, NY: Vintage.

· 1 2 ·

Cultivating the Social Imagination of Preservice Teachers Through Aesthetic Reflection

Tracie Costantino

The need to prepare teachers for diverse classrooms is well documented, including the importance of giving preservice teachers opportunities to work with diverse populations prior to entering the classroom (Hollins & Torres Guzman, 2005). These preservice experiences can help teachers to form empathic relationships with the students they will encounter in the diverse classrooms prevalent in public schools in the United States. Empathic relationships foster teachers' understanding of students' lives so that they can develop relevant curriculum and instructional strategies and address individual learning needs. This chapter explores the role aesthetic reflection might play in cultivating empathy in preservice art teachers through practicum experiences with diverse populations.

Maxine Greene (1988, 1995) has written extensively on how experiences in and through the arts can stimulate the imagination to provide "openings" for thinking of what might be. Greene has explained, "One of the reasons I have come to concentrate on imagination as a means through which we can assemble a coherent world is that imagination is what, above all, makes empathy possible" (1995, p. 3). Her idea of the social imagination, "the capacity to invent visions of what should be and what might be in our deficient society" (p. 5) focuses on using the arts as entry points for dialogues that cultivate a pluralism that is the foundation of democratic communities. Through the

empathic relationships constructed via aesthetic experience, schools and classrooms can become communities in which students may imagine the open possibilities of their lives, and both teachers and students may embrace the diverse perspectives and experiences of those they may consider "other."

How, then, might we prepare teachers to release their imaginations to engage with diverse student populations, so that they may nurture the social imaginations of their students? In this chapter, I will share the aesthetic reflections of preservice art teachers, created in response to practicum experiences in middle schools. These aesthetic reflections take the form of visual journal entries and a pre- and post-visual response assignment. Overall, they suggest the potential value of using aesthetic reflection as a means of gaining insight into preservice teachers' developing professional identity and preparedness for the diverse classrooms of contemporary schools.

What Is Aesthetic Reflection?

I define aesthetic reflection[1] as the shaping of media into form with the explicit intention to represent or convey reflective meaning. In the context of teacher preparation, the reflection is focused on practice, including developing a professional identity, knowledge of students, curriculum, and so forth. It is aesthetically constructed reflection on reflection-in-action (Schön, 1983/1991, 1987), which Schön defined as "thinking about what we are doing" while we are doing it (1983/1991, p. 54). He elaborated:

> There is some puzzling, or troubling, or interesting phenomenon with which the individual is trying to deal. As he [sic] tries to make sense of it, he also reflects on the understandings which have been implicit in his action, understandings which he surfaces, criticizes, restructures, and embodies in further action. (p. 50)

In aesthetic reflection, preservice teachers are representing in aesthetic form the awareness, tension, questions, and/or insight that was gained through reflection in a present state of action, as in an art classroom during a practicum experience. In the examples presented here, the aesthetic media are visual and primarily two-dimensional, with images often incorporating text, but aesthetic reflection may be practiced in any arts form.

Marrying the concepts of aesthetics and reflection is especially appropriate for art teacher preparation as it encourages preservice art teachers to think and express themselves in a modality (i.e., visual) they are comfortable with while challenging themselves to reflect, or think metacognitively, on their

newly developing knowledge of teaching and students. While the practice of reflection through aesthetic form may be considered synonymous with the fundamental art-making process, in this case the intention is explicitly reflective, as opposed to an implicit or subconscious reflection on an artist's experiences. Additionally, as with any work of art, the value of aesthetic reflection is the potential insight that may be gained by the artist/preservice teacher and the viewer/instructor. As Gadamer (2000) asserted, "Our experience of the aesthetic too is a mode of self-understanding. Self-understanding always occurs through understanding something other than the self, and includes the unity and integrity of the other" (p. 97).

The interrelationality of Gadamer's (2000) concept of the aesthetic occurs on multiple levels in this context of teacher preparation. There is the preservice teacher's engagement in aesthetic reflection for self-understanding, the preservice teacher's understanding of the other—in this case the middle school student as well as the cooperating teacher being observed—and the course instructor's engagement in the preservice teacher's product of aesthetic reflection that gives insight into his or her self-understanding and professional growth. Through the actual experience of aesthetic reflection, empathy may be cultivated in this interrelational understanding.

Thinking in Aesthetic Reflection

While text may be incorporated in the product of aesthetic reflection, in this context the modality was primarily visual (it could be, for example, aural or kinesthetic in other arts forms) with the practitioner engaged primarily in qualitative thought, or what Root-Bernstein and Root-Bernstein (1999) described as the metalogic of creative insight that is preverbal and pre-mathematical. Dewey (1934) described qualitative thought in art as thinking in terms of the relation of form and matter within a qualitative whole. Dewey's concept of aesthetic experience in the process of making art, as conceptualized within qualitative thought, is especially insightful for the kind of thinking that may occur in the context of an art lesson during a practicum experience, where a preservice teacher may be directly engaged with a student on a project. For example, Dewey wrote, "the ultimate cause of the union of form and matter in experience is the intimate relation of undergoing and doing in interaction of a live creature with the world of nature and man [sic]" (p. 132). The emphasis on interaction in experience is especially relevant here, and the kind of insight that may be gained from this interaction, or aesthetic experience, can be brought forward through visual translation in the form of aesthetic reflection.

Dewey (1930) emphasized the importance of acknowledging the situated-ness of qualitative thought, as embedded in experience, in his essay devoted to explicating qualitative thought:

> The special point made is that the selective determination and relation of objects in thought is controlled by reference to a situation—to that which is constituted by a per-vasive and internally integrating quality, so that failure to acknowledge the situation leaves, in the end, the logical force of objects and their relations inexplicable. (p. 246)

This quote implies the importance of reflection in acknowledging the signifi-cance of a situation. Dewey explained that qualitative thought is an associa-tive process in which significant relationships are intuitively grasped in an experience; "the immediate existence of quality, and of dominant and perva-sive quality, is the background, the point of departure, and the regulative prin-ciple of all thinking" (p. 261). Upon reflection, this qualitative thinking forms connections that may be analogic, metaphoric, or propositional.

Dewey described artistic thinking as an exemplar of qualitative thought. "The logic of artistic construction and esthetic appreciation is peculiarly signif-icant because they exemplify in accentuated and purified form the control of selection of detail and of mode of relation, or integration, by a qualitative whole" (1930/1984, p. 251). Dewey recognized the role of qualitative thought for both the artist and viewer, which applies to the relational quality of my development of the concept of aesthetic reflection in this teacher preparation context. The preservice art teacher is engaged in qualitative thought as she or he recognizes some qualitative whole in a student's work, and in her or his own aesthetic reflec-tion. The course instructor does so as well, in seeking to understand the mean-ing conveyed through the preservice art teacher's aesthetic reflection.

Explained in terms of professional reflective practice, Schön's (1983/1991) "puzzling, or troubling, or interesting phenomenon" (p. 50) is recognized via qualitative thought. The preservice art teacher seeks to understand that phe-nomenon through reflection-in-action while in the classroom during the practicum experience, and later through the process of aesthetic reflection, reflecting on the classroom experience. The qualitative thought of artistic practice can foster the analogic, relational thinking that may help the preser-vice teacher understand his or her perspectives, values, actions, and relations with others, especially in a teaching context.

The intuitive grasp of understanding of qualitative thought may be further distinguished and articulated in symbolic language as the preservice art teacher engaged in aesthetic reflection may form visual metaphors and/or incorporate

verbal elements to expand upon his or her intended meaning. As Dewey (1930) explained, "The pervasive quality is differentiated while at the same time these differentiations are connected. The result is an explicit statement of proposition" (p. 261).

This connective process of qualitative thought to reflection and distinction relates to Eisner's conceptualization of different forms of representation. Eisner wrote in *Cognition and Curriculum, Reconsidered* (1994) of the importance of providing learners with different forms of representation through which they may communicate meaning. According to Eisner, "forms of representation are the devices that humans use to make public conceptions that are privately held....This public status might take the form of words, pictures, music, mathematics, dance, and the like" (p. 39). He asserted that different forms of representation have constraints and affordances that influence not only the communication of meaning but the conceptualization of it as well. In this way, aesthetic reflection serves as a form of representation for preservice art teachers to conceptualize and communicate meaning with certain affordances, such as an aesthetic mode of reflection on reflection-in-action described above. By giving their reflections public status, the preservice art teachers are sharing their developing professional identity as well as connecting to their peers engaged in a similar process. Indeed, the sharing of aesthetic reflections in a teacher preparation classroom can cultivate an empathic community of reflection that can provide support for preservice art teachers' developing confidence in creating a shared respectful artistic community in their future classrooms.

The Interrelationality of Aesthetic Reflection—Cultivating Social Imagination

Gadamer's (2000) epistemology of aesthetic experience asserts that the knowledge gained from a work of art is one of insight into the self in relation to the socio-historic context in which one is situated. In other words, developing meaning through one's encounter with a work of art helps the viewer come to know something about him or herself in relation to the human world they inhabit. Through this self-knowledge one may be more open to encounter others and relate to them with more understanding, or empathy. In recapping what was outlined above, my premise is that within a professional practice context, the reflective aspect of aesthetic experience (i.e., Dewey, 1934), through the process of aesthetic reflection, may help a preservice art teacher gain the self-knowledge that will give them insight into others' life experiences, thereby

helping them become better teachers. For Gadamer asserted that the insight gained through aesthetic experience is transformative; I contend that through the process of aesthetic reflection on practice, preservice teachers may be transformed in their thinking about what it means to teach.

For Greene (1995), who builds on Gadamer in addition to Dewey, understanding what it means to teach may be especially cultivated through experiences with the arts. While Greene has emphasized the transformative quality of aesthetic experience in dialogue with works of art, encouraging teachers to share art with their students as a means of releasing their imaginations of what might be, she also addresses the potential for art-making to cultivate the social imagination and create an "in-between" space where community may be built. "In thinking of community, we need to emphasize the process words: making, creating, weaving, saying, and the like" (p. 39). Indeed, Greene called for a merging of the pedagogies of art education and aesthetic education so that students and teachers are engaged in both the making and seeing of possibility:

> I would like to see one pedagogy feeding into the other: the pedagogy that empowers students to create informing the pedagogy that empowers them to attend (and, perhaps, to appreciate) and vice versa. I would like to see both pedagogies carried on with a sense of *both learner and teacher* [emphasis added] as seeker and questioner…reflective about his or her choosing process, turning toward the clearing that might (or might not) lie ahead. (p. 138)

It is my hope that through aesthetic reflection, the preservice art teacher will both seek and question her actions, values, and intentions in relation to those of her students for the cultivation of those in-between spaces of empathetic community.

Context for Aesthetic Reflection

The examples of aesthetic reflection I am sharing in this chapter were produced over two semesters of a course to prepare art teachers for the middle and high school levels. Within this course, students observe and assist in local middle and high schools (in both urban and rural settings) over a period of six weeks. Most of the schools at which they observe have a significant percentage of low-income students, and a culturally diverse population consisting primarily of African American, Latino/Hispanic, and White students (the demographics vary by school with a higher percentage of African American and Latino/Hispanic students in urban schools and more White and Latino/Hispanic students in rural schools).

Throughout the course, students are asked to keep a visual journal, which combines the visual focus of a sketchbook with the reflective writing function of a journal.[2] In my experience, students in art teacher preparation have visual-dominant visual journals, with text incorporated strategically but not as the main modality. I use the visual journal in the course both as a mechanism for reflection for the students and to model strategies for using the visual journal at the secondary level. The visual journal has recently been made an explicit requirement where I teach, in the state art performance standards for the middle and high school levels, with its application in what I have identified as four main areas (see Figure 1).

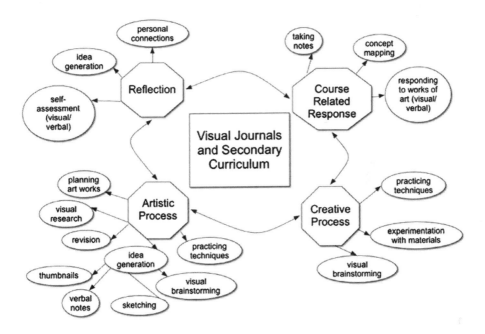

Figure 1. Description of four main pedagogical and curricular functions of the visual journal in secondary curriculum. Source: author.

In the secondary curriculum as reflected in the state performance standards, middle and high school students are asked to use the visual journal as a place for personal reflection and self-assessment, for idea generation and revision in the artistic process, for experimentation with materials and techniques and visual brainstorming as a part of the creative process, and for responding to course-related assignments. As can be seen in the above diagram, these four

areas are related and mutually informing, with individual visual journal entries often reflecting one or more of these different uses. In the teacher preparation course, students are typically engaged in the reflection and course-related response functions, although I expect that their responses will reflect the creative process. In the curricula they develop, however, preservice art teachers are incorporating all four functions into their lesson plans.

In the teacher preparation course, in addition to an open-ended, unstructured, reflective use of the visual journal inside and outside of class time, I give students specific content-related prompts to respond to as well as ask them to create a visual journal entry for each of their observations at the middle and high schools they visit. Responses to both the course-related prompts and the observation prompts reflect the students' developing professional identity as teachers, but it is in the responses to their observations, their aesthetic reflections on reflection-in-action, that suggestions of their developing empathy for students are present.

In addition to the visual journals, at the beginning and end of each semester I ask students to complete pre- and post-visual responses to the prompt: "create a representation of your perception of the middle/high school student. On the back of this sheet, make a list of adjectives describing the student." Students complete a separate pre/post prompt for the middle and high school student. They may use any two-dimensional media in their visual response. After completing their post-response at the end of the semester, I ask students to compare their pre- and post-responses and to write about whether, and how, their perceptions of the secondary student may have changed.

In reviewing students' visual journals and pre-post responses at the close of each semester, I started to see evidence of empathy in some of their responses. Not everyone exhibited empathy for the students they worked with in their aesthetic reflections, but many preservice teachers did, providing a powerful window for me, their instructor, into their developing value system as teachers.

I should preface the discussion of these aesthetic reflections with the caveat that this is not a formal research study, but a preliminary exploration of teaching and learning practice, with preservice art teachers' aesthetic reflections giving me an opportunity to reflect upon their learning. Still, it may be helpful to theorize briefly the analytic process I used, however instinctual it was. In examining the students' aesthetic reflections I took the stance similar to that of a viewer of art, taking in the whole of an image, then focusing on component parts and then back out again to reassess the whole, a process of qualitative thinking as described by Dewey.[3] In this chapter I focus on the preservice teachers' aesthetic reflections on middle school students. I begin with the pre- and post-visual responses.

Pre- and Post-Visual Responses: Perceptions of the Middle School Student

Generally, the pre-responses indicated that the preservice art teachers expected middle school students to be mostly concerned with their social life and their outward appearance. Preservice teachers often collaged symbols from visual culture that represented a focus on physical appearances (e.g., fashion, make up) and positioned figures within social situations (e.g., an adolescent boy and girl together). On the post-responses, many preservice teachers realized that while middle school students are concerned with their appearance and status within a social group, they also care about doing well in school and are more intellectually capable than first expected. As a result, the post-visual responses often included some visual symbols related to learning or intellectual curiosity. For example, see the post-response in Figure 2.

The preservice teacher who created these responses wrote for her reflection, "I thought that middle school students were closer to children than adults, but really they are smarter and more mature than I thought. They are deep, complex, insightful, and full of attitude." While the middle school student projects an attitude that may seem less than scholarly, this is a façade they present for their peers; for their teachers they want to be recognized as learners with potential.

This was a second significant trend in responses, that is, the awareness of the teacher's role in challenging students; while the student may not appear interested, it is the teacher's job to challenge and engage students. A preservice teacher explained this in her reflection on her pre- and post-responses: "[On my pre-response I showed that] students were in that transitioning stage of beginning to be able to develop higher thinking. However, on my second I wrote that we as teachers need to prompt them to develop that thinking."

Relatedly, the preservice teachers also realized that middle school students are more vulnerable than they present themselves and that it is important for a teacher to recognize this. For example, in the post-response after the field experience, a preservice teacher drew a male middle school student weighted down by his cry for help and flanked by signs describing characteristics that are external and seen on the left, such as apathetic, cocky, and young, and those that are hidden but influencing student behavior on the right, such as searching, scared to fail, and scared to try. Along the bottom of the composition the preservice teacher wrote in the student's voice, "I need to be accepted." This kind of understanding can help the teacher develop curriculum and instructional strategies that will not directly challenge these outward representations but instead foster occasions for success that will build the student's confidence.

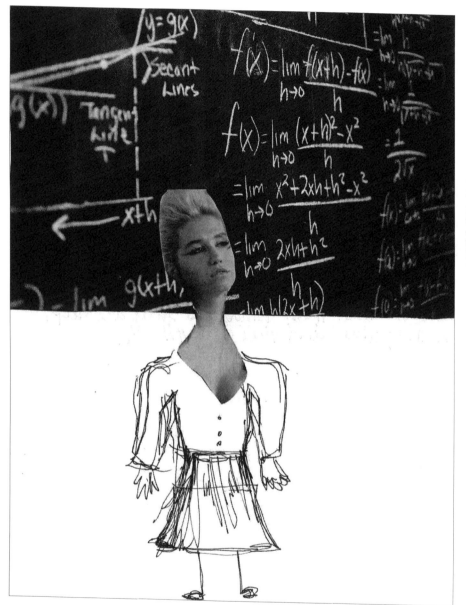

Figure 2. Post-response.

Visual Journals

An actual classroom example of how the preservice teachers raised their awareness of the capabilities of middle school students was discussed in course reflections and represented in several preservice teachers' visual journal entries on their field experience observations. One particular observation of a sixth grade class stood out. The cooperating teacher had designed an integrated lesson in collaboration with the science teacher. In science, the students were studying the layers of the earth. In response, the art teacher asked students to make a nonobjective painting metaphorically representing their inner layers using color to symbolize different characteristics. The art teacher opened each class by asking a few students to talk about their intentions in creating their painting. The preservice teachers were struck by how articulate the sixth grade students were in describing their artistic choices and generally in their ability to think metaphorically. One entry connected this awareness to knowledge of students as learners, which is a standard in the National Art Education Association's Professional Standards for Visual Arts Educators. This also reflects the preservice teacher's realization of the kind of curriculum that can engage students to employ higher-order thinking, relating back to a theme from the pre/post-responses in which preservice teachers recognized their critical role in developing challenging learning opportunities for students. Figure 3 is a predominantly visual reflection on the same observation by a different preservice teacher. In this case, the undergraduate student inserts her awareness, symbolized by the eye, into the metaphoric layers of the observation experience.

The visual journal responses from field experience observations were especially insightful from the spring 2011 semester, as the students had a more intensive practicum experience than students from the fall 2011 semester. The spring 2011 students spent four sessions visiting a local middle school, working directly with students in an art classroom during hour-long classes. As opposed to the usual field experience observations where students may hover around the classroom and interact with students intermittently as opportunity presents itself, or depending on how the cooperating teacher may encourage or facilitate student interaction, in this intensive practicum the preservice teachers sat with middle school students at their tables, usually in a ratio of one preservice teacher to two or three middle school students. This close interaction forced the preservice teachers to be responsive to students' learning needs as they supported the cooperating teacher's instruction.

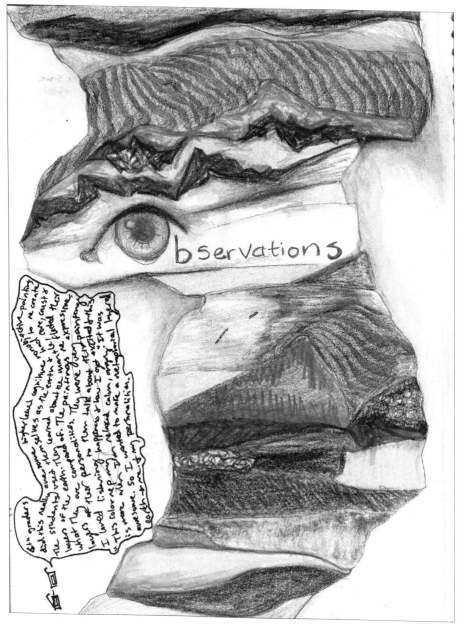

Figure 3. Visual journal entry reflecting on sixth grade students' cognitive abilities.

In the seventh grade, students were learning how to draw realistically following a step-by-step process working on facial proportions. In some instances this was a frustrating exercise for students as they struggled to achieve the required proportions the teacher was demonstrating for an eye, ear, nose, and mouth. It was also a tense situation for some preservice teachers as they struggled to ease the students' frustration and help them successfully complete the drawing assignment. This visual journal entry (Figure 4) conveys some of the dynamic.

Figure 4. Visual journal entry reflecting on observation of seventh grade class.

That the preservice teacher chose to overlay the assigned drawing task on examples of faces from art history as well as modern photography may imply different things. It could emphasize the tradition of portraiture and importance of learning how to draw realistically in art education pedagogy over the centuries, or it could be a critique of the assignment as the anonymous lifeless face of the drawing task is in stark contrast to the nuanced representations of faces in the print examples. Indeed, some preservice teachers wondered why the middle school students were required to draw the same-shaped facial features instead of drawing from observation of real faces (their own or their peers').[4] This preservice teacher leaves the interpretation open as she records the comments made by students at her table in relation to the assignment ("I can't do it!" and

"I need to work on my nose"); in relation to art class and school ("I don't like art. I like PE. I like lunch"); and in relation to the instructional discourse of the teacher ("Is the proportion right? Are all of the features in the right place?").

The visual journals also cultivated my empathy for the preservice teachers in this intensive practicum experience. For example, there was one preservice teacher who did not seem to take initiative in working with the students at her table, sitting somewhat passively as the students worked on their drawings. Her visual journal entries, however, revealed to me how nervous she was with this age group and how her efforts to interact with the students had not initially been met with success, but as the practicum continued her entries chronicled the progress she felt she was making, with her final entry depicting a smiling figure next to a check box of achievements, including making a connection with a student, and feeling accomplished by the last day of the practicum. With this quiet preservice teacher, her visual journal entries gave me a window into her experience and helped me to better understand and appreciate her perspectives on the practicum.

Cultivating empathy was not an explicit objective for this course or even an explicit priority for me as I taught the course, but upon reflection I have realized that empathy was an implied and assumed mechanism I operated under as I mentored students through their field experiences. My awareness of the power of empathy as revealed through the preservice teachers' aesthetic reflections came to me as a viewer of their work, and as a result, is something I now bring into the classroom and curriculum more clearly as I ask preservice teachers to consider deeply the lives of the students they will teach.

Conclusion

The U.S. National Art Education Association Professional Standards for Visual Arts Educators include Knowledge of Students as Learners as the second out of 13 standards. The aesthetic reflections of preservice art teachers from the two semesters discussed above helped me to assess how the preservice teachers were gaining an understanding of the middle school student so that they could better prepare relevant curriculum and instructional strategies. I was pleased to see that the preservice teachers learned to have higher expectations of this age group, realizing that the middle school student is not solely focused on social issues but is interested in learning and is capable of higher-order thinking as with the sixth graders who could articulate their artistic choices and represent metaphoric thinking in their artwork. This is especially significant since these

observations occurred in urban and rural classrooms with predominantly low-income and racially diverse student populations. With this knowledge of the potentialities of their students, teachers may provide educational experiences through art that may release the imaginations of their students for what may be. Indeed, the social imagination of these preservice teachers was released through their field experiences with diverse student populations and the opportunity to aesthetically reflect on these experiences and through their aesthetic reflections I was given passage into their flight.

NOTES

1. My use of the term differs from that of Immanuel Kant in his *Critique of Judgment*, in that I am concerned with the reflection that occurs in the process of visual response focused on professional practice, while Kant was referring to the contemplation of aesthetic objects.
2. There is a growing body of literature on the visual journal in art education. For example, Dias and Grauer (2005) and Grauer and Naths (1998).
3. In addition, there are numerous approaches to interpretation that might be cited here, especially in relation to translating the insight gained from qualitative thinking into propositional meaning. For example, Terry Barrett's (2002) book *Interpreting Art: Reflecting, Wondering, and Responding* has been influential on my analysis of students' visual responses.
4. Another benefit of this intensive practicum is that the preservice teachers had more interaction with the cooperating teacher, so that they could ask about her curricular choices. In this case, the teacher explained that she was scaffolding students' skills so that they can move from this exercise to a gridded portrait in the next grade. The cooperating teacher also recognized that middle school students often equate being good at art with being able to draw realistically. Her intention was to give them skills to build their confidence in drawing.

REFERENCES

Barrett. T. (2002). *Interpreting Art: Reflecting, wondering and responding.* New York, NY: McGraw-Hill.
Dewey, J. (1934). *Art as experience.* New York, NY: Penguin Putnam.
Dewey, J. (1984). Qualitative thought. In J. Boydston (Ed.), *John Dewey: The later works, v. 5* (pp. 243–262). Carbondale and Edwardsville, IL: Southern Illinois University Press. (Original work published 1930)
Dias, B., & Grauer, K. (2005). Visual thinking journal. In K. Grauer & R. Irwin (Eds.), *Starting with…*(2nd ed.). Toronto, Canada: Canadian Society for Education through Art.
Eisner, E. W. (1994). *Cognition and curriculum reconsidered* (2nd ed.). New York, NY: Teachers College Press.
Gadamer, H-G. (2000). *Truth and method* (2nd ed., Rev.). (J. Weinsheimer & D. G. Marshall, Trans.). New York, NY: Continuum. (Original work published 1960)
Grauer, K., & Naths, A. (1998). The visual journal in context. *Journal of the Canadian Society for Education Through Art, 29*(1), 14–18.

Greene, M. (1988). *The dialectic of freedom*. New York, NY: Teachers College Press.

Greene, M. (1995). *Releasing the imagination: Essays on education, the arts, and social change*. San Francisco, CA: Jossey-Bass.

Hollins, E. R., & Torres Guzman, M. (2005). Research on preparing teachers for diverse populations. In M. Cochran-Smith & K. M. Zeichner (Eds.), *Studying teacher education: The report of the AERA Panel on Research and Teacher Education* (pp. 477–548). Mahwah, NJ: Lawrence Erlbaum.

Root-Bernstein, R. S., & Root-Bernstein, M. (1999). *Sparks of genius: The thirteen thinking tools of the world's most creative people*. Boston, MA: Houghton Mifflin.

Schön, D. A. (1983/1991). *The reflective practitioner: How professionals think in action*. New York, NY: Basic Books.

Schön, D. A. (1987). *Educating the reflective practitioner: Toward a new design for teaching and learning in the professions*. San Francisco, CA: Jossey-Bass.

· 1 3 ·

Teaching What We Value

Care *as an* Outcome *of* Aesthetic Education

LAUREN PHILLIPS & RICHARD SIEGESMUND

In this chapter, we, an elementary-level art specialist and a higher education professor, seek to present the complexity of framing care as an aesthetic objective within a visual art curriculum. We do this in two parts. We begin with a discussion of the curricular theory and policy of teaching aesthetics to promote forms of caring by students. Then, in the second half of the chapter, Lauren, the elementary art specialist, reflects directly on her own specific lesson in which she negotiated teaching care with her students. In this chapter, we want to be forthright about the challenges of teaching to care to both the classroom teacher and the students. This is not always easy. Framing aesthetics as care changes how we think of the content of the visual arts classroom. By seeking to engage our students in transformational curriculum, we transform ourselves.

In education, it is common to think of curriculum and pedagogy as binary, where the stable and hard-content knowledge of a discipline represents curriculum (effect) and the pedagogical delivery of curriculum is active and soft (affect). Love and care are not words that are normally associated with curricular objectives or the big ideas from which we are to develop our curricula through a process of backwards design. If care appears in the vocabulary of teachers, it is normally evoked as a necessary pedagogical affect for the effective delivery of

curriculum. In this model, the tough business of school is taught sensitively. We teach the hard discipline-based content *with* care, thus, perhaps, softening some of the hard edges of schools. Framing teaching as transmitting knowledge from textbook to the student's brain is a robust and enduring notion in education that comes from a metaphor of school as serious business.

We reject this paradigm. This binary is based on a transmittal model of education, where the teacher—the possessor of content—delivers knowledge into the empty vessel of the student. The student's ability to mimetically reproduce the content knowledge of the teacher is evidence of learning.

Instead, we suggest the following question as appropriate for framing curriculum: What forms of knowing are necessary for acting effectively? Here, we assert that acting effectively is to act with care and empathy. Thus, we frame care as the hard business of school, which needs delivery through a sensitive pedagogy. In our view, care is the core content and chief educational objective of our discipline. We select from the skills and knowledge of our discipline (e.g., technical skills, art history, and critical analysis) to reach our objective of care: to be in conscious reciprocal relationship with another while attending to—as stated by the New Oxford American Dictionary—"what is necessary for the health, welfare, maintenance and protection of someone or something" (Stevenson & Lindberg, 2010, p. 263).

The capacity to care is rooted in empathy: "the ability to understand and share the feelings of another." Teaching students to be empathetic is an explicit educational objective of the visual arts. Empathy is more than an affective pedagogical tool that assists good teaching or a charming student attribute that is an ancillary outcome of instruction. Care and empathy are principal educational goals of the discipline of aesthetics.

Values Versus Standards

Teach what you love and let your children see that love is a motivational exhortation to help preservice visual art teachers find their own curricular pathway. In the visual arts, it is possible to talk about teaching to one's passions because, as it is taught in the United States, the discipline lacks uniform high-stakes assessment that dictates the content knowledge that students must demonstrate at the end of the school term. The absence of predetermined accountability measures for art teachers opens the door to the creation of personal, individualized curricula.

However, teaching what we love may not be as easy or self-evident as it sounds. First, the pressures on any individual school to meet mandated standardized test scores now imposed by the United States federal government is

so overwhelming that increasingly art teachers find themselves having to demonstrate how they are contributing to their school's required curriculum goals. This can range from pressure to devote more class time to talking and writing about art (in support of literacy agendas) to requirements that a certain amount of instructional time be given to scripted Language Arts and Mathematics curriculum divorced entirely from any pretense of an integrated arts lesson. Second, the arts themselves, in a quest for greater legitimacy, have, for the last 20 years, pushed for internal standards to which arts teachers must adhere. There are now recommended national standards for all arts teachers to follow. Individual state standards, and in some cases, local district standards for arts instruction complement these national standards. Thus, as standards-based curricula continue to ascend within the visual arts classroom, the ability to teach what you love may prove elusive. Standards trump values. There are too many demands on the teacher to be doing something else.

Furthermore, while the preservice art specialist may be inspired when spurred to teach what s/he loves, it is not readily apparent how love aligns with the push for classroom assessment and measurable actions by students that demonstrate attainment of learning goals. How do your students show you that they have seen and understood the love that you are supposedly demonstrating? What would children need to do for you, as an objective educator, in order for you to render an assessment of their learning? Perhaps, manifestations of qualities of love could include concern, care, and attention for the well-being of another animate or inanimate entity. In what other specific ways could they show their own authentic engagement with an idea?

Here we suggest that it may be possible to frame our values in the language of standards. At the core of exhortation to teach what you love and to show that love, is a statement of values. What follows from advocating teaching what we love, is the implicit suggestion that love is what we teach. We argue that we can forthrightly state care and empathy (operational aspects of love) as our educational objectives. In turn, this brings the realization that as art educators we should be less concerned with making beautiful things and more concerned about how the making of beautiful things enables us to demonstrate concern, care, and attention for the well-being of another thing or object.

Students develop these skills by engaging in learning on five different levels. First, students come to care for the visual media and tools they touch and manipulate. Second, a care of self emerges through the students' realization that their manipulation of visual media says something about who they are. Third, cooperative actions to help classmates and the teacher through both deeds and

words demonstrate a care of others. Fourth, a care of school can manifest as a care of place as students understand how they have worked together to a common end. Fifth, students will be able to build on these foundations to understand how care is important to the larger communities in which they live.

In our teaching, we model these values to our students in the hope that they will see them and try them on for themselves. We do not transfer knowledge. We ask our students to consider incorporating these values into their individual autobiographies of who they are. The goal of our teaching is less about the acquisition of the skills and knowledge content of our discipline and more about transformational learning using the tools of our discipline.

What we state here is not a radical new theory for teaching art. In our view, our art curriculum is one that teachers have used for years. However, in the past these values have been the implicit curriculum. Aesthetics, as a philosophy of care and responsible choice, allows these values to be openly stated as the explicit curriculum. It is time to do so.

Care Is Content, Not Pedagogy

Feminist approaches in education call for care to not simply be a pedagogical effect but instead the focus of teaching. This approach finds its roots in the curriculum theory of John Dewey, who argued that education was more than a place where knowledge and skills were transmitted. Schools were laboratories where cultural values were instilled and nurtured. Yet for that to happen, for care to transcend pedagogy and become curriculum, Noddings argued that a core discipline has to step forward and claim care as fundamental to its content. Today, care still needs to be embraced by a discipline as the content it teaches.

The historical development of aesthetics allows visual art to claim the teaching of care as core to its discipline. Art education, as practiced in K-12 schools, is not about training artists. It is not about making every child an artist. Art education is not artistic education. We agree with the Enlightenment philosopher Friedrich Schiller as well as contemporary arts educator Ellen Dissanayake, that core knowledge of human aesthetic practice centers on creating forms of being-in-relationship. In this view, the core knowledge of our discipline is how, through the visual, we have learned to care for each other. We do not achieve this by asking students to remember the complete history of human visual image-making from the beginning of time. We are not teaching cultural literacy or even edited exemplar lists of iconic images. We teach students to care: a state of empathetic relational awareness. These are experiences

that are felt in the moment; they are understandings that are unrelated to a linear concept of time. Thus, as educators, we scavenge and raid from art processes and moments of art history to select tools for teaching care.

A State Curriculum of Aesthetics as Care

In the United States, there is no national educational authority responsible for disciplinary content. There is no agency responsible for establishing standards or uniform assessments—although the federal government is free to establish voluntary standards that states may follow if they so desire. Education, by law, is the responsibility of each state. Therefore, each state defines its own curriculum content and assessments.

In 2009, Georgia adopted new state Visual Arts Performance Standards (GVAPS). Over a year-long process, art educators and administrators committed to supporting visual art worked together on drafting the new standards for elementary, middle, and secondary education. In this process, teachers spoke to classroom actions and outcomes that they felt were authentic to art.

Of particular note is the role of aesthetics in these new standards. The 2009 Standards replaced the Georgia Quality Core Curriculum (QCC), Fine Arts. The older QCC called for a content strand of Aesthetic Understanding that ran consistently through every grade level. The Georgia QCC defined Aesthetic Understanding as the student's ability to identify and discuss the role of the elements of art and principles of design in a work of art. Through this analysis, students could enter into discussion on the nature and value of art. In contrast, the GVAPS defines aesthetics as "a philosophy of what we care for and what we take care of. It is a philosophy of responsibility." For the first time in official Georgia curriculum guides, learning to care was expressly stated as an educational outcome through the study of a core subject area. This was different from something like character education, which was a series of affective traits separate to academic content knowledge. Instead, the GVAPS establishes learning to care as a fundamental part of the knowledge of visual art.

The GVAPS articulates five forms of care as educational objectives of art instruction: the care of materials, the care of self, the care of others, the care of the school and the care of the community. Rather than teaching the content of art through pedagogy of care, the new standards allow for teaching the content of care through an art-based pedagogy. Thus, the Georgia Visual Arts Performance Standards address Noddings' concerns and establish care as the outcome of aesthetic education.

Here, it is important to add that we are aware that aesthetics has no easy definition and provokes serious debates—so contentious that art educators Kevin Tavin and jan jagodzinski have proposed that we drop the word from our curriculum. As the philosopher Richard Shusterman pointed out, aesthetics has a highly problematic intellectual history, with at least three different ways of being conceptualized. The GVAPS permit teachers to select from three different interpretations of aesthetic understanding.

Rather than argue as to whose aesthetics is right, we simply choose to stand for what we believe. We contend that there is a significant and legitimate philosophical history to frame aesthetics as a philosophy of care, being-in-relation, and responsibility. A fullness of being-in-relation can be characterized as empathy. Such empathy infers diligent effort toward right action. Therefore, we begin to see two branches of axiology merging—aesthetics and ethics. We fully realize that this is a minority position. Then again, Deleuze and Guattari reminded us that to pursue aesthetics is to be minoritarian: aesthetics exists as "rupture with the central institutions that have established themselves or seek to become established" (1987, p. 247). Therefore, we acknowledge our definition as a philosophical reimagining of the discipline; however, it is a reimagining based on historical precedent. This may be a rupture, but it is well within a 300-year tradition of thinking.

At this point in the essay, we transition to Lauren's teacher research narrative into teaching care in her visual art classroom.

Origami Cranes:
Lauren's Teacher Research Reflection

I taught art at the same elementary school for over a decade. I moved to my new elementary school for many reasons: getting to work with another art teacher after years by myself, as well as going to a place that supports arts integration in all subjects. My new school is very similar to my old one. Both have large numbers of Hispanic students but also have students from a wide variety of cultural backgrounds. Both have high transient populations and are only seven miles apart, which means I have a few students who have attended both schools. All of this should have made my transition easier. Except, I felt that the distance was much larger. I missed my former students, my teacher friends, knowing where everything was. From outward appearances, my new students act like my old students. They love art class. They are helpful and kind. However, they were not "my" students yet. Did I expect them to love me as my

old students had? I wanted to compress years of relationships into a few months, forgetting that I did not have a caring relationship with my old students overnight. I wanted my new students to work hard for me, to take pride in their artwork as my old students had. My new students did those things, but I still felt a space between us. Their work, their behaviors, our interactions, did not reach up to my impossible standards.

Service learning is a core component to my curriculum. For many years I led an *Empty Bowls* event at my school. *Empty Bowls* involves the students making ceramic bowls that they sell as part of an effort to raise funds for the local food bank. *Empty Bowls*, while worthy, is not easy for children, even with "my" students at my previous school. No child likes giving away clay, especially white stoneware clay with beautiful glaze on it. I told my students that we were making our bowls for a great cause: the money we raised from selling the bowls would go to our local food bank. Nevertheless, I was making them give up their clay for charity. My students want to keep their treasures for themselves or to give them to a loved one of their choice. I had another purpose. I had my own curriculum objectives of teaching them to care.

To effect this transition, I asked my students how they felt when they were hungry, knowing full well that some would answer with first-hand knowledge of persistent hunger. Some talked about stomachaches that would not go away. Others discussed being too tired during class and getting in trouble for not paying attention. We talked about our food bank and how it helps families from our school. I told the story of how high school students in Michigan started *Empty Bowls* by selling handmade clay bowls to help their local soup kitchen over 20 years ago. Of course, this discussion was compressed into 10 minutes, along with a demonstration on how to make a slab bowl, so we really didn't have time for one of *Empty Bowls*' important criteria: a real educational component, one that questions why the richest country in the world has too many hungry people. I hoped to talk about that later. My biggest problem, at the moment, was convincing 25 fifth-graders that we were going to make something that someone else was going to take home.

Then a student raised her hand and asked what we were doing about Japan. "What about Japan?" I replied, temporarily forgetting the horrible natural disaster that happened only days before. "What are we doing to help Japan?" she asked again, a little more forcefully this time. I paused. While I had personally made donations to the Red Cross and Doctors Without Borders, I had not asked my students how they wanted to help. "Can we make our bowls for Japan?" she suggested. Other students nodded in agreement. I praised the students for their

kind thoughts but reminded them that we already promised our bowls to our food bank. I'm not sure why I told them "we promised" when it was obvious that "I promised." I never asked my students if it was ok for us to make *Empty Bowls*, or to which charitable organization they wanted to send their donations, or how they felt about making art for helping others. I assumed their acquiescence from day one. Now, one of my students basically questioned why only the teacher should decide who to help and I had no quick answer for her. Her question forced me to examine why I promote service learning as a major part of my art program yet left my students out of important parts of the process.

I did not mean to design a top-down approach to service learning in my art room. While working on my master's degree, I learned of *Empty Bowls* and other service-learning projects. It never occurred to me that art lessons could include conversations about caring for others, even though I often told my students that I cared about them. I began to think about the worlds my students inhabited, how their school experiences were completely different from mine. I noticed that my students were very accepting of newcomers, welcoming, in fact, showing the new students who moved in every month how to become part of our school. They seemed more sensitive to the feelings of others, although I had no quantitative proof of this. I just had stories of shared materials, kind words, and helpful actions. Yet these stories multiplied over the years and I realized, despite the lack of objective proof of caring in my classroom, my students were engaging in empathetic behaviors in art class. I wanted to design lessons that supported those behaviors.

In my school district, we construct our curricula following the Georgia Visual Arts Performance Standards. The GVAPS address the many ways students can learn about and make art, from production to assessment. Service learning projects such as *Empty Bowls* are not cited in the GVAPS, but they are supported:

> Art, when taught through a reflective pedagogy of care and responsibility, promotes self-esteem and positive relationships. It improves self-confidence and personal awareness. The study of art stimulates the imagination and encourages students to utilize their creative potential in learning about and producing original works of art. It promotes the development of personal and cultural identity for students. Art instruction provides opportunities for students to work individually and collaboratively to foster social development and cooperative interaction. Additionally, the standards promote an awareness of art as a vocation, avocation, and means for living an aesthetically rich life.

Here are standards that are written with care and responsibility, imagination and creativity, collaboration and cooperation, as part of the curriculum. Along with

the elements and principles of design, the GVAPS acknowledge the teacher's role in "the development of personal and cultural identity for students." This goes beyond memorization of artists and artifacts, painting color wheels, or making a pinch pot. While the emphasis remains on production and assessment, the GVAPS, as the previous quotation illustrates, allow for the teaching of care in the art room. This is a small opening in the state standards. Past the introduction to K-5 education, care is not mentioned again in specific teaching objectives, other than in the Connections section, where care of materials is stressed.

Nevertheless, the GVAPS conclude with an important two-page appendix on interpreting "aesthetic." This section ends by allowing teachers to choose to interpret aesthetics as "a philosophy of what we care for and what we take care of. It is a philosophy of responsibility." The section includes specific essential questions that teachers might use to structure these lessons, such as "How do my choices as an artist affect my experience in creating a work of art?" "How do my choices as an artist affect the experience of other people when they look at my art?" and "How does art affect and cause us to reflect on the spaces and places in which we live and work?" Therefore, calls for aesthetic understanding in the standards, or the objective from the introduction "for living an aesthetically rich life," all open the possibility to teach for care.

These standards acknowledge what art teachers have been practicing implicitly for years. Through the manipulation of materials, through a cooperative learning environment where multiple ways of thinking are valued and shared, through an appreciation of the many ways culture and history teach us about ourselves and others, the arts value an empathetic way of looking at the world. For those teachers who want to seize this opportunity, our standards now officially support caring as the art curriculum.

However, standards cannot force a teacher to create a caring environment. Even with my best intentions, my students reminded me during the *Empty Bowls* lesson that caring is an act of being-in-relation. Caring is democratic agency. I cannot just declare that my students will be empathetic, and they will be so through *Empty Bowls*. If I want to make my classroom more caring, then I have to make it more democratic.

I could not finish class without addressing the Japan question. After my students finished their clay bowls, I asked them how they would help Japan. Several students suggested donating money. Another student chimed in: "We could make those origami cranes like the ones in the window," pointing to the back window where the previous art teacher left paper cranes hanging. I have never taught paper cranes before. They seemed too hard for elementary kids,

even though I always had a few students who knew how to make them. I hesitantly agreed to teach origami cranes. Several students began to whisper to each other excitedly. I realized I needed to change my lesson plans.

As anyone who has attempted origami knows, folding the paper often requires knowing which "base" to use, and in the case of the origami cranes, two bases are used: the square base, which leads to the bird base. The square base is relatively easy; all of my fifth graders could complete it after practicing a few times, since only three folds are needed to make the necessary creases in the paper. Part of the reason why I teach origami lessons in all of my classes is to emphasize the importance of following directions. While creativity and individuality are cherished in my art room, there are times when learning how to follow a sequence to get a result pays big dividends. Students learn the steps to turn a flat piece of paper into a form, which they can creatively apply to other domains, not just in art class. I think students enjoy origami because they can solve a complex problem by using their hands. No language or computation is required. All you need to do is follow the pictures showing you the folds. So, even though the bird base is more difficult than the square base that precedes it, all we needed to do was follow the steps, one at a time, to turn the square base into a beautiful crane.

It was a little harder than I thought, for two reasons. One, language fails. Below are the instructions for folding the crane. For most readers, these will be incomprehensible. Words cannot say. For most of us, we must learn this with our hands, but not any hand motion will do. One has to learn to value the sharp fold line that crisp origami paper allows. Not any paper will do. You have to understand that the qualities of origami paper are different. In our folding, we create relationships of qualities through which we are lured to learning.

1. Start with the patterned side of the origami paper face down on the table. Fold square in half horizontally to get a rectangle. Unfold. Fold paper in half vertically. Unfold.
2. Reverse fold diagonally so that the non-patterned side is showing. Unfold. Fold across the other diagonal. Unfold.
3. Turn your paper like a diamond and bring the two side corners together to form a square base.

The second difficulty comes when students feel that their hands have failed them. Now there is real danger of being lost. Words fail and hands fail. They cannot see what to do. A teacher is inviting panic in the classroom. Here the care of the others, the care of the more competent peer, becomes critical. Of

course, I try to help those who struggle, but I cannot be everywhere. So quietly, without my having to ask, those children who understand begin to help their friends. Without being told what to do, my class begins to demonstrate the care of others.

After we finished the square base, I demonstrated each fold for the bird base step by step.

4. With the opening of the square base towards you, fold over the bottom edges of one side square base to meet the vertical line in the middle. It will look like a kite shape on top of a diamond.
5. Flip over and repeat on the other side.
6. Fold the top flap down and crease. Fold the top flap over the other side.
7. Unfold the paper on one side and pull the top layer of paper up from the bottom of the square base. Fold back against the top crease and press the paper flat in a bird base.
8. Flip over and repeat steps on the other side to finish the bird base.
9. With the open end of the bird base towards you, fold over the bottom edges of one side of the bird base to meet the vertical line in the middle. It will look like a thinner version of the kite shape folded earlier.
10. Flip over and repeat on the other side.
11. Fold over paper to opposite side. Repeat.
12. Fold up bottom point to the top. Repeat on other side.

This is a beautiful thing about origami. The students who know how to fold the paper become great teachers to those who do not. And they must learn to be teachers, for there is a rule in my classroom: No one is allowed to touch your work except you. Neither your neighbor, nor your art teacher, can do your work for you. So my helpers teach their peers by modeling, they do not fold the cranes for their peers.

13. Fold down top and bottom flap to make wings.
14. Invert one of the upper points to make the head.
15. Pull the other upper point to make the tail.
16. Gently pull wings apart.

With all of the great student helpers, we finished the cranes but many were not happy with them. Several cranes had torn edges from over-manipulating the paper. One student accidently tore off his crane's head. I assured them these

practice cranes were just the first step. "We will improve," I promised. This is the promise of Foucault: through aesthetic engagement, through what we care about, we will recreate ourselves. Through care, we will make ourselves. We envision what we are not yet. This is the care of self.

Unfortunately, it was the end of our week together, and these students were not scheduled to come back to art again since it was the end of the school year. Fortunately, though, their classroom teacher agreed to send the students to my room every morning before classes to fold cranes. With a week to go before our huge school art show and *Empty Bowls* fundraiser, five or six students came to my room before classes started and folded cranes. Working in small groups, we folded paper into cranes. Sitting together at a table, instead of me showing the folds at the front of the classroom, along with practicing the folds the week before, made folding the cranes easier. Each crane was an improvement over the previous effort. Two other classes folded cranes as well. Everyone was impressed with how quickly we put together our origami cranes project. The students talked about which cranes they wanted and how much money they thought we could raise. I was worried since we did not have time to advertise the cranes before our art show. I wondered if we could raise any meaningful amount of money. I realized that the amount was insignificant compared to what was learned. My students wanted to create art to help others. They did not just exhibit caring behaviors in the art room. They wanted to make something to help people they did not know, thousands of miles away.

This space of learning occurred because my colleagues on the faculty allowed the children a place where we could work together outside of the structure of the school day. Their classroom teacher allowed them to come to my room before class began. A paraprofessional covered my bus duty. These acts of relationship fostered my students' aesthetic engagement (which had found its genesis in their previous knowledge of Japanese art). Out of this aesthetic engagement, the students had made the school a more caring environment. In this place, they imagined how they might care for the world. Even though the folding was a struggle for most of the students, they persisted, perhaps because they knew that this piece of patterned paper was not for them, but for something much bigger.

By the day of the art show, we folded almost 60 cranes. The cranes sold for 50 cents, though many people donated more. We raised nearly 50 dollars that night, which was given to relief efforts in Japan. It was a small donation, but the act of a small group of students made that possible. I discussed with my students how powerful that action was. I think many children (and adults) feel powerless

when they are confronted with large problems, such as the disaster in Japan. I felt helpless in the face of so much suffering. However, my students reminded me that we did not have to stand by and do nothing. We could act compassionately, using our art, to help others. Even though it was attempted during the last two weeks of school, with little preparation, and inventing the procedures as we went along, the origami cranes lesson worked for my students. It happened because they questioned their art teacher and realized that they had power to affect change. It became possible because my curriculum allowed me the flexibility to shift my focus from elements of design to the principles of caring and compassion.

REFERENCES

Alheit, P. (2009). Biographical learning—within the new lifelong learning discourse. In K. Illeris (Ed.), *Contemporary theories of learning* (pp. 116–128). New York, NY: Routledge.

Consortium of National Arts Education Associations. (1994). *National standards for arts education*. Reston, VA: Music Educators National Conference.

Deleuze, G., & Guattari, F. (1987). *A thousand plateaus: Capitalism and schizophrenia* (B. Massumi, Trans.).Minneapolis, MN: University of Minnesota Press.

Dewey, J. (1916). *Democracy and education*. New York, NY: The Free Press.

Dewey, J. (1989). Art as experience. In J. Boydston (Ed.), *John Dewey: The later works, 1925–1953* (Vol. 10: 1934, pp. 1–400). Carbondale, IL: Southern Illinois University Press. (Original work published 1934)

Dissanayake, E. (2000). *Art and intimacy: How the arts began*. Seattle, WA: University of Washington Press.

Foucault, M. (1988). *The history of sexuality: Volume 3, the care of the self* (R. Hurley, Trans.). New York, NY: Vintage.

Garrison, J. W. (1997). *Dewey and Eros: Wisdom and desire in the art of teaching*. New York, NY: Teachers College Press.

Georgia Department of Education (1998). *Quality core curriculum (QCC), fine arts*. Retrieved from https://georgiastandards.org/Standards/Pages/QCC.aspx

Georgia Department of Education. (2009). *Georgia performance standards: Visual arts*. Retrieved from http://www.georgiastandards.org/Standards/Pages/BrowseStandards/FineArts.aspx

Greene, M. (2001). *Variations on a blue guitar: The Lincoln Center Institute lectures on aesthetic education*. New York, NY: Teachers College Press.

jagodzinski, j. (2010). Between aisthetics and aesthetics: The challenges to aesthetic education in designer capitalism. In T. Costantino & B. White (Eds.), *Essays on aesthetic education for the 21st century* (pp. 29–42). Rotterdam, The Netherlands: Sense.

Noddings, N. (1995). Teaching themes of care. *Phi Delta Kappan, 76*(9), 675–679.

Phillips, L. (2003). Nurturing empathy. *Art Education, 56*(4), 45–50.

Schiller, F. (2004). *On the aesthetic education of man* (R. Snell, Trans.). Mineola, NY: Dover. (Original work published 1795)

Shusterman, R. (2006). The aesthetic. *Theory, Culture & Society, 23*(2–3), 237–252.

Siegesmund, R. (2010). Aesthetics as a curriculum of care and responsible choice. In T. Costantino & B. White (Eds.), *Essays on aesthetic education for the 21st century* (pp. 81–92). Rotterdam, The Netherlands: Sense.

Stevenson, A., & Lindberg, C. A. (Eds.) (2010). *New Oxford American dictionary*. New York, NY: Oxford University Press.

Tavin, K. (2007). Eyes wide shut: The use and uselessness of the discourse of aesthetics in art education. *Art Education, 60*(2), 40–45.

Taylor, P. G. (2002). Singing for someone else's supper: Service learning and empty bowls. *Art Education, 55*(5), 46–52.

Vygotsky, L. S. (1978). *Mind in society: The development of higher psychological processes* (M. Cole, Ed.). Cambridge, MA: Harvard University Press. (Original work published 1935)

Wiggins, G. P., & McTighe, J. (2005). *Understanding by design* (2nd ed.). Alexandria, VA: Association for Supervision and Curriculum Development.

· 1 4 ·

Empathy and Art Education

RICHARD HICKMAN

Introductory Remarks on the Term *Empathy*

To anyone with an interest in language, the word "empathy" is a bountiful one, and although it might seem a jejune approach to a chapter, I will begin by considering the word itself. Etymologically, "empathy" is derived from Greek, but Greek friends get alarmed by its use in English, as it denotes almost the opposite of its modern Greek sense: the English-speaking world understands the word to mean something akin to sympathy, but speakers of modern Greek equate it with hostility. In my modern Greek dictionary, εμπαθεια is given as "hatred, bitterness" and the adjective εμπαθησ is translated as "malicious, spiteful, malevolent"; the original Greek meaning was simply "passion," and this has evolved in the direction of negative emotions. While this might be seen as merely an interesting diversion, it does serve to indicate the importance of context when using the term. Moreover, there are different kinds of empathy, and one can, for example, empathise both with other people and with aspects of the material world.

Kunyk and Olson (2001) reviewed the use of the term "empathy" in nursing literature and found that five conceptualizations of it were in use: empathy as a human trait, empathy as a professional state, empathy as a communication process, empathy as caring, and empathy as a special relationship. They conclude

that empathy is not yet a "fully mature" concept in that there is little consensus among, in this case, nursing professionals (p. 324). Nevertheless, there is a considerable body of literature and other resources in the fields of nursing and medicine that support the use of art to help develop empathy amongst professionals (see, for example, the resources produced by New York University School of Medicine: *The HeART of Empathy: Using the Visual Arts in Medical Education*). Lawrence, Shaw, Baker, Baron-Cohen, and David (2004) asserted that empathy has a "multidimensional nature," identifying two main strands: cognitive empathy, and emotional empathy. Cognitive empathy is described as being the "intellectual/imaginative apprehension of another's mental state" (p. 911), while emotional (or affective) empathy is an emotional response to the emotional responses of others. Citing Davis (1994), they further distinguish affective responses to others' mental states as being "parallel" and "reactive." In the case of the former, the response matches that of another (such as feeling fear at another's fright), while the latter involves a more active response that goes beyond simply mirroring the emotion of another, bringing into play more sophisticated effects such as sympathy or compassion.

In art, "empathy" is a relatively recent addition to the vocabulary, dating from the late nineteenth century and popularised in the early twentieth century, via the German term *"Einfühlung."* Theodore Lipps (1854–1914) proposed an aesthetic theory based on *Einfühlung*. He postulated that as a spectator of a work of art, one imaginatively projects oneself into the art object. *Einfühlung* has a distinctive meaning of "feeling into" something, rather than "feeling with" and is a more extensive concept than "sympathy," in that it signifies the ability to comprehend another's state without actually experiencing that state. Wilhelm Worringer's 1907 thesis entitled *Abstraktion und Einfühlung: ein Beitrag zur Stilpsychologie* (Abstraction and Empathy: Essays in the Psychology of Style) built on the aesthetic theories of Lipps. He focused in particular on the notion that our own sense of beauty comes from being able to relate to the specific work of art. He asserted that stylized art reveals a psychological need to represent the essence of phenomena—to represent the world in a spiritual way rather than materially. For an intriguing commentary on empathy in contemporary aesthetics, see Baldacchino (in press).

The Neuroscientific Foundation

Simon Baron-Cohen (e.g., 2011) has helped popularise the public's understanding of the nature of empathy and has been instrumental in publicising the neuroscientific basis of our understanding of it. Carol Jeffers (2009a, 2009b)

explored the place of empathy in art education with reference to empirical work in neuroscience and to observations of her own students. Jeffers (2009a) asserted that "through the artworks and cultural objects they find personally significant, students of all ages can explore their concepts of self within a community of others and experience the power of empathy" (p. 19). She drew attention to her experiences of student-to-student empathic interactions in art classes, referring to "harmonious connections between students, their artworks, cultural objects, and classmates" (p. 22). The mirror mechanism discoveries of Rizzolatti (2005) and co-workers show that each time an individual observes an action done by another, a set of neurons that code that action fire in the brain. Put simply, if you observe someone draw or paint, or if you even read the words "draw" or "paint," the same neurons fire in your brain as if you were the one engaging in that activity.

However, Turella, Pierno, Tubaldi, and Castiello (2009) examined the neuroscientific literature and found that there is "relatively weak evidence for the existence of a circuit with 'mirror' properties in humans" (p. 10). While there is discovery of the existence of mirror neurons in macaque monkeys and evidence of some indication of there being similar neurological mechanisms in humans, one needs to be careful about extravagant claims that do not acknowledge the complexities of human interaction, such as we witnessed with discoveries relating to brain hemisphericity (and more brazenly with regard to the so-called "Mozart effect," which, put simply, refers to the transference of positive cognitive effects of listening to Mozart, from ability in music to, for example, mathematics). However, some generalised claims in the area of empathy research can be made, including claims about sex differences. Savoie (2009) for example, drawing upon the work of Baron-Cohen and colleagues (e.g., Baron-Cohen, Knickmeyer & Belmonte, 2005), noted the sex differences based on a continuum of strong empathising traits (female) to strong "systemising" traits (male). These differences are frequently found in the art classroom, with research confirming the stereotypes of girls depicting peaceful domestic scenes and boys favouring scenes of action and violence, often involving machines, monsters, and dinosaurs (see Chen & Kantner, 1996; McNiff, 1982; Speck, 1995).

Evolutionary Psychology

I must confess to having a little sympathy with exponents of evolutionary psychology as a framework for understanding certain aspects of human behavior and development. Bearing in mind some of the assertions arising from research in neuroscience, we can now say with a degree of confidence that humans are

biologically adapted to be social creatures; our physiology pre-disposes us towards empathy. I would go further and say that we are also biologically pre-disposed to "create aesthetic significance" (Hickman, 2010, p. 110), to engage with materials and media to make meaning—to communicate our abstract thoughts, feelings, and imaginings in a concrete and practical way to others. Dutton (2009) encapsulated the principal arguments surrounding the notion that human beings have an "art instinct." There is no shortage of critics who would take issue with this assertion, and some draw attention to weaknesses in Dutton's overall thesis that modern humans' aesthetic behaviour can be traced back to the Pleistocene period. There is, however, an increasingly coherent argument in support of the notion that "creating aesthetic significance" can be considered a fundamental human trait. Ellen Dissanayake (2000, 2007) for instance, argued that art, or at least "making special," is a fundamental evolutionary adaptation, developing the argument she put forward in an earlier text (Dissanayake, 1988), where she made a case for viewing art from a "species-centric" perspective. The important thing here is to recognise that humans tend to "make special" for the benefit of others; we create interesting and beautiful forms in order to communicate something that is of significance not just to ourselves but to other people. Art objects can provide a shared focus for thoughts and feelings.

Dissanayake, like Dutton, referred to the fact that all human (and for that matter, animal) characteristics that are necessary for the continuation of the species are in some way enjoyable; art making is a natural human characteristic that has evolved because of its importance in perpetuating *Homo sapiens*. Aligning myself with Dutton, I would contend that aspects of behaviour that are associated with art-making might have a biological rather than a purely cultural foundation: All humans (to the best of my knowledge) seem to have a strong interest in creating narratives and an enjoyment of problem solving; human beings also appreciate and value skillfully made objects. I have no doubt that humans in general show a distinct preference for certain forms and spatial relationships, not least "golden section"-type ratios (1:6:18, given the mathematical symbol φ or *Phi*); in other words, we have a common, shared aesthetic sense. While this goes against much of the thinking in post-modern academic circles, particularly social scientists, there appears to be a growing body of knowledge that underpins the notion of a common humanity and a shared aesthetic sense; I have no doubt that we are at the beginning of a resurgence in interest in formalist aesthetic theory.

Steven Pinker (2003), a Harvard University psychologist, has popularised a rejection of the "blank slate" (Pinker, 2003) conception of human nature.

Pinker believes that art is a by-product of three other adaptations, namely, the hunger for status, the aesthetic pleasure of experiencing adaptive environments, and the ability to design artefacts to achieve desired ends. To these I would add the pleasure of genuine communication with others via an empathetic response to made objects. For educators, if we accept that young people have an "art instinct," then it is incumbent upon us to ensure that this instinct is nurtured and developed. In writing about art education and the evolution of the social brain, Blatt-Gross (2010) drew attention to how arts practice, particularly visual arts, can help to bond students socially. She suggested that:

> through the use of narrative, the construction of personally relevant meaningful realities, the sharing of knowledge and skill [...] and the physical manifestation of cognitive achievements [...] the arts can help to establish a classroom environment with similarities to the society of intimates that our ancestors found so beneficial. (p. 364)[1]

The idea that art might be something more than a cultural construct should not be dismissed by art educators—after all, the notion gives added credence to the belief that art should be an integral part of any school curriculum.

Empathy and Art Education

It is gratifying that the potential value of art education in developing empathy is recognized at the highest levels—the President's Committee on the Arts and the Humanities published *Reinvesting in Arts Education: Winning America's Future Through Creative Schools* in May 2011, drawing attention to the work of McCarthy, Ondaatje, Zakaras, and Brooks (2004). This RAND report examined the evidence for both private and public benefits associated with engagement with art and concluded that the discussion of these benefits, which in America has tended to focus on those considered to be transferable, should place far more emphasis on the intrinsic pleasures of the arts, which benefit not only individuals, but also the public good. Benefits claimed that are of interest to educators include focused attention, capacity for *empathy* [my emphasis], cognitive growth, social bonds, and expression of communal meaning. Unfortunately, these are only claims, with little empirical evidence to support them. Moreover, common sense would tell us that engaging in art-making does not of itself make people more empathetic.

Antoniou (2011), in examining some children's engagement with art, found an interesting example of the power that some art works can have on children. Katerina, an 11-year-old Cypriot girl, was particularly sensitive to the

relationship between artist, artwork, and viewer. From in-depth interviews with her, Antoniou noted that Katerina's involvement in art-making was principally a therapeutic process, during which Katerina expressed her feelings through images on paper.

> She found that this activity offered her comfort and made her feel better. She perceived this comfort coming both from the artwork, which understood her, as she said, and also from those who saw the artwork because they could see in it how she felt and they therefore could support or help her—or at least that is what she was hoping for. Similarly, when looking at artworks made by other children, Katerina tried to "read" them the same way that she expected others to read her artworks. She looked for the emotions enclosed in them. She felt strong bonds with artworks which she thought carried emotions or moods similar to hers, because she felt that she was not alone as those artworks "felt" the same way as she did. (p. 229)

Katerina revealed through her responses that she was aiming for emotional and practical support when making and looking at artworks, wanting to feel that someone understood her emotions. This understanding would be revealed either through their responses when looking at her artworks or through the creation of artworks that carried the same emotions that she did. Antoniou (2011) also noted that Katerina seemed to suggest that art was not merely the means through which people could express their emotions, but that the artwork itself also had emotions and could therefore "feel" her as well.

I am concerned here with art in *education*, and there are particular characteristics of art education that are interrelated and can be associated with the development of empathy; I highlight four of them: The Studio Environment, making, noticing, and imagining.

The Studio Environment

The first characteristic that I want to consider is the learning environment, typically the studio. Here, I am referring to the art classroom, a place frequently referred to in the literature as a "haven" (Tallack, 2000), an "oasis" (Sikes, 1987), a "sanctuary" (Hargreaves, 1983), and a place where student interaction can be actively encouraged (Hickman, 2011). A key feature of many art classrooms is the sense of community; students are often encouraged to engage in group work, and discussion of art objects is commonplace. Student-to-student interaction can take place via an art work, with the art object (which might, for example, be an installation) being the focus, and students responding to it and to each other. Students are often expected to engage in group criticism of their work, and this affords a focused opportunity to engage in meaningful interaction.

Significant art works are multi-layered phenomena, replete with meaning, and can provide a focus for students in discussion of things that are meaningful to them. They can provoke both affective and cognitive responses (Lawrence et al., 2004) and facilitate dialogue between students:

Can you see what I see?

Do you feel what I feel?

Are you thinking what I'm thinking?

The observations made by Jeffers (2009 a and b) echo those of commentators on nursing practice (Smith et al., 2004; Wikström, 2001a, 2001b), who refer to the value of art in creating empathetic environments, and to using art-making to create a safe environment for the discovery of personal knowing and empathy.

This leads me to highlight a second characteristic of art education that can be associated with the development of empathy—the place of *making*.

Making

I have used the phrase "practical sagacity" to refer to an attribute of effective teachers of art (Hickman, 2011). Through their practice and through their practical engagement with various materials and media, effective art teachers use their own wisdom in a demonstrably creative way to scaffold learning, drawing out in a practical way the inherent wisdom of their students. If we take, as I do, one outcome of creative behavior to be something that is of quality and is worthwhile, then the outcome of creative teaching ought to be, among other things, the promotion of wisdom. This, in turn, facilitates an awareness of the needs of others. This is particularly apposite when considering problem-solving activities, such as those commonly occurring in designing and making. In order to satisfy the needs of a client, it is useful, if not necessary, to identify personally with that client's needs.

Art education's concern for making is society's way of helping fulfil the intrinsic urge to create and respond to aesthetic significance. I argue that human beings have an innate desire to create something of significance. In so doing, humans have the unique ability to both empathise with their immediate environment and to make qualitative judgments about it. People who are engaged in creating aesthetic significance form a special relationship with their created work. In the case of representational drawing, for example, this can go further as we investigate, interrogate, and metaphorically penetrate the object of depiction; we inevitably "feel into" the object of representation. So there are several aspects to the relationship between empathy and making: empathising with media and material; empathising with clients' needs; and

empathising with the focus of attention in the material world through artistic re-presentation, or mimesis.

Noticing

The development of perception, in particular aesthetic perception, is the third area that I wish to discuss. I am concerned here with noticing—although not just noticing, but *noticing*—the emphasis indicating that I am referring to really looking hard at things and seeing them as if for the first time. This is one goal for aesthetic education. At this point we might ask ourselves, "What does it mean to be aesthetically educated?" The term has an unfortunate ring of elitism about it but is nevertheless a useful one and more specific than, for example, "environmentally aware." Being aesthetically educated implies that some teaching has taken place and that such teaching has focused on the aesthetic dimension of human experience, an awareness of the relationship between context and function as well as between form and content. In day-to-day terms this might manifest itself in, for example, noticing litter (and not contributing to it). My personal view has been, for as long as I can remember, that if one is visually sensitive, then one does not despoil the environment; if one is aesthetically aware, this entails having sensitivity not only towards art objects but also to one's environment. However, aesthetic perception is not just concerned with noticing *things*, it is an awareness of and sensitivity towards others, what Maxine Greene might term "wide-awakeness" (Greene, 1977).

Imagining

It is a stated aim of many art education programs to promote the imagination. Involvement with practical art making—creating aesthetic significance—helps students to become acquainted with materials that facilitate imaginative expression. Imagination involves the actual construction of new realities; it is not simply fantasy or the conjuring up of mental images of things not experienced. Creating these new realities can further stimulate the imagination; art making provides a conduit for the imagination to flow from internal genesis to external manifestation. Maxine Greene (1977) asserted that "of all our cognitive capacities, imagination is the one that permits us to give credence to alternative realities" (p. 3). Art-making activities allow people to create worlds where they can be free to invest personal significance, to consider alternatives, and to consider possibilities. Such activities can involve imagining what it might be like to be another person, or even an animal, and it is in this way that empathy is engendered.

A link between empathy and creativity has been suggested by a number of workers in the field (e.g. Bastick, 1982; Richards, 2007). Interest in creativity from politicians, economists, and others outside education has ebbed and flowed over the decades but remains on an upward trajectory, and the business world in particular has long recognised the importance of entrepreneurial spirit. Through promoting inventiveness and risk-taking and by facilitating the development of practical problem-solving through manipulation of materials, art teachers can enhance creative behaviour through developing lateral thinking skills. However, it is through developing students' understanding of the visual (and tactile) world through perceptual training and giving time and space for students to explore their inner worlds of feelings and imagination that empathy is developed. It is at this intersection—between entrepreneurialism and imagination—where empathy becomes something of profound and wide-ranging value. In particular, if we can create an empathetically oriented workforce as a result (in part) of focusing upon it within our education systems, we will be in a position to take the "rabidity" out of unfettered capitalism and to promote an environmentally sound approach to industrial and economic growth.

An Agenda for
Empirical Research in Art Education

I have outlined four interrelated aspects of visual art education that can be associated with the promotion and development of empathy: the studio environment; the facilitation of perceptual development; the provision of opportunities for making; the value accorded to imagination. Advocates of visual art (and arts) education have often been accused of "flag waving," with references to dubious or irrelevant claims, such as the Mozart effect mentioned above. Sympathetic commentators, notably Hetland and Winner (2004), have carefully examined the research bases for instrumental claims and have found only tenuous evidence, but they point to the need to acknowledge the intrinsic value of an education in art: "the arts are the only arenas in which deep personal meanings can be recognised and expressed" (p. 158). There is, then, a need to conduct more empirical research in this area. In particular, we need to find answers to the following:

~ Does engagement in art activities measurably develop empathy?
~ What art activities most effectively promote empathy?
~ How might involvement in art-making facilitate the development of imaginative faculties?

~ How might interaction with art objects facilitate the develop-
 ment of imaginative faculties?
~ How might the extent of any of the above be determined?

Lawrence et al. (2004), in the study referred to above, conducted a series
of rigorous research experiments that examined the reliability and validity of
a self-report scale designed to measure social understanding (known as the
Empathy Quotient). They concluded that it is a valid and reliable scale. This
indicates that something that is notoriously difficult to measure, in this case
social understanding, in which empathy plays a crucial part, can be deter-
mined empirically. It should therefore be possible (although still difficult) to
empirically quantify the effects of engagement with art in developing empathy.
Elliot Eisner's aphorism at the beginning of his chapter on the educational uses
of assessment and evaluation in the arts in his book, *The Arts and the Creation
of Mind*, seems apposite here: "Not everything that matters can be measured,
and not everything that is measured matters" (p. 178). Empathy matters, and
while we might not need to measure it as such, we do need to quantify in some
way the extent to which (if at all) art, either through making or perceiving,
helps develop people's capacity for empathising with others. I am not advocat-
ing or privileging quantitative approaches to research, but arts educators do
need to ensure that the field has rigorously gained empirical evidence to sup-
port claims. Notwithstanding my example from the work of Lawrence et al. in
neuroscience, I would suggest that qualitative approaches (such as interview and
field observation) derived from ethnography would be an appropriate way for-
ward. What is clear to me is that arts educators need to draw upon the meth-
ods and methodologies of other disciplines and also to engage in more
inter-disciplinary debate. This is not a one-way exchange; the pedagogical
practice of artists and art teachers has an enormous amount to offer other sub-
ject areas, especially in terms of grouping strategies, learning environment, and
use of resources. I would venture to say that it is not the subject as such that
might (or might not) promote empathy, but the way that it is taught.
 Engagement with art can, of course, mean many things. At the very least
a distinction needs to be made between interacting with art objects and mak-
ing art objects—both appear to have a part to play in facilitating empathetic
responses and development. In exploring the contribution that engagement
with art can make to people's lives, it is hoped that concepts embodied in this
chapter will provide useful material for art education advocacy.

NOTE

1. The phrase "society of intimates" refers to anthropological research about the value of small cultural groups for survival.

REFERENCES

Antoniou, F. (2011). *Children's engagement with art: Potential paths of children's art-making and responses to art* (Unpublished PhD dissertation). University of Cambridge, England.

Baldacchino, J. (in press). *Art's way out: Exit pedagogy and the cultural condition*. Boston, MA: Sense.

Baron-Cohen, S., Knickmeyer, R.C., & Belmonte, M.K. (2005). Sex differences in the brain: Implications for explaining autism. *Science, 310*, 819–23.

Baron-Cohen, S. (2011). *Zero degrees of empathy: A new theory of human cruelty*. London, England: Penguin/Allen Lane.

Bastick, T. (1982). *Intuition: How we think and act*. Chichester, NY: John Wiley & Sons.

Blatt-Gross, C. (2010). Casting the conceptual net: Cognitive possibilities for embracing the social and emotional richness of art education. *Studies in Art Education 51*(4), 353–366.

Chen, W.J.,& Kantner, L.A. (1996). Gender differentiation and young children's drawings. *Visual Art Research, 22*(1), 44–51.

Davis, M. H. (1994). *Empathy: A social psychological approach*. Dubuque, IA: Brown & Benchmark.

Dissanayake, E. (1988).*What is art for?* Seattle, WA: University of Washington.

Dissanayake, E. (2000). *Art and intimacy: How the arts began*. Seattle, WA: University of Washington.

Dissanayake, E. (2007). What art is and does: An overview of contemporary evolutionary hypotheses. In C. Martindale, P. Locher, & V. M. Petrov (Eds), *Evolutionary and neurocognitive approaches to aesthetics, creativity, and the arts* (pp.1–14). Amityville, NY: Baywood.

Dutton, D. (2009). *The art instinct: Beauty, pleasure, and human evolution*. New York, NY: Bloomsbury.

Eisner, E. (2002). *The arts and the creation of mind*. London, England: Yale University Press.

Greene, M. (1977). Toward wide-awakeness: An argument for the arts and humanities in education. *Teachers College Record, 79*(1), 119.

Greene, M. (1995). *Releasing the Imagination*. San Francisco, CA: Jossey-Bass.

Hargreaves, D.H. (1983). The teaching of art and the art of teaching. In M. Hammersley & A. Hargreaves (Eds.), *Curriculum practice: Some sociological case studies* (pp. 127–150). London, England: Falmer.

Hetland, L., & Winner, E. (2004). Cognitive transfer from arts education to non-arts outcomes: Research evidence and policy implications. In E. Eisner & M. Day (Eds.), *Handbook on research and policy in art education* (pp. 135–161). Reston, VA: National Art Education Association.

Hickman, R. (2010, 2nd ed.). *Why we make art—and why it is taught*. Bristol, England: Intellect.

Hickman, R. (2011). *The art and craft of pedagogy: Portraits of effective teachers*. London, England: Continuum.

Jeffers, C. S. (2009a). Within connections: Empathy, mirror neurons, and art education. *Art Education, 62*(2), 18–23.

Jeffers, C. S. (2009b). On empathy: The mirror neuron system and art education. *International Journal of Education & the Arts, 10*(15). Retrieved from http://www.ijea.org/v10n15/

Kunyk, D., & Olson, J. (2001). Clarification of conceptualizations of empathy. *Journal of Advanced Nursing, 35*(3), 317–325.

Lawrence, E.J., Shaw, P., Baker, D., Baron-Cohen, S., & David, A.S. (2004). Measuring empathy: Reliability and validity of the Empathy Quotient. *Psychological Medicine, 34*, 911–924.

McCarthy, K.F., Ondaatje, E.H., Zakaras, L., & Brooks, A. (2004). *Gifts of the muse: Reframing the debate about the benefits of the arts.* Santa Monica, CA: RAND.

McNiff, K. (1982). Sex differences in children's art. *Journal of Education, 164*(3), 272–289.

New York University School of Medicine: *The heART of empathy: Using the visual arts in medical education.* Retrieved from http://litmed.med.nyu.edu/Annotation?action=view&annid=12975

Pinker, S. (2003). *The blank slate: The modern denial of human nature.* London, England: Penguin.

President's Committee on the Arts and the Humanities. (2011). *Reinvesting in arts education: Winning America's future through creative schools.* Retrieved from http://www.pcah.gov/resources/re-investing-through-arts-educationwinning-americas-future-through-creative-schools

Richards, R. (Ed.). (2007). *Everyday creativity and new views of human nature: Psychological, social and spiritual perspectives.* Washington, DC: American Psychological Association.

Rizzolatti, G. (2005). The mirror neuron system and its function in humans. *Anat Embryol 210*, 419–421. Retrieved from http://www.springerlink.com/content/pt461rv48044h461/

Savoie, A. (2009). Boys' lack of interest in fine arts in a coeducational setting: A review of sex-related cognitive traits studies. *International Journal of Art & Design Education, 28*(1), 25–36.

Sikes, P.J. (1987). A kind of oasis: Art rooms and art teachers in secondary schools. In L. Tickle (Ed.), *The arts in education—Some research studies* (pp. 141–165). Beckenham, England: Croom Helm.

Smith, R., Bailey, M., Hydo, S., Lepp, M., Mews, S., Timm, S., & Zorn, C. (2004). All the voices in the room: Integrating humanities in nursing education. *Nursing Education Perspectives, 25*(6), 278–283.

Speck, C. (1995). Gender differences in children's drawings. *Australian Art Education, 18*(2), 44–54.

Tallack, M. (2000). Critical studies: Values at the heart of education? In R. Hickman (Ed.), *Art Education 11–18: Meaning, purpose and direction* (pp. 105–123). London, England: Continuum.

Turella, L., Pierno, A.C., Tubaldi, F., & Castiello, U. (2009). Mirror neurons in humans: Consisting or confounding evidence? *Brain and Language 108*(1), 10–21.

Wikström, B. (2001a). Works of art: A complement to theoretical knowledge when teaching nursing care. *Journal of Clinical Nursing,10*(1), 25–32.

Wikström. B. (2001b): Work of art dialogues: An educational technique by which students discover personal knowledge of empathy. *International Journal of Nursing Practice, 7*, 24–29.

Contributors

Tom Anderson (PhD, University of Georgia). Dr. Anderson has been teaching at Florida State University for 30 years. He is the author, or co-author, of more than 50 refereed research papers and three books in the field of art education. His driving interests are art/education and the environment, art education for social justice, and the social foundations of art and education. More information is available at: eartharteducation.com and http://arted.fsu.edu/People/Faculty/Tom-Anderson-Ph.D

Terry Barrett (PhD, Art Education, The Ohio State University). Dr. Barrett is a Professor in the Department of Art Education and Art History, University of North Texas. He is also Professor Emeritus of Art Education at The Ohio State University, where he is the recipient of a Distinguished Teaching Award for courses in art and photography criticism and aesthetics within education. He has authored six books: *Making Art: Form & Meaning*; *Why Is That Art? Aesthetics and Criticism of Contemporary Art*; *Interpreting Art: Reflecting, Wondering, and Responding*; *Criticizing Art: Understanding the Contemporary*; *Criticizing Photographs: An Introduction to Understanding Images*; and *Talking about Student Art*. He is editor of the anthology *Lessons for Teaching Art Criticism*, former senior editor of *Studies in Art Education*, and has served as a visiting scholar in the United States and abroad.

Donald Blumenfeld-Jones (EdD in Curriculum Studies, UNC-Greensboro) is currently Associate Professor of Curriculum Studies in the Mary Lou Fulton Teachers College of Arizona State University. He founded and directs an elementary education teacher-prep program titled ARTs (Arts-based Reflective Teaching). He has received the James B. Macdonald Prize in Curriculum Studies, and Outstanding Alumni Award from UNC-Greensboro's School of Human Health, Physical Education, and Dance. He has delivered numerous international keynote speeches addressing human rights, ethics, the arts, and education. His new book (in press) is *Curriculum and the Aesthetic Life: Hermeneutics, Body, Democracy and Ethics in Curriculum Theory and Practice*, (Peter Lang). He has published on Levinas in *Educational Theory*, *Teacher Education and Practice* and in an edited book, *The Moral Work of Teaching: Preparing and Supporting Practitioners*, from Teachers College Press.

Liora Bresler (PhD, Stanford University). Dr. Bresler is a Professor at the University of Illinois, Champaign. She is also the Hedda Anderson (Visiting) Chair in Lund University, Sweden; a Professor II at Stord University, Norway; and an Honorary Professor in Hong Kong Institute of Education. Bresler has published 100+ papers and book chapters and has written and edited several books on the arts in education, including the *International Handbook of Research in Arts Education* (2007). Her work has been translated into German, French, Portuguese, Spanish, Hebrew, Finnish, and Chinese. Bresler has won the Distinguished Teaching Life-Long Career Award at the College of Education (2004) and the Campus Award for Excellence in Graduate Teaching at the University of Illinois (2005). Other awards include Distinguished Fellow in NAEA (2010), the Edwin Ziegfeld Award for Distinguished International Leadership in Art Education by the United States Society for Education Through Art (2007), and The Lin Wright Special Recognition Award by The American Alliance for Theatre and Education (2007).

Tracie Costantino (PhD, Curriculum and Instruction, University of Illinois at Urbana-Champaign). Dr. Costantino is an Associate Professor of Art Education at the University of Georgia. Her research focuses on the nature of cognition in the arts, creativity, and the transformative potential of aesthetic experience as an educative event. Her interest in interdisciplinary curriculum and creative learning at the undergraduate level has been supported by funding from the National Science Foundation for a collaborative project integrating art and engineering. In addition to numerous published articles and book

chapters, recent work related to the transformative potential of aesthetic experience was published in the book Costantino co-edited with Boyd White, *Essays on Aesthetic Education for the 21st Century* (Sense, 2010).

Laura Evans (PhD in Art Education, The Ohio State University). Dr. Evans is an Assistant Professor of Art History and Art Education in the College of Visual Arts and Design at the University of North Texas. She is the Director of the University's Museum Education Certificate, a unique program that allows students to focus solely on the educative aspects of art museums. Previous to her PhD, Evans was an academic fellow at the National Gallery of Art in the Department of Education and earned her Master's in Museum Studies at the University of Toronto.

Richard Hickman (PhD, Reading University). Dr. Hickman is a Fellow of Homerton College, Cambridge and Reader in Art Education at the University of Cambridge, where he is course leader for the Art & Design component of initial teacher education. Dr. Hickman began his career in art education as a lecturer in art education at Reading University (as a joint appointment with a local school) in 1985. He later taught in Singapore (Nanyang Polytechnic University) before joining Cambridge in 1997. Richard is author of *The Art & Craft of Pedagogy* (Continuum, 2011) and *Why We Make Art and Why It Is Taught* (Intellect, 2005); he edited *Research in Art & Design Education* (Intellect, 2008), *Art Education 11–18* (Continuum, 2004), and *Critical Studies in Art & Design Education* (Intellect, 2005). He has had seven solo exhibitions of his paintings, exhibiting in England, France, Singapore, and Australia.

Juli Kramer (PhD in Curriculum and Instruction, with a Cognate emphasis in Counseling Psychology, University of Denver). Dr. Kramer teaches K-12 Art Methods at the University of Denver and is the principal of Denver Academy of Torah High School, a small, private Modern Orthodox school. Her research focuses on healthy youth development, creativity, and care theory. She won the NAEA's Elliot Eisner Doctoral Research Award in Art Education in 2011 as well as the American Psychological Association Graduate Student Ethics Prize in 2005. Her ethics prize paper, "Ethical Analysis and Recommended Action in Response to the Dangers Associated with Youth Consumerism," was published in *Ethics and Behavior* in 2006. Kramer presents regularly at national and regional conferences on using aesthetic learning experiences to enhance positive youth development in both formal and informal educational settings.

Indrani Margolin (PhD, Ontario Institute for Studies in Education at the University of Toronto, in Curriculum: Holistic & Aesthetic Education). As Assistant Professor at the University of Northern British Columbia in the School of Social Work, her research and teaching interests span: Alternative therapies, arts-based methodologies, and inquiry into the bodyself. In 2010, Dr. Margolin received the Canadian Association for the Study of Women and Education Doctoral Student Award in recognition of her dissertation entitled, *Beyond Words: Girls' Bodyself*. She also has a Master of Social Work degree from Wilfrid Laurier University. Currently she is a co-investigator on a CIHR gender and social inequities grant that employs arts-based methods to understand the recovery process of mental illness for women. Publications include: "Poetic Consciousness in Pedagogy," *Education*; "Wellness through a Creative Lens: Meditation and Visualization," *Journal of Religion & Spirituality in Social Work*, and a co-authored educational reader on dance.

Sherry Mayo (EdDC.T., Art & Art Education in College Teaching, Teachers College, Columbia University). Dr. Mayo is the Director of The Center for Digital Arts at Westchester Community College. Recent publications include: "A Model for Collective Aesthetic Consciousness," *International Journal of Art, Culture and Design Technologies*, (Jul.–Dec. 2011), *1, 2*; *Studio Artists at the Human-Computer Interface: A Case-Study of Arts Technology Integration in Studio Practice* (2009), (VDM Verlag Dr. Müller Aktiengesellschaft & Col. KG); and "The Prelude to the Millennium: The Backstory of Digital Aesthetics," *The Journal of Aesthetic Education*, (2008). Juror's Choice Award for Drawing (2010), WAAM (Woodstock Artists Association & Museum), Far & Wide: 2nd Annual Woodstock Regional, juried by Patricia Phagen.

Lauren Phillips (PhD candidate, MAEd, BSEd in Art Education, Georgia State University). She has taught art at the elementary level in Gwinnett County (GA) for 13 years and currently teaches art at Nesbit Elementary. Since 2001, Lauren has served as a co-president for the East Metro district of the Georgia Art Education Association. She has presented at state and national art education conferences as well as publishing her work in *Art Education*. In 2011 she was named the National Art Education Association's Southeastern Elementary Art Educator of the Year.

Believing that art can make a positive impact on the community, Lauren and her students have participated in Empty Bowls fundraisers since 2004, raising money for local food banks by selling student-created clay bowls.

Richard Siegesmund (PhD in Art Education, Stanford University). Currently, Dr. Siegesmund is Associate Professor of Art & Design Education at Northern Illinois University. Retired from the University of Georgia, Lamar Dodd School of Art, he is also the former President of Integrative Teaching International, and a co-editor of *Arts-Based Research in Education: Foundations for Practice* (2007). Most recently, he published with Karinna Riddett-Moore, "Arts-Based Research: Data Are Constructed, Not Found," in *Action Research: Plain and Simple*, edited by Sheri Klein. In 2010 he was a Fulbright scholar to the Faculty of Education at the National College of Art and Design (NCAD) in Dublin, Ireland. He is also the recipient of the National Art Education Association's Manuel Barkan Memorial Award for significance of published research and was recognized by the Georgia Art Education Association for Distinguished Service within the Profession.

David Swanger (EdD in Language and Literature Education, Harvard University). Dr. Swanger held a joint appointment in Education and Creative Writing/Literature at the University of California, Santa Cruz, for 35 years before becoming Professor Emeritus of Education and Creative Writing. He has written four books of poems, the most recent of which, *Wayne's College of Beauty* (2006), won the John Ciardi Prize for Poetry from Mk Bk Press. Scholarly work includes *The Poem as Process* and *Essays in Aesthetic Education*. Swanger has won poetry fellowships from the N.E.A. and the California Arts Council, and his poems have been read by Garrison Keillor on *The Writer's Almanac*. His poems have also been published extensively in journals and anthologies, as has his writing on poetics and aesthetic education. Swanger is Poet Laureate of Santa Cruz County, California.

Boyd White (PhD, Concordia University). Dr. White is an Associate Professor in the Department of Integrated Studies in Education, Faculty of Education, McGill University. Teaching and research interests are in the areas of philosophy and art education, particularly on the topic of aesthetics and art criticism and their facilitation of meaning making. He is the author of numerous journal articles and has chapters in various texts, among them, *ReVisions: Readings in Canadian Art Teacher Education (3rd ed.)*, *Starting with . . . (3rd ed.)*, and *What Works: Innovative Strategies for Teaching Art*. Texts include: *Aesthetics Primer* (2009, Peter Lang) and *Aesthetic Education for the 21st Century*, co-edited with Tracie Costantino (2010, Sense). He also edited *Canadian Review of Art Education: Research and Issues*, 2001–2007.

Sean Wiebe (PhD, University of British Columbia). Dr. Wiebe is an Assistant Professor at the University of Prince Edward Island, teaching courses in language and literacy, curriculum theory, and global issues. His research explores issues in writing pedagogy, autobiography, teacher narratives, and arts-based methodologies. Dr. Wiebe is a poet, philosopher, and provocateur. His career has spanned 20 years in education, beginning as a secondary English teacher before moving to educational administration and higher education.